The Mask of Socrates

SATHER CLASSICAL LECTURES, VOL. 59

PAUL ZANKER

The Mask of Socrates

The Image of the Intellectual in Antiquity

Translated by Alan Shapiro

UNIVERSITY OF CALIFORNIA PRESS

BERKELEY LOS ANGELES OXFORD

*The preparation of this work was made possible in
part by a grant from the National Endowment for the
Humanities, an independent federal agency.*

*This work is supported by a grant from the Sather
Fund of the University of California, Berkeley.*

University of California Press
Berkeley and Los Angeles, California

University of California Press, Ltd.
Oxford, England

Library of Congress Cataloging-in-publication Data

Zanker, Paul.
 [Maske des Sokrates. English]
 The mask of Sokrates : the image of the intellectual in antiquity
/ Paul Zanker ; translated by Alan Shapiro.
 p. cm. —— (Sather classical lectures ; v. 59)
 Includes bibliographical references and index.
 ISBN 0-520-20105-1
 1. Art, Classical. 2. Authors, Classical——Portraits.
 3. Philosophers——Greece——Portraits. 4. Philosophers——
 Rome——Portraits. 5. Intellectuals in art. 6. Greece——
 Intellectual life. 7. Rome——Intellectual life. 8. Civlization,
 Classical. I.. Title. II. Series.
 N7585.Z3613 1995
 704.9'42'0938——dc20 95-12409
 CIP

Printed in the United States of America

9 8 7 6 5 4 3 2 1

The paper used in this publication meets the minimum requirements of
American National Standard for Information Sciences—Permanence of
Paper for Printed Library Materials, ANSI Z39.48-1984.

CONTENTS

ACKNOWLEDGMENTS

This book would never have come about if not for the invitation to deliver the Sather Classical Lectures at Berkeley in the spring of 1991. As an archaeologist, I sought out a topic that I hoped would attract the interest of an audience of philologists, historians, and philosophers. Though this book builds on earlier work developed in classes and seminars in Munich, without the challenge of the Sathers, I would not have dared attempt this synthetic account of a topic so broad and complex, which has already been the subject of much specialized research. My first debt of thanks is therefore owed to all my colleagues in the Department of Classics at Berkeley. The hospitality and friendship of these colleagues, especially the then chairman, Mark Griffith, made the months in the Bay Area a truly memorable experience for me and my family—one that we often look back on with great nostalgia.

For the publication, it has seemed to me necessary to revise fully and in places to expand the lecture texts. The basic structure and style of the presentation, however, retain the essaylike character of the lectures, and I have tried to restrict most of the more technical and scholarly discussion to the notes. The completion of the manuscript in this form would not have been possible without an invitation to spend the 1993–94 academic year at the Wissenschaftskolleg in Berlin. The remarkable intellectual atmosphere there, marked by open and stimulating exchange of ideas in many areas, has, I hope, greatly benefited the manuscript, even as it has, regrettably, enlarged it considerably.

Over the years I have received much help and encouragement from students, colleagues, and friends. Of those who have given a critical reading to all or parts of the manuscript or helped in other ways, I

would especially like to thank Marianne Bergmann, Glen W. Bowersock, Hans-Ulrich Cain, Anthony Grafton, Nicola Hoesch, Rolf von den Hoff, Wolfgang Kemp, Ernst Peter Wieckenberg, along with the members of the Sather Committee in Berkeley. Tatjana Catsch, Derk W. von Moock, and Simone Wolf have rendered indispensable assistance in the preparation of the final manuscript. Lastly, a special word of thanks to Alan Shapiro, who not only sacrificed his own valuable time to make the English translation but also helped me, through his pertinent questions and comments, to clarify a number of important points.

I. Introduction: Image, Space, and Social Values

The image and appearance of the intellectual change along with his society and his particular role in it, for every age creates the type of intellectuals that it needs. We ourselves have witnessed such a change just since the late sixties. That era gave rise to a type of politically and morally activist, left-wing intellectual, who had an impact on public discourse and protest far beyond the borders of classroom and campus, a type that is now dying out, along with his characteristic features, from the unconventional, working-class clothes to his manner of speaking and general life-style. Our consumer- and leisure-oriented society has spawned its own replacements for the sixties intellectual: the apolitical "moderator"; the entertainer; the analyst and prognosticator, who spots new trends or may even be employed to try to create them. The partisan critic and reformer is no longer in demand, rather the commentator who is himself essentially conformist and unaffiliated.

This new breed of intellectual also looks very different from his predecessors, often assimilating the clothes and manners of the dynamic and successful entrepreneur or media mogul, with whom he in fact happily associates. Most, however, are indistinguishable from the average businessman and probably share a similar income and image of themselves as "specialists." In short, their image reflects, in equal measure, both how they see themselves and the role they play in society.

But regardless of his specific role—the disaffected critic and provocateur, the educator, or the sympathetic and popular entertainer—every society needs intellectuals and cannot do without them. It gives

rise to the particular type it needs most at any given time: prophets and priests, orators and philosophers, scholars, monks, professors, scientists, commentators, media experts, filmmakers, and museum curators. We need them to shape the mood and opinions of the public, to invent the concepts, visual imagery, and styles that are the prerequisites for a social dialogue. We need them as much to plan a party as a revolution, to dissent and criticize but also at times to rule and govern.

I trust the reader will not expect from a humble archaeologist a precise definition of the concept 'intellectual'. I use the word simply as a convenient shorthand, in order to avoid having to repeat such cumbersome formulations as "poets and thinkers, philosophers and orators." Neither the Greeks nor the Romans recognized "intellectuals" as a defined group within society. Such a sense of group identity seems to have arisen for the first time within the context of French intellectuals' involvement in the Dreyfus affair.[1] Nevertheless, as in most other societies, prophets, wise men, poets, philosophers, Sophists, and orators in Greco-Roman antiquity did consistently occupy a special position, both in their own self-consciousness and the claims they made for themselves, and in the influence and recognition they enjoyed. Of course, the roles they played were very different in the two cultures. Even so, it seems to me legitimate to inquire into the image of the intellectual in a given period, from the point of view of claims made and recognition accorded, as well as, more broadly, that period's attitude toward intellectual activity.

As an archaeologist, my primary interest is in the specific visual images—votive and honorific statues, grave monuments, and portrait busts—not with the far larger and more complex problem of self-identity as conveyed in literary sources (for example, the inspiration of the poet by the Muses or the ideal of the philosopher-king). My subject is the intent and effect of the image within the parameters of, on the one hand, a given era's collective norms and values and, on the other, the expectations of the subject and the patron for whom the work was made. Instead of a long theoretical disquisition, a brief look at some examples from more modern times may help clarify my purpose.

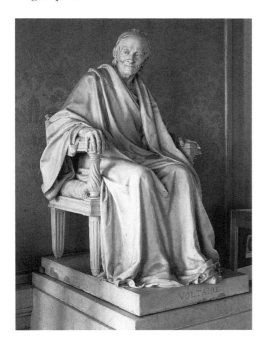

FIG. I　Voltaire by Jean-Antoine Houdon
(1781). Paris, Comédie Française.

The Modern Intellectual Hero

Jean-Antoine Houdon's portrait of Voltaire (fig. 1), from 1781,[2] is perhaps the most celebrated monument of a European intellectual of the modern era. It shows the subject, who had died two years before, seated on an "ancient," thronelike seat, wearing a philosopher's robe and the "wreath of immortality" in his hair. Thus did Houdon himself characterize Voltaire, who had sat for his portrait shortly before his death. The statue combines in extraordinary fashion the intellectual lucidity and physical frailty of the aged Voltaire with his own apotheosis. The monument was originally intended to stand in the Académie Française, not only to commemorate Voltaire himself, but as testimony to the self-conscious pride of the Academy membership. The

statue of Voltaire celebrates the Enlightenment as the highest moral and spiritual authority, and the leaders of the Enlightenment here lay claim to a position of authority in the state and society. They set the philosopher, in the guise of Voltaire, on a throne—not just any throne, but an ancient one, as an ancient philosopher. In this way classical antiquity is invoked to legitimate the self-conscious political claims of the intellectual élite. Needless to say, no ancient philosopher ever sat on a throne.

It was, by contrast, an entirely different complex of values and necessities that inspired nineteenth-century Germany to honor its culture heroes in a veritable cult of statuary. After the wars of liberation in German lands had brought neither political freedom nor national unity, the citizenry began to seek in cultural pursuits a substitute for what they still lacked. For example, they erected monuments to intellectual giants, usually at the most conspicuous location in the city, an honor that until then had been reserved for princes and military men. These monumental statues were planned and executed by local and national committees and associations, and their unveiling was accompanied by dedication ceremonies and even popular festivals. There arose a true cult of the monument, which included broadsheets, picture books, and luxury editions of "collected works." With all this activity, the Germans began to see themselves, faute de mieux, as "the people of poets and thinkers."

This is especially true of the period of the restoration and, in particular, the years after the failed revolution of 1848, when monuments to famous Germans, above all Friedrich von Schiller, sprouted everywhere. These statues were not just objects of veneration and national pride but served the populace as models of citizen virtues with which they could identify. The great men were deliberately rendered not in ancient costume, and certainly not nude, but in contemporary dress and exemplary pose.

Perhaps the most famous of these monuments—and the one considered most successful by people of the time—was the group of Goethe and Schiller by Ernst Rietschel, set up in 1857 in front of the theater in Weimar (fig. 2). A fatherly Goethe gently lays his hand on the shoulder of the restless young Schiller, as if to quiet the overzealous

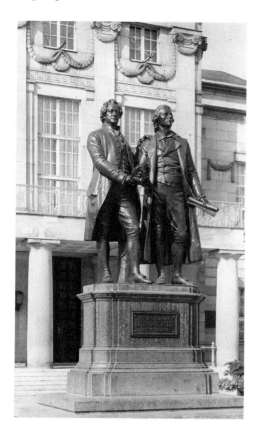

FIG. 2 Monument to Goethe and Schiller by
Ernst Rietschel (1857). In front of the theatre in
Weimar.

passion for freedom of the younger generation. The relationship of the
two poets (which in reality was somewhat problematical) is thus styl-
ized into a symbol of authentic German male bonding, a classical para-
digm and standard of conduct for the citizenry.3

It is, however, no accident that the statue bases on which the poets
stand are just as high as those of princes and rulers. We gaze up to them
from the drudgery and confusion of daily life. "There is something
higher than the daily routine," 4 namely, the everlasting works of po-

etry and art, in which we can find consolation and edification. Although born of political disappointment, these monuments erected by the bourgeoisie in no way represent a call to political action, not even the Schiller monuments of the postrevolutionary period. On the contrary, they attest to an implicit attitude in which the political has been sublimated in favor of pragmatic citizen virtues. This process was facilitated by the fact that the great Weimar poets were in the service of the court and, like many other successful intellectuals of the time, proudly displayed the honors and medals bestowed by the prince.[5]

In the late nineteenth century, the cult of the monument spread throughout Europe. But the poets, musicians, and artists who are thus honored are turned into solitary, superhuman figures before whom posterity can only kneel in awe and wonder. The earlier images of the fellow citizen realistically depicted in contemporary dress give way to a new vision of giants and titans, nude in the manner of the antique. Statues like Rodin's Victor Hugo or Max Klinger's somewhat later Beethoven (fig. 3) render the apotheosis of the great mind in such exaggerated form that, not just for modern taste, it verges on the ridiculous. Contemporary reaction was also divided, unlike in the preceding period.[6] The French poet in his exile resists the reactionary storm breaking over his country, depicted as mighty waves threatening him in his rocky seat. The German composer, on the other hand, in his heroic detachment, is utterly divorced from the present. This is a remarkably complex cult statue that reflects more the feverish imagination of its creator than the beliefs of his contemporaries.[7]

Beethoven is enthroned high up on a kind of rocky outcrop, solitary and half-naked. The mighty eagle at his feet makes the allusion to Zeus obvious. But this hero, despite his vigorous pose, determined expression, and clenched fist, is not a ruler. Originally Klinger wanted a line from Goethe's *Faust* carved on the rock: "Der Einsamkeiten tiefste schauend unter meinem Fuss." Scenes from classical and Christian mythology are represented on the exterior sides of the throne, including the Crucifixion of Christ, the Birth of Venus, Adam and Eve, and the family of Tantalus. The great genius sees the unity of the world that is hidden from others. His music is a kind of religious revelation, and in this role as prophet he becomes a god himself. That this is truly the

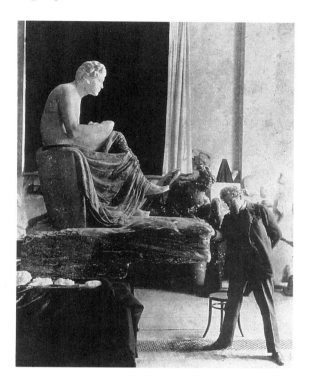

FIG. 3 Max Klinger at work on his monument to
Beethoven (1902).

message intended is confirmed by the circumstance that Klinger car-
ried out his work on the statue for many years without a commission,
at enormous personal cost in expensive materials, and, when it was
finished, wanted to have it displayed in a specially built cult place. (This
was in fact done, first in the exhibition of the Vienna Secession and
later in the museum at Leipzig.)

The creator of this gigantic vision, however, withdrew to play the
role of priest in the cult. Like most artists and writers of this period,
Klinger deliberately cultivated a bourgeois image and appearance. He
had himself photographed, wearing the proper suit, with his titanic
statue. He is just another adorant of the "immortals." There is a deep
divide between the present and the great men of the past, who, with

their works, hover above contemporary life like guiding stars, unattainable and unwavering, like spiritual revelation. The educated look up to them and derive sustenance from them. They enhance the quality of our leisure time but otherwise deliver no categorical imperatives, like the earlier monuments of the artist as model citizen. Art and life had become completely separate realms. Appropriately, many of the later monuments were not displayed in city squares, but rather in parks and public gardens, put there as part of local beautification campaigns.[8]

I shall resist the temptation to pursue this line of inquiry and develop a full typology of the imagery of intellectuals in the modern era. These few examples were intended simply to illustrate my approach and the kinds of questions I wish to pose. Each of the three, almost randomly chosen, instances that I have dealt with could easily find a parallel among the portraits of Greek intellectuals that would be in one way or another equivalent. But this would not get us very far, for when we look closely, the historical framework is as different as the portraits themselves. The point I wish to stress most is that in both cases a successful interpretation is utterly dependent on how well we can reconstruct the specific context in which a particular portrait was created and displayed. As with modern portraits, we have to ask where the monument was set up, who commissioned it, and what circumstances obtained in a particular society. Specifically, what value was attached to intellectual activity, and what was the relationship between society at large and the individual intellectual or group of intellectuals? In light of the extremely fragmentary and incomplete nature of the evidence, as will shortly become clear, it is much easier to pose these intriguing and, in recent years, increasingly fashionable questions than to answer them.

Archaeologists have thus far dealt with the material at our disposal from this perspective either in very restricted instances or not all. Positivist scholars, who laid the groundwork over a century of intensive and detailed scrutiny, concentrated primarily on problems of identification and dating. The culmination of this approach is Gisela Richter's admirable 1965 corpus *The Portraits of the Greeks,* in which the portraits

are ordered chronologically according to when the subjects lived, rather than when the portrait type was created, as if the goal were to produce a set of photographs for a modern *Who's Who*. Those scholars who were more interested in the content of the portraits have devoted themselves almost exclusively to questions of the "character" and "spiritual physiognomy" of each individual and have sought in the portraits a reflection of spiritual and intellectual qualities. Chief among these is Karl Schefold, whose book *Die Bildnisse der antiken Dichter, Redner und Denker* of 1943 is the only study that deals with the most important portraits of Greek intellectuals in chronological order.9

What makes my approach different from Schefold's is that my focus is not on the figure of the individual intellectual, but rather on the position and image of intellectuals as a class within a particular society and the changes we can detect in periods of transition from one era to the next. What I propose is a history of the image of the intellectual in antiquity. For this reason I shall proceed basically chronologically, even though much of my text retains the essaylike flavor of the lectures on which it is based. Nevertheless, I believe this method has a certain distinct methodological advantage, given the problems of identification that beset so many portraits. That is, even anonymous portraits and those that can be dated only approximately retain their interest as evidence for the question of general attitudes within a given period. In most instances it matters less *who* is represented than *how* he is represented—though admittedly it is frustrating to acknowledge that even in the case of some portraits of evidently key figures we are still groping in the dark.

Roman Copies, or Through a Glass Darkly

Regrettably, we cannot move directly from these preliminary remarks to the subject at hand without a brief detour to consider what I call the foggy mirror in which we must view much of the portraiture of ancient intellectuals. It is a fact that almost all portraits of the great Greek poets and thinkers are known to us only in copies of the Roman

period. This means that each individual case is open to difficult, sometimes insoluble problems of reconstruction, analogous to the philologist's textual criticism. I will spare the reader in the present context a long excursus on the methods of so-called *Kopienkritik.*[10] But it is a fundamental principle of any historian that before he can use his primary sources and evaluate their importance, he must ask why and for what purpose they were created in the first place.

In our case, this question leads us straight to an essential chapter in the history of the image of the intellectual. These copies served specific purposes for the Romans that had nothing whatever to do with their original function as honorific statues in the agora or dedications in sanctuaries. For the Romans they functioned as the icons in a peculiar cult of Greek culture and learning, a topic I shall pursue in some detail later in this book. For the moment, let us just cast a critical eye on these copies, in consideration of their usefulness for the reconstruction of the lost original.

Since the Romans were primarily interested in the faces of the famous Greeks, which they believed they could "read" in the same way as modern critics do, they usually had only the heads copied. Of course such a bust or herm was also cheaper than a life-size statue and took up less space.[11] But Greek artists had produced only full portrait statues, into the Late Hellenistic period, and for the Greeks, from Archaic times on, the true meaning of a figure was contained in the body. It was the body that expressed a man's physical and ethical qualities, that celebrated his physical and spiritual perfection and beauty, the *kalokagathia* of which we shall presently have more to say. The most important qualities transcended the individual person, for the function of the portrait statue was to put on display society's accepted values, through the example of worthy individuals, for a didactic purpose. Personal and biographical details were of lesser importance.

The portrait bust, which largely shaped the reception of Greek portraiture in the Roman Empire, arose first only in the course of the Hellenistic period.[12] Just one example may serve to illustrate how much is lost in this reduction to only a head, and what problems and uncertainties it creates for a proper interpretation. How are we to interpret the vigorous expression of this High Hellenistic portrait of a

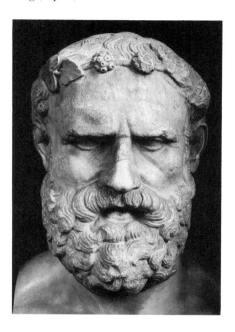

FIG. 4 Head wreathed in grape leaves, of
the same type as the old singer in fig. 79.
Paris, Louvre.

poet, preserved in several herm copies (fig. 4)? What kind of a body
should we imagine went with such a head? Would we ever have
guessed that this is the expression of an impassioned singer, moving in
rapt emotion to the music, as we now know thanks to the chance dis-
covery of an almost fully preserved statue (cf. fig. 79)?

A further problem is the reliability of Roman copies of the heads.
The issue is not only one of the competence of the sculptor, but of the
level of interest, or lack of interest, on the part of the original buyer.
There were passionately cultivated Romans who sought in such statues
conversation partners, who used them, as Seneca says, as *incitamenta
animi* (*Ep*. 64.9–10). These individuals presumably wanted carefully
detailed sculptures of high quality, but that does not necessarily mean
the same thing as faithful copies. The knowledgeable Roman patron
had his own preconceptions of the Greek subject and was looking for

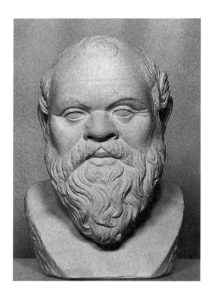

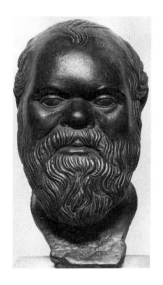

FIG. 5 Socrates. Roman copy of a
Greek original of ca. 380 B.C.
(Type A). Naples, Museo Nazionale.
(Cast)

FIG. 6 Socrates. Post-
antique bronze cast after a
now lost Roman copy of
the same Greek original as
fig. 5. Munich, Glyptothek.

the kind of "talking head" that would reveal something of the subject's
character and work. The obvious solution was to take a face that did
not seem expressive enough and embellish it, if necessary with physi-
ognomic detail. We may see a good example of such embellishment in
the finest of the copies of the earliest Socrates portrait, an Early Im-
perial bust in Naples (fig. 5). Only recently has a careful comparison
with other copies of this type revealed that the gentle smile that distin-
guishes this face must be an innovation of the copyist, an attempt to
"humanize" the Silenus features and, perhaps, to suggest a touch of
irony. A bronze head in the Munich Glyptothek, however, seems to
provide a reliable rendering of the original face (fig. 6). And yet the
head is probably not even ancient, but rather a modern cast of a now
lost Roman copy! This is, admittedly, an extreme case, but it does il-
lustrate some of the constant perils we face in the study of Greek por-
traits and their transmission.

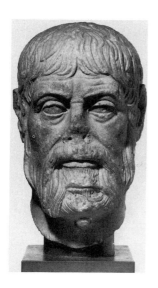

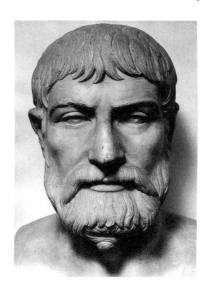

FIG. 7 Pindar. First-century B.C. copy of a statue of ca. 460 B.C. Oslo, National Gallery.

FIG. 8 Pindar. Second-century A.D. copy of the same type as fig. 7. Naples, Museo Nazionale.

In addition, the prevailing tastes of each period could play a considerable role. Since, for example, Augustan art did not look kindly on wrinkles, and youthful faces were the order of the day, the portraits of Menander made at this time were beautified in the same way as those of the emperor and his fellows. In the case of Menander, if we did not have more subtle copies from other periods, we would be ignorant of certain essential features of the original. By contrast, the last decades of the Roman Republic valued above all faces with emphatic physiognomic traits. For the copyists, this meant heads with extra wrinkles and more expressive faces. A striking example is the portrait of the poet Pindar (d. 446 B.C.) that has only recently been identified. A very detailed copy of the first century B.C. in Oslo probably exaggerates the original's features of old age and adds a realistic quality to the flesh and skin texture unknown in the period when the portrait was created (fig. 7). An equally finely worked head in Naples (fig. 8), on the other

hand, assimilates the poet so fully to the style of the Hadrianic period, especially in the eyes and facial expression, that one could take it at first glance for a likeness of one of that emperor's contemporaries.[13]

But it was the lack of interest on the part of Roman patrons that took a far greater toll on quality and fidelity to detail. Perhaps no group of Roman copies can claim as many examples of hasty workmanship and poor quality as the portraits of the Greeks. The chief culprits are serial and mass production. Portrait herms were often displayed in villa gardens lined up in long galleries. They were simply part of the decorative scheme of wealthy homes, like the furniture, completely divorced from any cultural interests the owner may have had. There were even instances where hundreds of such herms were arranged alphabetically, providing nothing more than a visual dictionary of Greek learning. Phrases carved on the herm shaft—a snatch of poetry, a saying of the philosopher, or even a quick biographical sketch—served as mnemonic devices for rudimentary education (cf. p. 208).[14] In these circumstances, obviously, quality and detail were of secondary importance, and even the names and quotations on the herms could get mixed up. But the most grievous loss that results from this mode of transmission is any secure information on the specific location of the original portrait, its setting, and the occasion for which it was put up.

But I do not want to belabor this bleak situation any further. Rather, I propose to show, in three detailed case studies, how, in spite of the unpromising state of the evidence, we can indeed reach some secure answers to the question of context posed earlier. These examples belong to the fifth and fourth centuries B.C. and thus are among the earliest portraits that we have. In view of the meagre amount of material preserved, we can hardly come to any general conclusions. But in each of these three instances we shall encounter certain features that turn out to have a general applicability to the study of the portraiture of Greek intellectuals.

Wisdom and Nobility: An Early Portrait of Homer

Of the earliest known portrait type of Homer, a life-size statue created about 460 B.C., only copies of the head are preserved.[15] The form of

FIG. 9 Homer. Early Imperial copy of a portrait of
ca. 460 B.C. Munich, Glyptothek.

the body is unknown, as are location, patron, artist, and occasion. Nevertheless, we can still reconstruct some sense of the conceptual framework of this portrait type. A subtly carved head in the Glyptothek in Munich (fig. 9) of the Early Imperial period seems to give a reliable copy of the original. Its fidelity is confirmed by two other, less finely worked examples, which in turn enable us to spot the divergences in the remaining copies.

The sculptor imagined Homer as a blind old man, turned slightly to one side and listening to his own inner voice. Old age does not carry negative connotations here, as so often in Greek poetry. Signs of decrepitude in the cheeks, temples, and the deeply sunken eyes are indicated with the utmost discretion. This Homer is a handsome old man—*kalos gerōn*—full of dignity. This is best expressed in the long, carefully arranged hair and lush, well-tended beard, as well as other features of the physiognomy, such as the full lower lip. Above all, the treatment of the locks of hair on the brow contributes to this impression of beauty and nobility.

The hair is carefully arranged over the skull and held in place by a band or fillet, while on the sides and in back it falls freely in thick locks. The bald pate that is typical of the iconography of old men is, in addition, concealed by a complicated arrangement: two broad strands are drawn from the crown forward and knotted over the brow. This both calls attention to the subject's baldness and at the same time artfully hides what might detract from his beauty. Similarly, the long locks on the sides are intended to mitigate the sunken cheeks.

That this arrangement of hair over the forehead is a realistic feature, a hairstyle that men actually wore, is confirmed by a vase painting of ca. 510–500 B.C., in which Priam wears strands of hair similarly knotted over his bald head (fig. 10). This must be a fashion for old men of the Late Archaic period, which reflects in turn the negative associations of old age and its effect on the body. The aristocrat tries to conceal the less attractive features of the aging process.[16] This particular Late Archaic coiffure was probably out of fashion by the time the portrait of Homer was made, thus characterizing him as a distinguished older man of an earlier generation. We are reminded of the noble old men who advise their king in Greek tragedy.

FIG. 10 Hector arms for battle; at his left, his aged
father, Priam. Red-figure amphora by Euthymides,
ca. 500 B.C. Munich, Antikensammlungen.

The notion of Homer's blindness is an old one, first attested by the
sixth century (*Hymn. Hom. Ap.* 172). The model for it is most likely
the portrayal of the blind singer Demodokos in the *Odyssey* (8.62ff.).
Even before that, the figure of the blind singer was widespread in
Egypt and the Near East. Perhaps this conception arose from a com-
mon experience of early civilizations, that the blind often had unusu-
ally good memories, a talent that made them useful.[17] In the portrait,
however, blindness is not presented so much as a biographical detail,
but as a prerequisite for the poet's extraordinary memory and wisdom.
Just as the closed eyes are charged with meaning and more than just a
realistic touch, so too the lines in the brow signify more than just age.
Their strict parallelism looks rather emblematic and probably alludes as
well to the poet's prodigious powers of memory. It is surely no coinci-
dence that the same lines appear on the brow of the old seer lost in medi-
tation from the east pediment of the Temple of Zeus at Olympia.[18]

True knowledge is ancient knowledge. The composing of verse is
conceived in this portrait as a gift from the gods, akin to that of the

seer, a form of revelation. Greek mythology is full of seers and poets whose powers are directly connected with their blindness. This is true, for example, of Demodokos, the singer at the court in Phaeacia,

> whom the Muse loved above all other men, and gave him
> both good and evil; of his sight she deprived him, but
> gave him the sweet gift of song.
>
> (*Od.* 8.63 – 65, trans. R. Lattimore)

The prophetic power of the blind is generally considered as a kind of compensation. The great seers like Teiresias and Phineus went blind because they had seen the gods, because they knew too much and revealed their knowledge to men. But blindness is more than a punishment or destiny. It sharpens the other senses, especially the power of memory, and thus for some authors becomes a prerequisite for particular transcendental gifts. According to a saying of the Delphic oracle, memory is "the face of the blind." [19] This apparently reflects a widespread belief. The philosopher Democritus was said to have blinded himself so that his spirit would not be distracted by the outside world.[20] By emphasizing Homer's blindness, the artist celebrates above all a wisdom that derives from unsurpassed powers of memory.

But how should we imagine the lost body that went with this head? The nearly upright position of the head, on which all the best copies agree, suggests a standing rather than a seated figure. Based on the standard iconography of old men in this period, he must have been either leaning on a staff, the attribute of the elderly and especially the blind (Soph. *OT* 455), or at least holding one in his hand.[21] The Late Antique poet Christodoros, ca. A.D. 500, seems to have seen just such a statue of Homer in the Baths of Zeuxippos in Constantinople:

> He stood there in the semblance of an old man, but his old age was sweet, and shed more grace on him. He was endued with a reverend and kind bearing, and majesty shone forth from his form. . . . With both his hands he rested on a staff, even as when alive, and had bent his right ear to listen, it seemed, to Apollo or one of the Muses hard by.
>
> (*Anth. Gr.* 2.311 – 49)[22]

A statue of this type is in fact known, though in a version of the fourth century B.C., from a copy found in the gardens of the Villa dei Papiri, which might allow us to associate the portrait of Homer with a similar body.[23] Unsure of his step because of his blindness, he would have supported himself on the staff and, in so doing, turned his head ever so slightly to the right, away from the viewer. This very expressive turn of the head is well preserved in several of the copies. That is, the poet stands directly facing the viewer and yet remains fixed in his own world.

On the question of who put up the original statue and where, we can only speculate. But as luck would have it, the earliest attested statue of Homer belongs to the same period as our original, and Pausanias, who mentions it in his description of the sanctuary of Zeus at Olympia (5.24.6, 5.26.5), also provides some helpful information on its context. About 460 B.C. Mikythos, a well-known Sicilian statesman who had served as regent for the children of the tyrant Anaxilaos in Rhegion and Messana and subsequently emigrated to Tegea in the Peloponnese, made dedications at Olympia of unheard-of proportions, for the recovery of his son. This included a group of at least twenty statues by the sculptor Dionysios of Argos, displayed at a prominent spot north of the great temple.[24] The poets Homer and Hesiod apparently stood alongside the Olympians and other gods, including Asklepios and Hygieia. Their location by the gods can best be interpreted to mean that Homer and Hesiod are the messengers of the gods, who mediate between them and mankind, a sentiment also expressed in a well-known passage of Herodotos: "It was Homer and Hesiod who created a genealogy for the gods, who gave the gods their epithets, allotted them their honors and responsibilities, and put their mark on their forms" (2.53).

This interpretation is also supported by the fact that Mikythos' dedication included a statue of the mythical singer Orpheus as well. He stood like a prophet beside the statue of his divine patron Dionysus, whose mysteries had been associated with the so-called Orphic Hymns since the sixth century.[25]

Even though our portrait type is certainly not to be identified with the Homer in Mikythos' dedication, which was under-life-size, at

least it provides us some notion of where and in what context a statue of Homer could be set up in the fifth century, that is, in a sanctuary, along with other statues, as part of a dedication that expressed certain concerns and intentions of the dedicator. In the case of Mikythos, his son's illness may not have been the only motive. No doubt this recent émigré to mainland Greece managed to call attention to himself in spectacular fashion by making a dedication of such outsized proportions. The very fact that the two poets were so prominent in the group says something about the importance of such figures in Greek society of the time.

In this connection, the "realism" of the Homer portrait also takes on some significance. He is not like those images of mythical old men in vase painting or even the seer from Olympia, who, despite bald head and white hair, have an ageless and idealized face. Rather, Homer's face is marked by a new kind of physical immediacy, not so much in its individual traits, but as the face of a typical old man who is at the same time an individual, with protruding cheekbones, sharply arched brows, sagging flesh, furrows, and wrinkles. Along with contemporary likenesses of Themistocles and Pindar, he is among the very earliest Greek portraits.[26] This new kind of portraiture brings Homer out of the distant past and into the present.

In this light, we might imagine that such a portrait, especially one displayed in a conspicuous public place like the dedication of Mikythos, was meant as a conservative response to the enlightened criticism of men like Xenophanes, who spoke out not only against the agonistic values of the aristocracy, but against traditional religious piety associated with Homer.[27] In any case, a portrait like this surely implies the recognition accorded the *sophia* that poets and thinkers had claimed for themselves. In this same period, in Athens, Aeschylus' *Eumenides* brought him the status of political and religious commentator, even a kind of theologian of the city.[28]

It is astonishing that a society like that of the Greeks in the sixth and fifth centuries, which so glorified youthful vigor, should have accorded the ultimate spiritual and religious authority to the figure of a decrepit old man. We should keep in mind that in a sanctuary like Olympia such a portrait statue would have stood not far from divine and heroic statues like the Riace Bronzes (fig. 11). The juxtaposition

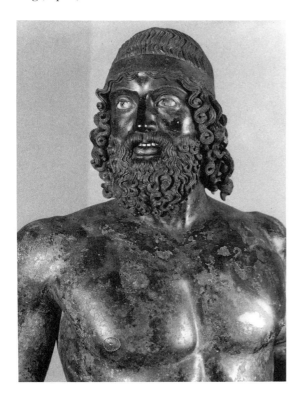

FIG. 11 Bronze statue of a hero found in the sea at
Riace. Greek original ca. 450 B.C. Reggio Calabria,
Museo Nazionale.

of two such antithetical statues must have intensified the contrast, the
unbounded glorification of youth and strength in a warrior or athlete
set against the wisdom of age and corporeal frailty. The polarity of
these images exemplifies the diversity and vitality of Greek culture.
Finally, in this Homer are the roots of the extraordinary portraiture of
aging philosophers of the Hellenistic period.

The reconstruction of the statue of Homer and its possible context
are of course too vague and speculative to be conclusive. The question
of where the actual statue stood simply cannot be answered.[29] But this
example has at least demonstrated that even a single relatively faithful
copy can offer new insights, when we focus on the question of con-

text. And that it is often better to ask unanswerable questions than to ask none at all.

In the Greek imagination, all great intellectuals were old. The portrait of Homer stands at the beginning of a long tradition that reaches to the end of antiquity. There exists no portrait of a truly young poet, and certainly not of a young philosopher.

Anacreon and Pericles

Our second example also involves the statue of a poet, but of a very different kind. In his description of the Athenian Acropolis, which he visited in the 170s A.D., Pausanias mentions a statue of the poet Anacreon east of the Parthenon:

> On the Athenian Acropolis is a statue of Pericles, the son of Xanthippus, and one of Xanthippus himself, who was in command against the Persians at the naval battle of Mycale. But that of Pericles stands apart, while near [*plēsion*] Xanthippus stands Anacreon of Teos, the first poet after Sappho of Lesbos to devote himself to love songs, and his posture is as it were that of a man singing when he is drunk.
>
> (1.25.1)[30]

The statue of Pericles stood near the Propylaea and not far from the Athena Lemnia, a location intended to remind the viewer of Pericles' accomplishments as a statesman. Tonio Hölscher has rightly supposed that father and son were deliberately not placed together in order to avoid the impression of an undemocratic concentration of power in one family. The proximity of the statues of Xanthippus and Anacreon has been explained on the basis of a friendship between the two, though the evidence for this is uncertain.[31]

Of the statue of Pericles only copies of the head are preserved, while we know nothing whatever of the statue of Xanthippus. Thanks to one of those rare strokes of archaeological fortune, however, a statue found in the ruins of a Roman villa near Rieti gives an almost complete copy of the statue of Anacreon (fig. 12).[32] An inscribed herm copy of the same type secures the identification. That this is indeed

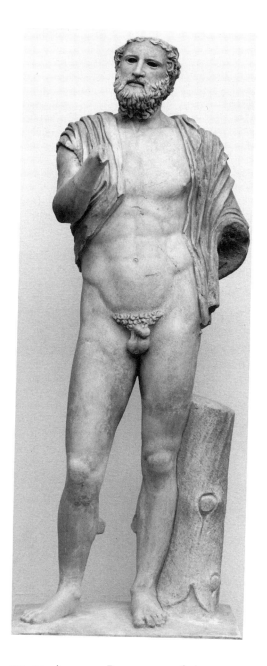

FIG. 12 Anacreon. Roman copy of a bronze
statue ca. 440 B.C. Copenhagen, Ny Carlsberg
Glyptotek.

the portrait seen by Pausanias is very likely, though, as often, incapable of definite proof. Pausanias' emphasis on the proximity of Anacreon's statue and that of Pericles' father suggests that the two were somehow connected. The statue of Anacreon can indeed be dated stylistically to the period when Pericles was in power, and probably originated in the circle of Phidias, who played such a major role in Pericles' Acropolis building program. It is only logical to assume that we are dealing with a dedication of Pericles or his immediate circle, as has often been thought.

But why would Pericles, of all people, at the height of his power, have wanted to honor posthumously this friend of aristocrats and tyrants, who first came to Athens and the court of the Peisistratids aboard an official trireme sent for him by the tyrant Hipparchus on the death of Polykrates of Samos, and had died at Athens a full two generations earlier at the ripe old age of eighty-five? Why should democratic Athens, on the eve of the Peloponnesian War, honor a poet associated above all with extravagant banquets and drunkenness (cf. Ar. *Thesm.* 163; Kritias, in Ath. 13.600E), the very embodiment of the soft and unmanly Ionian way of life?[33] Any answer to these questions must come from the statue itself.

The poet is singing and playing a stringed instrument, the *barbiton.* His *enthousiasmos* is best expressed by the way the head is slightly thrown back and turned to the side. The drunkenness, however, is indicated only very discreetly. Only when we set him beside other statues of the time, with their firm stance, are we aware of a slight instability of Anacreon, especially in a side view.[34] The poet is presented as a participant at a merry symposium, rather than as a poet as such. Hence also his nudity, the short mantle thrown over the shoulders, and the fillet in his hair, all elements of the iconography of Athenian male citizens, as we see them on countless red-figure vases, taking part in the symposium and subsequent *kōmos.* Singing and playing the *barbiton* are also characteristic of these drunken revelers.

Anacreon's contemporaries about 500 B.C. had in fact depicted him on vases as an older, bearded man in a long robe, dancing and playing, surrounded by exuberant young revelers. Sometimes he wears a flowing mantle and the Ionian headgear that would later be mocked as

FIG. 13 Three revelers in elegant Lydian dress. Col-
umn krater, ca. 470–460 B.C. Cleveland, Museum
of Art. A. W. Ellenberger Sr. Endowment Fund, 26.
599.

effeminate—in the company of older revelers also clad in this exotic
"Lydian" costume, including parasol, earrings, and pointy shoes. In
the early fifth century, older Athenians did evidently still wear such
outfits at *kōmos* and symposium (fig. 13), as a gay reminder of the good
old days of their youth under the tyrant Peisistratus and his sons.[35] In
any event, to judge from these vases, Anacreon was already during his
lifetime a representative of the soft Ionian way of life and the uninhib-
ited drinking party.

The image of the drunken singer is also the basis for the statue of
Anacreon, though with a significant alteration. Unlike the vase paint-
ers, the sculptor shows the poet nude, with a handsome, ageless phy-
sique. Only the unusual length of the beard and fullness of the frame
might be subtle hints of advancing age.[36]

A comparison with the well-known vase painting of Sappho and
Alcaeus confirms that Anacreon is indeed depicted in the guise of a

FIG. 14 Sappho and Alcaeus on a krater or
wine cooler by the Brygos Painter, ca. 470 B.C.
Munich, Antikensammlungen.

symposiast and not as poet or professional singer (fig. 14). Alcaeus
wears the long, flowing robe characteristic of singers and flute players
and looks intently at the ground as he sings. (The painter has indicated
the singing with little bubbles issuing from his mouth.) Sappho turns
to him in admiration, attesting to the effect of his song.37 This is,
incidentally, one of our very few depictions of a female poet.

Anacreon is presented as the restrained and in every sense exem-
plary symposiast, quite unlike the uninhibited revelers, Anacreon him-
self among them, of Late Archaic vase painting. Drunkenness and ec-
stasy are hinted at with great discretion. The garment is carefully
arranged over the back and in front barely moves. The face shows no
more emotion than the well-known contemporary portrait of Pericles

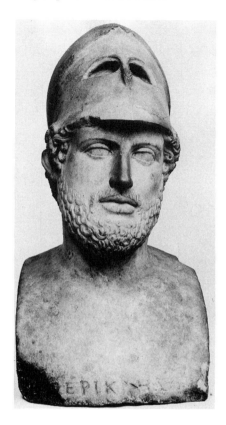

FIG. 16 Anacreon. Early Imperial copy
of the same statue as fig. 12. Berlin,
Staatliche Museen.

FIG. 15 Pericles. Herm copy of a bronze
statue ca. 440 B.C. London, British
Museum.

(figs. 15, 16). The point of this is clear: even on this jolly occasion the
singer never loses his composure, and shows himself to be the very
image of a model citizen of High Classical Athenian society, when it
was none other than Pericles himself who set the standard of behavior.
We may recall the stories of Pericles' conduct in public, and especially
the tradition about his solemn, immobile countenance, which never
registered joy or pain but lost its masklike composure only at the death
of his youngest son (Plut. *Per.* 36; cf. 5).[38]
 The head of a slightly earlier (though probably not Attic) statue of

Pindar may give some indication of the range of possibilities for facial characterization in this period (cf. fig. 7).[39] Pindar is shown with the deeply wrinkled face of an older man, his strained expression best understood as a sign of intellectual activity. At the same time, as Johannes Bergemann has pointed out, the old-fashioned and carefully stylized beard could be meant to associate the poet with the conservative and luxury-loving aristocratic circles for whom he composed his verse. Such biographical traits are entirely possible in this period, as we can also see, for example, in the statue of an elderly poet who rushes off with an energetic stride, evidently toward a specific goal. Even if this figure has thus far resisted interpretation, it is nevertheless clear that we are once again dealing with a specific biographical element.[40]

Just as Pindar has a look of severity and concentration, so we might well have expected for Anacreon an expression of gaiety and delight. Instead, Anacreon's face is so fully devoid of emotion that, in a copy that omits the characteristic turn of the head, we might easily have mistaken him for a king or hero.[41] Such was the determination of the sculptor to emphasize the subject's exemplary behavior, just as in the portrait of Pericles.

The way the mantle is draped actually emphasizes the poet's nudity and calls attention to a striking detail that has barely been noticed before: he has tied up the penis and foreskin with a string, a practice known as infibulation (or, in Greek, *kynodesmē*) (see fig. 17). The explanations for this practice in ancient authors—as a protective measure for athletes or a token of sexual abstinence in a professional singer (Phryn. *PS* 85B; Poll. 2.4.171)—all come from relatively late sources and are not satisfactory in the present instance.[42] But many examples of *kynodesmē* in contemporary vase painting (fig. 18) suggest another explanation. Here it is almost exclusively symposiasts and komasts who have their phallus bound up in the same manner as Anacreon, and as a rule they are older men, or at least mature and bearded. Satyrs are also so depicted, evidently for comic effect.[43] To expose a long penis, and especially the head, was regarded as shameless and dishonorable, something we see only in depictions of slaves and barbarians.[44] Since in some men the distended foreskin may no longer close properly, allowing the long penis to hang out in unsightly fashion, a string could be

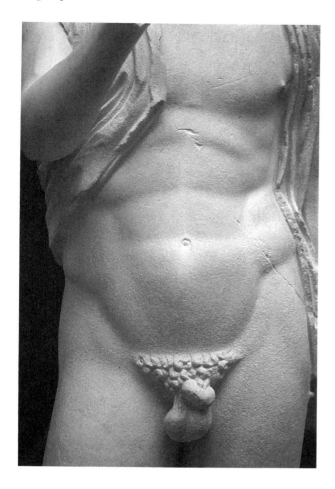

FIG. 17 Detail of the statue of Anacreon in fig. 12
showing *kynodesmē.*

used to avoid such an unattractive spectacle, at least to judge from the
evidence of vase painting. The vases also make it clear that this was a
widely practiced custom. We may then consider it a sign of the mod-
esty and decency expected in particular of the older participants in the
symposium. Once again, in the ideology of *kalokagathia,* aesthetic ap-
pearance becomes an expression of moral worth.

 The borrowing of this detail from the world of Athenian daily life

FIG. 18 Symposiast with his penis bound up. Stamnos by the Kleophon Painter, ca. 440 B.C. Munich, Antikensammlungen.

lends a realistic element to the nude figure. This Anacreon is no longer the representative of an extravagant and decadent bygone way of life. He becomes instead a contemporary, whose conduct at the symposium is a model of restrained and proper enjoyment. By underlining his nudity, the statue celebrates the perfection of the body, just as those of younger men. This Anacreon is a handsome and distinguished man, a *kaloskagathos*. In the Athens of this period, when the Parthenon was going up, it is hard to understand a statue like this as anything other than an exemplar of correct behavior, expressing precisely what Thucydides puts in the mouth of Pericles in his famous Funeral Oration (2.37, 41), the praise of Athens for its festivals and enjoyment of life;

thus the statue is a vision of the perfect citizen. In Athens, physical exercise and military training are not part of a hardened and joyless way of life, as in Sparta; rather, they are part of the pleasures of a free and open society.[45]

For all the iconographical similarities between Anacreon and the komasts in vase painting, we should not forget that the same image, when isolated and magnified to the scale of a life-size portrait statue, takes on a very different public character and meaning. Only in this context does it become the exemplar of certain social values. In fact in this period, the symposium was becoming less popular as a subject for vase painting, and the symposiasts themselves are mostly depicted behaving rather modestly and properly, as if following the model of Anacreon.[46]

When the Athenians saw Anacreon, the poet of the celebration, beside the great general Xanthippus, they had before them two prototypes, together representing the twin ideals of Athenian society that blend so harmoniously in Pericles' vision. We might note, however, that the Corinthian envoys at Sparta accuse the Athenians of being just the opposite (Thuc. 1.70). Because of their fierce ambition and nationalism, "they go on working away in danger and hardship all the days of their lives, seldom enjoying their possessions because they are always adding to them. Their idea of a holiday is to do what needs doing." Whether or not such charges were made in reality, and whether justified or not, one thing is clear: the honoring of Anacreon, the poet of the symposium, at this location, in this form, and at this point in time must surely have had a programmatic character. The statue proclaims that gaiety and enjoyment are as much a part of the superior Athenian way of life as sports and warfare, and that life was as pleasurable and happy in this new age of Periclean democracy as it had been in the old days of the tyrants and their "Lydian" decadence.[47]

Whether my interpretation is entirely correct or not, this posthumous statue of Anacreon stood for a very specific set of values. That is, its purpose was less to celebrate an individual famous poet than to be the embodiment of a certain social ideal: the poet as exemplar. In principle this would still be the case if the statue had instead been put up by the opposition camp, the oligarchs.[48]

Socrates and the Mask of Silenus

This third case study is an example not of the confirmation of collective norms, but of their denial, in paying honors to Socrates, who in life had so provoked and annoyed his fellow citizens with his questioning that they finally condemned him to death in 399 B.C. The earliest portrait of the philosopher originated about ten to twenty years after his death and shows him in the guise of Silenus. In flouting the High Classical standard of beauty so blatantly, this face must have disturbed Socrates' contemporaries no less than his penetrating questions.[49]

Starting with the influential circle of intellectuals around Pericles and the enormous success of the Sophists, there arose in Athens a tension between society at large and this new breed of intellectual, who exercised such great influence on political, religious, and moral thought.[50] We find traces of this tension in the parodies of Sophists in Old Comedy and even in vase painting. In both media, this ridicule targets bodily and aesthetic deficiencies. Such parody would seem to be the origin of a strategy, later employed so effectively by certain philosophers, such as the Cynics, of having themselves portrayed old and ugly or with unconventional appearance as an act of provocation. As in many cultures, the Greeks tended to dismiss the unpopular, the marginalized, and the dissident as physically defective and ugly. Their prototype is the ugly, bandy-legged Thersites (*Il.* 2.212ff.), in whom the Cynics would later, appropriately enough, take an interest. For the Greeks, this kind of ridicule was from the very beginning a form of social discrimination and moral condemnation, for in the ideology of *kalokagathia* a man's virtues and his noble heritage were expressed in the physical perfection of his body.

The earliest "portrait" of Socrates, in Aristophanes' *Clouds* of 423 B.C. (101ff., 348ff., 414; cf. *Birds* 1281f.), makes fun of his appearance.[51] Like his pupils, he is pale and thin from strain and deprivation, dirty and hungry, with long hair. Indifferent to his own appearance, he parades through the city barefoot, staring people down and trying out his corrupting intellectual experiments on them. It has long been recognized that this description of Socrates' physical appearance is as much a conventional topos as the caricature of his supposed teachings.

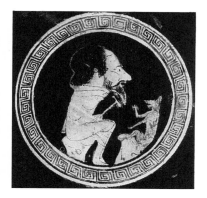

FIG. 19 So-called Aesop on a red-figure cup, ca. 440 B.C. Rome, Vatican Museums.

FIG. 20 Caricature of a Sophist debating (?). Red-figure askos, ca. 440 B.C. Paris, Louvre.

In any event, the starving thinker of the *Clouds* has little in common with the fat-bellied teacher with the face like a Silenus mask described by Socrates' own pupils Plato and Xenophon. Rather, it is a common stereotype, which we find occasionally in caricatures of "intellectuals" in vase painting.

On a small red-figure askos,[52] for example, of ca. 440 B.C., a naked, emaciated little man with an enormous head leans far forward on his slender staff and seems to be simply lost in contemplation. Just so, we are told, Socrates could stand still for hours, concentrating on a problem (fig. 20). The vase probably caricatures one of the leading thinkers of the day. The creature's bare skull, swelling out in all directions, seems about to burst with all the profound thoughts churning inside it. He is nevertheless an Athenian citizen, and not a member of one of those categories of inferiors like slaves or barbarians, as we can infer from the characteristic pose of resting on the staff and short mantle.

The same is true of another example of a comical thinker, again with emaciated body and oversized head, who has always been identified in the scholarship as the writer of fables, Aesop (fig. 19).[53] With furrowed brow and open mouth, he listens carefully to the teachings of the fox sitting before him. He has pulled his mantle tightly around

his meagre body, as if he were shivering. Like Aristophanes' Socrates, he is ugly, with long hair, bald head, and unkempt, scraggly beard, and is clearly uncaring of his appearance.

These modest vase paintings probably convey some idea of the general antipathy that greeted the new breed of intellectual giants of Periclean Athens, on which Aristophanes could draw for his caricatures. Too much thinking and intellectual exercise are not for good, upstanding people: they make you strange and an object of ridicule.

The historical Socrates, from all that the ancient sources report, must have been strikingly ugly. But in this he was surely not alone among the Athenians. That his unfortunate appearance became such a focus of attention must derive from the offensive nature of his intellectual activities. The likening of Socrates to silens, satyrs, and Marsyas, as we hear from Plato and Xenophon, probably originated with his enemies and detractors, for the particular traits that are usually mentioned in the comparison—the squat figure with big belly, broad and flat face with bulging eyes, the large mouth with protruding lips, and the bald head—were all considered, by the standards of *kalokagathia,* not only ugly, but tokens of a base nature (Cic. *Tusc.* 4.81).[54] The decision to adapt the comparison with Silenus for a portrait statue intended to celebrate the subject, however, presupposes a positive interpretation of the comparison, such as we do in fact find, in particular, in the speech of Alcibiades in Plato's *Symposium.* Perhaps Socrates himself had already laid the groundwork for this new interpretation by accepting the comparison with his characteristic irony.

The copies of the head from this portrait statue convey very different nuances, though on all major elements of detail they are in agreement (fig. 21). That is, they all follow the basic analogy with Silenus iconography, especially in the flat, strangely constricted face, the very broad, short, and deep-set nose, the high-set ears and bald head, and the long hair descending from the temples over the ears and the nape of the neck (fig. 22). But at the same time, a comparison with images of the actual Silenus leaves no doubt that in Socrates the silen features have been at least partly mitigated.[55] This is particularly true of the eyes, the well-groomed beard, the hair, which, though long, is ex-

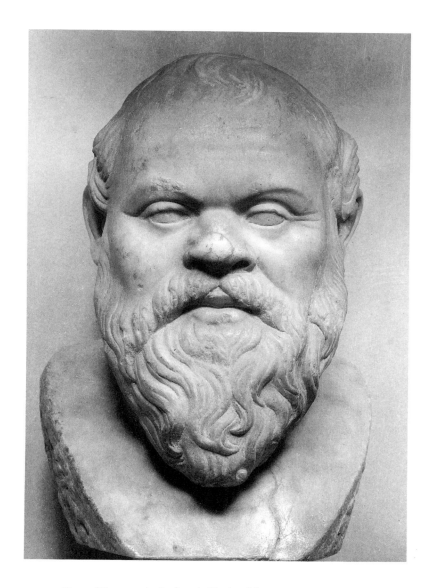

FIG. 21 Bust of Socrates (as in fig. 5). Naples, Museo
Nazionale.

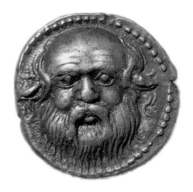

FIG. 22 Silenus on a silver coin
from Katane in Sicily, ca. 410 B.C.
Berlin, Staatliche Münzsammlung.

tremely carefully coiffed, and the full but well-formed lips. There is in
addition probably a hint of introspection that can be detected in most
of the copies. These positive features are the more remarkable in that
literary descriptions emphasize Socrates' bulging eyes, swollen lips,
and unkempt hair. Evidently the intention of the statue's patrons was
to tone down the Silenus comparison by combining it with unmistak-
able features of propriety, to make an unambiguously positive state-
ment. Furthermore, the Silenus mask of this portrait is a countenance
artfully constructed of prescribed iconographical formulas. In real life,
Socrates' ugliness might have been of an entirely different nature.

What sort of body could have been combined with this head? The
loss of the body is especially frustrating in light of the complex associ-
ations of the head. It seems most unlikely that such a head could have
sat on a perfectly handsome and conventional body, like that of the
later portrait statue of Socrates (cf. fig. 33). An unimpressive bronze
relief from Pompeii (fig. 23), about fifteen centimeters in height, made
as a furniture appliqué, may give us a rough idea of the lost statue.[56]

The scene, known in a number of versions, is itself an eclectic pas-
tiche of several prototypes, made by a Late Hellenistic artist, and prob-
ably depicting Socrates' initiation into the mysteries of love by Dio-
tima. The figure of Diotima is based on the Tyche of Antioch. For the

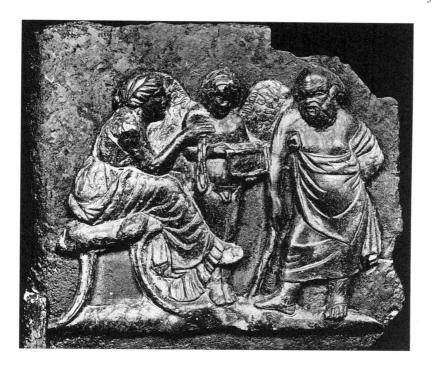

FIG. 23 Socrates and Diotima. Bronze relief from
Pompeii, first century B.C. Naples, Museo Nazionale.

figure of Socrates, the artist has used a motif, standard in vase painting
from the late sixth century on, of a man relaxing on his staff with the
other arm casually propped on his hip. The motif appears occasionally
as late as on Attic grave stelai of the fourth century, but not in the
Hellenistic period. This would imply an early date for the prototype,
unless we prefer to think of a historicizing invention. The motif ex-
presses the qualities of leisure and delight in conversation that were
such important elements of the ethos of Classical Athens. It marks the
Athenian citizen who is not gainfully employed but has long stretches
of free time in which to stand around discussing all that is going on in
the city. Even the Eponymous Heroes on the Parthenon Frieze are
represented in this manner.[57] This image of Socrates would thus be
that of the properly behaved citizen, but at the same time, as in the

portrait head, with unmistakably ugly and deviant features—the small stature and bulging belly—just as described in our literary sources.

But we have yet to ask why the statue's patrons accepted in the first place an image of Socrates' ugliness, one that likened him to the semi-human followers of Dionysus best known for their indecent and drunken ways. And why above all in Athens, where all deviations from the ideal body were apt to be eliminated in art, as a glance at the countless Classical Attic gravestones will remind us?

There is surely more than one aspect to the comparison of Socrates to Silenus. In being likened to a mythological creature, he is presented as an extraordinary human being, transcending conventional norms. The old Silenus, unlike the rest of his breed, was considered the repository of ancient wisdom and goodness and for this reason appears in mythology as the teacher of divine and heroic children. As early as about 450 B.C. a vase painting shows Silenus with his citizen's staff in the role of the watchful *paidagōgos*.[58] The connotation as the wise teacher was thus an obvious one for the portrait of Socrates-as-Silenus.

But the Silenus analogy does more than just pay homage to Socrates as the remarkable teacher; it presents a challenge as well. The deliberate visualization of ugliness represented, in the Athens of the early fourth century, a clash with the standards of *kalokagathia*. That is, a portrait like this questioned one of the fundamental values of the Classical polis. If the man whom the god at Delphi proclaimed the wisest of all could be ugly as Silenus and still a good, upstanding citizen, then this must imply that the statue's patron was casting doubt on that very system of values. We have to look at this statue of Socrates, with its fat belly and Silenus face, against the background of a city filled with perfectly proportioned and idealized human figures in marble and bronze embodying virtue and moral authority.

Such doubts can have originated only in the circle of Socrates' friends. It was long ago suggested that the statue might have been intended to stand in the Mouseion of Plato's Academy, founded in 385, where we know a statue of Plato himself, put up by the Persian Mithridates and made by the sculptor Silanion, later stood (D. L. 3.25). We may perhaps go even a step further and consider a possible connection between the concept behind the statue and an element of Platonic

thought contained in the very passage of the *Symposium* that compares Socrates to Silenus. The discussion there revolves around the contrast between interior and exterior, between appearance and reality. Socrates himself, it is suggested, is like a figure of a flute-playing Silenus (evidently a familiar object, perhaps of wood), which, when you open it, contains a divine image (*Symp.* 215B). True philosophy recognizes the "seemingness" of the external and leads instead to the perception of actual being. Socrates' body may be seen as an exemplar of these precepts, for the seemingly ugly form conceals the most perfect soul. This idea implies that the entire value system of Athenian society is built upon mere appearance and deception, misled by its fixation on the external form of the body.

Seen in this light, the portrait of Socrates makes a rather forceful and provocative statement and becomes a kind of extension of Socratic discourse into another medium. As the living Socrates once did, the statue now challenges his society on a fundamental principle of its identity.[59] We are witnessing here the discovery of a new dimension in the portraiture of the intellectual, one that will not be exploited again until the philosopher statues of the Early Hellenistic age.[60]

In the next chapter we shall see how this rigid value system, founded upon the principles of *kalokagathia* and conformity, persisted for more than a full half century, at least in the public sphere of the Athenian city-state, and even managed to bring about a transformation in the provocative image of Socrates.

II. The Intellectual as Good Citizen

*We should not imagine that we are able to see such a head in the
same way Plato's contemporaries saw it.*

—Hans-Georg Gadamer

Recently, the Glyptothek in Munich acquired a particularly fine Ro-
man copy of the portrait of Plato (fig. 24). Among those who tried to
penetrate the stern countenance was the philosopher Hans-Georg
Gadamer, who detected "Attic wit . . . , something of extreme skep-
ticism, abstracted and distant, almost mocking," especially in the
mouth and eyes. At the same time, the distinguished interpreter
shrewdly called attention to Plato's dialogues, "the successor to Attic
comedy," to qualify the provisional nature of his own reaction.[1]

Archaeologists have also attempted, with a similarly direct ap-
proach, to find in Plato's face a reflection of his character, fortunes, or
intellect. So, for example, Wolfgang Helbig saw an "ill-tempered,
even malevolent quality," while Ernst Pfuhl found an "inner tension
joined with the painful resignation that comes of bitter disappoint-
ment." Helga von Heintze discovered how "the innermost thoughts
and experiences reveal themselves in the earnest, knowing, and con-
centrated gaze and the firmly closed mouth." Clearly, viewers find in
this face what they look for, based on their personal preconceptions of
the subject, especially in this case, where the different renderings of
the expression in the various preserved copies seem at different times
to favor one or another interpretation.[2]

But even archaeologists had to work their way gradually into the
Plato portrait before they could arrive at such profound interpreta-
tions. "The head occasioned mainly great disappointment when it first
became known, for it did not correspond at all to the way people imag-
ined Plato. . . . They sought in vain a characterization of the 'divine
Plato,'" or they regretted that the artist "rendered little or nothing of

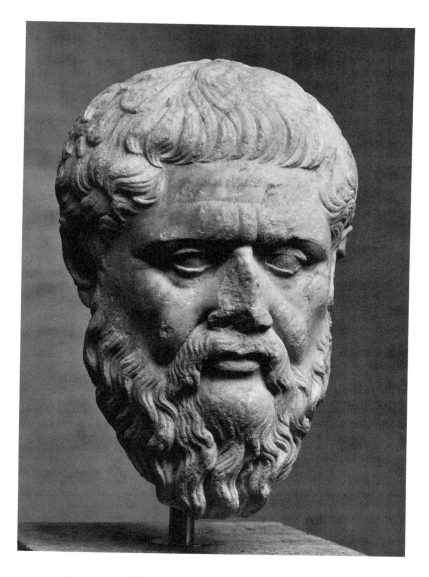

FIG. 24 Plato. Copy of the time of the emperor Tiberius of a portrait statue of the mid-fourth century B.C. Munich, Glyptothek.

the subject's true nature." 3 This lack of expressiveness and individual characterization in Late Classical portraits must have been felt already in the Hellenistic period, when the portrait of Plato was reshaped into a more communicative one, in the style of contemporary Stoic notions of the physiognomy of the thinker (cf. pp. 92ff.).4

The Romans had already tried this kind of psychological reading of the *imagines illustrium* of the Greeks, which were exhibited by the thousands in their homes, gardens, and libraries, usually as herms or busts with the name inscribed. Just like the modern viewer, they wanted to know "qualis fuit aliquis," as Pliny the Elder put it (*HN* 35.10f.), in order to use the portraits in their own intellectual retreats. Since they no longer understood the body language of Greek statuary, they usually had copies made only of the heads, assuming, quite naturally, that these were realistic, individual likenesses in the same sense as their own portrait sculpture.

Even modern viewers who are aware that the Greeks always made full-length portrait statues nevertheless find themselves confronted by disembodied heads and remain, like the Romans, *nolens volens,* fixated on them. In so doing, we perhaps look *too* closely and ask too much of a face that was intended to be seen in a very different context. Nor are we any better able than the Romans to free ourselves of deeply ingrained ways of seeing, in our case especially shaped by our experience of photographic likenesses. As a result, we search for any indication of individual physiognomy that we can associate with the character and work of the subject. Even when we know that this was not the original intention of a Classical portrait, we can hardly escape our own conditioning.

We must admit, then, that we have no direct access to an understanding of Plato's physiognomy. We can only try, by indirect means, to create the theoretical framework for such an understanding. What is of interest for our inquiry is not the often-asked but unanswerable question of how true to life the portrait is, but rather how specific intellectual traits are indicated. In other words, does this portrait characterize Plato in any way whatsoever as a philosopher, or simply as a mature Athenian citizen conforming to the basic expectations of the polis?

It is my contention that in fourth-century Athens there was no such thing as a portrait of an intellectual as such, and indeed that in the social climate of the democratic polis there could not have been. In order to demonstrate this, I should first like to deal with some retrospective portraits of famous fifth-century Athenians from the period of the Plato portrait. These are statues for which we can reconstruct the context in which they were originally displayed and we can gain a rough idea of their original content. Then I shall return to the question of Plato's much-interpreted expression. Finally, at the end of this chapter, I shall consider two portraits that demonstrate how the strict standards of behavior of the Classical polis broke down in the Early Hellenistic period, giving rise to new options, including the representation of intellectual qualities.

Statues Honoring the Great Tragedians

About the year 330 B.C., Lycurgus, the leading politician in Athens, who was also in charge of state finances, proposed in the Assembly a decree for the erection of honorific bronze statues of the three great Classical tragedians, Aeschylus, Sophocles, and Euripides, who had been active roughly a century before. The statues were to be set up in the Theatre of Dionysus, where their plays had been performed and where, in addition, the Assembly itself met (ps.-Plut. *X orat., Lyc.* 10 = *Mor.* 841F; Paus. 1.21.1−2). An authentic and definitive text of their works was also to be established and used as the basis for all future productions. This remarkable project was part of an ambitious program of patriotic national renewal.[5]

Sophocles: The Politically Active Citizen

The statue of Sophocles belonging to the dedication seems to be faithfully rendered in an almost fully preserved copy of the Augustan period (fig. 25).[6] Sophocles stands in an artful pose that appears both graceful and effortless. The mantle carefully draped about his body enfolds both arms tightly. The right arm rests in a kind of loop, while the left, under

FIG. 25 Sophocles. Roman copy of a statue
ca. 330 B.C. Rome, Vatican Museums.

the garment, is propped on the hip. The drapery allows even the legs little room for movement. Yet at the same time that he is so heavily wrapped, the position of the one advanced leg and the one arm propped up conveys a sense of energy and a commanding presence. The head is turned to the side and slightly raised, the mouth open. We have the impression that the poet is making a certain kind of public appearance. Among the Attic grave stelai, which repeatedly display the narrow range of acceptable poses and drapery styles that reflect standards of citizen behavior in this period, there is no male figure who matches this combination of being both heavily wrapped and yet making such an elegant and self-assured appearance. There is, however, a statue of the orator Aeschines, only slightly later in date, in a similar pose (fig. 26). This raises the possibility that Sophocles, too, is depicted as a public speaker.7

The model orator was expected to demonstrate extreme modesty and self-control in his appearances before the Assembly, and particularly to avoid any kind of demonstrative gestures. Thus this particular pose, with very limited mobility and both arms completely immobilized, along with the self-conscious sense of "making an appearance," would be particularly appropriate for an orator. Alan Shapiro has recently called attention to a red-figure neck amphora by the Harrow Painter, dated ca. 480 B.C., on which a man is depicted in the same pose as Sophocles, standing on a podium, in front of him a listener leaning on his staff in the typical citizen stance (fig. 27). Most likely we have here indeed a representation of an orator.8

But why depict a tragic poet of the previous century in the guise of an orator? The issue of what constituted the proper bearing and conduct for public speakers, the correct attitude toward the state and its citizen virtues, was the subject of a lively debate in Athens in the years just before Lycurgus put up his dedication. If we may believe Aeschines, most politicians of his generation no longer observed the traditional rules of conduct but gesticulated wildly for dramatic effect, just as the demagogue Kleon had been accused of doing in the late fifth century. Aeschines' great rival Demosthenes seems to be one of those who at least sympathized with these supposedly undisciplined speakers.9

FIG. 26 Statue of the orator Aeschines. Early
Augustan copy of a statue ca. 320 B.C. Naples,
Museo Nazionale.

In his plea for speakers to display a calm and self-controlled appear-
ance, Aeschines invokes the example of earlier generations and, in par-
ticular, cites a rule stating that the speaker must keep his right arm still
and wrapped in his cloak through the duration of his speech. Aeschines
would naturally have equated this proper stance with ethical and moral

FIG. 27 An orator speaks from the podium.
Attic neck amphora, ca. 480 B.C. Paris,
Louvre.

correctness (*sōphrosynē*). In this connection he refers explicitly to a statue of the lawgiver Solon in the Agora of Salamis:

> And the speakers of old, men like Pericles, Themistocles, and Aristides, were so controlled [*sōphrones*] that in those days it was considered a moral failing to move the arm freely, as is common nowadays, and for this reason speakers did their best to avoid it. And I can give you definite proof of this. I'm sure you have all been across to Salamis and seen the statue of Solon there. You can then verify for yourselves that, in this statue in the Agora of Salamis, Solon keeps his arm hidden beneath his mantle. This statue is not just a memorial, but is an exact rendering of the pose in which Solon actually appeared before the Athenian Assembly.
>
> (*In Tim.* 25)

Aeschines' opponent, Demosthenes, quickly responded to this, also in the Assembly, and made direct reference to the supposedly authentic statue of Solon:

> People who live in Salamis tell me that this statue is not even fifty years old. But since the time of Solon about 240 years have passed, so that not

even the grandfather of the artist who invented the statue's pose could have lived when Solon did. He [Aeschines] illustrated his own remarks by appearing in this pose before the jury. But it would have been much better for the city if he had also copied Solon's attitude. But he didn't do this, just the opposite.

(*De falsa leg.* 251)

The controversy over the statue of Solon provides us not only proof of the importance of the pose with one arm wrapped up in the mantle. It also represents rare and valuable testimony to the function and popular understanding of public honorific monuments in the Classical polis. That is, in certain situations and in particular locations, a statue such as this one could become a model and a topic of discussion and could take on a significance far beyond the occasion of its erection. The statue was thus incorporated into the functioning of society in a manner altogether different from what we would expect from our own experience.

Aeschines himself, of course, appeared exactly in the pose of the speakers of old. And in the view of both his supporters and his detractors, he did so in a strikingly elegant and admirable manner. The statue in his honor, referred to earlier, does indeed show him in this very pose.[10] His statue evidently led Demosthenes to make the ironic comment that in his speeches Aeschines stood like a handsome statue (*kalos andrias*) before the Assembly, a pose for which his earlier career as an actor had prepared him well.[11] But this is apparently just what Aeschines intended, to stand as still as a statue.

The debate over how one should properly appear before the Assembly was not, of course, simply a matter of aesthetics. In Classical Athens, the appearance and behavior in public of all citizens was governed by strict rules. These applied to how one should correctly walk, stand, or sit, as well as to proper draping of one's garment, position and movement of arms and head, styles of hair and beard, eye movements, and the volume and modulation of the voice: in short, every element of an individual's behavior and presentation, in accordance with his sex, age, and place in society. It is difficult for us to imagine this degree of regimentation. The necessity of making sure their appearance and

behavior were always correct must have tyrannized people and taken up a good deal of their time. Almost every time reference is made to these rules, they are linked to emphatic moral judgments, whether positive or negative. They are part of a value system that could be defined in terms of such concepts as order, measure, modesty, balance, self-control, circumspection, adherence to regulations, and the like. The meaning of this is clear: the physical appearance of the citizenry should reflect the order of society and the moral perfection of the individual in accord with the traditions of *kalokagathia*. Through constant admonition to conform to these standards of behavior from childhood on, they became to a great extent internalized. No one who wanted to belong to the right circles could afford to throw his mantle carelessly over his shoulders, to walk too fast or talk too loud, to hold his head at the wrong angle. It is no wonder that the individuals depicted on gravestones, at least to the modern viewer, look so stereotyped and monotonous.

The statues of Sophocles and Aeschines are therefore meant to represent not only the perfect public speaker, but also the good citizen who proves himself particularly engaged politically by means of his role as a speaker. The motif of one arm wrapped in the cloak had been a topos of the Athenian citizen since the fifth century and would continue into late antiquity, both in art and in life, as a visual symbol of *sōphrosynē,* here meaning something like respectability. Indeed, rigid standards of behavior as an expression of generalized but rather vague moral values are a well-known feature of other societies. In fourth-century Athens, however, we have the impression in other respects as well that the aesthetic regimentation and stylization of everyday life increased as the values expressed in the visual imagery became increasingly problematic.

A glance at earlier occurrences of the Sophocles motif will help clarify its significance when applied to the public speaker. In vase painting of the fifth century, it is primarily adolescent boys who wear their mantle in the style of Sophocles, with both arms wrapped up. They appear in two contexts in which it was essential for them to display their modesty (*aidōs*): standing before a teacher and in scenes of erotic courtship.[12] The average citizen, by contrast, is usually de-

picted in a more relaxed pose. In the fourth century we occasionally find men with both arms concealed like Sophocles, usually as pious worshippers on votive reliefs.[13] Here again the point is to display modesty and awe, in this case before the divinity. The revival and spread of this long-antiquated gesture of extreme self-control for public speakers in the fourth century also carry a deliberate message for the demos and for the democratic system then in a state of crisis. It was precisely this concern for the democracy that was the focus of Lycurgus' political program.

But let us return to the statue of Sophocles. It presents the famous playwright not at all in that guise, but rather as a model of the politically concerned citizen. The fillet in his hair probably refers to his priestly office.[14] It is of no consequence whether the historical Sophocles did in fact take a particularly active role in politics or not. One of his contemporaries, Ion of Chios, remarks of him drily: "As for politics, Sophocles was not very skilled [*sophos*], nor was he especially interested or engaged [*rhektērios*], like most Athenians of the aristocracy" (Ath. 13.604D). The poet did, however, serve as general in the year 441/0.[15]

In any event, nothing about the statue of Sophocles alludes to his profession as a poet, neither the body nor the head (cf. fig. 40), which, with its well-groomed hair and carefully trimmed beard, perfectly matches the conventional portrait of the mature Athenian citizen on grave stelai and, like the portrait of Plato, has understandably often been perceived as lacking in expression. But this was just what those who commissioned the statue intended: to show Sophocles as a citizen who was exemplary in every way, including in his political activity, no more and no less than an equal among his fellow citizens, a man whom Lycurgus and his friends would wish to count as their contemporary.[16]

Aeschylus: The Face of the Athenian Everyman

Identifying the portraits of the other two tragedians in Lycurgus' dedication is unfortunately more problematical, the evidence more fragmentary. A head that has convincingly been associated with the lost

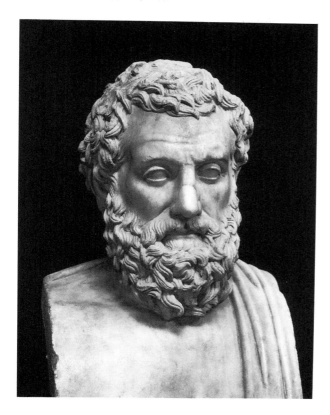

FIG. 28 Portrait herm of the playwright Aeschylus.
Augustan copy of a statue ca. 330 B.C. Naples, Museo
Nazionale.

statue of Aeschylus portrays a man somewhat younger than Sophocles
(fig. 28).[17] The subtly indicated lines in the brow are a feature that he
shares, as we shall see, with many images of contemporary Athenian
citizens. He too is a conventional type, as is evident from a comparison
with the head of an Athenian named Alexos, from a wealthy family
tomb monument of the same period (fig. 29).[18] As with Sophocles,
there is no hint of intellectual activity in the expression, nor anything
of Aeschylus' own character, for example, his severity (Aristophanes

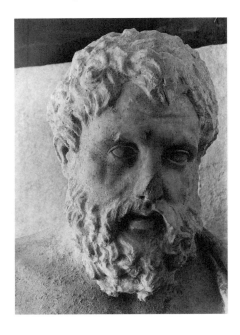

FIG. 29 Head of Alexos from an Attic grave
stele ca. 330 B.C. Athens, National Museum.

Frogs 804, 830ff., 859). Rather than as poet, he too seems to have been
depicted simply as a good Athenian citizen.[19] As for the body type,
which is thus far not preserved, we can suppose, based on his age (in
his middle years), on the billowing mantle on the herm copy in Naples,
and on the typology of such figures on the gravestones, that he must
have been standing erect.

Euripides: The Wise Old Man

For the portrait of Euripides in Lycurgus' dedication the only candi-
date, on stylistic grounds, is, in my view, the inscribed copy known as
the Farnese type (fig. 30).[20] It shows the poet as an elderly man with
bald pate, a fringe of long hair, and subtle indications of aging in the
face. Not just an ordinary old man, however, but a *kalos gerōn,* like the

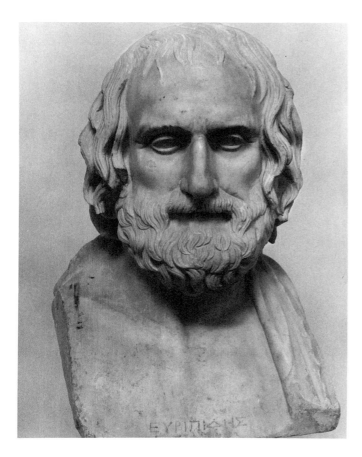

FIG. 30 Portrait herm of the playwright Euripides.
Roman copy of a statue ca. 330 B.C. Naples, Museo
Nazionale.

earlier portrait of Homer. In the highly conventional vocabulary of
Attic gravestones, this type of old man is often shown seated, especially
when he is the principal person being commemorated. (fig. 31). This
is an allusion not just to physical weakness, but to the status and au-
thority of the older man within the family (*oikos*) and the polis.[21] The
dignified, seated position of the elderly paterfamilias is, furthermore,

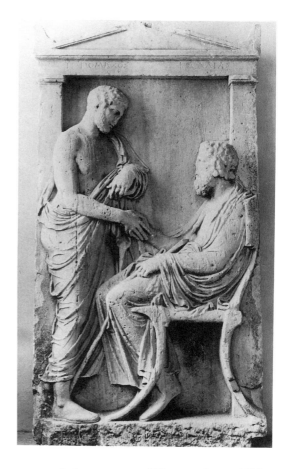

FIG. 31 Attic gravestone of Hippomachos and Kal-
lias. Piraeus, Museum.

an accurate reflection of the rituals of daily life. We may be reminded
of the dignified figure of old Kephalos, at the beginning of Plato's *Re-
public,* who receives his guests seated on a *diphros* (*Rep.* 328C, 329E).

The portrait of Euripides of the Farnese type actually appears once
on a seated figure, on a relief of the first century B.C. (fig. 32), which,
on the basis of other elements, such as the chair and the overall style,
could reflect an original of the late fourth century. The figure is com-

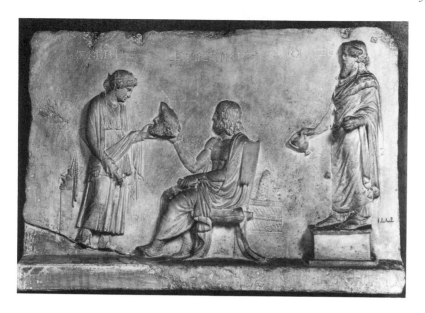

FIG. 32 Votive relief (?) of the seated Euripides, with the personification of the stage (*Skēnē*) and an archaistic statue of Dionysus. Istanbul, Archaeological Museum.

bined with two that are stylistically later in date, a personification of the stage (*Skēnē*) and an archaizing statue of Dionysus, an eclectic mixture in which, we may well suspect, lurks a quotation of a well-known Classical portrait statue of a poet. Indeed, the classicistic artists of such reliefs as a rule did not "invent" any new figure types. The book roll and the pillow are already elements in the iconography of Late Classical grave stelai. And the mantle drawn up over the back, a standard characteristic of old men, as we see it on the herm in Naples, finds a parallel on this relief.[22] In his raised right hand, Euripides takes a mask proffered to him by *Skēnē*. In the original portrait statue, to judge from the iconography of the gravestones, that hand could have held the old man's staff.

If we imagine the Euripides statue in this way, then we may well ask why he alone of the three tragedians was shown as an old man. It is

true, of course, that Euripides lived to be eighty, but then Sophocles
was ninety, and Aeschylus did not die young either. Euripides in his
lifetime was clearly ranked behind Aeschylus and Sophocles and was
even accused by his contemporary Aristophanes of lacking any citizen
virtues. But in the course of the fourth century, his reputation under-
went an enormous transformation, so that by the time of Lycurgus he
was considered the most outstanding of the great tragedians (Aristotle
calls him *tragikōtatos* at *Poetics* 1453a29f). For Plato and Aeschines he
was simply the wise poet, and later he would even be called by Athe-
naeus the philosopher of the stage (*skēnikos philosophos*).23 Wisdom
and insight are precisely the qualities that set the elderly apart from
younger men; this is why they enjoyed special privileges both in the
life of the city and within the family. So, for example, men over fifty
had the right to speak first in the Assembly (Aeschin. *In Tim.* 23).24
Not by accident, the relatively few instances on Attic gravestones of
this period of a figure holding a book roll are always seated older men
like Euripides. That is, they are the only individuals in this highly styl-
ized medium of the bourgeois self-image who are celebrated for their
education and knowledge. The aged Euripides would thus have been
shown seated to emphasize his extraordinary wisdom relative to the
other two tragedians. When we try to imagine the three as a single
monument, rather than as separate statues, a grouping of two standing
figures and one seated would, by the standards of the gravestones, be a
perfectly acceptable one.

If this was indeed the principal message conveyed by Euripides' por-
trait, we might well expect in his facial physiognomy a clear character-
ization as an intellectual. Scholars have often seen in this face framed
by heavy locks of hair an expression of the supposed melancholy and
pessimism that were attributed to Euripides even in antiquity on the
basis of his plays, or, at least, as Luca Giuliani recently put it, a definite
"Denkermimik." 25 But, once again, modern viewers, influenced by
their own expectations, see more than the artist actually intended. Eu-
ripides is shown as an older man, and, as on some images of old men
on the gravestones, the barely visible wrinkles in the forehead and the
eyebrows gently drawn together may suggest a certain element of
mental effort or contemplation, but nothing more. A comparison with

the earlier portraits of intellectuals, such as those of Pindar (fig. 7), Lysias, and Thucydides (fig. 42),[26] makes it clear that the sculptor was in no way trying to express a specific kind of mental concentration. On the contrary, the very "normality" of Euripides' old man's face presumably once again reflects the statue's true intentions. Like Aeschylus and Sophocles, Euripides is portrayed as an Athenian citizen, a venerated ancestor, just like those so prominently displayed on the grave monuments of wealthy families at the Dipylon. It seems appropriate, in this context, that in his one preserved oration Lycurgus praises Euripides not so much as a poet, but rather as a patriot, because he presented to the citizenry the deeds of their forefathers as *paradeigmata* "so that through the sight and the contemplation of these a love of the fatherland would be awakened in them."[27]

Thus in the monument proposed by Lycurgus in the very place where the Assembly met, the three famous poets were presented as exemplars of the model Athenian citizen, probably in three different guises: Sophocles as the citizen who is politically engagé, Aeschylus as the quiet citizen in the prime of life, and Euripides as the experienced and contemplative old man. Their authority, of course, grew out of their fame as poets, yet they are celebrated not for this, but instead as embodiments of the model Athenian citizen.

I should add that most of what I have been suggesting remains valid even if one questions the identification of the portrait of Aeschylus or the association of the portrait of Euripides with Lycurgus' dedication. Even if the context were otherwise, as we shall see, nothing would change in the basic conception of these portraits. The only loss would be in the programmatic interpretation within the framework of Lycurgus' political goals.

A Revised Portrait of Socrates

The Lycurgan program for the patriotic renewal of Athens was all-encompassing. Practical measures for protecting trade and rebuilding offensive and defensive military capability went hand in hand with an attempt at a moral renewal. Religious festivals and rituals were revived

and given added splendor; new temples were built, and old ones renovated. The political center of the city was given a new prominence through a deliberate campaign of beautification that turned the most symbolically charged structures into a stage setting for the city and its institutions. Thus the Theatre of Dionysus, the Pynx, and the gymnasium in the Lyceum were all rebuilt and expanded, as were other buildings and commemorative monuments such as the state burials of the fifth century. Just as in the time of Pericles, the city's physical appearance, its public processions, and publicly displayed statuary were all conceived as parts of an overall manifestation of traditional institutions.[28]

But whereas fifth-century Athens had been a society oriented toward the future, now the city was essentially backward-looking in its desire to preserve and protect. The reminders of the past were intended to strengthen solidarity in the present and increase awareness of the political and cultural values of the democratic constitution now under siege by the Macedonian king and his supporters in the city. The past was to be brought into the present, to make people conscious of their cultural and political heritage. It is no coincidence that in these same years a cult of Demokratia was installed in the Agora and a new monument of the Eponymous Heroes was erected in front of the Bouleuterion.[29] It was in this political and cultural climate that the statues of the great tragedians were put up. They too were intended to strengthen the sense of communal identity and to provide a model for the kind of good citizens that the city needed.

The statues of the three playwrights were not the only examples of retrospective honorific monuments in this period. It is possible that the new statue of Socrates was created as part of the Lycurgan program of renewal. Unlike the portrait with the silen's mask set up shortly after the philosopher's death, this was a statue commissioned by the popular Assembly and erected in a public building. It is reported that the commission to make the statue went to the most famous sculptor of the day, Lysippus of Sicyon (D. L. 2.43).[30]

Alongside numerous copies of the head, we are fortunate enough in this instance to have one rendering of the body, though only in a small-scale statuette (fig. 33). Socrates is now depicted no longer as the

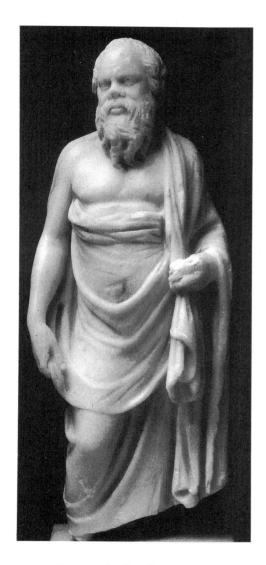

FIG. 33 Socrates. Small-scale Roman copy of an
original of the late fourth century B.C. H:
27.5 cm. London, British Museum.

outsider, but rather once again as the model citizen. He wears his himation draped over the body comme il faut and holds firmly both the overfold in his right hand and the excess fabric draped over the shoulder in his left so that this artful arrangement will not come undone when he walks. These gestures, which seem so natural and insignificant, are in fact, to judge from the gravestones and votive reliefs, part of the extensive code of required behavior that carried moral connotations as well. Careful attention to the proper draping of the garment and a handsome pattern of folds are an outward manifestation of the "interior order" expected of the good citizen. In the pictorial vocabulary, such traits become symbols of moral worth, and, in the statue of Socrates, this connotation is particularly emphasized by the similar gesture of both hands.[31]

The philosopher who was once likened to a silen now stands in the Classical contrapposto pose, his body well proportioned, essentially no different from the Athenian citizens on grave stelai like that of Korallion (fig. 34). The body is devoid of any trace of the famed ugliness that his friends occasionally evoked, the fat paunch, the short legs, or the waddling gait. If we assume for the earlier portrait of Socrates, as I have previously suggested, a body type to match the Silenus-like physiognomy of the face, then the process of beautification, or rather of assimilation to the norm, represented by Lysippus' statue would have been most striking in a comparison of the earlier and later bodies.

The same is true for the head and face, although here the later type does take account of the earlier by adopting some of the supposedly ugly features of the silen (fig. 35). These had by now most likely become fixed elements of Socrates' physiognomy. If we suppose that Lysippus was consciously reshaping the older portrait of Socrates, then the procedure he followed in doing so becomes much clearer. The provocative quality of the silen's mask has disappeared, and the face is, as far as possible, assimilated to that of a mature citizen. Hair and beard are the decisive elements in this process of beautification. They set the face within a harmonious frame. The long locks now fall casually from the head and temples, and the few locks at the crown are made fluffy, so that the baldness looks rather like a high forehead. The face itself is

FIG. 34 Grave stele of Korallion. Athens, Kerameikos.

articulated with more traits of old age than was the case with the silen's mask. Some of the copyists even heightened this tendency of the original portrait, turning Socrates into a noble old man. Thus by the later fourth century, Socrates is no longer the antiestablishment, marginalized figure or the teacher of wisdom with the face of a silen, but simply a good Athenian citizen.[32]

The setting of this statue is no less remarkable than the makeover of Socrates' image. According to Diogenes Laertius (2.43), the statue stood in the Pompeion. This was a substantial building fitted into the

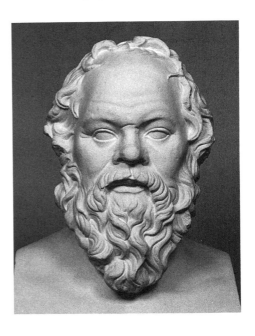

FIG. 35 Portrait of Socrates (Type B). Roman copy after the same original as the statuette in fig. 33. Paris, Louvre.

space between the Sacred Gate and the Dipylon. Its purpose, as its name implies, was to serve as a gathering place for the great religious processions at the Panathenaea. Another of its functions seems to have involved the training of the Athenian ephebes. Pinakes with portraits of Isocrates and the comic poets, including Menander, suggest that the building played some role in the intellectual life of the city as well. It is even possible that the Pompeion was restored by Lycurgus at the same time as the nearby city wall.33 In any event, Socrates was to be honored at one of the key centers of religious life and the education of the young. The man once condemned for denying the gods and corrupting the young had become the very symbol of Attic *paideia,* presented as the embodiment of citizen virtues, a model for the youth!

A General in Mufti: Models from the Past

It was not only the great intellectuals who received such monuments as part of this collective act of remembrance, but other famous Athenians from the city's glorious past. A good example is the posthumous statue of Miltiades, who had led the Athenians to victory over the Persians at Marathon. Unfortunately, only three copies of middling quality preserve the head of the statue created about the middle of the fourth century or a bit later.34 Despite the rather limited evidence at our disposal, we may make one important inference on the basis of an inscribed herm in Ravenna (fig. 36): the great general was not depicted in helmet or nude, or in armor, as would be usual in the fifth century, but rather in a civilian's mantle, like Socrates and the tragedians. The programmatic message is unmistakable: even the victor of Marathon, after his great triumph over the Persians, had returned to civilian life, an exemplary member of the democracy in the spirit of egalitarianism (his conviction for treason and subsequent death in prison conveniently forgotten). This message is here underlined by the particularly expressionless face, which, when put alongside portraits such as those of Pericles and Anacreon, can signify only a complete self-control. The transformation of Miltiades into an average citizen is all the more extraordinary in as much as the Athenians had long been familiar with portraits of *stratēgoi* who were depicted as such, and, as the example of Archidamus makes clear, knew well what the face of a man bent on power could look like.35

The statue of Militiades will most likely also have been set up by the polis. Indeed Pausanias (1.18.3) saw in the Prytaneion statues of both Militiades and the other victor over the Persians, Themistocles. And both had been reused by the Athenians in the Imperial period to honor contemporary benefactors, one a Roman, the other a Thracian—a not-uncommon frugality. Pausanias' comment on the "rededication" of the statues is a strong argument for identifying the original Militiades with the type preserved in the herm copy. Assuming the statue was a standard figure in long mantle, the reuse would simply have been a matter of replacing or reworking the head, whereas a nude or armed

FIG. 36 Herm of the general Miltiades. An-
tonine copy of a portrait statue ca. 330 B.C.
Ravenna, Museo Nazionale.

statue of the *stratēgos* would have presented much greater problems.³⁶
When we consider all the traditional political associations of the Pry-
taneion, it seems a reasonable supposition that these two statues of
great commanders also belong to the time of Lycurgus. This cannot,
however, be confirmed by stylistic arguments, since the portrait of
Miltiades could date as early as ca. 360 B.C.

Quite apart from the question of its date, the portrait of Miltiades once more lends support to our interpretation of the statues of the tragedians in the Theatre of Dionysus, as well as that of Socrates in the Pompeion, as paradigms of the good Athenian citizen. In these honorific monuments, the intellectual qualities of the great writers and philosophers of old were of as little concern as the martial valor of the generals. Rather, by representing the great Athenians of the previous century as if they were outstanding contemporaries instead of giants of a bygone era, the impression was created of a seamless continuity between past and present. We are dealing here with a self-conscious act of collective memory, not with a nostalgic reverence for remote and inimitable figures, as will be the case later on.

This attempt to recall and incorporate the great men of Athens's past in the present had not, however, started with Lycurgus. Portraits honoring Lysias and Thucydides, whose furrowed brows we shall return to shortly, had been put up a generation or two before Lycurgus' dedication of the tragedians.37 Some time after Lycurgus, apparently, statues of the Seven Wise Men were put up, again in the guise of distinguished contemporaries: even Periander, tyrant of Corinth, was converted into a good citizen (fig. 37)!38 Indeed, we may suppose that almost all portrait statues of the great men of the fifth century that were put up in Athens in the fourth century had the same kind of exemplary function. But under Lycurgus this form of didactic retrospection, when coupled with other measures, first took on a particularly programmatic character. Thus it makes little difference for our understanding of them whether the statues of Socrates or Miltiades actually belong ten or twenty years earlier or later.

The Athenians always felt that their loss of primacy in the political and military sphere was compensated by a cultural superiority to other Greeks, evidenced in their democratic constitution and the Attic way of life that they considered unique, as well as in specific accomplishments such as the staging of great festivals, the Periclean buildings on the Acropolis, and even the works of the great playwrights. The strategies employed to sustain this notion included the elevation of daily life to the level of aesthetic experience, along with the continual cultivation of the memory of the great events and figures of the past. In the

FIG. 37 Herm of Periander, tyrant of Corinth, as one of the Seven Wise Men. Antonine copy of a portrait statue of the late fourth century B.C. Rome, Vatican Museums.

visual arts of the fourth century we can already detect conscious evo-
cations of High Classical style, so that the act of memory is cloaked in
the appropriate artistic form.39 The programmatic idea of a compre-
hensive *paideia,* as propagated by Isocrates, and the notion of Athens
as the "school of Hellas" are both slogans that attest to the remarkable
success of these efforts. After the collapse of their imperial aspirations,
the Athenians succeeded in establishing a claim to cultural preemi-
nence that they kept intact virtually to the end of antiquity. Later on
we shall see how this phenomenon influenced the way many intellec-
tuals saw themselves, even under the Roman Empire.

Plato's Serious Expression: Contemplation as a Civic Virtue?

Thus far we have dealt only with retrospective portraits and must now
ask, how did contemporary intellectuals in fourth-century Athens
have themselves portrayed? What was the relation between their own
self-image and the way they presented themselves? Certainly Plato and
Isocrates were no more lacking in self-assurance than the Sophists. By
about 420–410 B.C., Gorgias had dedicated a gilded statue of himself
in Delphi, prominently displayed on a tall column (Pliny *HN* 33.83;
Paus. 10.18.7).40 Both the separation of the intellectual from society
at large and at the same time the claim to a position of leadership in
the state had, if anything, increased since the days of the Sophists. The
formation of large circles of disciples in the rhetorical schools and
around the philosophers, as well as the partial withdrawal of these
schools from public life, their rivalries and their vigorous criticism of
the status quo, had in the course of the fourth century led to a situation
in which both teachers and pupils attracted the attention of the public
even more than in the time of Aristophanes. The great interest that the
comic poets took in contemporary philosophers attests to their vivid
presence in the public consciousness.41

By coincidence, we hear in our sources of two impressive funerary
monuments in the decade 350–340, in both of which the intellectual
activity of the deceased was explicitly commemorated. One was a

monument for Theodectes, the poet from Phaselis, with statues of the most famous poets of the past, starting with Homer. The other was the family tomb monument of Isocrates, which had portraits in relief of his teachers, including Gorgias instructing the young Isocrates at an astronomical globe—a motif known to us from later works. Thus the great orator continued even in death to broadcast his plea for a universal *paideia*. Did these men's contemporaries perceive such tombs as being at odds with the social ideal of equality? Is it just accidental that both tombs are private monuments for men with well-known royalist sympathies? Isocrates was said to have congratulated Philip of Macedon on his victory at Chaeronea, and Theodectes seems to have been a favorite of Alexander's.[42]

In these circumstances, we might have expected that the portraiture of such self-assured individuals would make direct reference to their intellectual claims and abilities, whether in dress and pose or facial expression, beard, or hairstyle. Unfortunately the pitiful state of our evidence does not permit any definite answers, especially with regard to body types. While we have a whole series of head types, we have not one body that can be identified as belonging to a portrait of a contemporary intellectual of the fourth century. We may, however, suppose that their bodies looked little different from those of the retrospective portraits of the famous poets or of Socrates or, for that matter, of the male citizen on the gravestones. This is, at least, what we would expect from what we know of their heads. This brings us back to the difficult question of how to interpret Plato's expression in his famous portrait type (figs. 24, 38).[43]

A small bronze bust, only fifteen centimeters high, that recently appeared on the art market has considerably enriched our understanding of the original Plato portrait (fig. 39a, b).[44] This version has an aquiline nose, erect head, and the mantle falling over the nape of the neck and the shoulders. Plato is portrayed as a mature man, but not elderly. His hair does not fall in long strands, like that of Euripides, but rather is trimmed into even, fairly short locks. His beard is long and carefully tended, similar to Miltiades' (see fig. 36). The only clear signs of age are the sharp creases radiating from the nose and the loose, fleshy

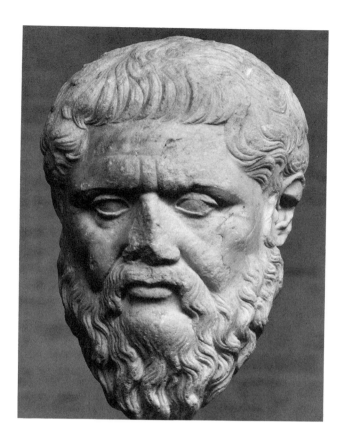

FIG. 38 Portrait of Plato, as in fig. 24. Munich,
Glyptothek.

cheeks. Both style and characterization suggest that the portrait could
well have been created during Plato's own lifetime and not, as usually
assumed, after his death in 348/7.[45] Perhaps the original is to be iden-
tified with a statue set up in the Academy by one Mithridates, presum-
ably a pupil of Plato's, whose inscription is recorded by Diogenes
Laertius: "The Persian Mithridates, son of Rhodobatos, dedicates this
likeness of Plato to the Muses. It is a work of Silanion" (3.25). It was,

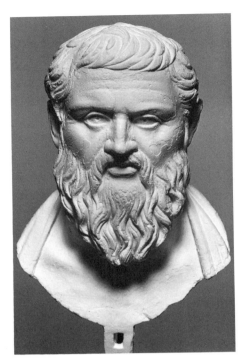
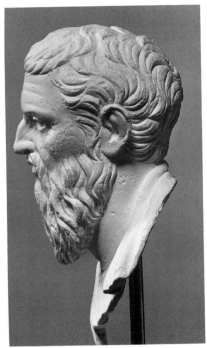

FIG. 39 a–b Small bronze bust of Plato, from the same
original as fig. 38. Kassel, Staatliche Kunstsammlungen
(from a cast).

then, a votive to the Muses, like the portrait of Aristotle (D. L. 5.51),
and would have stood in the shrine of the Muses in the Academy,
though it is not clear whether this shrine was the one in the public
gymnasium of that name or in Plato's gardens nearby.

 The serious expression of the face is created primarily by the two
horizontal lines across the brow and the drawing together of the eye-
brows, forming two short vertical lines above the ridge of the nose.
This network of wrinkles, however, which is only hinted at in some
copies, as in Munich, but more deeply engraved in others, is a wide-
spread formula. It occurs in most intellectual portraits of the fourth

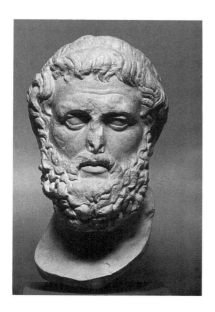

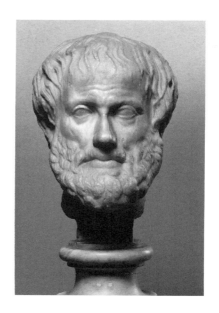

FIG. 40 Portrait of Sophocles. Detail of the statue in fig. 25.

FIG. 41 Portrait of Aristotle (384 – 322). Roman copy of a statue of the late fourth century B.C. Vienna, Kunsthistorisches Museum.

century, more or less pronounced, whether for Aristotle (fig. 41) or Thucydides (fig. 42), Theophrastus (fig. 43), the tragedians dedicated by Lycurgus, or Socrates. One could even think back to the mid-fifth-century portrait of Pindar. At that time, however, it had been standard practice, at least in Athens, not to include any indications of effort or emotion in citizen portraits, as we saw attested in the images of Anacreon and Pericles. The serious expression of Plato is therefore an innovation of the fourth century, a departure from, or rather a relaxation of, the earlier convention.

Nevertheless, for the contemporary observer, this trait cannot have been a *specific* and *exclusive* indicator of intellectual activity, for the expressions of mature male citizens on Attic grave stelai often have a similar character, and it is hardly possible in each individual case to

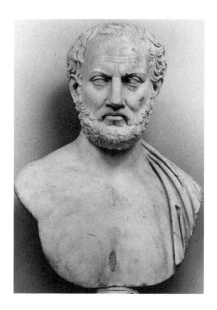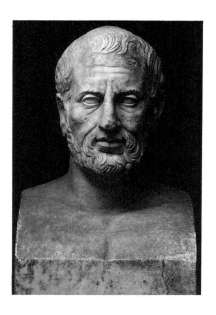

FIG. 42 Portrait of the historian Thucy- FIG. 43 Portrait herm of Theophrastus
dides (ca. 460–400). Roman copy of a (ca. 372–288). Roman copy of a statue
statue of the mid-fourth century B.C. ca. 300 B.C. Rome, Villa Albani.
Holkham Hall.

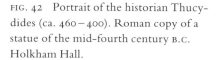

be certain if it is really meant to convey an air of introspection
(fig. 44a–d).[46]

As Giuliani has shown, such a serious expression, with the brows
drawn together, could have been understood at this time as signifying
intelligence and thoughtfulness. In our sources, even a young man is
counseled to appear in public with such a countenance.[47] But this
particular quality is never mentioned in isolation by contemporary au-
thors, rather always in the context of other traditional expressions of
the well-bred Athenian citizen, such as a measured gait, modest de-
meanor in public, and modulated voice. And these are the very stan-
dards of behavior, as we have seen, by which the morally correct citi-
zen, the *kaloskagathos,* was measured. In other words, the canon
of citizen virtues, already well attested in the time of Pericles, was

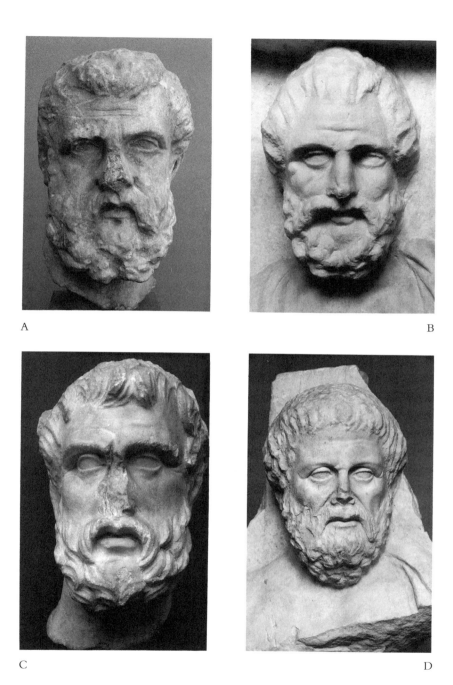

A B

C D

FIG. 44 a–d Four portraits of mature Athenian citizens
from grave stelai of the later fourth century B.C.:
a, Copenhagen, Ny Carlsberg Glyptotek; b, Athens,
National Museum; c and d, Copenhagen, Ny Carlsberg
Glyptotek.

enhanced in the course of the fourth century with an additional intel-
lectual quality embodied in the new facial expression.

We may well imagine that some well-known intellectuals in Athens,
and even more likely their pupils, did indeed cultivate such a serious
demeanor in their public appearances, for which they were ridiculed
by the comic poets.[48] But this did not stop the admirers of the great
masters from having them portrayed with an introspective look, even
if, as in Plato's case, so subtly that the basic citizen image is barely
altered. We must once again remind ourselves that we tend to see these
portraits too close up. No contemporary viewer would have perceived
the facial expression in the disconnected fashion we do, when we stare
at a photograph and look for the wrinkles. He always saw the face as
but one element of the whole statue. As writers of the time attest, the
serious expression was not the primary component, rather an extra
touch in the traditional citizen image.

Unfortunately, no copy of the body belonging to the statue of Plato
has yet come to light, though we may assume that it was somewhat
similar to that of Socrates (see fig. 33). Since Plato is not portrayed as
an old man, the gravestones would lead us to think that he could hardly
have been shown seated in the manner that, as we shall see, first appears
with the most authoritative Hellenistic thinkers. Like that of Aristotle
and other philosophers of the Classical period, Plato's teaching style
involved much physical movement (D. L. 3.27). The dialogue was
more than just a literary genre.[49]

But the most interesting aspect of this whole issue is the way in
which the serious expression of the philosophers is transferred to the
nonspecific citizen image. That this could occur at all presumes that,
in spite of the mocking of the comic poets, the new visual formula
carried basically positive associations. The fact, however, that the lined
forehead and drawn-together brows occur on the grave stelai primarily
for elderly and even older men makes the formula even less specific.
That is, even if this trait was originally intended for the portraits of
intellectuals as the mark of the thinker, this cannot apply equally to all
the faces of older citizens that now display it. For them, it inevitably
becomes a vague and ambiguous formula, which can express strain as
well as introspection, perhaps sometimes even grief or pain. For the

ancient viewer whose eye was accustomed to these images, Plato's expression would lose any specific significance and could hardly convey "a considerable degree of specialized mental activity as the general characteristic of the intellectual." [50]

The great impression made by the publicly known intellectuals of the fourth century on their fellow Athenians can perhaps be inferred from yet another remarkable phenomenon. Among the portraits of anonymous older men on the grave stelai can be found a number of faces that are strikingly similar to those of famous intellectuals. A portrait of an old man in Copenhagen, for example, once part of a grave stele, recalls the portrait of Plato so closely that one could almost ask if this were the philosopher's own tomb monument (fig. 44d). [51] But this is unlikely on typological grounds alone, since older men like this one with the same expression are usually subsidiary figures in the background. Furthermore, this is not a unique instance. Other heads on gravestones recall the portraits of Aristotle (fig. 44b), Theophrastus, and Demosthenes, while at the same time the unsurpassed artistic dimension of these portraits, compared with the grave reliefs, with their new means of expressing personality, is obvious. [52] Such similarities between the portraits of intellectuals and those of ordinary Athenians suggest that not only their meditative expressions but also certain individual physiognomic features of the famous philosophers and rhetoricians were so familiar and widely admired that some of their contemporaries affected similar styles of hair, dress, and bearing. We hear in the literary sources, for example, that Plato's followers were made fun of for imitating his hunched stance, and in the Lyceum some of Aristotle's distinguished students adopted the master's lisp (Plut. *Mor.* 26B, 53C). Theophrastus is a good example of just how popular an intellectual figure could become in Athens: people came in droves to his lectures, and half the city took part in his funeral (D. L. 5.37, 41).

If what I have been suggesting is true, it would imply that Classical portraits, while adhering closely to a standard typology, do nevertheless occasionally reproduce actual features of the subject's physiognomy—in Plato's case, the broad forehead and the straight line of the brow, in Aristotle's; the small eyes (which are also mentioned in the

literary sources). Athenian citizens will have similarly imitated even more eagerly the faces of influential statesmen and other well-known and well-liked personalities. The fact, however, that such assimilation is attested only in the portraiture of intellectuals is probably to be explained by the choices made by the proprietors of Roman villas for their collections of portrait busts (cf. pp. 203ff.). Viewed as a whole, Athenian portraiture of the fourth century experienced a continual and pervasive process of differentiation in facial types. The driving force behind this may well have been the urge to assimilate to the likeness of famous individuals.

We may, then, reaffirm that Plato was depicted not as a philosopher, but simply as a good Athenian citizen (in the sense of an exemplary embodiment of the norms), and this is true of all other intellectuals of fourth-century Athens for whom we have preserved portraits. Nor was Plato's expression likely to have been read by his contemporaries as a reference to particular intellectual abilities.

Furthermore, Plato's beard was, at the time, not yet the "philosopher's beard," but the normal style worn by all citizen men. It was only by the Romans that it was first interpreted as a philosopher's beard, a point seldom recognized in archaeological scholarship (cf. pp. 108ff.). Nevertheless, the length of Plato's beard has rightly caused some puzzlement.53 On the gravestones, it is primarily the old men who wear such a long beard, while those who, like Plato, have not yet reached old age tend to wear it trimmed shorter.54 Given the extraordinarily high degree of conformity in Athenian society, such deviations could certainly be meaningful. The key may be contained in an often-adduced fragment of the comic poet Ephippus, a contemporary of Plato's, who makes fun of one of Plato's more pompous pupils, whom he describes as *hypoplatōnikos* (frag. 14 = Ath. 9.509B).55 His chief characteristics include an elegant posture, expensive clothing, sandals with fancy laces, carefully trimmed hair, and a beard grown "to its natural length." Even this, however, does not imply a specifically self-styled philosopher, but rather a noticeably elegant and soigné appearance characteristic of some of Plato's pupils. As would later be true of the Peripatetics, the members of the Academy evidently valued a

distinguished, not to say "aristocratic," appearance. The portrait of Plato makes the same statement, when one considers especially how carefully cut and arranged the hair is across the forehead, as well as the beard, which is, strictly speaking, too long for a man of his age. If, then, there is anything about the portrait of Plato that suggests a subtle differentiation from the norm, it would be in the realm of aristocratic distinction.

The search for the portraiture of intellectuals in fourth-century Athens leads finally to a kind of dead end. We find an extraordinary situation, in which both Athenian citizens and outsiders, quite independently of their profession or social status, and even including critics of the state and its institutions such as Plato and his pupils, identified with a highly conformist citizen image. This identification was entirely voluntary and is equally applicable to publicly and privately displayed monuments. There must have existed a general consensus on the moral standards embodied in this citizen image. The phenomenon may be likened to that of the standard houses of uniform size that we find in newly planned Greek cities.[56] In both instances, aesthetic symbols express a notion of the proper social order that has been fully internalized, independently of the current political situation at any given time. Even for the famous teachers of rhetoric and philosophy, with their high opinions of their own worth, the message "I am a good citizen" was evidently more important than any reference to their abilities or self-perception as intellectuals. In fact, as the votive and funerary reliefs attest, they were no different in this respect from the craftsmen and other fellow citizens who followed a specific profession or enjoyed a particular status.[57]

Political Upheaval and the End of the Classical Citizen Image: Menander and Demosthenes

After the death of Alexander, Athens's political stability was shaken by a seemingly endless series of reversals. For several generations, oligarchic and tyrannical regimes alternated with democratic ones, both moderate and radical, each often lasting no more than a few years.

Nearly every change of government brought with it the exile or return from exile of the main protagonists.[58] It is only natural to suppose that these constant political volte-faces had a destabilizing effect on the general mood and the acceptance of traditional standards of behavior in the democratic state. This insecurity would especially have infected the relationship between the individual and the community, creating an urgent need for a new spiritual orientation independent of political values.

In these circumstances, the traditional image of the Athenian citizen also experienced a kind of crisis. I should like to demonstrate this with two exemplary cases, the statues of the comic poet Menander and the orator Demosthenes, both public honorary monuments for which we can reconstruct reasonably well the original location and the historical circumstances. Both statues are rightly regarded as cornerstones of Early Hellenistic art. I wish to place them here alongside the Late Classical portraits of Sophocles and Aeschines primarily to illustrate once again, by means of the contrast, the peculiarly self-contained nature of the Classical citizen image. The values and desires expressed in these new monuments were not in themselves new, but they could, it seems, find public recognition only in the changed political circumstances. In retrospect, this only confirms the suspicion that the moral standards embodied in the imagery of the Classical citizen were a direct concomitant of the democratic political consciousness.

The statue of the comic poet Menander was put up most probably soon after his death in 293/2, in the Theatre of Dionysus in Athens, in a prominent spot at one of the principal entrances. According to the preserved inscription, it was the work of two sons of the renowned Praxiteles, Kephisodotus the Younger and Timarchus. I will pass over the complicated history of the transmission of this portrait type and instead take as my starting point the results of the recent reconstruction by Klaus Fittschen, imaginatively realized with the help of plaster casts (fig. 45).[59] Because, however, the reconstruction still does not give the complete picture (since it is impossible to take account of all the copies at once), a more extensive description will be necessary, to

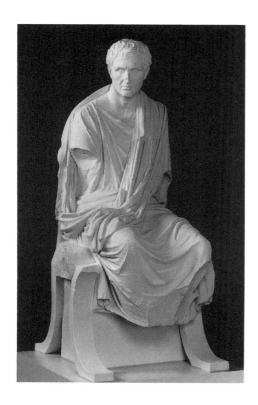

FIG. 45 Honorific statue of the poet Menander
(342–293). Reconstruction by K. Fittschen with
the help of plaster casts. Göttingen University,
Archäologisches Institut.

give an idea of the full state of our evidence as transmitted by the
copies.

Everything about this statue runs contrary to the old ideals. The
poet, who died at fifty-two, is shown as approximately that age, yet he
is seated on a high-backed chair that, on Classical grave stelai, had been
reserved for women and elderly men. The seated motif has now taken
on an entirely new set of connotations. The poet is presented to us as
a private individual who cultivates a relaxed and luxurious way of life.

The chair is a handsome piece of furniture, with delicate ornament. The domestic ambience is underlined by the footstool, slid in at an angle, and the overstuffed cushion that overlaps the sides. Later on we shall see what an important role these cushions play in the iconography of the poet.

Menander sits upright, his garment carefully draped, yet his posture fully relaxed. His legs are positioned comfortably, one forward, the other back, the right arm resting in his lap, and the left descending to the pillow. His shoulders are drawn together, and the head is lowered and, in an involuntary movement, turned to the side. The poet gazes out, as if lost in thought, unaccompanied and unobserved. Why, then, has the artist attached such importance to his handsome appearance and to portraying his calm and idyllic existence? His outfit is also very different from that of earlier portrait statues. The undergarment that he wears would have been considered effeminate in the time of Lycurgus. In addition, the himation is much more voluminous than before, the excess fabric arranged so casually and yet artfully and elegantly as to give the play of folds their full effect. On his feet are handsome sandals with a protective strap over the toes.

The hairstyle, "casually elegant," in the words of Franz Studniczka, betrays a deliberate concern for careful grooming, while the clean-shaven face takes up the fashion introduced by Alexander and the Macedonians, and must be understood as the sign of a soft and luxurious life-style (cf. p. 108).

We have already noted how variable the face of Menander is in the different copies. Of the seventy-one copies recently compiled by Fittschen, there is not one that can simply be assumed to be most faithful to the original. It must somehow have conveyed youthful beauty as well as exertion, have been both distanced and introspective. Two busts, in Venice (fig. 46) and Copenhagen (fig. 47), may provide the two poles between which we should imagine the original. The face is, in any event, expressive and personal in an utterly new way.[60] The artist allows the viewer a glimpse into the private realm of the subject. The public and impersonal character of the statue of Sophocles (fig. 25) becomes in retrospect even clearer.

The whole portrait matches rather well what we hear in our sources about the poet's manner and personal style. The most revealing anecdote relates Menander's appearance before Demetrius Poliorcetes, when he hurried to welcome the new ruler. "Reeking of perfume," as Phaedrus writes, he pranced before the new overlord of Athens in long, flowing robes, swiveling his hips, so that the Macedonian at first took him for a pederast, before he heard who he was. But then he too was impressed by Menander's extraordinary beauty (Phaedr. 5.1). Incidentally, the contemporary source from which this quotation must derive specifically mentioned that Menander entered the king's presence with a group of "private individuals" (*sequentes otium*), which implies that they were already recognized as a particular segment of society.

The statue of Menander, in its appearance and the way of life it reflects, embodies the very type so repugnant to the radical democrats: the wealthy and elegant connoisseur who withdraws entirely from public life. As is well known, Menander's comedies are essentially apolitical renderings of everyday life. If we can trust later sources, this image seems to be an accurate reflection of his own life. Evidently he did not even live in the city but deliberately withdrew to the Piraeus with his lover, to enjoy a nonconformist way of life.[61] And in this respect Menander was not alone. Earlier on, in the Peripatos, the philosophical school with royalist leanings where Menander studied together with his friend Demetrius of Phaleron, an elegant and luxurious style was highly prized. Even Aristotle was said to have called attention to himself by wearing many rings (Ael. *VH* 3.19). When Demetrius of Phaleron ruled Athens as regent of the Macedonian Kassander (317–307 B.C.), he was accused of leading a decadent life filled with lavish banquets, beautiful courtesans, and expensive racehorses. And it is unimaginable that the extravagant life-style of Demetrius Poliorcetes did not make a deep impression on the Athenians. Surely some of this will have rubbed off on the wealthier Athenians during his long stays in the city. Thus arose the cult of *tryphē,* a gay joie de vivre associated with this particular circle, a style that would soon become emblematic of the royal image of the Ptolemies in Egypt.[62]

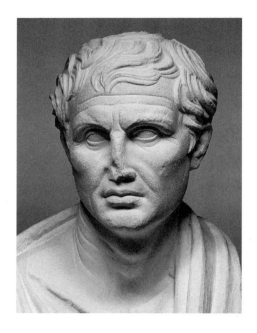

FIG. 46 Bust of Menander. Venice, Seminario
Patriarchale. (Cast.)

But the monument to Menander was set up by the Athenian people,
at a conspicuous location, and even stood on a tall base that empha-
sized its official character. If the figure celebrates elements of a particu-
lar way of life, we cannot dismiss these as the traits of one famous in-
dividual who was looked on as an outsider in Athens. Rather, the
oligarchy now in power, installed by Demetrius Poliorcetes, chose to
celebrate a way of life that had always been cultivated at the courts of
kings and tyrants but was anathema to the democratic polis. Certainly
Lycurgan Athens would not have put up a statue to a man like this or
at least would never have celebrated in him these particular qualities.

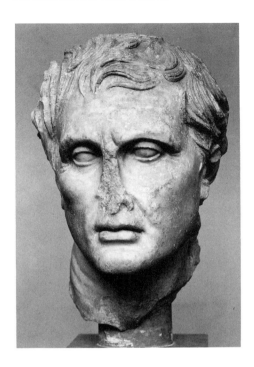

FIG. 47 Augustan copy of the portrait of Men-
ander. Copenhagen, Ny Carlsberg Glyptotek.

The occasion for the statue was once again, as in the case of Lycurgus'
honors for the tragic poets, the great fame and popularity of Menan-
der's work, yet he is not portrayed as a poet. What his friends admired
most about him was rather his way of life. Thus Menander's statue can
also be seen as a kind of role model, not, however, for a polis oriented
toward the ideal of civil egalitarianism, but only for a small segment of
wealthy oligarchs and their sympathizers. Or were these now perhaps
in the majority?

The statue of Demosthenes, by the otherwise unknown sculptor
Polyeuktos, put up about a decade later, may be seen as a counter-
point to the Menander portrait, emanating from the camp of the
democrats (fig. 48).[63] The simple garment and beard reflect once

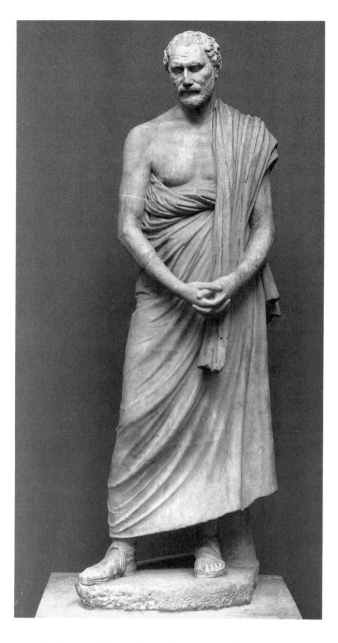

FIG. 48 Statue of Demosthenes (ca. 384–322). Roman copy of the honorific statue set up in 280/79 B.C. (with the hands correctly restored). Copenhagen, Ny Carlsberg Glyptotek.

again traditional values. But both pose and expression now proclaim for the first time the extraordinary intellectual capacity required for political achievement.

The political situation had once again changed soon after the death of Menander. After 287 the city itself was again free, the old democratic constitution reinstated. Yet there was less room for political maneuvering, so long as a Macedonian garrison remained in the Piraeus. The rehabilitation of Demosthenes, sworn enemy of the Macedonians and defender of freedom, was commissioned by his grandson Demochares, himself a leading democratic politician who had been in exile for seventeen years because he refused to collaborate with the oligarchic regime. The honorific statue of Demosthenes was a clear sign of the renewed Athenian resolve to be independent. The statue's location underlines its political significance. It stood in the middle of the Agora, near the Altar of the Twelve Gods, the famous monument to the goddess Peace, and the statues of Lycurgus and Kallias (Paus. 1.8.2).

Unlike Sophocles and Aeschines, Demosthenes seems to be entirely absorbed in himself. His hands are clasped before him, the head turned to the side, and the gaze directed downward. Despite what looks at first like a quiet pose, the orator is actually shown in a state of extreme mental tension. The brows are almost painfully drawn together, and the position of the arms and legs is not at all relaxed. Everything about the statue is severe and angular, at times even ugly. It has none of the genial quality or self-assured presentation in public of Sophocles or Aeschines (figs. 25, 26). In such a state of concentration, one does not pay attention to the proper fall of the mantle or a graceful posture. Yet Demosthenes' pose cannot be explained simply as a neutral characteristic of the statue's style; rather it expresses a specific message.

As so often in portrait studies, commentators have tried to find biographical clues to the statue's interpretation. The clasped hands are supposed to be a gesture of mourning, to suggest that the failed statesman laments the loss of freedom, a warning to future generations.[64] Yet neither the epigram beneath the statue nor the long accompanying decree gives any hint of failure. The epigram reads: "O Demosthenes, had your power [*rhōmē*] been equal to your foresight [*gnōmē*], then

would the Macedonian Ares never have enslaved the Greeks." The contrast is between *gnōmē* and *rhōmē,* and Demosthenes is celebrated as a man of determination and insight. Both notions are contained in the word *gnōmē.* Since the epigram originated in the circle of the radical democrats, it cannot be taken to imply any criticism of Demosthenes' failure. It merely laments the fact that he did not have access to the necessary military might to implement his political goals.

The statue also celebrates Demosthenes' *gnōmē* by rendering the activity in which he won his reputation, as a public speaker.[65] Plutarch reports how excitable Demosthenes became when speaking extemporaneously (as opposed to when he delivered a rehearsed speech). His emotional speaking style was criticized by his opponents as too populist, and Eratosthenes (*apud* Plutarch) refers contemptuously to the "Bacchic frenzy" in which the orator came before the Assembly. Demetrius of Phaleron is even more specific: "The masses delighted in his lively presentation, while the better class of people found his gestures vulgar and affected" (Plut. *Dem.* 9.4; see also 11.3).

I believe this passage suggests the correct interpretation of the clasped hands. The statue revives these old accusations of theatrical gestures but refutes them and at the same time praises Demosthenes for his passionate commitment. That is, it asserts, in spite of the extreme effort and concentration of the great patriotic speeches, the speaker never lost his self-control. He grasps his hands firmly before him to show that he has mastered his emotions. Though extremely tense, he does not move his arms, and the mantle remains properly draped. But he is no actor, like his rival Aeschines, who would assume a rehearsed and artificial pose. Rather than showing himself off, he is concerned only with the matter at hand.

The gesture of the clasped hands has, like most others, multiple meanings in Greek art. It can indicate a high emotional state, as Medea before the murder of her children, but also a state of calm and self-control, as on the gravestones. Its specific meaning must be read from the context. I believe my interpretation is confirmed by the occasional reappearance of the clasped hands motif—and an even stronger version in which the two hands grasp each other tightly—on Hellenistic grave stelai, alongside other formulas for depicting a public appear-

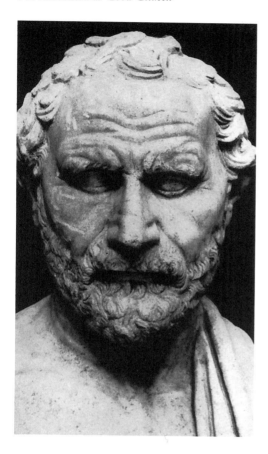

FIG. 49 Bust of Demosthenes. Cyrene, Museum.

ance.[66] The gesture can also be found in some later portrait statues that have already been taken to be those of orators, including two torsos of the High Hellenistic period, where it is so dramatically exaggerated as to suggest the "Asiatic" school of rhetoric: the passionate speaker literally wrings his hands.[67]

The "unprecedented pathos" of Demosthenes' facial expression (fig. 49), as Giuliani observes, is indeed to be understood as "a signal for burning political commitment."[68] This is not the expression of a man in mourning. The contracted brows reflect the struggle to find

FIG. 50 Portrait of the general Olym-
piodorus. Roman copy of a portrait
ca. 280 B.C. Oslo, National Gallery.

the mot juste. We are witnessing here a new paradigm for expressing
intellectual activity, one that we shall soon encounter again in the por-
traits of the Stoics. A comparison with the very different expression of
Olympiodorus (fig. 50), in the portrait of this contemporary general
who drove the Macedonians from the Mouseion in 287, makes clear
that, after the generalized citizen faces of the fourth century, we are
now dealing with a new mode of expression that conveys specific tal-
ents and situations. Olympiodorus' expression embodies *rhōmē;* De-
mosthenes', *gnōmē.*

Alongside the energy and concentration of Demosthenes, his rival
Aeschines' appearance—flawless but utterly lacking in emotion—

looks in retrospect rather insincere, mere surface beauty. It is quite conceivable that the statue of Demosthenes was intended as a kind of countermonument to that of Aeschines (fig. 26). Beside the realism of Demosthenes, Aeschines' pose looks rather theatrical, the undergarment and hairstyle effeminate. The portrait of Demosthenes proclaims instead that genuine achievement is gained through extreme effort, that is (and this is the part that is new), intellectual effort. A message of this sort presupposes a very different set of values. The statue's purpose is no longer to present a prescribed model of citizen virtue, but rather to celebrate extraordinary abilities and accomplishments.

With this monument, democratic Athens distances itself from its own earlier ideal of an emotionless *kalokagathia*. For the first time, an honorific statue of prime political significance celebrates superior intellectual power as the quality of decisive importance. This means, however, that in the representation of Athenian citizens a previously unknown hierarchy becomes apparent. In spite of the many references to earlier tradition, Demosthenes is no longer the exemplary citizen, simply one among equals, like Sophocles and other fourth-century intellectuals. Instead, he is presented as a towering, even heroic figure. Ironically, it was the democratic faction of Demochares that was responsible for this first major break with its own long-cherished image. And this break is but a foretaste of the wholesale shift in values that will reshape the society of the Early Hellenistic age.

III. The Rigors of Thinking

But you deny that anybody except the wise man knows any-
thing; and this Zeno used to demonstrate by gesture: for he
would display his hand in front of someone with the fingers
stretched out and say, "A visual appearance [visum] *is like*
this"; next he closed his fingers a little and said, "An act of
assent [adsensus] *is like this"; then he pressed his fingers*
closely together and made a fist, and said that that was compre-
hension (and from this illustration he gave to that process the
actual name of katalēpsis, *which it had not had before); but*
then he used to apply his left hand to his right fist and squeeze
it tightly and forcibly, and then say that such was knowledge
[scientia], *which was within the power of nobody save the wise*
man—but who is a wise man or ever has been even they them-
selves [the Stoics] do not usually say.

— Cicero *Academica* 2.145

Among the terra-cotta figurines of the early third century are two new types depicting young men for which there are no parallels in earlier Greek art (figs. 51, 52). Both are seated, awkwardly hunched over, in contemplation. So lost in thought are they that they forget to sit up straight, even though the Greeks earlier attached great importance to correct posture. One of the two lifts his right hand to his cheek and looks wistfully to one side. The other props a heavy head on his chin, his whole body looking tensed from the strain of contemplation.[1]

The contrast between these and the typical image of the ephebe on Classical grave stelai is striking. Instead of allusions to athletic prowess or the handsome body in the perfect contrapposto pose, the quality now celebrated as a praiseworthy virtue of the well-bred youth is intense contemplation. The high social status of these young men is indicated by their clothing and the way in which they keep the left arm

FIG. 51 A contemplative
young man. Terra-cotta
statuette. Paris, Louvre.

FIG. 52 Contemplative young
man. Terra-cotta statuette. Mu-
nich, Antikensammlungen.

wrapped up in the garment. The later statuette, with the head propped
on the chin, in particular makes it clear that thinking is regarded as
hard work, requiring tremendous concentration and effort.

Such a departure from traditional iconography is usually not the
invention of a coroplast, but rather inspired by the major arts. And
indeed, an impressive statue of a philosopher in the Palazzo Spada in
Rome, which derives from an original of the mid-third century, pre-
serves almost the identical motif (fig. 57). Most likely the terra-cottas,
which have been found in various parts of the Greek mainland, are a
half century earlier than the prototype of the statue in the Palazzo
Spada and are in turn dependent on another statue of a thinker of

which no large-scale copies have survived. The more important point, however, is that the terra-cottas demonstrate what a powerful impact the new statue types of the intellectual had on Greek society of the Early Hellenistic period. And, most interestingly, they show that the very act of intense contemplation was already considered a sought-after quality in the early third century. Otherwise images of this type would not have been adapted to the repertoire of the coroplasts, who specialized in such popular types as fashionably elegant women and adorable children.

In contrast to the citizen image of Athenian intellectuals of the fourth century, the portraits of third-century philosophers and poets present us for the first time with a series of images conceived specifically as those of intellectuals. These portraits do at last celebrate intellectual capacity or actually show the thinker at work. What is more, they differentiate between different kinds of mental activity. Thus poets are represented differently from philosophers, who in turn are distinguished according to their manner and temperament. It is in these portraits of the third century that the ancient philosopher first acquired his unmistakable countenance.[2] Indeed, the third century must be considered in general the most creative era in the portraiture of the ancient intellectual.

As always, the statue's message was expressed by the entire body. Even more so than with the formulaic citizen image, it is essential to know what kinds of bodies went with the impressive and innovative new portrait heads. Unfortunately, the state of our evidence is again extremely fragmentary. Nevertheless, we can gain a fairly complete picture for at least some of the major works. And again we must inquire into the specific context and function of each individual statue. Who was honoring each particular philosopher—the city or his own pupils, where did the statue stand, and to whom was its message principally directed?

Zeno's Furrowed Brow

Let us look first at the Stoics. Their founder, Zeno of Kition in Cyprus, was apparently, like Socrates, far from a perfect physical speci-

men. The sharp-tongued Athenians nicknamed the haggard and feeble Zeno "the Egyptian Vine" (D. L. 7.1). Diogenes writes: "He looked serious and severe, and his brow was always furrowed" (7.16; cf. Sid. Apoll. *Epist.* 9.9.14). Modern archaeologists, like the Romans before them, have naturally treated the surviving portrait, preserved in numerous copies (fig. 53),[3] as a shrewd character study of the supposedly sullen and inaccessible philosopher. But since this too was an honorific statue—and probably made at public expense—this is very improbable. Rather, the literary characterization of the *frons contracta* seems to be invented first in the Roman period, on the basis of the by then well-known statue, to reflect current interest in biographical and psychological traits.

In an honorary decree from Athens, passed on the initiative of the Macedonian king Antigonus Gonatas immediately after Zeno's death in 262/1, he is celebrated as a teacher of philosophy and educator of the youth. The Athenians here, interestingly, emphasize the fact that he actually lived by his own moral teachings—a revealing indication of just how skeptically they continued to view their philosophers:

> Whereas Zeno of Citium, son of Mnaseas, has for many years been devoted to philosophy in the city and has continued to be a man of worth in all other respects, exhorting to virtue and temperance those of the youth who come to him to be taught, directing them to what is best, affording to all in his own conduct a pattern for imitation in perfect consistency with his teaching, it has seemed good to the people—and may it turn out well—to bestow praise upon Zeno of Citium, the son of Mnaseas, and to crown him with a golden crown according to the law, for his goodness and temperance, and to build him a tomb in the Ceramicus at the public cost. And that for the making of the crown and the building of the tomb, the people shall now elect five commissioners from all Athenians, and the Secretary of State shall inscribe this decree on two stone pillars and it shall be lawful for him to set up one in the Academy and the other in the Lyceum. And that the magistrate presiding over the administration shall apportion the expense incurred upon the pillars, that all may know that the Athenian people honour the good both in their life and after their death.
>
> (D. L. 7.10–12, trans. R. D. Hicks)

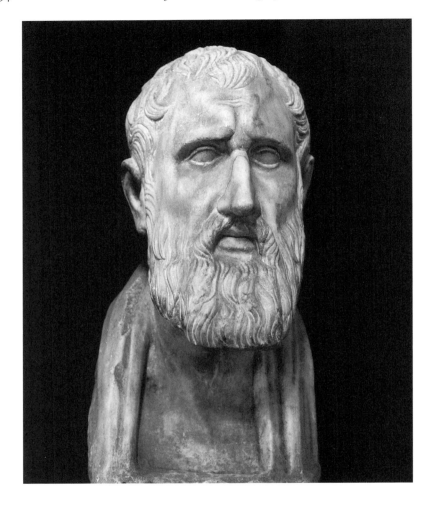

FIG. 53 a–b Zeno of Kition (ca. 333 – 262). In-
scribed bust. Roman copy of a statue presumably
set up after his death. Naples, Museo Nazionale.

There follow the names of the members of the commission. In other
words, the polis in this way clearly recognizes and defines both the
achievement of the Stoic who taught publicly, in the Agora and the
gymnasia, and his own role in society. The contemporary designation
of his school as the "Stoa" clearly expressed its public nature. The Stoa

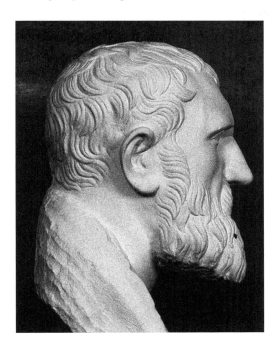

Poikile, famed for its fifth-century paintings, was a columned portico fronting directly on the Agora, in which Zeno and his successors often taught, in plain view and accessible to all. This public instruction is also recorded in the erection of the two stelai carrying the decree in the Lyceum and the Academy, the two most important gymnasia in Athens. The portrait statue of Zeno mentioned by Diogenes Laertius (7.6) could have stood in one of these places as well, though this is not a part of the popular decree. Perhaps the statue was an initiative of Antigonus Gonatas himself, who had heard Zeno lecture, tried to lure him to his court, and surely considered himself a pupil.[4] The portrait preserved in the copies could reflect this very statue.

In the context of such a portrait, intended to honor the subject, the powerful contraction of the muscles in the brow can carry only a positive connotation, that is, it must signify effortful and concentrated thinking. The sculptor has made this all the more obvious by leaving the rest of the face, with the conventional features of old age, rather

bland, thereby focusing all our attention on the brow. With its long aquiline nose, the strongly modeled face projects forward, like a ship's prow, giving the impression of tremendous energy.

The image projected is that of a mighty and original thinker whose energy is irresistible. The reason for the powerful visualization of the rigors of thinking should probably be sought in Zeno's insistence on the importance of strenuous effort in the process of recognition and on the scientific evaluation of sensory impressions. The rigor of the characterization stands in striking contrast to the manner of such Late Classical portraits as that of Theophrastus (see fig. 43) and goes even beyond Demosthenes' expression of mental concentration (see fig. 49). Whereas the latter represents a momentary concentration in a particular situation, Zeno's brow seems to stand as a timeless symbol for the thinking process. One would like to know how this conception came about—whether, for example, the sculptor was advised by Zeno's friends and pupils. But unfortunately we do not even know who commissioned the statue.

In comparison with the later portrait of Chrysippus (figs. 54 – 56) and the Stoic image of the anticitizen, displaying his poverty and disregard for his own body, Zeno's appearance is remarkable for the proper styling of his traditional coiffure, with locks combed forward and evenly over the crown to cover his baldness. He must have intended, through his appearance, to distance himself clearly from the Cynics.[5] The severe and sharply contoured beard, however, could be a particular idiosyncrasy, as we shall later see.

Unfortunately, no copy of the body that went with this portrait has yet turned up. But when we recall the statue of Demosthenes, we will surely want to complete Zeno's face, deep in concentration, with an equally tensed body. But whether it was a seated or a standing statue is not clear from the contradictory indications provided by the preserved busts. Nevertheless, a seated figure seems to me preferable, on the basis of the bronze bust in Naples showing the head projecting forward and part of the drapery.[6]

Zeno referred to his pupil Kleanthes as a second Herakles (D. L. 7.170). The hero who had to struggle through all his labors, as the

post-Classical age imagined him, was a favorite figure with the Stoics. Kleanthes, who learned only with difficulty, was in turn a favorite of Zeno's, even though others made fun of him for being slow to catch on, because he "held fast what he had won through a great effort in an iron memory." He had earlier competed as a boxer (his pupil Chrysippus was said to have been a runner) and, while a student of Zeno's, worked nights fetching water from the fountains in the Gardens. The embellishment of Stoic biographies with such anecdotes affords us a glimpse into the style and self-image of Zeno's school. The notion that thinking always requires great effort and constant struggle was evidently understood in a most positive sense and thus expressed itself both in the metaphorical use of language and in visual analogies employed by the Stoics. We need only recall Zeno's well-known and later on still-popular image of the clenched fist, which holds the laboriously gained truth in an iron grip (Cic. *Acad.* 2.145), or of Kleanthes' fingers worn to the bone from nervously rubbing them together while thinking (Sid. Apoll. *Epist.* 9.9.14).7

Chrysippus, "The Knife That Cuts Through the Academics' Knots"

It is in the portrait of the Stoic philosopher Chrysippus that the notion of thinking as hard work found its most extraordinary expression. The seated statue (fig. 54a, b) is preserved in one good copy of the body and many of the head and was probably put up immediately after the death of Chrysippus (ca. 281–208 B.C.).8 An elderly man, his back bent over with age, he sits on a simple stone block, that is, in a public place, the Agora or one of the gymnasia. Like an old man, he has drawn up his feeble legs and is trying to pull the garment tighter around his bare shoulders against the cold. Even in old age, the hardened Stoic, wanting nothing, refuses any comforts, such as a backed chair or an undergarment. But inside this frail, almost pitiful body— notice especially the sunken chest—resides an invincible, feisty spirit. The artist's intention is to show how the power of the spirit triumphs over the weaknesses of the body.

FIG. 54 a–b Chrysippus (ca. 281 –
204). Reconstruction of a statue pre-
sumably set up after his death. Mu-
nich, Museum für Abgüsse Klassischer
Bildwerke.

The philosopher's projecting head collides with an imaginary op-
ponent (fig. 56). The left hand, under the mantle, is clenched in a fist,
while the right is extended in argument, the fingers perhaps ticking off
in order his winning points. In a manner characteristic of most Early
Hellenistic art, the viewer is drawn into the pictorial space and be-
comes, as it were, the philosopher's interlocutor.9 The gesture of the
outstretched right hand, to which Cicero specifically refers, accom-
panying the energetic thrust of the head, seems to be an individual
characteristic of Chrysippus. More than just an aggressive speaking
style, it represents a particular form of thinking, that is, argumenta-
tion and logical deduction. It was in this sphere that Chrysippus, the
great dialectician, was considered superior to all his contemporaries.
An epigram composed by his nephew Aristokreon celebrates him as
"the knife that cuts through the Academics' knots." The epigram was

carved beneath one of the several statues of Chrysippus in Athens that are attested in our sources (Plut. *Mor.* 1033E).[10]

This is not a rhetorical gesture of the master teacher, but rather the effort of direct confrontation with an interlocutor who has to be won over. Only the arguments count, and the old man must expend his last

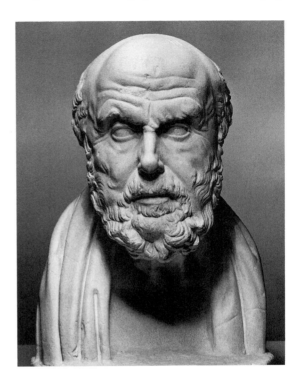

FIG. 55 Bust of Chrysippus. Naples, Museo
Nazionale.

ounce of strength to put his winning point across. In contrast to the
generalized formula for thinking expressed in Zeno's mighty brow, the
face of Chrysippus reflects the immediacy of a momentary mental ef-
fort. Like the whole body, the muscles of the brow are shown in a
powerful and spontaneous motion (fig. 55). We are meant to see how
ideas and arguments are brought forth by the old man's strenuous ef-
forts. When we come to compare the detached portraits of the Epi-
cureans (fig. 62), it will become even clearer that for the contemporary
viewer who frequented more than one philosophical school this Stoic
image must have embodied a highly polemical stance toward the rival
schools.[11]

The statue of Chrysippus was also most likely a public honorary
monument, and, like Zeno, he was honored with a public burial (Paus.

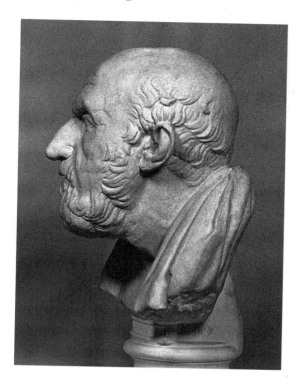

FIG. 56 Bust of Chrysippus. London, British Museum.

1.29.15). He had, after all, given instruction tirelessly in public for decades. No fewer than three statues are attested in Athens, two of them in or near the Agora. Pausanias mentions one "in the Gymnasium of Ptolemy at the Agora" (1.17.2), and Cicero saw the other, a seated statue, "in Ceramico . . . porrecta manu" (*Fin.* 1.39), probably at the northern entrance to the Agora, which was thick with honorific monuments. Diogenes Laertius (7.182) knew the same statue, which, based on the descriptions, is probably the one preserved in the copies.

The statue, like the honorary decree for Zeno, thus celebrates Chrysippus as a teacher, as a man from whom one could learn to think and to argue. At the same time, the statue's ethical claims, the message concerning attitudes toward the body, also has a didactic intent. The statue called to mind a man who, into old age, was still active in the Agora and the gymnasia. "He was the first who had the courage to

hold his lectures in open air in the Lyceum" (D. L. 7.185). In so doing, he made his arguments not only in words, but with the example of his own way of life, especially his toughness and freedom from bodily necessities. He had turned his own body into a paradigm, to paraphrase the text of the decree for Zeno. Naturally the average young Athenian could no longer see in such a figure an actual role model, but only those who became his disciples and devoted themselves to philosophy. We are presented here with a leading thinker, a powerful mind and a strong conscience, but no longer a model citizen upholding the norms of the democratic state, as had been the case with the mantle-clad poets and philosophers of the fourth century.

The Thinker's Tortured Body

The portrait of Zeno and the statue of Chrysippus are the only images of Stoic philosophers of the third century that can be identified with certainty. But there exist other portraits based upon the concept of thinking as a strenuous and laborious undertaking. For our purposes, it is not so crucial whether these actually represent Stoics, philosophers related to the Stoics, or even scholars of other kinds. Rather, we are concerned with particular paradigms for intellectual activity, as they developed at particular periods in time and were then translated into visual imagery.

The badly damaged statue of a philosopher now in the Palazzo Spada, found without its head, was skillfully restored in the seventeenth century and completed with an ancient head that did not originally belong to it (fig. 57).[12] The baroque sculptor chose a portrait head with a pronounced "thinker's brow" to complement the pose of the statue, but unfortunately it belongs to the Early Imperial period. The motif of a man completely lost in his own thoughts, bending over and staring out, which we have already encountered in Early Hellenistic terra-cottas, has here taken on a new, more dramatic quality. The philosopher sits unobserved on a stone bench with carved, two-stepped base. To the ancient viewer this would signal an association with the gymnasium. The subject has drawn the crude mantle carelessly across his body. His legs are placed far apart in an almost unseemly pose,

FIG. 57 Statue of a seated philosopher. The Roman
portrait head does not belong. Copy of a statue
ca. 250 B.C. Rome, Palazzo Spada. (Cast.)

especially when compared with the dignified manner of the seated
Epicurus (fig. 62). This is further emphasized by setting the right foot
on the upper profile curve of the bench. In the bronze original, this
foot probably rested only on the heel, to convey a restless, swinging
motion of the leg, the psycho-motor expression of the inner tension
of the thought process. (The copyist, who was understandably con-
cerned to protect the front part of the foot, has added a stone ledge
that serves no other purpose and so spoils the composition.) The right
arm is drawn toward the head, with the elbow resting squarely on the
agitated leg. Nor is the left arm propped calmly on the thigh; it is
caught in an involuntary movement, with the hand clenched in a fist
underneath the garment, like that of Chrysippus. Tension permeates

FIG. 58 a–b So-called Kleanthes. Bronze statuette
after a portrait of an unidentified philosopher
ca. 250 B.C. London, British Museum. (Cast.)

the entire body. The hand and the head have probably been correctly
restored by the baroque sculptor. At any rate, the head must, like those
of Zeno and Chrysippus, have expressed above all the strenuous effort
of thinking.

The basic conception reminds one of the famous and ubiquitous
Thinker of Rodin. The difference is that the ancient philosopher does

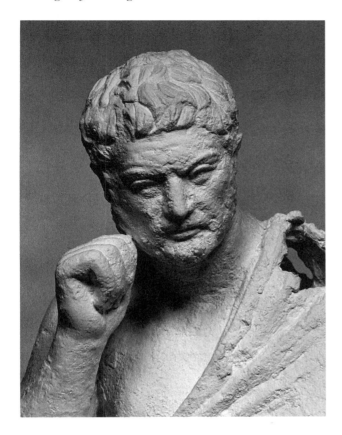

not in desperation look upon the abyss of Hell or the void. On the contrary, his mental efforts are presented as something praiseworthy, as a nearly Herculean labor. It is striking that this old man with the wrinkled belly has such powerful shoulders and arms. Various identifications have been proposed, on the basis of a fragmentary inscribed name, of which only ARIST . . . can be made out. So far no solution to the puzzle is possible. The motif of mental effort would indeed suit a Stoic, yet we should note another aspect. This is evidently a *solitary* thinker, a new kind of paradigm, which hardly seems appropriate for a teacher.

A related work of the same period, unfortunately preserved only in small-scale copies, is a seated statue (fig. 58a) that Schefold wanted, on

the basis of the gesture, to identify (though without conclusive arguments) as Kleanthes of Assos (331–232 B.C.), the favorite pupil and successor to Zeno, of whom we have already heard.[13] The artist who created this statue was once again primarily interested in a careful observation of certain psycho-motor reactions of the human body in a state of extreme mental concentration. Only a bronze statuette in the British Museum gives some idea of the lost original. It renders the powerful and fleshy body and the full face of a man who has not yet reached old age (fig. 58b).

At first glance, this thinker seems to be comfortably seated with his legs crossed. But in reality he too is completely caught up in his intellectual effort. Like the Spada philosopher (fig. 57), he is oblivious of his surroundings, and the act of thinking has tensed his entire body, removing him from the world around him. Both arms are caught in spontaneous and unconscious motion. The left pushes and pulls the garment to the side, while the right seems not so much to support the head as to push it to one side. The fabric of the mantle, which had been properly draped, has as a result slipped to the side. Both hands make a fist, and the feet are nervously entwined and pressed against each other. As in the case of the Spada philosopher, this uncontrolled motion is emphasized by a particular detail, the left foot resting in an extremely precarious manner, with only the edge of the sandal's sole touching the ground. In other words, the right foot has been moved up and down by the agitation of the left foot.

If we recall the pose of Euripides and of the elderly men on Late Classical grave reliefs (figs. 31, 32), it will be clear just how flagrantly these two seated statues flout the conventions of proper civilian dress. In both instances, the artist employs a carefully observed body language in order to visualize an inner tension and agitation. In the face of the bronze statuette, mental concentration is expressed not only by the contraction of the eyebrows and forehead, but in addition by the open mouth. One might be tempted to take the short and closely trimmed beard, similar to that of Chrysippus, as an argument for identifying the subject as a Stoic, but there are too few reliable copies to permit a specific identification.

It was only natural that this new image of thinking as a laborious

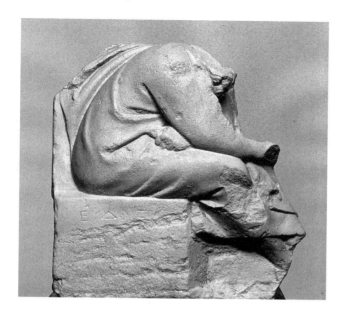

FIG. 59 Relief with the figure of the mathematician and astronomer Eudoxus (ca. 408–355), his body bent over. Budapest, National Museum. (Cast.)

process that manifests itself in the entire body also affected the visual imagery of famous intellectuals of the past. When, in the following chapter, we consider the emotional, sometimes almost violent facial expressions of these portraits of thinkers, we shall have to imagine them combined with correspondingly agitated bodies. Unfortunately, there are very few copies of the bodies that went with such portraits preserved in Roman decorative art. One exception is a statuette of Antisthenes from Pompeii, who sits with the legs tensed and, like De-mosthenes, holds his arms still with hands clasped. But this type is probably not derived from a public honorific statue.[14] A particularly impressive example is the famous mathematician and astronomer Eu-doxus of Cnidus (fourth century B.C.), who broods on his equations on a relief fragment of Early Imperial date (fig. 59).[15] His arms clasped and legs crossed, he sits leaning far forward on a simple block of stone, like the statue of Chrysippus. His right hand reaching out could have

held a staff with which he drew in the sand. The compact and somewhat cramped composition seems to be derived from a statue of the Middle Hellenistic period. Modest works like this one are particularly valuable, because they give us at least some idea of the variety of body types and poses that could be employed to express the notion of concentrated and strenuous mental effort.

Chrysippus' Beard

I should like to return once more to the Stoics, and in particular to Chrysippus' beard. But first, a word about philosophers' beards in general. As we have seen, Athenian intellectuals of the fourth century, like all other adult men, wore a beard. Shaving first came into fashion with Alexander the Great. In Athens, it was thus probably the pro-Macedonians who were the first to adopt the fashion, while traditionalists and democrats did not. By the early third century, when being clean-shaven had become the norm, a beard must of necessity have taken on connotations such as "conservative" and "political outsider." The Hellenistic kings and their courts, I believe, all adopted the new fashion.[16] But the philosophers had an additional reason for wearing a beard. It is a law of nature that hair grows on a man's chin, and to shave it off is a denial of the natural order of things. A man who shaved, so they believed, also gave himself a soft and unmanly appearance. The clean-shaven look was effeminate and raised suspicions of sexual lust and a weakness for luxury. Significantly, Alcibiades had been one of the first to shave and also wore his hair in long locks.[17] By chance, we know verbatim Chrysippus' own argument on this point, from his treatise *On the Good and Pleasure:*

> "The custom of shaving the beard increased under Alexander, although the foremost men did not follow it. Why, even the flute-player Timotheüs wore a long beard when he played the flute. And at Athens they maintain that it is not so very long ago that the first man shaved his face all round, and had the nickname Shaver." "For really, what harm do our hairs do us, in the gods' name? By them each one of us shows himself a real man,

unless you secretly intend to do something which conflicts with them."—
"Again, Diogenes, seeing a man with a chin in that condition, said: 'It
cannot be, can it, that you have any fault to find with nature because
she made you a man instead of a woman?' And seeing another person
on horse-back in nearly the same condition, reeking with perfume and
dressed in a style of clothing to match these practices, he said that he had
often before asked what the word horse-bawd meant, but now he had
found out. At Rhodes, although there is a law which forbids shaving, there
is not so much as a single prosecutor who will try to stop it, because ev-
erybody shaves. And in Byzantium, although a fine is imposed on the bar-
ber who has a razor, everybody makes use of one just the same." These,
then, are the remarks of the admirable Chrysippus.

(Ath. 13.565, trans. C. B. Gulick)

In the face of the new fashion for shaving, which the visual evidence
suggests quickly spread throughout the Mediterranean,[18] the philoso-
phers clung to their now old-fashioned beards, as far as we can tell,
without exception. In the early years of the third century, a poet of
New Comedy, Phoinikides, already speaks of "the philosophers who
wear beards [*pōgōn' echontes*]" (frag. 4),[19] implying that the majority of
men were by this time clean-shaven.

It was in these circumstances that the wearing of a beard, combined
with certain hairstyles, clothing, and modes of behavior, first came
to symbolize the "otherness" of the philosophers. Their appearance
clearly defined them as a conservative group, standing in opposition to
their own age and legitimating their stance with an appeal to the "cus-
toms of old." They make claim to a higher (because older) form of
wisdom and use this to challenge their contemporaries. This appeal to
the past was to become a consistent element in the imagery of ancient
philosophers, reaching all the way to late antiquity.

At the same time, the beard becomes the favorite object of ridicule.
In principle society recognizes the role of the philosopher as moral
authority, yet in times of doubt or crisis that authority is always ques-
tioned. Does the beard really suit the philosopher? In other words,
does he really practice what he preaches? The decree for Zeno had
explicitly asserted this congruity between the claims of the educator,

on the one hand, and a moral way of life, on the other. During the Roman Empire, the beard became *the* symbol of the philosopher's moral integrity. In the time of Marcus Aurelius, the Athenians had reservations about awarding a chair in philosophy, endowed by the emperor, to an otherwise eminently qualified Peripatetic, simply because he had difficulty growing a beard. The situation was considered so grave that the decision had to be left to the emperor in Rome (Lucian *Eun.* 8ff.).[20]

Though all philosophers wore beards, they wore them in different styles: trimmed or not; full length, half, or short; carefully tended or unkempt. Already in the third century, it seems, one could recognize what school a philosopher belonged to, and his way of thinking, by the state of his beard and hair. From here on, one's beard and hairstyle became a statement of the philosophical teachings one accepted and, as a rule, by extension, of a certain way of life. The symbolic values of hair and beard that arose in the third century B.C. remained in effect well into the Imperial period. Alciphron, a writer of the second century A.C., describes the appearance of a group of Attic philosophers at a birthday party, at which they would later behave rather badly:

> So there was present, among the foremost, our friend Eteocles the Stoic, the oldster, with a beard that needed trimming, the dirty fellow, with head unkempt, the aged sire, his brow more wrinkled than his leathern purse. Present also was Themistagoras of the Peripatetic school, a man whose appearance did not lack charm and who prided himself upon his curly whiskers. And there was the Epicurean Zenocrates, not indifferent to his curls, he also proud of his full beard, and Archibius the Pythagorean, "the famed in song" (for so everybody called him), his countenance overcast with a deep pallor, his locks falling from the top of his head clear down to his chest, his beard pointed and very long, his nose hooked, his lips drawn in and by their very compression and firm closure hinting at the Pythagorean silence. All of a sudden Pancrates too, the Cynic, pushing the crowd aside, burst in with a rush; he was supporting his steps with a club of holm-oak—the cane was studded with some brass nails where the thick knots were, and his wallet was empty and hung handy for the scraps.
>
> (Alciphron 19.2–5, trans. A. R. Benner and F. H. Forbes)[21]

The preserved portraits in general bear out Alciphron's witty characterizations, though we must bear in mind that the particular features of each individual school may have changed in the course of time. The Stoics are regularly described as being unkempt, with short and uncombed hair. It is not, however, explicitly attested that they wore their beards close cropped, like Chrysippus. But this is easily explained by the same reasoning that the Stoic Musonius gives for cropping the hair as a "pure functionality." That is, one interferes with a natural process only when, for whatever reason, it becomes a hindrance (*Diatr.* 21). In contrast to the Peripatetics, who wore carefully trimmed beards, the Stoics rejected the very idea of such attention; likewise any other kind of care for the body, as in the tradition of the Cynics, because this represented a distraction from thinking and exalted the body. It is better to cultivate one's understanding than one's hair, according to Epictetus, who cites Socrates in this context (*Diss.* 3.1.26; 42). Since neatly styled hair and trimmed beard were of great concern to the Peripatetics, the Academics, and the Epicureans, the close-cropped and uncombed hair and unkempt beard of the Stoics were a polemical statement and made clear that they despised as unmanly any kind of attempt to beautify the body. This may indeed be the meaning of Zeno's untended and jagged beard with its exaggerated angles (cf. p. 96).

In the case of Chrysippus, however, the beard has a more particular ethical message that seems to allude to a specific element of Stoic teaching. What I have in mind is a seemingly incidental detail that was overlooked by some ancient copyists, as well as by modern scholarship. The close-cropped beard not only gives the impression of being unkempt, like his hair, but it seems to grow rather irregularly. In some places it is quite sparse, yet ugly, bushy patches grow in other places where one would not expect any growth (fig. 60).[22] This peculiar pattern had a set of quite specific connotations and associations among Chrysippus' contemporaries that are distinctly negative.

Pseudo-Aristotelian physiognomic writers compared men whose beards grew like this with apes, "disgusting, ridiculous, and evil animals." For this reason, as H. P. Laubscher has pointed out, fishermen, peasant farmers, and slaves—in short, all those who were looked down

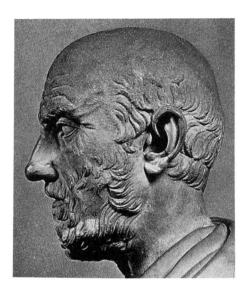

FIG. 60 Chrysippus. Rome, Vatican Museums.

on by a society of freeborn citizens—are depicted with such irregular growth of beard (fig. 61), as also, in the mythological sphere, the wild and uncivilized satyrs.[23] In this way they are characterized as morally inferior. Thus for Chrysippus to emphasize his irregular growth of beard by cutting it short, instead of trying to conceal it, and for his friends to have him portrayed after his death with such a morally loaded imperfection, in the context of these well-established physiognomic conventions, could imply only a deliberate response to the prejudices of society. Slaves and peasants are human beings too, the beard proclaims; social categories are purely random and do not exist for the philosopher. Furthermore, nature makes a man's beard grow one way or another; however it grows is right and has nothing to do with his character or morals. The first portrait of Socrates had similarly represented an opposition to the norms of *kalokagathia* (p. 38). Chrysippus' attitude assigns hair and beard and everything associated with them to the *adiaphora,* that is, things that in Stoic doctrine are neither good nor bad in and of themselves.

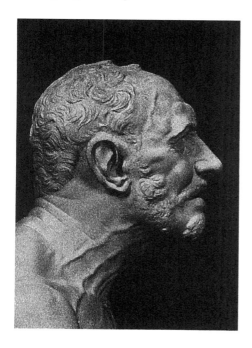

FIG. 61 Head of the "Old Fisherman." Roman
copy of a third-century B.C. statue. Paris,
Louvre.

The very fact that well-known Stoic teachings and ways of life were
incorporated, in such detail, into the portrait itself must mean that
knowledgeable people had some say in determining the conception of
this statue. Evidently Chrysippus' pupils used the portrait as a vehicle
for propagating the missionary work of their teacher.

The "Throne" of Epicurus

The situation is entirely different when we come to the portraits of
the Epicureans. They never taught publicly but instead withdrew to
Epicurus' garden outside the city, the Kepos, to live together—more
like a gathering of friends, a commune, or a sect than a school—seek-

ing the path to happiness and pleasure without disturbance and fear, under the guidance of a teacher of surpassing insight. The goal was a life of "joy and pleasure" by reaching a state of "painlessness of the body" and "lack of excitement of the soul." In Athens the disciples of Epicurus were so closely identified with a life outside the community of the polis that they were often referred to simply as "those from the Garden" (Sext. Emp. *Math.* 9.64). It is therefore highly improbable that any public statues were put up in the third century in honor of these men who so ostentatiously withdrew from the civic and political life of the city. More likely, the portraits stood in the Kepos itself, at least in the early period, and served there to recall Epicurus and his friends Metrodorus, Hermarchus, and Polyaenus, who were also known as "guides" or "leaders" (*kathēgemones*) and enjoyed the particular devotion of pupils who were referred to as *kataskeuazomenoi*.24 The existence of a well-known "*mnēma* of the Epicureans" in the Kepos is explicitly attested (Heliod. *Aeth.* 1.16.5).

We are fortunate to possess copies that give a good idea not only of the statue of Epicurus, but of those of his friend Metrodorus and his successor Hermarchus. Probably all three were put up soon after the subject's death, in 277 (Metrodorus), 270 (Epicurus), and 250 (Hermarchus).25

If we take a look at these three Epicurean statues (figs. 62–64), on the one hand (they are all more or less fully preserved in copies or can be reconstructed), and the statue of Chrysippus (cf. fig. 54), on the other, it is immediately clear both how closely all the Epicureans adhere to the same manner of pose and appearance and how fundamentally different these are from the image of the Stoic. Instead of the Stoic expression of mental strain and the hunched-over body, all three Epicureans sit calmly and quietly in classically balanced poses, the mantle carefully draped about them.

Even when seated they maintain a kind of contrapposto between the rear leg actively thrust back and the forward leg relaxed, as well as a comparable chiastic positioning of the arms. For them, evidently, thinking is not such hard work that it would be reflected in the body. The display of conventionalized standards of behavior, as in the citizen image of the fifth and fourth centuries, comes naturally and effortlessly. This is particularly noticeable in the statues of Epicurus and

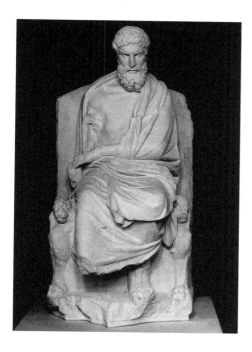

FIG. 62 Epicurus (ca. 342–270). Reconstruction by K. Fittschen of the statue presumably set up after his death. Göttingen University, Abgußsammlung.

Hermarchus in the prescribed wrapping up of the left arm. This correct, though rather "public," posture hardly seems to suit the private image of a man quietly seated in contemplation and presents in any event a striking contrast to Chrysippus' intense concentration on intellectual pursuits or the psycho-motor tension and movement of statues related to that of Chrysippus.

This unmistakable gesture of the Epicureans can be understood only as an explicit and self-conscious indication of a desire to hold to the old traditions, a token of virtue and modesty, at a time when these very values were being called into question by other members of Athenian society. Epicurus and his friends quite ostentatiously attach great importance to the proper behavior. Anyone who withdrew from the

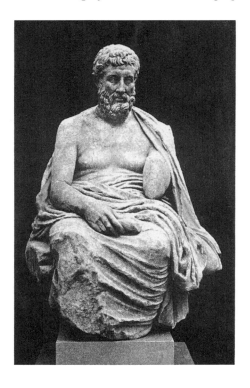

FIG. 63　Metrodorus (ca. 331 – 277). Recon-
struction of a statue set up after his death.
Once Copenhagen, Ny Carlsberg Glyptotek.

city, like "those from the Garden," was well advised to insure that in
spite of this he appeared to be an irreproachable citizen. Indeed, Epi-
curus by no means rejected the rules of society but rather understood
them as the prerequisite to a philosophical life of inner happiness. The
maintenance of the proper citizen etiquette was taken for granted in
the Kepos.[26]

The elegant wavy hair of Epicureans, the locks carefully arranged
on the forehead, and especially the strikingly "classical" stylization of
their beards (figs. 66 – 68) all demonstrate how important they consid-
ered a cultivated appearance that was based on the ideals of the past.
The wearing of a beard—even a carefully tended beard like those of

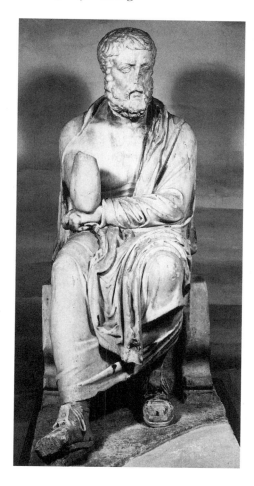

FIG. 64 Hermarchus (born ca. 340). Under-
life-size Roman copy of a statue ca. 250 B.C.
Florence, Museo Archeologico.

respectable Athenian citizens of an earlier age—had by now become
a token of otherness. And yet the handsome Epicurean beard conveys
a very different set of values from the unkempt or crudely trimmed
beard of the Stoics, not to mention that of the Cynics. For the Epicu-
reans, the beard implies not only an acceptance of the traditions of the
polis, but also an identification with the upper class.

While at first glance the three statues of Epicureans look very similar, there are in fact important differences, which reflect the strict hierarchy that obtained in the Kepos. Epicurus sits on an impressive "throne," Metrodorus on a backed chair, and Hermarchus on a simple stone block.[27] Some have likened Epicurus' chair, with its ornamental lion-paw feet, to the thrones of the gods, and thereby linked it to the hero cult that was established for the founder of the Kepos after his death. This seems to me, however, unlikely, since Epicurus himself is not depicted as a hero, but in every respect as an Athenian citizen. For a contemporary viewer, a more obvious comparison would be with the *prohedria* (the front-row seats) in the Theatre of Dionysus, reserved for priests and outstanding citizens, as well as for benefactors of the city. The association would have suggested itself on account of the shape of the seat (fig. 65), especially since the elaborate seat of the priest of Dionysus, with its lion-paw feet, in the middle of the front row, stood in the same relation to the other seats of honor as Epicurus' throne to the backed chair of Metrodorus. The Kepos has thus usurped this symbol of signal public honor for officials and dignitaries, in order to mark Epicurus' achievements and his position within the school. In this way the great wise man, who showed the way to a happy life, was singled out by his pupils as the highest spiritual authority.[28]

Another conceivable association would be that of an academic "chair." As early as the time of the Sophists, an especially impressive seat seems to be a sign of the instructor's special authority and dignity. Plato portrays the Sophist Hippias of Elis giving instruction from a *thronos,* while his pupils sat around him on stone benches (*Prt.* 315). But, as we shall see, Epicurus is in fact not shown as a teacher giving instruction, so that the connotation of the academic chair is unlikely.

Against the background of the Classical image of the Athenian citizen, this kind of honor represents something new. The singling out of Epicurus from the other two *kathēgemones* makes it clear that the Epicureans were not concerned with a search for truth through persuasive argumentation and passionate discussion, like the followers of Chrysippus, but rather with devotion to and perpetuation of a unique spiritual guide and teacher.

FIG. 65 Honorary seats in the Theatre of Dionysus in
Athens.

The same hierarchy can also be clearly detected in the faces of the
three portraits. Epicurus' is marked by a curious contrast between the
restless and powerfully muscled philosopher's brow and the otherwise
placid expression of the face (fig. 66). Yet the brow is still different
from, say, Zeno's or Chrysippus', where the mental effort looks forced
and strained. Epicurus' eyebrows are raised, but hardly in motion. The
raised brows are a token of superiority, reflecting his absolute author-
ity. The powerful muscles above the brows can therefore not be un-
derstood as an expression of a momentary mental struggle, especially
when the body is so relaxed. Apparently the sculptor wanted to express
the idea of tremendous intellectual capacity, a state of being rather than
a sudden action.[29]

Metrodorus' brow, on the other hand, does not betray even a trace

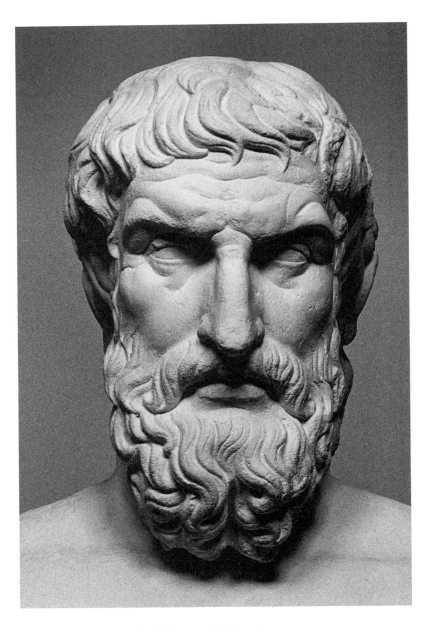

FIG. 66 Epicurus on a double herm with Metrodorus.
Rome, Capitoline Museum. (Cast.)

FIG. 67 Bust of Metrodorus. Rome, Capito-
line Museum. (Cast.)

FIG. 68 Small bronze bust of
Hermarchus. H: 20 cm. Na-
ples, Museo Nazionale.

of intellectual effort (fig. 67). Rather, its serenity, lack of expression,
and perfect balance strike us more as an echo of Classical citizen por-
traits. This was, it would seem, precisely the intention. The Classical
formula for characterizing a distinguished man in middle age is taken
up and quoted, in order to make visible certain goals of Epicurus'
teachings, such as inner tranquility and a life of enjoyment. In this way,
the carefully tended hair and beard, as well as the elegant manner of
dress and seated posture forge an association with the polis values of
the past.[30]

With Hermarchus, however, we do seem to sense a measure of
mental strain, or perhaps, concern (fig. 68). In the better copies, the
brows are gently drawn together, and the wide fringe of hair emphasizes
the severity of this portrait of old age. Like Epicurus, Hermarchus was
a native of Mytilene on Lesbos, and they had come together to Athens

and there lived and philosophized together for more than forty years. Hermarchus was thus already an old man when, after Epicurus' death, he became head of the Kepos and devoted himself to preserving his friend's heritage as faithfully as possible.[31]

Hermarchus' dress and pose (cf. fig. 64), as we have seen, deliberately imitate those of Epicurus, but with an important difference in the pose of the head and probably also of the right arm. Hermarchus' raised arm is a gesture of teaching, and his head is raised and turned to the side, as if toward an interlocutor. Epicurus, by contrast, bent his head and looked out in front of him, as Fittschen's reconstruction with casts has confirmed (fig. 62). The lower right arm, like Metrodorus' left, was gently drawn back toward the body and turned inward. The drooping shoulder also suggests a quietly relaxed positioning of the arm.[32] We may infer from this difference that Hermarchus was shown more as the teacher, Epicurus as the tranquil thinker marked by inner concentration. This in turn reflects the different roles that they played: Epicurus is the great pioneering thinker, remote and unattainable on his seat of honor; Hermarchus, the loyal disciple who preserves and propagates the inheritance of the master.

Bodies, Healthy and Unhealthy

The portrait of Epicurus displays yet another "individual" characteristic. His body, especially those parts of it that are exposed, is rendered as extremely feeble. This is particularly exaggerated in a small statuette in the Palazzo dei Conservatori in Rome (fig. 69).[33] But even in the fine copy of the statue in Naples, the body is flabby and unarticulated in a manner unknown in any other statue type. If the statues of the three philosophers did indeed stand alongside one another in the Kepos, this trait of Epicurus must have been especially noticeable. It is probably meant as a reference to the long, debilitating illness of Epicurus' later years. But again, it is not intended so much as a biographical trait, but rather as a sign of the exemplary and virtuous way of life. The equanimity with which the master not only endured his pain to the end but overcame it through the memory of his earlier happiness

FIG. 69 Small-scale copy of the portrait of
Epicurus. H: 23.5 cm. Rome, Palazzo dei
Conservatori.

was much admired by his friends and pupils, who saw him as proof that
the truly wise man who follows Epicurus' teachings can attain *ataraxia*
and *eudaimonia* (peace of mind and happiness) even in the most diffi-
cult circumstances (D. L. 10.22).

Metrodorus' relaxed and ample body (fig. 63), on the other hand,
looks like the embodiment of a life of pleasure. As we have already
observed of the head and masklike face, his body also represents a mas-
culine ideal of Classical art, here expressing well-being, serenity, and
conviviality with one's fellow man. The comfortable backed chair on
which he sits, like that of Menander and Poseidippus, suggests a pleas-

ant domestic ambience. Metrodorus is completely at ease, leaning back comfortably and placidly looking out. He holds a book roll in his left hand, and the right, drawn back to the body, could have held the edge of his garment. Once again we encounter here the old polis ideal at a time when the polis was long gone. What is particularly significant, however, is that this ideal is now evoked by people whose fulfillment in life can be conceived only in the private sphere. One of Metrodorus' writings bore this revealing title: *On the Circumstance That Private Life Leads to Happiness Sooner Than Public* (Clem. Al. *Strom.* 2.21 = II.185 Stahlin).

Just as in Epicurus' own teachings, the statues of his friends and disciples focus on the central goal, the condition of spiritual peace and inner joy. Only the master himself is presented as the pioneering spirit, in fact more as a kind of prophet than as one who teaches his students how to think. In the Kepos, great importance was attached to internalizing the teachings of the master. Epicurus had his pupils learn certain key sayings by heart and memorize them so that they would have them ready to hand at any moment. These sayings of the master, the *kyriai doxai,* functioned as a kind of catechism (D. L. 10.35,85). Perhaps there is an allusion to this constant memorization in the book rolls in the hands of all three statues, or to pastoral letters of Epicurus, which served the same purpose. Epicurus and Hermarchus pause in their reading, the book roll open, while Metrodorus holds his untied in the right hand, as if he were about to start reading.[34] It is rather striking that it should be the statues of Epicureans that hold the book roll. It cannot be meant simply as a symbol of education, as it will be in later Hellenistic portraiture, since Epicurus explicitly rejected the notion of education for its own sake.

In retrospect, a comparison of the portraits of Epicurus and his two *kathēgemones* with those of Chrysippus and the other mighty thinkers reveals that the former must have had a different purpose. The great teachers are presented as exemplars who have already attained the goal. They are both a reminder and an admonition to succeeding generations. This portrayal is in accord with what we may conjecture about the statues' function in the Kepos, where friends and pupils regularly gathered for ceremonies in memory of Epicurus, Metrodorus, and

members of Epicurus' family, perhaps in front of the *mnēma* mentioned earlier. The whole calendar of the Epicurean year was organized around these memorial services, at which they would read from the works of the great teachers. In later times, we have evidence for an actual cult of the Epicureans, complete with icons: 35 "They carry around [painted] portraits [*vultus*] of Epicurus and even take them into their bedrooms. On his birthday they make sacrifices and always celebrate on the twentieth of the month, which they call *eikas*—those same people who, so long as they are alive, insist that they do not want to be noticed" (Pliny *HN* 35.5). In the context of such rituals, the portraits served as a memorial and an honor, as well as an inspiration to follow in their path.

A statuette of the first century B.C. confronts us with a very different image of an Epicurean (fig. 70). If only the head were preserved, with its carefully tended hair and beard, and the contented expression similar to that of Metrodorus, we might well be tempted to identify him as one of the third-century Epicureans. But the proudly displayed fat belly and the uninhibited self-satisfied demeanor, recalling the statue of the Cynic in the Capitoline (cf. fig. 72), suggest that this is not a portrait statue at all, but rather a genre figure, a typical Epicurean. We may be reminded of the type that Horace had in mind, in his ironic characterization of himself:

> As for me, when you want a laugh, you will find me in
> fine fettle, fat and sleek, a hog from Epicurus' herd.
>
> (*Epist.* I.4.15f.)

This is evidently the image that many people outside the Kepos had of the typical Epicurean: a prosperous bon vivant, always carrying with him the sayings of the master. At least this was the case by the time of Horace, after the popular stereotype had established itself, thanks mainly to New Comedy, that the Epicurean principle of pleasure applied mostly to eating and drinking (fig. 70).36 The statuette's portrayal of the old hedonist is not marked by genuine mockery, only gentle bemusement. He is indeed a sympathetic figure. This interpre-

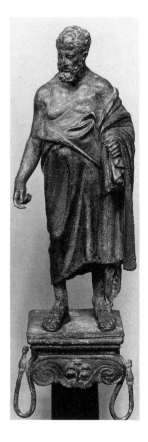

FIG. 70 Furniture attachment with statuette
of a "typical" Epicurean. First century B.C.
H: 25.5 cm. New York, Metropolitan Mu-
seum of Art.

tation is also implied in the statuette's original function, for it was the
crowning element of a candelabrum that took the form of a column,
like those used as table supports. The Ionic capital has two hooks from
which lamps could be hung. Thus the jolly old man was visible mainly
at symposia. This is a work of exceptional charm, in both style and

iconography, that succeeds in an eclectic combination of contradictory elements in the imagery of the philosopher.37

This statuette is a reminder that almost all preserved portraits of the Classical and Hellenistic periods are witnesses to the manner in which the subject understood and wished to present himself. We learn from them a great deal about the image that these intellectuals wanted to project, but as a rule little about how their contemporaries outside their own circle saw them, or to what extent the popular image matched the self-conscious one expressed in the official portraits. One would like to suppose that there had been earlier images that made fun of the all-too-serious thinkers. The statue types that happen to be preserved in Roman copies most likely represent only a small sampling of the variety of images of intellectuals of the Early Hellenistic age. We have, for example, no certainly identified portrait of a third-century Academic or Peripatetic. Surely there continued to be philosophers who clung to the traditional citizen style, such as the long-bearded philosopher on the familiar frescoes from Boscoreale, leaning on a knotty staff in the Classical manner.38 Furthermore, not all the famous teachers and thinkers were depicted seated, as one might think. For example, the well-known bronze head of an intense philosopher from the Antikythera shipwreck, whose expression and manner recall the portrait of Chrysippus, belonged to a standing statue with the right hand raised in a rhetorical gesture.39 Stance and pose were presumably no less varied than facial expression.

Another type that seems to have been particularly important was that of the reader, which we have already met in the statue of Metrodorus (fig. 63). Even outside the Kepos, this was already a standard part of the repertoire for representing the intellectual in Early Hellenistic art. Schefold has called attention to two statuettes and suggested identifications for these two as the Academic philosophers Krantor of Soloi and Arkesilaos, probably because the Academics early on turned to the interpretation of Plato's works, and because they were generally reputed to be great readers (D. L. 4.26, 5.31f.).40 (The story is told of Arkesilaos that he could not go to bed at night without having first read a few pages of Homer, "and in the early morning, when he

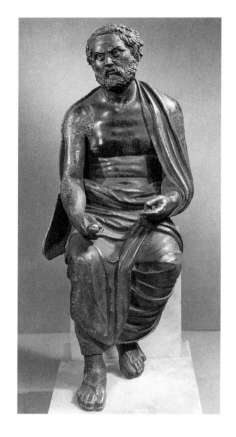

FIG. 71 Portrait of a man reading.
Bronze statuette after an original of the
third century B.C. H: 27.5 cm. Paris,
Cabinet des Médailles.

wanted to read Homer, he used to say that he was going to see his
lover" [D. L. 4.31]. Unfortunately, this is not sufficient grounds for an
identification!)

The intellectual depicted in the statuette from Montorio (fig. 71)
gestures with his left hand toward the book roll that he holds in his
right, like one who is about to begin reading. The left arm is envel-
oped in the cloak, like that of other seated statues, yet it is captured in

a momentary movement. This is probably meant to suggest the start of a session of reading, "reaching for a book." The head, turned to the side in a contemplative gesture and looking up, would also suit this context. He could scarcely be a philosopher giving instruction, for that entails a gesture of the right hand. Perhaps he is meant to represent a philologist. An interesting life-size seated statue in the Louvre, also derived from an original of the third century, must also have depicted a reader, to judge from the bent-forward position of the upper body and the arms.[41] Particularly noticeable is the casual pose, recalling that of Poseidippus (cf. fig. 75): yet another way of expressing concentration. In the well-known philosopher statue from the Ludovisi Collection, now in Copenhagen,[42] at one time associated with a portrait of Socrates, the figure of the reader acquires an almost exemplary quality through its very high placement and deliberate frontality. The original from which this statue derives probably belongs to the mid-second century, a period in which the motif of reading was of interest not as a process to be physically rendered, but rather as a paradigm for the educated man.

Who Would Honor a Cynic?

The statue of a Cynic of the mid-third century B.C., preserved in a superb copy of the Early Antonine period, seems to satirize the new breed of pioneering thinkers (fig. 72). That this old man is indeed a Cynic has long been supposed, on the basis of his appearance, which is the antithesis of the good citizen's: he is slovenly, wears a short mantle made of coarse, dense material, and is barefoot. These are all characteristics of the Cynics, originally inspired by Socrates (Xen. *Mem.* 1.6.2; D. L. 2.28, 41).[43] The only element inappropriate for the Cynics, who were "practical philosophers" opposed in principle to any kind of formal education, is the book roll in the right hand. This is, however, an addition of the eighteenth-century restorer, who apparently could not imagine a philosopher without such an attribute of the intellectual.

The whole figure is practically an assault on the viewer. An ugly,

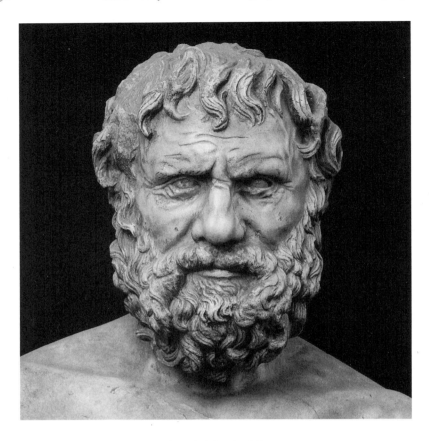

FIG. 72 a–b Statue of an unidentified Cynic philoso-
pher. Rome, Capitoline Museum.

belligerent old man and social outcast, he looks us straight in the face.
In his right hand was originally a staff, which perhaps was even pointed
at the viewer. Everything about his appearance expresses contempt
for bourgeois manners and values: the clumsy, flat-footed stance,
drooping shoulders and belly sticking out, the garment sloppily
wound around the body and awkwardly held together in the fist, the
uncombed, matted hair falling in his face, the untended clump of
beard, and, finally, the wrinkled face with its vacuous, squinting look.
 Here we have the complete antithesis not only of the ideal of the

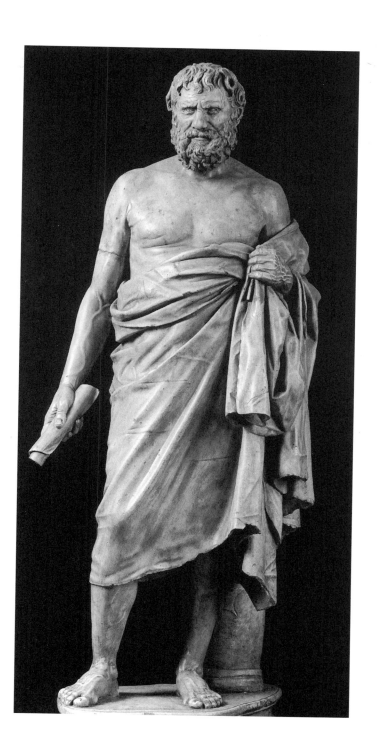

proper citizen, but of the new image of the serious philosopher as well. Instead of presenting an expression of concentrated thought, he squints like someone who is either nearsighted or blinded by the sun. We need only compare the stylistically closely related countenance of Chrysippus (fig. 56) to see that the Cynic is not meant to express the concentration of serious thought or, for that matter, the ravages of old age or man's mortality, but rather the self-satisfaction of a social dissident.

The public display of such a statue was itself a celebration of the provocative and antisocial behavior of the Cynics, calling into question every traditional value, a kind of fire-and-brimstone sermon decrying the pretensions and hypocrisy of bourgeois society. The simple, self-sufficient life has evidently not done this old man any harm. He seems well fed, and despite his lifelong avoidance of the gymnasium, he is shown as still tough and strong. His appearance has been likened to the iconography of poor people such as fishermen and peasants. But unlike these, he shows none of the physiognomic characterization that in this period would carry connotations of inferiority.

Who could have commissioned such a statue? It is hard to believe that a polis would have chosen to honor such a subversive provocateur with a public monument. It is equally unlikely that a man like this had a wealthy following of students and friends. But it is entirely possible that one individual, even a Hellenistic king, could have dedicated such a statue in a sanctuary or gymnasium, as a way of asserting that this was the only kind of "practical philosophy" that he truly found credible as a way of life. Though it is true that the Cynics believed in going "back to nature," to a simple life free of the "unnatural" constraints of social convention, this does not mean that they rejected the social order in principle. They too believed that virtue can be taught and saw themselves in the role of educators (D. L. 6.105). Krates of Thebes, for example, Diogenes' eldest pupil and the first teacher of Zeno, was very popular with his fellow citizens, because he actually discussed their problems with them. People opened their doors to him, enjoyed his visits, and revered him as a kind of *lar familiaris*.44

The face of the old man in the Capitoline Museum is unique in the corpus of preserved Hellenistic portraiture. Undoubtedly there were

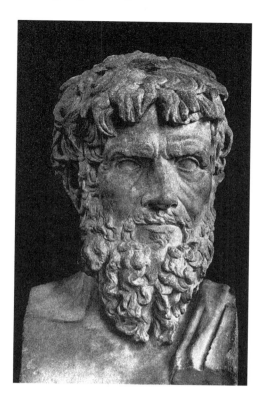

FIG. 73 Head of a Cynic (?). Roman copy of a
statue ca. 200 B.C. Paris, Louvre.

other "character studies" of this kind, in which sculptors commemo-
rated the behavior and appearance of those who practiced a kind of
antiphilosophy and a defiant alternative life-style. This is, at least, the
impression we get from several copies of anonymous philosopher por-
traits of the late third or early second century, whose hostile expression
and slovenly appearance evoke thoughts of the Cynics and related
groups. A particularly impressive example is a head in the Louvre with
disgruntled countenance, wild beard, and matted hair over the brow
(fig. 73). The original was probably an important work of the High
Hellenistic period.45

The Philosopher and the King

The philosopher statues of the third century are thus the first true portraits of the intellectual in Greek art, for they are the first that attempt to render the thinking process itself, its goals and achievements. Whereas the portraits of thinkers and philosophers in the fifth and fourth centuries had depicted contemplation—when at all—as merely one element of the ideal citizen, within a rigidly structured art form, the purpose now is to convey, exclusively and as concretely as possible, different conceptions of intellectual activity. The sharp differences in appearance between the representatives of the different philosophical schools show that the primary concern was still not with the individual thinker, but rather with depicting the intellectual process—however defined by the various schools—as a special achievement. The philosopher represented a challenge to pupil and fellow citizen alike, whether by the force of argumentation or through his ethical stance. The portraiture makes a specific claim, as does the philosophy itself. The fact that each of the different messages reached only a portion of the population is a concomitant of the changed social constraints.

For the Stoics, thinking means above all mental struggle, the triumph of the active mind over the frailty of the body. Ever since the Archaic kouroi, Greek artists had celebrated the male body as the outward manifestation of the subject's physical and spiritual perfection, his *kalokagathia*. In statues like that of Chrysippus, the body loses its preeminence and now functions only as a foil for expressing the triumph of mind over matter. But thinking and intellectual activity are not simply praised as an end in themselves. Rather, they stand in the service of a moral and rational way of life. As had always been the case, the body expresses one's ethical stance: in a negative sense for the Stoics and Cynics, in a positive sense for the Epicureans, whose "classical" bearing and regular physical features convey an inner calm and self-assurance based on a sense of intellectual superiority.

In the urge to instruct, these philosopher statues accord perfectly with the old traditions of the polis. But the way in which they heroize

their subjects is new: Chrysippus with his irresistible argumentation, the intellectual superiority of Epicurus and Zeno. They belong to an entirely different category from the monuments in honor of leading citizens of the past or present age. Rather, they demand a special position, just as their subjects, while alive, occupied a special position within the city. These statues set alongside the civilian magistrates, benefactors, and leading citizens a new, self-designated authority comparable only to the images of kings.

The painfully distorted posture of the Stoics should not obscure the fact that these portraits intended, in their own way, to stand alongside those of kings, in spite of (or perhaps because of) the apparently ludicrous nature of this claim. For example, the statue of Chrysippus stood near an equestrian monument, probably for one of the kings, behind which he must have seemed to be hiding. The peculiar conjunction of these two statues inspired Karneades to an ironic parody of Chrysippus' name: "He [Chrysippus] had an inconspicuous little body [*sōmation euteles*], as one can see from his statue in the Kerameikos, which hides behind the nearby equestrian monument, which is why Karneades named him 'Kryphippos,' on account of his horse-hiding" (D. L. 7.182). Karneades is here making fun of his chief philosophical opponent, the man whose dialectics kept him occupied his entire life. But beyond that, the anecdote contains for us an important hint as to what effect such a statue had in the context of neighboring monuments. It shows how a philosopher statue was perceived alongside an equestrian statue of a king, probably over-life-size and certainly in a dramatic pose. The frailty of the bent-over old man achieved its full effect only when placed beside the monuments of the mighty. As Ernst Buschor put it, the "pathos of tranquility" was consciously set beside the "pathos of power." The intention was to cast a shadow on the brilliance of the royal epiphany, to expose it as transient and hence superficial. The philosopher's thoughts will in the end outlive kingdoms and imperial powers.

The Early Hellenistic age was evidently well aware of this special relationship between intellectuals and the men in power. It is reflected in a whole series of stories and anecdotes of the third century, starting

with the famous visit of Alexander the Great to Diogenes in his bar-rel.46 Karneades' joke does, admittedly, suggest that, after two or three generations, the proud claim of the philosopher with the feeble body was no longer fully understood. And the statue that was put up for Karneades himself is a different matter altogether (see p. 181).

Poseidippus: The Hard Work of Writing Poetry

An age that was able to express such subtle distinctions among the various schools of philosophical thought must also have sought ways to express visually the very different activity of the poet. But in fact, in comparison with the rich repertoire of philosophers, the few securely identified portraits of contemporary Early Hellenistic poets seem at first rather a disappointment—at least for the student expecting to find images of poetic inspiration and art.

Menander, as we have seen, was portrayed as a man of fashionable appearance who loved the life of luxury, one considered soft and os-tentatious compared to the old polis ideal, but in this way became the model for a new generation in Athens at the beginning of the third century. Yet nothing about his statue refers to his being a poet. The same is true of another seated statue of a poet of similar date, the so-called pseudo-Menander in the Vatican. In its relaxed pose, this statue too expresses the private values of *tryphē*.47 It is only on Late Helle-nistic copies of the Menander portrait that we may perhaps see an at-tempt to adjust the facial expression to make it more dramatic.48 The actual sense of poetic inspiration, however, is first achieved on a group of reliefs that portray a heroized Menander, nude to the waist, in the act of writing, accompanied by his two sources of inspiration, the Muse and the mask (fig. 74).49 But the original that lay behind these reliefs is a creation of the Late Hellenistic age, probably intended for display in Roman villas. Evidently by this time the stylish Menander of the Early Hellenistic statue was perceived as too bourgeois; what was wanted instead was a more imposing image. This is accomplished above all in the bare chest and the elevated poise of the head.

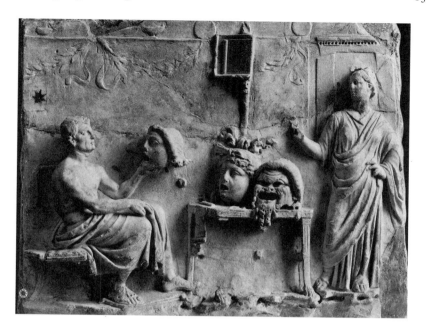

FIG. 74 Menander with his Muse. First-century B.C.
relief. Rome, Vatican Museums.

It would be most interesting to know whether this kind of image of
the inspired poet ever carried over into honorific statuary of the Early
and High Hellenistic periods, or if it occurs only in the retrospective
portraits with which we shall deal in a later chapter. The only work
that might be relevant here is the statue of the Attic comic poet Posei-
dippus (316–ca. 250 B.C.), of the mid-third century (fig. 75).[50] At first
glance, he may be even more disappointing than the Menander, if it is
inspiration and spirituality we are after. The head of the inscribed copy
in the Vatican, however, with its gloomy countenance, is not that of
the Greek poet, but of a Roman of the late first century B.C. who has
usurped the statue of a poet to try to pass himself off as a cultivated
gentleman. But thanks to a remarkable discovery by Fittschen, we now
know the authentic portrait type of Poseidippus in a fine copy of the
head. The careless sculptor who reworked the poet's head into that of

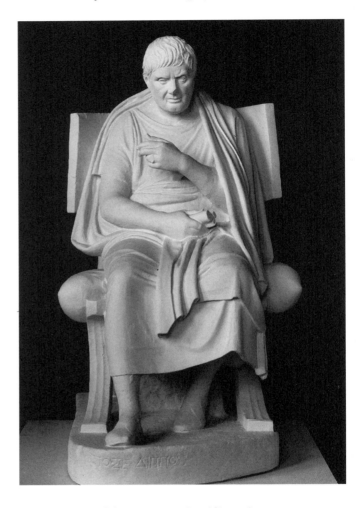

FIG. 75 Statue of the comic poet Poseidippus (316 –
ca. 250). Reconstruction by K. Fittschen.
Göttingen University, Abgußsammlung.

the Roman left a few locks of Poseidippus' hair on the nape of the
neck, and these locks enabled Fittschen to recognize the true Poseidip-
pus in a previously anonymous portrait type (fig. 76). It is a massive
head, with broad, full face, and had previously been taken to be the
portrait of a Late Republican politician, although the existence of a

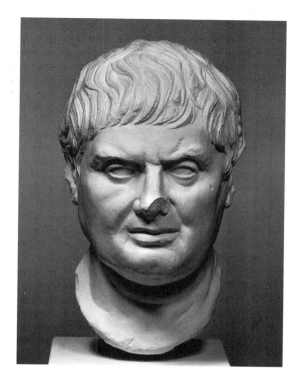

FIG. 76 Portrait of Poseidippus. Geneva, Musée d'Art
et d'Histoire. (Cast.)

herm in the Uffizi with the same portrait type should have suggested
otherwise. In short, it is a triumph for good old-fashioned detective
work, based on counting locks of hair and a thorough documentation,
and, at the same time, a warning not to put too much confidence in a
stylistic chronology, especially in Hellenistic art!

Quite unlike Menander, Poseidippus sits with his feet far apart, in a
rather inelegant pose, on a chair with an extremely heavy, curved
backrest. His legs are awkwardly positioned, the body slightly bent
over as if about to cave in. We need only compare the roughly contem-
porary statues of Epicurus and his circle to realize the full effect of this
heavy and pedestrian pose. He is a ponderous, well-nourished gentle-
man with noticeable paunch. We have already observed in many phi-

losopher portraits how realistically both the physiognomy of the face and the anatomy of the body could be rendered. Realism in the depiction of old age was in those instances not simply a matter of observation or of sculptural style, but the medium of philosophical instruction. Thus we should not assume that the sculptor wanted merely to convey the idea that Poseidippus was a man of ample proportions. Rather, it is more likely that the emphasis on the plump body and massive head carries a more general message. Probably it alludes to the ideal of Dionysiac extravagance and *tryphē* that was especially favored at the court of the Ptolemies. Certainly the cooks play important roles in the plays of Poseidippus, and in New Comedy in general, and this too is not unrelated to the notion of *tryphē* as a way of life.[51] It seems that in the third century, the well-fed body and full face were considered attractive, especially once the Ptolemies, as the protagonists in this new Dionysiac ethos, had themselves so depicted.[52] Indeed, the changing preference for thinner or heavier bodies in different time periods is, in the end, also a symbolic expression of particular social values.

This is not the only respect in which the portrait of Poseidippus seems to conform to the fashion of his age. Like Menander, he is also clean-shaven, and the same is true of the relatively few portraits of other Hellenistic poets that can be recognized as such among preserved Roman copies. In the light of our earlier discussion of beards and their connotations, this could hardly be an insignificant detail. Evidently, poets tended to follow contemporary fashion, unlike the philosophers, and did not perceive themselves in the same way as distanced from society at large or as the guardians of traditional values.

Poseidippus' fleshy face has, in addition, a peculiar expression (fig. 76). Although the brows are again drawn together, the nervous and agitated play of the features does not convey a sense of strain and intellectual effort, as in the Stoic philosophers. Instead, the mouth is relaxed and slightly open, while the eyes do not look straight at us but are directed somewhat downward. It seems that the artist was indeed trying to convey something of the laborious process of composing verse. The unusual pose of the raised arm with relaxed, open hand could suggest that he is keeping time, unconsciously rehearsing the

meter as he searches for just the right word. The closest parallel for the raised arm is on a copy of the Menander relief that Margarete Bieber recognized as the original, Late Hellenistic version. One may also be reminded of the depiction of a young poet on a Roman funerary altar of Trajanic date.53 If this is indeed the key to the correct interpretation, then we might go further and see the loose and gawky seated posture as an expression of "abstractedness," a consequence of his concentration on the poetic process. A comment of Pliny the Elder (*HN* 35.106) suggests that in other media of Early Hellenistic art as well there were indeed images of poets with their own particular expression. In describing a work by the painter Protogenes, he mentions the Alexandrian tragic poet Philiskos, a contemporary of Ptolemy II, represented "in a meditative pose" (*meditans*). This description recalls a fine caricature in terra-cotta of the late third century B.C. that was found in Olympia but was made in Alexandria (fig. 77).54 It represents a poet deep in meditation, his massive head weighed down by heavy thoughts. The pose of the body could well be inspired by an honorific statue, as a comparison with the thinker in the Palazzo Spada suggests (fig. 57). Footstool and pillow once again allude to the private sphere, while the contrast between the simple chair and the elevation of the figure, as if on a throne, is evidently an element of caricature. It comes as no surprise that this testimonium to the mockery of intellectuals should have originated in Alexandria.

Poetry, then, is characterized in the statue of Poseidippus not as a stroke of ecstatic inspiration, but as a long and strenuous and not especially enjoyable process. One would be tempted to speak of the "forging of verses" if this did not conjure up an unfortunate association with Wagner's *Meistersinger.* The parallel with the statues of Stoic philosophers is obvious, though the difference is also clear. The poet's work is not strictly a matter of a powerful act of will, but more of searching, of listening to his inner voice, of feeling his way. The public aspect is here fully suppressed. Though the form of the statue is a conventional one, the poet behaves quite differently from Menander. Like the statues of the reading philosopher, this one also gives the viewer the impression of peering unobserved into a private and intimate world, almost of being a voyeur.

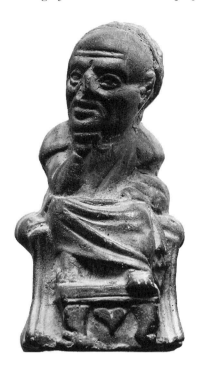

FIG. 77 Caricature of a tragic poet (?).
Alexandrian terra-cotta statuette, late
third century B.C. Olympia, Museum.

The movement of the right arm, as well as the introverted facial
expression, is strikingly reminiscent of Joshua Reynolds's portrait of
1769 of the writer Dr. Samuel Johnson.[55] One wonders whether
Reynolds might have drawn inspiration from the statue in the Vatican,
already well known then, or if the ancient and modern artists arrived
independently at the same psychological insights.

Soft Pillows and Softer Poets

Just as Menander (fig. 45) had done, Poseidippus also sits on a notice-
ably plush cushion. It is possible that this is a specific visual symbol in

the iconography of the poet, based on the idea of a comfortable domestic ambience as the prerequisite to poetic inspiration.

This interpretation suggests itself in spite of the meagre state of our evidence. The statue of the so-called pseudo-Menander, which was found together with that of Poseidippus, likewise shows the poet in a relaxed pose on a backed chair with thick cushion.[56] The same motif is also found in the reliefs depicting Menander mentioned earlier, as well as the famous wall painting in the Casa di Menandro in Pompeii. That the cushion is not restricted to comic poets can be inferred from the statue of the tragic poet Moschion (fourth–third century), though in this case, unlike Menander, Poseidippus, and the pseudo-Menander, he wears a simple mantle without the undergarment, and his chair does not have the backrest.[57] The most impressive example, however, is on the Late Antique diptych in Monza with a poet and Muse. The poet with shaven head (perhaps of the Late Republic) is seated with legs crossed upon a throne with a particularly luxurious cushion. The book rolls and diptychs strewn on the floor, together with the poet's expression, looking out dreamily into the void, can be taken to express poetic activity.[58] The notion that being a poet is well suited to a comfortable, "private" life-style could well have been widespread even before the Early Hellenistic statues. On a painted grave stele of the mid-fourth century, a certain Hermon sits casually leaning back on a splendid chair with a high back and thick cushion.[59] His literary association is made clear by the large cabinet of book rolls beside him, a rather rare motif at this period.[60] If this observation is correct, then the pillow in the statue of Menander may already be understood as a specific "poet's cushion."

Nevertheless, in the few surviving Hellenistic portraits of poets, at least those whose body is unknown, it is not possible to discern a particular facial expression of a poet, as it is, say, for most third-century philosophers. If, for example, the portrait formerly identified as Vergil did not occur as part of a double herm together with the so-called Hesiod, in one copy wearing an ivy wreath, we would not even be able to recognize him as a poet (fig. 78),[61] for many civilian portraits of the Hellenistic period are marked by a decidedly contemplative quality. In the case of "Vergil," the suggested dating and interpretation

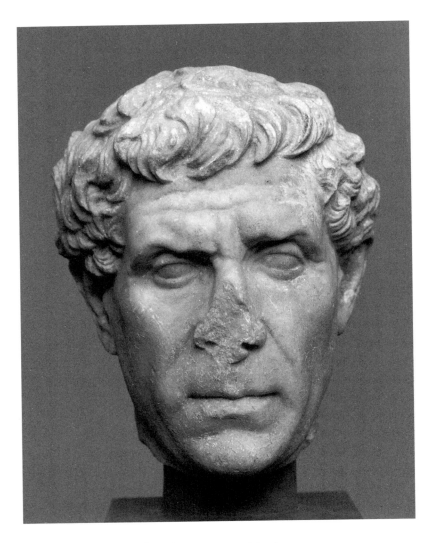

FIG. 78 Portrait of a Hellenistic poet, not yet identi-
fied. Roman copy of a statue of the second century
B.C. Copenhagen, Ny Carlsberg Glyptotek.

fluctuate between the late third and the first centuries B.C., between Greek and Roman poets. Stylistic arguments would support a High Hellenistic dating, in the early second century B.C., but even then will not determine with certainty whether a Greek or a Roman poet is depicted here.

The sculpture was above all trying to convey, as in the case of Poseidippus, intellectual activity in the sense of a restless searching quality, in the powerful but sudden movement of the brow. The expression, which constitutes only one element of the face, is, like that of Poseidippus, almost one of suffering. There is, at any rate, nothing strained or convulsive about it. Mighty mental effort, as we have observed in the Stoics and their associates, is apparently not part of the image of the Hellenistic poet. His work is more dependent on inspiration than on grim perseverance. A striking feature is the full and luxuriant hair, on a man of rather advanced age, perhaps again an allusion to the elegant life-style of the poet.

IV. In the Shadow of the Ancients

Stand here still and look on Archilochus, the Singer from ancient times [ton palai poiētan].
—Theocritus of Syracuse *Anthologia Graeca* 5.664

There are fundamental differences between the statue of the comic poet Poseidippus (fig. 75), the last monument we considered in chapter 3, and that of an old lyric poet in Copenhagen (fig. 79). The former is a portrait of a contemporary poet laboring mightily to find just the right words, while the latter is an extraordinary vision of the poetic force embodied in a "singer from ancient times" (*ton palai poiētan*). The statue of Poseidippus must have been created about the middle of the third century, that of the lyric poet perhaps a half century later. Yet the differences cannot be attributed to changes in style or varieties of sculptural schools alone. Rather, as the Hellenistic period wore on, a gulf arose between the portraiture of contemporary intellectuals and the visual imagery of the great minds of the past. This contrast has barely been recognized in previous scholarship, and I should like to make it the focus of this chapter. Retrospective portraits as such were, of course, nothing new. What, then, is the difference between such imagined portraits of the fifth and fourth centuries as the Anacreon on the Acropolis (fig. 12) or the Sophocles in the Theatre of Dionysus (fig. 25) and works like the singer in Copenhagen? What was the purpose of this new kind of portraiture?

The Old Singer

The singer is known from a superb copy of the first century B.C., almost completely preserved (fig. 79).[1] He held a lyre in his left hand

and the plectrum in the right, just like the statue of Anacreon, which, incidentally, was found in the same Roman villa at Rieti. But while the Classical statue's physique and contrapposto stance conform fully to the standard citizen image of the Periclean age, the old singer is presented to us as an awe-inspiring figure from the distant past. He sits on a tall throne with mighty lion-paw feet and has a thick, old-fashioned cloak of matted wool draped about his hips. He wears a luxuriant beard that is utterly different from the contemporary fashion. His powerful build implies that in his youth he was a tough opponent, while the slack limbs and the creases in the chest and belly are striking reminders of his advanced age.

But old age has not stilled the singer's energy and passion. He has sung himself into a state of ecstasy, his entire body seized by the enthusiasm with which he strikes his stringed instrument. His feet are intertwined, as if they had to brace themselves against the surge of energy and prevent the old man from leaping up. The upper body, with the instrument, curves like a spiral to the right, but the head, in its passionate movement, is turned away from the viewer. The singer is completely caught up in his song, enthralled by the instrument and oblivious of the world around him. To judge by the excited expression of his face, the verses he recites have a contentious tone. His inlaid eyes, now gone, must have considerably heightened the pathos of the expression.

A certain identification of the singer is not possible; Pindar and Archilochus have been suggested. What is certain is that the artist meant to represent a specific poet. The detailed characterization presupposes a viewer who was able to infer an association between the portrait and the poetry or the life of the poet. The viewer would have made such observations as these: it must be a lyric poet of the distant past whose work is highly prized in the present, as indicated by the beard, cloak, and throne; this is a poet of strong temperament who sang contentious songs, lived into old age, and had been very strong as a young man. He must have composed not only hymns and battle songs, but also drinking songs for the symposium. The ancient viewer would have inferred this last element from the ivy wreath, a rare attribute, which is preserved in most of the copies (cf. fig. 4).

FIG. 79 a—b Statue of an old singer. Roman copy
of a statue ca. 200 B.C. Copenhagen, Ny Carlsberg
Glyptotek. (79a restored.)

Of all the renowned Archaic poets, the one who fits this description best is Alcaeus of Lesbos (ca. 600 B.C.). He himself speaks in one poem of his "greying breast," and we know how passionate and contentious he remained well into old age.[2] The severe and serious Pindar, with his mighty kithara, was imagined very differently in this same period, as we can see in the majestic enthroned statue that stood in an exedra in the sanctuary of Serapis in Memphis.[3] It follows from these observations that we have here most likely a "character portrait" reconstructed from the subject's poetry and what was known of his biography. A retrospective portrait of this kind can have been created only in an environment where there were people familiar with poetic traditions who felt a need for such an image and were able to advise the sculptor accordingly. The statue presupposes a viewer who is also a cultivated reader.

A Peasant-Poet

The portrait of the old singer is not a unique phenomenon. There is a whole series of these retrospective images of great men of the past among the Roman copies of Hellenistic intellectual portraits. But unfortunately, as is so often the case, for almost all of them only the head is preserved, thereby severely limiting our ability to interpret them. This is true, for example, of the most problematic case, a portrait that was once taken to be Seneca and has thus acquired in the archaeological literature the rather odd nickname of Pseudo-Seneca. We are fortunate that the superb copy in a bronze bust from the Villa dei Papiri in Herculaneum (fig. 80a–c) gives at least a hint of the body type.[4] The head represents a complete break with the traditional aesthetic of Classical art. Among Hellenistic portraits, apart from the statue of the Cynic in the Capitoline (cf. fig. 72), there is no other even remotely comparable to this one in its unrestrained rendering of passion, old age, and dishevelment. Rather, the closest comparison might be with the roughly contemporary statue of the pitiful old fisherman, which may give us some idea of the realism with which the poet's desiccated body must have been depicted.[5] Peter Paul Rubens already combined the portrait with the fisherman's body, even though he was aware of the head that went with it. If the large number of copies of the Pseudo-Seneca, one of them a double herm together with Menander, did not guarantee that he must represent one of the most famous Greek poets, we might have suspected that the type is not a portrait at all, but rather a genre figure.

The hair falls over the brow in straggly locks. This is not, however, meant to express poetic inspiration or enthusiasm, as in other instances, but evidently the unkempt appearance of the peasant. This is particularly obvious at the nape of the neck, where the locks are caked with dirt and sweat, as well as in the crudely trimmed and irregularly growing beard. This last detail is a clear allusion to the iconography of the peasant, as we have seen in our discussion of the portrait of Chrysippus (p. 112). In pseudo-Aristotelian physiognomic theory, peasants and fishermen were marked by their irregular beards (along with other negative traits) as ridiculous and even as morally inferior beings. In the

bronze bust of the Pseudo-Seneca, this trait is only hinted at, but enough to evoke the imagery of fishermen and peasants, with their negative connotations, when contrasted with the beards of contemporary philosopher portraits (excepting Chrysippus, of course). This impression is reinforced by the leathery skin, dried out by the sun, forming ugly furrows on the neck and shoulder, as well as by the shriveled body with bones protruding in face and neck.

But this old man is in no way characterized as sick or dispirited. Instead, he is filled with a passionate energy. The tension in the forehead and eyebrows suggests extreme concentration, as he searches for just the right word. There is something compelling in his expression, as if he just has to express himself, as if something is driving him that is stronger than he is. But who would listen to this unkempt old man, an outsider in polite society?

As in the case of the seated singer, this portrait seems to aim at capturing a specific set of biographical data, at rendering in its particular pathos a specific and unmistakable spiritual physiognomy comprising these elements: manual labor, poverty, a disregard for personal appearance, and a breathless, almost fanatical manner of speech. All this seems to point to the peasant-poet Hesiod, who was called to poetry by the Muses while he was tending his goats on Mount Helikon and who lived and, in his verses, described a life of inexorable toil, worry, and disappointment. That later ages did indeed imagine Hesiod as an old man is confirmed by Vergil, who evokes him as the "old man from Ascra" (*Ecl.* 6.70: *Ascreus senex*).

But I am less concerned here with the identification of the portrait, which must remain a conjecture until an inscribed copy is discovered, than with the boldly rendered "biographical physiognomy" of this old man. One of the great poets of the past is presented with the physiognomic traits of the peasants and fishermen who had always been despised by bourgeois society and had to struggle to eke out a living. This is more than just a retrospective, literary portrait of a poet. Rather, like the silen's mask of Socrates and, later, the portrait of Chrysippus, it is a polemical statement of the independence of intellectual talent from noble birth or societal convention. Even a man who stood on the margins of society, who did not have the benefits of *paideia,* could

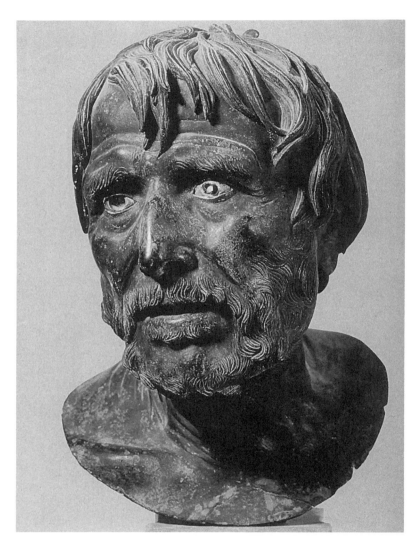

FIG. 80 a–c Hesiod (?). Augustan bronze bust after an original ca. 200 B.C. Naples, Museo Nazionale.

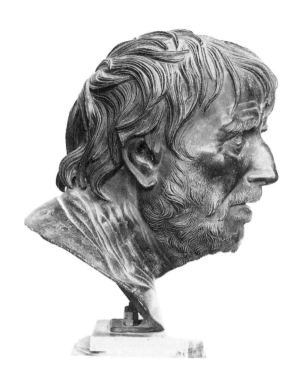

B

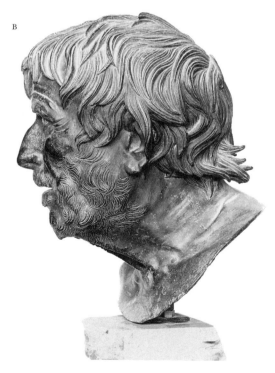

C

become a great poet. And again, a body worn out by toil and privation could still harbor a great spirit. Neither humble birth nor manual labor could rob this man of the power of the poetic word. An image like this implies a fundamental challenge to prevailing norms and values, even if only retrojected into the distant past. We shall return to this point presently.

Invented Faces

Hellenistic artists, confronted with the new task of creating retrospective literary portraits, must have developed an astonishing range of subtly differentiated types. Although we are mainly dependent on bust and herm copies often of dubious quality, the varied facial expressions of these portraits alone illustrate how the sculptors strived to translate each subject's intellectual, personal, and biographical traits into a "spiritual physiognomy." A few specific examples may make this clear. I have chosen four retrospective portraits that represent different kinds of intellectuals, two poets and two philosophers or scholars, all of them derived from prototypes that can be dated by stylistic criteria to the Middle Hellenistic period, that is, the years ca. 220 to 150 B.C.

A portrait from the Villa dei Papiri is identified by a painted inscription as that of the epic poet Panyassis of Halicarnassus (fig. 81).[6] He was said to have been put to death by the tyrant Lygdamos about 450 and was the author of a Herakles epic that was highly esteemed by Hellenistic philologists and poets. His countenance is tense, almost suffering, the expression quite different, say, from that of a grim old man whose wreath has been thought to mark him as a poet as well (fig. 82), even though both heads show a comparable contraction of the forehead. The piercing look of the latter poet and "the expression of a decrepit and ugly face, filled with hate and sarcastic bile," have suggested the name of Hipponax, the sixth-century poet known for his vicious invective verse.[7]

Equally striking is the contrast between Panyassis' facial expression and the expression of detached observation in the face of a portrait that has, on convincing grounds, been taken as that of the most

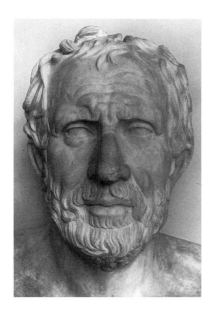

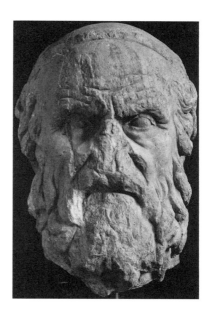

FIG. 81 Portrait of the epic poet Pan-
yassis (died ca. mid-fifth century B.C.),
after an original of the High Hellenis-
tic period. Naples, Museo Nazionale.

FIG. 82 So-called Hipponax. Helle-
nistic original of the second century
B.C. Athens, National Museum.

famous physician of antiquity, Hippocrates of Cos (fig. 83). The seated
statue from which this head derives depicted the old man with what
must have been his characteristic inclination of the head, and therefore
probably with the body tensed as well.[8] The calm objectivity of the
so-called Hippocrates is in turn utterly different from the severe and
penetrating, almost fanatical intensity of a portrait for which a relief in
the Terme Museum has recently suggested an identification as the pre-
Socratic philosopher Anaximander (fig. 84).[9]

My deliberately subjective readings of these portraits, based on gut
feeling and psychologizing interpretation, are of course not binding
but only meant to provoke a response. And even if my reactions are
not at all those intended by the artists, the important thing is the
phenomenon itself, a completely different conception of the notion
of portraiture. No longer, as in the retrospective portraits of the fifth

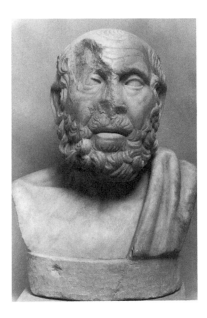 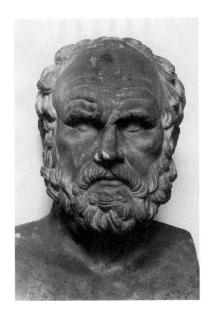

FIG. 83 Hippocrates. Bust from the grave of a physician, after an original of the High Hellenistic period. Ostia Museum.

FIG. 84 Portrait of the pre-Socratic philosopher Anaximander (?). Roman copy of a Hellenistic original. Rome, Capitoline Museum.

and fourth centuries, is the goal a paradigmatic display of virtues accepted by the entire society and thereby a didactic and hortatory effect. On the contrary, these new retrospective creations, with their vivid expressions, would be unthinkable in the context of publicly displayed monuments in the Hellenistic cities, as honorific or votive statues. Those statues as a rule continued the fourth-century traditions of the garment correctly draped about the body and the controlled pose based on Classical draped figures. Their expressions may have occasionally conveyed a sense of energy or contemplation, but violent or dramatic elements were avoided (pp. 188f.).[10]

For these portraits striving to capture a literary image, in contrast, there was obviously no need to adhere to such conventions, since the subjects belonged in any case to the far-distant past. Thus in their dress, in their physical characteristics, in the language of gesture and

facial expression, they stand intentionally apart from contemporary conventions of the citizen image. This separation in turn implies that these portraits must have fulfilled new and different functions.

As we have noted, the retrospective portraits presuppose an educated viewer, who would understand the biographical and literary allusions, who was familiar with the literary judgments and characterizations applied to each figure, and who might even have taken part in the ongoing discussion of the great thinkers of the past. It seems only reasonable to associate the origins of this new kind of portraiture with the rise of Hellenistic philology and of the new breed of scholar who flourished in particular at the royal courts.[11] The Museum in Alexandria, founded by Ptolemy I, in whose library "the king had assembled the writings of all mankind, all those that deserved serious attention" (Eus. *Hist. eccl.* 5.8.11), became a model, and not just for other rulers. The great philosophical schools and gymnasia in Greek cities began to collect the writings of earlier authors, since the reading and interpretation of texts had become the focal point of a new form of education that gradually engaged the whole of Hellenistic society. From the beginning, Alexandrian scholars were conscious of a sharp break between past and present. The writers of the past belonged to a glorious but remote epoch, and their writings were a precious legacy that had to be conserved and used as a source of wisdom and guidance. Contemporary poetry belonged to a different genre that could not be compared to that of the past. This is the same gulf that separates the portrait statues of a Menander or Poseidippus from those of the old singer or the so-called Hesiod.

The professional scholar and *poeta doctus* under royal patronage was a new breed of intellectual, living in splendid isolation from urban society, freed from the normal citizen responsibilities and able to devote himself fully to his scholarly work. "The melting pot of Egypt nourishes many men, bookish scribblers forever quarreling in the bird cage of the Muses": thus the sharp-tongued Skeptic Timon of Phlius (frag. 12 Diels), who passes judgment from the perspective of an intellectual still fully integrated in the society of the polis. But it was this very isolation, the clustering of scholars in academies and philosophical cliques, that gave rise to a new pursuit, the study of earlier writers as a purely literary and aesthetic pastime, along with an interest in every biographical an-

ecdote, the same interest we see informing the retrospective portraits. If we wish to gain some idea of the range of associations that the ancient viewer might have made, we might take a brief look at two literary genres of the period, the *bioi,* originating mainly in the tradition of the Aristotelian school, and the epigrams on poets. It may be no accident that, in just the period when the retrospective portrait was at its height, the late third and early second centuries, we hear of a writer of *bioi* named Satyros. Fragments of his *Life of Euripides* survive, and they betray an intention to demonstrate, in Ulrich von Wilamowitz's words, "die Harmonie zwischen Wesen, Leben, und Dichtung." Satyros' reconstruction of Euripides' life is derived mainly from the poet's work, and this is just how we must suppose the sculptor (or his adviser) proceeded. Biography and portrait, both inspired by the new philological bent, had the same goal: to gather impressions from the great man's work and then translate these into a specific image, a uniquely individual presence. But while the intellectual level of most of the *bioi,* as they are known to us, is rather modest, the portraiture—to judge from certain Roman copies—must have included some true masterpieces. Satyros, incidentally, is known to have written lives not only of poets, but of great men of all sorts, including Alcibiades, Philip of Macedon, and even philosophers such as Diogenes.[12] We may therefore assume that the retrospective portrait statues also included philosophers, statesmen, and other historical worthies.

Even more informative, and certainly more enjoyable to read, are some of the more artful epigrams. These imagine the reader at the tomb or even before a statue of one of the poets of old and try to evoke reminiscences of his life and work. The process of idealization goes together with a distancing of the reader's present from the "once upon a time" of the past.[13]

The Cult of Poets

Though literary and intellectual in conception, these retrospective portraits, in the purposes they served, went far beyond the interests of a small circle of scholars. The reading and interpretation of literary masters was not restricted to the "bird cages" at the royal courts. The

great library at Alexandria itself was open to all who wished to study and read. Indeed, the preoccupation with literature seems to have become a kind of all-embracing social dialogue in Hellenistic Greek cities of the third and second centuries. While the youth were educated in the classics and made to learn them by heart, their elders would congregate at the gymnasia to hear an itinerant scholar, poet, or philosopher, or other speakers employed by the city. These public lectures often focused on the interpretation of great writers of the past. In this way, the poets of old and the philosophers were elevated to the status of authorities who provided guidance in all of life's important matters. Cities would institute genuine hero cults for their own intellectual heroes, complete with appropriate sacrificial rituals. The establishment of such cults is in itself of less interest for us (kings and benefactors also enjoyed this highest form of public honor) than the artistic elaboration that they occasioned and inspired.

At the very top of the hierarchy, of course, stood Homer, the font of all wisdom, religion, and culture. The relief of the sculptor Archelaos of Priene (fig. 85a, b) translates into visual terms a complete vision of Homer as the ancestor of Hellenic culture.[14] The monument was probably the votive relief of a contemporary poet who had won a tripod in a poetic contest (perhaps in honor of Homer himself) and dedicated it, along with a statue of himself, to Apollo and the Muses. His simple draped statue stands at the right, just at the foot of the hill of the Muses. Below, we are looking into a sanctuary of Homer. He is enthroned, like Zeus, a tall scepter in his right hand and a book roll in the left, while the personifications of the various literary genres, arranged in a careful hierarchy (Historia, Poiesis, Tragodia, Komodia), sacrifice a bull in his honor. The sacrificial attendant is a boy called Mythos. The master's twin works, Iliad and Odyssey, kneel beside the throne. In front of the footstool, two mice nibble on a roll, probably an allusion to the *Batrachomyomachia,* which was then considered a genuine work of Homer. From behind the throne, the standing figures of Chronos and Oikoumene crown the poet.

Unlike the other figures, these two bear unmistakable portrait features, probably a discreet homage to a royal couple whom we can no longer identify. They may have been responsible for the splendid Homereion depicted here or another one like it. Four female figures

FIG. 85 a Votive relief of a poet in honor of Homer, by the sculptor
Archelaos of Priene. Ca. 150 B.C. London, British Museum.

on a smaller scale watch the sacrifice from a corner: Arete and Mneme
(Memory), with their younger sisters Pistis (Faith) and Sophia. A little
girl, Physis, turns to Pistis with a look of supplication and tugs at the
hem of her sister, who bids her be silent.

The whole is an extravagant panegyric, celebrating the central im-

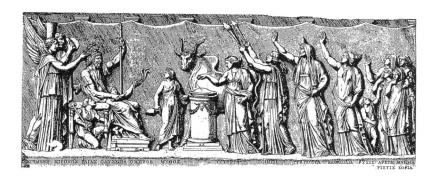

FIG. 85b Detail of an etching. From *Ex calcographia Domenici de Rubeis* (Rome, 1693).

portance of Homer and, through him, of literature and poetry in education. Particularly striking is the great value attached to certain skills. Among all the Muses, their mother, Mnemosyne, is singled out and stands closest to Zeus. The message of this relief is clear: the standards for the education of the young must be derived from the great literary works of the past, for these are the source of cultural memory. But those writers themselves are all nourished by a single source, Homer. This is truly an image to warm the heart of a classical philologist.

The Archelaos Relief not only presents us with an all-encompassing vision of learning but also gives some idea of how statues of Homer may have been set up in the numerous sanctuaries of the poet in Hellenistic cities that are attested in the literary sources. The Homereion in Alexandria is described as follows by Aelian: "Ptolemy Philopator erected a temple to Homer and placed within it a magnificent seated statue of the poet and, in a semicircle around him, all the cities that laid claim to Homer" (*VH* 13.22). We may suppose that these various cities, personified in statues in the Homereion at Alexandria, also had richly outfitted sanctuaries of Homer. One that is well attested was in Smyrna, where Strabo saw a temple with cult statue (*xoanon*), surrounded by columned porticoes. His use of the word *xoanon* implies a particularly ancient-looking cult statue, perhaps of wood. This was no doubt intended to legitimize the city's claim to being Homer's birth-

place. "The people of Smyrna have a special claim to Homer, and they even call a bronze coin the Homereion," observed Strabo (10.1.37). But cities of the Greek mainland also accorded the father of poets cultic honors. We hear, for example, of sacrifices conducted by the Argives at a bronze statue of Homer (*Cert. Hom. et Hes.* 18).

In addition to Homer, many other intellectual heroes enjoyed cult worship. In Priene, for example, stood a heroon of Bias, who had for centuries been numbered among the Seven Wise Men. This small city even issued silver coins about the middle of the second century B.C. with a full-length figure of Bias, probably a rendering of the statue that stood in the "Bianteion" (fig. 86b). The coin depicts a tripod alongside the statue, an allusion to an often-told story. One day in Priene, some people found a golden tripod at the shore bearing the inscription "For the wisest." The city awarded the tripod to Bias, but he in turn, in pious modesty, dedicated it to Apollo (D. L. 1.82).[15] We see here how such a heroon attracted cult legends, just as did the sanctuaries of the traditional gods and heroes, and how cities would strive to propagate these legends, like that of Bias' tripod, throughout the Greek world.

The Archilocheion on Paros, which probably dated back to the Archaic period, was, like other heroa, associated with the poet's grave and a gymnasium.[16] In the third century, a Parian named Mnesiepes ("Collector of Epics") had a temple in honor of Archilochus either built or renovated, by order of the Delphic oracle. A long, partially preserved inscription tells legends from the life of the poet that the dedicator claims to have collected from ancient tales. In reality these stories are paraphrases of Archilochus' poetry, including the story, modeled on Hesiod, of how he was called by the Muses, who made him a gift of a lyre as he was driving a cow to market. A later inscription, of the first century B.C., contains a list of the poet's writings and deeds in chronological order.

These dedications, with their detailed reports of the life and work of Archilochus, "testify to the poet's continued importance to the people of Paros, who would visit the shrine and read the inscriptions. It is significant that what interested them about Archilochus was not so much his poetry as the relationship of his poetry to his life."[17] In this instance, the sanction of Delphi was particularly important, not only for the cult on Paros, but for its fame beyond the island. Paros

FIG. 86 a–d Four Hellenistic coins of Greek cities,
representing local intellectual heroes of the past: *a*, Ar-
chilochus of Paros; *b*, Bias of Priene; *c*, Anaxagoras
of Clazomenae; *d*, Stesichorus of Himera (photos
enlarged).

issued coins in the first century B.C. with a portrait of the poet as a
youthful figure nude to the waist, holding a lyre in his left hand and a
book roll in the right (fig. 86a). [18] His one-time reputation for slander
and dubious citizen conduct was long forgotten, and all that remained
was his fame as a great poet.

There were other cities as well that were putting their intellectual
heroes on coins by the second and first centuries B.C. Clazomenae, for

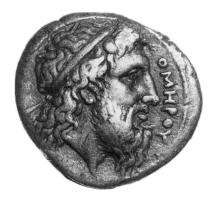

FIG. 87 Homer. Coin from the island of Ios (3:1). Berlin, Staatliche Münzsammlung.

example, minted coins showing the philosopher Anaxagoras (fig. 86c), and Sicilian Himera the poet Stesichorus (fig. 86d), both represented as vigorously active figures. Stesichorus sings and plays a stringed instrument, while Anaxagoras is shown as a teacher, in the same pose as Hermarchus. The majority of such coins, however, appear first under the Roman Empire. Yet such early examples as those just mentioned suggest how important these figures were to the Greek cities already in the Hellenistic period, both for their image of themselves and for their understanding of their own traditions.[19]

Most numerous, however, are the coin portraits of Homer,[20] minted in several of the cities of Asia Minor. The little island of Ios, for example, which claimed to possess the tomb of Homer, had already in the fourth century B.C. circulated splendid silver coins with a head of Homer that, without the inscription, could easily be mistaken for an image of Zeus with flowing locks (fig. 87). The die cutter probably did in fact simply use a Zeus type with which he was already familiar. We see from this how early Homer was turned into a mythical figure, and how the assimilation of his image to that of Zeus derived from an earlier notion of Homer's unique significance. The figure of the singer is assimilated to that of the gods and heroes of whom he sang.

A B

C

FIG. 88 a–c Homer on coins of the cities of Smyrna (*a–b*) and Chios (*c*).

The city of Smyrna minted several different portrait types, starting in the first half of the second century B.C., some of them simultaneously. Not all of these images could be based on existing statues, much less "cult statues." This variety shows clearly the intense fascination of Homer in this period, how the popular imagination constantly reshaped his image, while at the same time imagery of the Olympian gods could only imitate fixed Archaic and Classical prototypes. The most popular coin type of Homer in Smyrna shows a Zeus-like enthroned figure, as on the Archelaos Relief, holding a scepter and (in place of the thunderbolt!) a book roll. In one of the earliest issues, he is even more closely assimilated to Zeus, with bare chest and the right hand, with the book roll, outstretched in a commanding gesture (fig. 88a). At the same time, however, beginning in the decade 180

to 170, Smyrna also issued a contemplative Homer, with the head propped on one hand (fig. 88b). Later came other images, the poet reciting dramatically from his work and, on nearby Chios, the poet quietly reading in his *Iliad* (fig. 88c). This incongruous notion of the quietly reading Homer was also a Hellenistic innovation, in some other medium (cf. fig. 104). The activities of Homeric scholars and connoisseurs are, as it were, retrojected onto the poet himself. The act of reading, of meditating on and immersing oneself in his verse, acquires an almost religious aura.

The Divine Homer

There can be little doubt that one's expectations and attitude toward such a statue as that of Homer on the Archelaos Relief, almost more of a cult image, are quite different from how one might approach the traditional honorific statue for a poet or philosopher. The ancient viewer was invited to discern and reflect upon the biographical and literary elements present in the image, to meditate piously upon them in the spiritual setting of a shrine. It was this aura of the sublime that was evidently the very effect aimed at in a number of the retrospective portraits.

It is this particular aspect I should like to focus on in considering the famous portrait of the blind Homer.[21] Again we have copies of only the head, but some idea of the body may be supplied by the Archelaos Relief and the coin types (figs. 85, 86) that depict Homer as extremely old and blind. The tradition of Homer's blindness is an old one, as we have seen, perhaps derived originally from the blind singer Demodokos in the *Odyssey*. In any case, it is certainly present in the well-known portrait of the elderly Homer created about 460, with which we have dealt in chapter 1 (fig. 9). The blind Homer was, nevertheless, always only one of several ways of portraying the poet, as the other versions on coins attest. But whereas the early portrait, created at the time of the "Severe Style," conveys a sense of profound calm, the Hellenistic sculptor has rendered his vision of Homer in highly dramatic terms (fig. 89). If the earlier portrait merely hinted at the

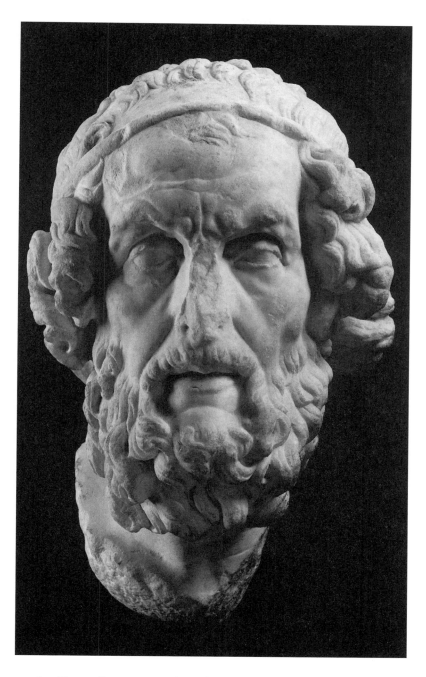

FIG. 89 Homer. Roman copy of a High Hellenistic
statue ca. 200 B.C. Boston, Museum of Fine Arts.

blindness in the closed eyes, here it is rendered with almost clinical accuracy, with the eyes half-closed and the muscle degeneration around them. And if the early portrait presented a figure that, for all its loftiness, might still be likened to images of contemporary older men, this is now out of the question. The Hellenistic portrait belongs to another category. The heavy, archaizing locks framing the face, the fillet containing the hair rolled up in the back—also an archaizing trait—and the full, heavy beard all conjure up the majestic aura of a god.

The deep-set, lifeless eyes and the whole expression of the facial features are in certain ways rendered very variously by the Roman copyists. As in the case of Menander, it seems to me hardly possible to reconstruct an authentic version of the prototype out of the more than twenty-five surviving copies. Once again it is precisely the copies of highest quality that may turn out to be instead interpretations of the original, pursuing their own interests and intentions. Roughly speaking, the copies may be divided into two groups. Some sculptors emphasize the active features of the face, others the passive. One group of copies emphasizes the intricate forms of the coiffure, especially the archaizing rounded locks at the temples, while the other confuses these, sometimes in an apparently intentional attempt to render a wild and unkempt mass of hair. We may best illustrate the difference in a juxtaposition of two of the most impressive copies, though bearing in mind that because the two *are* so outstanding in workmanship, they will have absorbed much of the Roman taste of the period in which they were carved.

A head in Boston, probably of Flavian date, stresses more the active features (fig. 89).[22] Brows and forehead are overlaid with little rippling muscles that seem to be in continual irregular motion. Our impression is of a fervid imagination in high gear, and we barely notice the elements of decrepit old age. In the famous head in Naples, on the other hand, a Late Antonine copy, the dominant impression is of the frailty of old age (fig. 90).[23] The visionary aspect is linked to a sense of agonizing struggle. The forehead is almost painfully drawn up, and the eyes and face have a kind of dead look. It was this head that the young

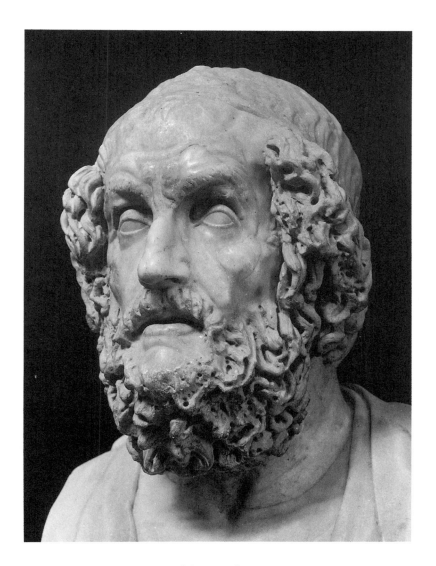

FIG. 90 Homer. Roman copy of the second century
A.D. after the same statue as fig. 89. Naples, Museo
Nazionale.

Goethe had in mind in his impassioned description for Lavater's *Physiognomische Fragmente:*

> I enter the presence of this figure uninformed. I say to myself: the man sees nothing, hears nothing, doesn't move, doesn't react. In this head, the midpoint of all the senses is in the high, gently arching hollow of the brow, the seat of memory. Every image is stored here; all the muscles rise up, to conduct the figures of the living down to the cheeks that will give them voice. . . . This sunken blindness, the vision turned inwards, energizes his inner life all the more, and makes the father of poets complete. These cheeks have been molded by never-ending speech, these muscles of speech the well-worn paths down which gods and heroes have made their way to mankind; the willing mouth, only the gateway to such images, seems to babble like a child's, has all the naïveté of youthful innocence; and the enclosure of hair and beard contains and ennobles the breadth of the head.[24]

In the Boston head, in contrast, the power of the will wins out, especially in the mouth and eyes: the mouth holds firm, trying to shape into words the vision of the mind's eye. Even if none of the copies can be proved to be the most "reliable," we must nevertheless once again assume that the original somehow combined the different and sometimes contradictory traits captured in the varying interpretations of the copyists: physical frailty and extreme old age, on the one hand; a godlike loftiness and dazzling inspiration, on the other. The head in Boston and others of its type, with the complicated treatment of the hair and facial features, come closer, in my view, to the High Hellenistic original than the group to which the head in Naples belongs. One could imagine the Boston head joined to an imposing seated statue of the type on the Archelaos Relief, but not the head in Naples. Perhaps the High Hellenistic prototype was adapted by a Late Hellenistic sculptor who stressed such elements as the frailty of age and the unkempt hair and beard of the old man. But since these later copies do not share any features that clearly distinguish them typologically from the version to which the Boston head belongs, it is probably more likely that the Naples head and others like it are independent

variants whose only common element is a reflection of the style of the Antonine period.[25]

Nevertheless, the important point for our interest is that the reinterpretation of Homer's face continued uninterrupted into the Imperial period and that the copyists were neither able nor willing to conceal their own conceptions of the great poet. We should also remember that the Roman patron had, at least theoretically, not only a choice among the different versions of this particular type, but a choice of several types as well. (In addition to the two versions of the blind Homer just discussed, there was yet another popular type, probably Late Classical in origin, showing Homer with the wide-open eyes of the seer and long hair at the nape of the neck, the so-called Apollonios type.) The various portraits, with their diverse emphases, were of course meant to evoke in the viewer a whole range of associations. Alongside the enthroned prince of poets, the seer heralding the gods and heroes, there may be another conception, exemplified by the pseudo-Herodotean *bios,* of Homer as a poor singer wandering from city to city. This image, however, first became widespread only in Imperial times.[26] It could be the inspiration for the head in Naples and others like it.

Hellenistic Kings and Archaic Poets

The presentation of this type of literary portrait as a kind of cult image, on the one hand, and the more detailed, biographical approach that appealed to the viewer's own literary training, on the other, are not mutually exclusive. Rather, the spiritual aura only intensified the appreciation of the portrait as a work of art and erudition. Generally speaking, in Hellenistic art the object was expected to offer a whole spectrum of associations. This is why, for example, among freestanding sculpture in the round, it was the statue groups that were particularly popular. A multiplicity of figures allowed the message to be enriched with several layers of meaning, and the Hellenistic world, as the inscriptions also reveal, was an extraordinarily communicative place.

FIG. 91 Exedra with portraits of famous poets and phi-
losophers. Third century B.C. Memphis, Serapeion.

In the area of literary portraiture as well, the statue group seems to
have been of central importance.

We have already seen one example of a meaningful grouping of fig-
ures, replete with learned allusions, on the Archelaos Relief. A group
of famous poets, original works most likely of the later third or early
second century, has been found in the sanctuary of Serapis at Memphis
(fig. 91).[27] Twelve over-life-size statues of "ancient" poets and think-
ers were arranged here in a semicircle around the seated figure of Ho-
mer. Their display, however, represents a renovation of the monument
in late antiquity. Once again, the sculptor seems to have used innova-
tive physiognomic characterization to differentiate the various literary
genres.

The exedra was placed for maximum effect at the egress of a grand
processional street. In earlier times, such an ambitious group would
have been conceivable only for mythological heroes or as a gallery of
ancestor portraits of a royal house. Astonishingly, among the fragments
found at Memphis were two fragmentary heads wearing the royal dia-
dem, one of them a youth. Apparently members of the ruler family
responsible for the monument were also depicted among or alongside
their intellectual heroes. In other words, the intellectual giants of the
past would have been presented as good counselors to the king, as the
source of his wisdom and authority. Beyond the immediate historical

or political circumstances, this is clearly a celebration of universal learning as a quality of the good ruler. The cult of learning that manifested itself in the hero shrines of Hellenistic cities finds a close parallel in the public image cultivated by the Ptolemaic kings.

The meagre state of the surviving evidence does not allow us, unfortunately, to reconstruct the manner in which retrospective portraits were displayed in other contexts, such as the urban heroon, like the Archilocheion on Paros, or the gymnasia. We may suppose, however, that the association of local literary heroes with their native city would most likely have provided the backdrop for the display of the corresponding portraits, and that cult legends of the type we have preserved for Bias and Archilochus played a central role in this context as well.

The Retrospective Philosopher Portrait: Socrates, Antisthenes, and Diogenes

Another, even more particular function of the retrospective portrait can be inferred from some of the philosopher statues. A Middle or Late Hellenistic Socrates is perhaps the most fascinating of the new interpretations of older philosopher portraits (fig. 92).[28] The artist incorporates elements of both fourth-century portrait types (cf. figs. 21, 35) but creates a new interpretation of the silen's mask. It is for him no longer a metaphor for wisdom, but simply a formula to express extreme ugliness. This new Socrates also has a hideously broad and unattractively shaped nose, a completely bald pate, and sunken cheeks, all of which bespeak an individualized physiognomy. Yet at the same time he is characterized as a mighty thinker in the powerfully arching cranium.

The combination of the dramatically tensed brow and the dignified locks of the archaizing beard with the ugly little pug nose has an almost comic effect for the modern viewer. Socrates has been turned into an intellectual pioneer in the Stoic mold, recalling the mighty strain in the face of a Zeno or Chrysippus (figs. 53, 55). One might easily imagine the commission for this image coming from a Stoic school that wanted to honor its spiritual ancestor with a monument that captured

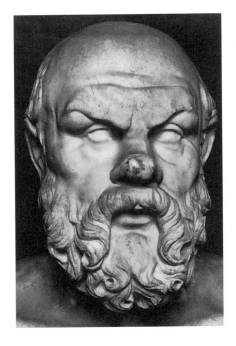

FIG. 92 Socrates. Roman copy of a Hel-
lenistic statue. Rome, Villa Albani.

his mental powers in a compelling and contemporary fashion, unlike
the Classical portrait type. This vision would of course have been com-
pleted with an appropriate body, most likely seated in a vigorous pose
of cogitating or instructing. There are several types of seated figures of
Socrates that survive in various media, but unfortunately none can be
associated with certainty with the type of the portrait head in the Villa
Albani.[29]

A similar situation might obtain for the impressive portrait of Soc-
rates' pupil Antisthenes, who was revered as a spiritual ancestor by
both Cynics and Stoics (fig. 93). The dating of the portrait type, which
is preserved in an inscribed herm copy, has been an unusually thorny
problem for scholars.[30] The basic iconographical type is that of the

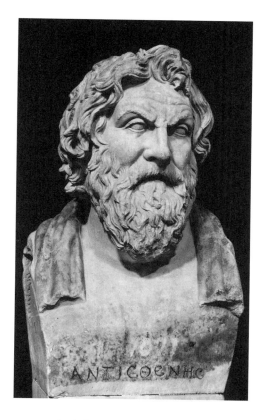

FIG. 93 Antisthenes (ca. 450–370). Herm copy
of a Hellenistic portrait. Rome, Vatican
Museums.

Classical old man of fourth-century grave stelai, with long and some-
times disorderly hair, but here combined with a dramatically rendered
brow of the deep thinker, an element that does not occur in Classical
portraits. There are physiognomic traits as well, which seem to be
linked to the character and intellectual qualities of this particular
thinker. All this suggests that the type belongs to that of the retrospec-
tive portraits, which in turn supports a dating first suggested long ago,
in the early second century B.C.

A clue to the interpretation of the head is suggested by the striking

contrast between the carefully tended beard and the vigorous move-
ment of the long and uncombed hair, something unique to this head
among philosopher portraits. The contrast seems to be deliberate, and
beard and hair may not necessarily convey the same message. The locks
rising from above the forehead had been a popular symbol of strength
and energy ever since the portraits of Alexander the Great; and cen-
taurs, silens, and giants were all characterized as "wild" creatures by a
similar treatment of the hair. It is tempting to see here a reference,
again recalling the *bioi,* to Antisthenes' vigorous and abrasively con-
tentious character or to his much-admired moral rigor. We may even
remember how the chauvinistic Athenians never forgot Antisthenes'
half-barbarian origins as the son of a Thracian mother. It is quite con-
ceivable that such a reference could be intended in a biographical por-
trait of this type; Diogenes Laertius' biography, at least, begins with a
mention of this circumstance of the philosopher's birth.

 The vigorous movement of the forehead, the eyebrows raised with
an almost ferocious intensity, proclaim the intellectual energy of this
toothless old man. The well-tended beard, on the other hand, may be
interpreted simply as a classical "philosopher's beard," if the second-
century date is correct. That is, the beard was meant to label him as
"one of the philosophers of old." This handsome and old-fashioned
beard balances the individualized characterization embodied in the
wildly unkempt hair and underlines the seriousness of Antisthenes'
philosophy, irrespective of his "character." The pose of the head and
the bunching of the drapery at the back of the neck suggest a seated
statue. He was evidently depicted as a teacher, unlike the Cynic in the
Capitoline (fig. 72). Nor does Antisthenes betray any other Cynic fea-
tures, and the portrait was surely not conceived as that of the founder
of this philosophical "sect." We could, however, imagine a Stoic con-
text for this portrait, as for the Hellenistic Socrates.[31]

 The well-known statuette of Diogenes may also be best interpreted
within the framework of specific biographical and philosophical/di-
dactic interests (fig. 94).[32] The completely naked body is unique in
the iconography of Greek philosophers and might lead one to wonder
if this could be an innovation of the Imperial period, reflecting the

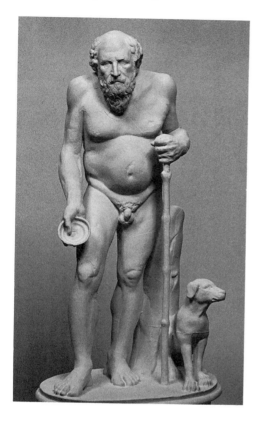

FIG. 94 Diogenes (414–323). Statuette of the
Imperial period after a Hellenistic original.
H: 54.6 cm. Rome, Villa Albani. (Cast.)

popular mockery of the philosopher or an interest in the purely anec-
dotal. On the other hand, the keenly observed realism, especially in
the startlingly misshapen and ugly body, is in the direct tradition of
works of the third century B.C.

A tired old man, he walks slowly, bent over a staff that he holds in
his left hand. The right hand was probably outstretched and might well
have made a gesture of begging, as in the eighteenth-century restora-
tion. The body is stiff and ungainly; neither standing still nor moving
is easy for the old man. The sagging belly shows that this old man, who

had nothing but contempt for exercise and training in the gymnasium, never did anything to stave off the outward signs of aging. Yet his begging managed to keep him well fed, and the contrast with, say, the emaciated "Old Fisherman" (fig. 61) is obvious. Though these traits could be taken in the anecdotal spirit of later Roman mockery of the intellectual, the impressive bald head of the philosopher, the thoughtful expression, and long, dignified beard (best preserved in the copy in Aix-en-Provence) nevertheless suggest that this Diogenes and his teachings are to be taken seriously. This is surely not the kind of head one would have expected to go with this body, but the sculptor knew what he was doing in this striking contrast.

Once again the ruthless depiction of a decrepit body must be understood in the context of contemporary negatively charged imagery of fishermen and peasants. But, as in the case of the supposed Cynic in the Capitoline (fig. 72) and the Pseudo-Seneca, our reaction is meant to be one of admiration. Diogenes taught his pupils to despise societal convention, including the care of the body, and to renounce all material possessions as a prerequisite to a true independence and spiritual freedom. The naked body is evidently meant to express visually the uncompromising way of life and defiant protest of the founder of the Cynics, truly philosophy in action.

Whereas the realistic appearance of the Cynic in the Capitoline reminds the viewer of the appalling and irritating public behavior of such men and thus presupposes one's experience of them, Diogenes' nudity has a very different significance. Even though the depiction of the body is highly realistic, the figure does not represent an actual encounter. The artist is not striving for the directly provocative effect of the Capitoline Cynic. Even the Cynics did not really walk naked through the streets but wore the *tribōn* made of coarse material (D. L. 6.22). The nudity has rather a didactic meaning and embodies a moral challenge. The sculptor assumes a familiarity with Cynic writings on the part of the viewer, and the statue calls these teachings to mind and "preaches" them, as Diogenes himself once did by means of his appearance: freedom from want and contempt for the body, for physical beauty and bourgeois conventions. Our encounter with the naked Diogenes is, as it were, literary; it takes place not in public, but at home or in

the philosophical school, which is to say in our head. When later Roman writers speak of the *nudi cynici* (Juv. 14.309; Sen. *Ben.* 5.4.3), they have in mind just such a portrait.

The iconography of the head, on the other hand, stands in the tradition of Late Classical portrait types, as does that of Antisthenes. Some scholars have even thought they detected similarities to the portrait of Socrates, which escape me.33 We may once again suspect that the commission for the original came from the Hellenistic Stoics, who are known to have been the first to collect anecdotes about Diogenes.

In spite of his promotion to the status of a serious philosopher, this Diogenes has nothing to do with the popular hero of the Enlightenment, going about with his lantern and searching for the truth, literally bringing it into the light. The Diogenes of this statuette remains purely a figure of dissent. He has no program to offer and no interest in "progress." At most he stands at the threshold of a philosophical school, by exhorting the viewer to contemplation and exposing the superficiality and "unnaturalness" of conventional life-styles through his own unorthodox behavior. When we find him again, on simple gravestones of the Early Empire, reclining in his cask, he has become nothing more than a memento mori, a symbol of contempt for the world, since death is inescapable.34

As we have seen, the retrospective portraits of intellectual heroes of the past arose out of a particular need: they functioned as icons in a unique cult of *paideia,* even to the point of being actual cult statues in hero shrines. Gradually it seemed the whole of society in urban centers was reading and interpreting the great writers of the past, scholars and orators as well as poets and philosophers. In an age when the structure of individual identity was changing and the inexorable power of Rome loomed on the horizon, these portraits were for the Greeks the principal guardians of their cultural identity. One could see them as a kind of exercise in collective memory in the quest for stability and proper orientation in life. The new cult manifested itself not only in the heroa, but in many branches of education that took in a whole spectrum of both private and collective forms of veneration of the poets and philosophers of the past.35 Alongside public lectures and

poetic and musical competitions in the gymnasia, there is evidence from the private sphere as well. The appearance of images of the poets and illustrations from their work from the first century on, not only on gemstones and silver vessels, but also on the painted walls of Delian houses and even on humble terra-cotta bowls, gives some idea of the ubiquitous presence of this literary culture in the cultivated home.[36] A good example of this is a silver cup from Herculaneum, probably of Augustan date but employing an earlier motif. The scene is the apotheosis of Homer. The poet is carried aloft by a mighty eagle (as Roman emperors later will be). On either side sit female personifications of the *Iliad* and *Odyssey*, who assume a remarkable pose, lost in contemplation, that anticipates the proper attitude of the educated reader.[37]

The attitude toward the intellectual giants of the past is now marked by pious meditation, reverence, and the distance inspired by great awe, in contrast to the public monuments honoring the tragedians in Lycurgan Athens. These new images are bold visions, freed from the bourgeois conventions of contemporary life and retrojected onto an idealized past. At first glance the situation may seem to parallel the glorification of the intellectual hero by the educated bourgeoisie of the late nineteenth century (cf. pp. 6ff.). But Hellenistic readers and devotees were different in genuinely and quite actively seeking guidance for their own lives in the writers of the past. Culture was not some ideal world relegated to a few leisure hours spared from the "real world" of commerce and social interaction. Rather it was the focal point of life as it was lived and the foundation of both personal and collective identity.

The "Gentrification" of the Philosopher Portrait: Carneades and Poseidonius

This new state of affairs must naturally have had some impact on how contemporary intellectuals saw and presented themselves, especially in the philosophical schools of the Late Hellenistic period. Whereas philosopher statues of the third century had posed a challenge to society

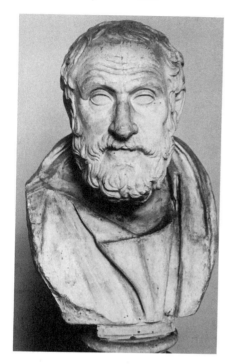

FIG. 95 Carneades (ca. 214 – 128). Bust (now lost) after an honorific statue ca. 150 B.C. Copenhagen, Museum of Art. (Cast.)

in their bold indifference to conventional norms and their claim to spiritual leadership, those of later philosophers gradually adapt themselves to these very standards of the bourgeois image. With the growing rivalry between the philosophical schools, the stark contrast in image of earlier times eventually disappears.

When a statue of the celebrated philosopher Carneades was dedicated in the Agora by two Athenian citizens about the middle of the second century or just after (fig. 95), the sculptor took as his model the statue of Chrysippus not far away (fig. 54).[38] Both were depicted seated and giving instruction, turning their concentrated attention to an imaginary interlocutor. The similarity is quite surprising, for Carneades was the head of the revived Platonic Academy, and his own

fame was due not least to his lifelong struggle with the dialectic of Chrysippus. He was supposed to have said of himself: "Without Chrysippus there would have been no Carneades" (D. L. 4.62).

However striking the similarities to the older portrait, there are also differences. Like the standard honorary statues of the day, Carneades wears a chiton under his himation. Toughness and the refusal to succumb to the needs of the body and one's own mortality are no longer a part of the philosopher's message. In place of the careless external appearance and passionately aggressive energy of Chrysippus, we see an elegant figure, with well-groomed beard and a countenance of fine proportions derived from Late Classical art. Yet the strenuously raised furrows of the brow recall at first glance the expressions of the Stoics. If we compare this, however, with the portraits of Zeno, or even Chrysippus (cf. figs. 53, 60), it becomes clear that in Carneades a different kind of thinking is meant: not the vigorous and direct attack on an opponent, but rather a distanced scrutiny and weighing of arguments. Interestingly, the contraction of the brows that was so characteristic of third-century portraits is no longer present. Instead, the deep furrows running in "orderly" parallel lines dominate the facial expression. This is a man of contemplation, who listens carefully and calmly formulates his argument. The portrait makes no particular ethical claims.

The fact that the statue quotes from an earlier Hellenistic philosopher portrait seems to be not a special case, but rather symptomatic of a broader trend. By the mid-second century, the great poets and philosophers of the previous century already enjoyed the status of classics. This retrospective tendency, which had informed so much of Hellenistic culture by the middle of the second century, is particularly tangible here. This backward-looking stance is accompanied by a kind of eclecticism, which had the effect of smoothing over any uncomfortable disagreements between philosophical schools. Under these circumstances, it is not so astounding after all if the image of a Stoic is taken as the model for that of the leader of the Academics.

There is yet another way in which the portrait of Carneades differs from that of his predecessor. The long hooked nose and crooked

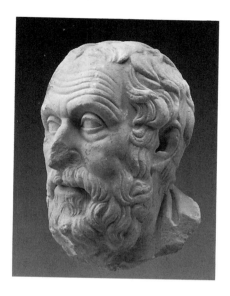

FIG. 96 Carneades. Roman copy of the
period of the emperor Trajan. Munich,
Glyptothek.

mouth, which are well preserved in a new copy in Munich (fig. 96), are striking features of an unmistakable, individual physiognomy. For the first time, a Hellenistic portrait of a philosopher clearly reveals the man himself, as an individual, not merely in his role as the representative of a particular school. Not surprisingly, of all the philosopher statues in Athens, this one made the greatest impression on the young Cicero (*Fin.* 5.4).

In the course of the second century, philosophers of every stripe were steadily integrated into urban social and political life. A typical example is Athens, which in the year 155 B.C. sent the heads of three philosophical schools, the Stoa, the Peripatos, and the Academy, as envoys to Rome (where Carneades held his famous speeches for and against justice). In 124/3, the polis officially recognized these same three schools as centers of education, and at the funeral of the great

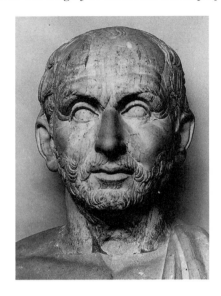

FIG. 97 Stoic philosopher of the late
second century B.C., perhaps Panaitios
(died 109 B.C.). Roman copy. Rome,
Vatican Museums.

Stoic Panaitios all the philosophers in Athens took part as a corporate
entity. There was a reconciliation between Epicureans and Stoics, and
some Epicureans even agreed to serve as public magistrates.39

Along with this rapprochement of the philosophical schools, it ap-
pears that the differentiation of the portraits according to school that
had been the norm in the third century, expressed in particular mi-
metic and physiognomic formulas, gradually disappeared, to make way
for a more general look of contemplation. This is the same look, as we
shall soon see, to which many citizen portraits of the period also adapt.
There are, unfortunately, no securely identified philosopher portraits
of the later second century. The portrait of a man with unusually large
eyes might be that of a Stoic (fig. 97). The closely shorn but untended
beard recalls Chrysippus, while the forehead raised in a gesture of
skepticism is closer to Carneades. The portrait is preserved in three

copies found in Rome and must represent a popular figure in Late Hellenistic philosophy. A possible candidate would be Panaitios, who molded out of the classical tradition a straightforward and pragmatic ethical theory well suited to the needs of Roman aristocrats. The style of the portrait would be consistent with a dating toward the end of his life in 109.[40]

The end of this development may be represented by the portrait of Poseidonius of Apamea in Syria (ca. 135 – 50 B.C.), created about 70 B.C. (fig. 98). Poseidonius was a pupil of Panaitios and, like him, taught on the island of Rhodes. The portrait is known from only a single copy of superb quality, a bust of early Augustan date.[41] From the preserved portion of the chest we can infer that the figure was standing and clad in chiton and himation, thus no different from standard portrait statues of contemporary Greeks and essentially the same as those of the fourth century B.C. The modest expression no longer betrays him as a philosopher, and certainly not as a Stoic struggling with his thoughts. In fact only the beard signals the philosopher, and it is so closely trimmed as to be barely noticeable. Nevertheless, unlike the beard of the so-called Panaitios, this one has been carefully trimmed. A number of contemporary portraits are known from Rhodes featuring this kind of closely trimmed beard, but it is unlikely that all of them are philosophers. Rather, it must be a kind of "philosopher look" that was fashionable in this university town. The typical citizen image and the would-be philosopher seem, at least on Rhodes, to have become virtually indistinguishable.

Most striking, however, in the portrait of Poseidonius is the self-consciously classicizing quality, which becomes almost oppressive in the "Polyclitan" locks of hair. This is the hallmark of a man who saw it as his primary responsibility to gather the spiritual heritage of the Greeks and pass it on to the Romans who flocked to his lectures. For a man of his eclectic philosophy, there would have been no point in modeling his image after that of Chrysippus. There is nothing left in this portrait of intellectual passion. The quiet, serious features are those of a tenured professor, self-satisfied both with his own methods

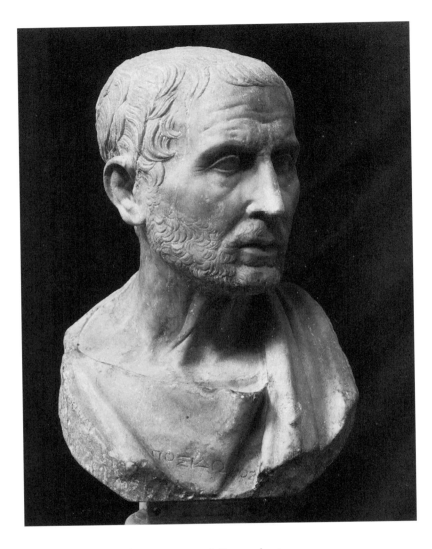

FIG. 98 Poseidonius (ca. 135 – 50 B.C.). Roman bust
after an original of the philosopher's lifetime. Naples,
Museo Nazionale.

and research and with the recognition accorded him by his pupils and by society, a man who identifies fully with the values of that society and has no more interest in changing it.

Yet in spite of these changing circumstances, the philosopher remained a figure of great authority in the Late Hellenistic age. His reputation now rested primarily on his role as interpreter of the classical tradition. For example, a certain Hieronymos, active on Rhodes in the second century B.C., had himself depicted, on the doorway of his funerary *naiskos,* reading and lecturing to a circle of his pupils. Characteristically, he holds an open book roll from which he reads and interprets the text.[42] The role of interpreter is in turn closely linked to that of the educator and counselor.

This association is well expressed by a relief of the first century B.C. (fig. 99) that has provoked a great deal of interest on account of a mysterious psi-shaped symbol.[43] Underneath the large framed picture (or window?) bearing the enigmatic sign, a philosopher is seated with his family. His portrait, like that of Poseidonius, is patterned after Late Classical models. Although he has no other heroic traits and sits comfortably in a chair, he is shown on a much larger scale than all the other, standing figures. This is presumably a grave monument that a father commissioned for the resident philosopher to whom he had entrusted the education of his three children. The difference in scale is supposed to convey the great awe in which the teacher is held, and the success of his teaching is expressed in the well-bred manners and poses of the children, a young man, a youth, and a girl. The father is characterized by his bald head and realistically rendered face as an unmistakable individual and wears the same outfit as the philosopher and elder son, a himation without a garment beneath it. This is not the current fashion and marks him as an adherent of the philosophical way of life. If we interpret the curious symbol above the philosopher as a psi, it could be a reference to the concern for the peace and security of the soul common to all those depicted here. The intimate ambience of the scene brings to mind the Greek philosophers employed in the households of contemporary Roman aristocrats. But there, no matter how much the Romans valued the company of the philosopher and

FIG. 99 Grave relief (?) of an in-house philosopher
with his host family. First century B.C. Berlin, Staat-
liche Museen.

relied on his advice in times of spiritual crisis, they would not have
accorded him such a position of honor within the family. The relief is
thus a particularly impressive testimony to the high status accorded
philosophical teaching in the Late Hellenistic world.44

The "Intellectualization" of the Citizen Portrait

A brief look at the imagery of the ordinary citizen in Late Hellenistic
art will make clear that we are dealing here with a reciprocal process.
At the same time that the distinguishing characteristics of the philoso-
pher portrait become less pronounced, citizens of the Greek cities put
the emphasis on learning and a contemplative nature in their own self-
image. From the second century on, reading and contemplation are

FIG. 100 Portrait of a contemplative citizen,
from a Late Hellenistic funerary or votive
monument. Athens, National Museum.

seen as outstanding values and appropriate motifs for the representa-
tion of a male citizen on his tomb monument. It is only against the
background of this intellectualization of everyday life that we can un-
derstand the place of the retrospective portraits within this cultural sys-
tem.[45] A number of portraits of the later second century from Delos,
Athens, and elsewhere have a markedly contemplative expression. Oc-
casionally a raised brow seems to allude directly to the appearance of
Carneades or another philosopher (fig. 100).[46] We have already ob-
served the beginnings of this process of assimilation in the portraiture
and grave reliefs of the Late Classical period (cf. pp. 67ff.). Now, how-
ever, it becomes much more apparent and is no longer limited to older
citizens.

The contemplative expression is, however, often combined with
a dramatic turn of the head and other formulas that denote energy

and determination, derived from the repertoire of contemporary ruler portraits. The citizen male evidently sought to portray himself as a combination of philosophical meditation and energetic vitality, or, in more personal terms, a combination of the new intellectual hero of the polis and the dynamic and beneficent monarch. The resulting ambiguity is perhaps reflected in the oddly contradictory appearance of certain heads.47

The description of this physiognomy as "contemplative" would be no more than a subjective impression if we did not have other evidence of the central importance of philosophy, scholarship, and learning that helps give voice to these "contemplative" men. We have already noted the significance of the gymnasia, as well as the appearance of learned motifs on objects of daily use and even in the painted decoration on the walls of private homes. A particularly valuable testimony is the widespread adoption of the imagery of *paideia* on the funerary reliefs. These are preserved in large numbers, especially from the cities of Ionia, and provide direct evidence of the way in which a broad stratum of the bourgeoisie wished to see itself represented.48

The first thing we notice on these reliefs is the large number of book rolls and writing tablets and implements. These meaningful attributes are displayed on shelves, presented by slaves, and of course also held by the deceased and others. They may belong to youths of school age, to men in the prime of life, or to old men, and even some women are also celebrated in this manner for their *paideia*. The epigrams accompanying the reliefs confirm that such attributes do refer specifically to the notion of learning and education. The virtues of a "universal" learning are suggested in the plethora of volumes, often depicted in bundles or stored in a case.

In addition to this general praise of learning through the use of attributes, there are also more explicit images, particularly from those cities that have left us the largest number of grave stelai. For example, in Smyrna, Cyzicus, and Delos, it is not unusual for an older man to be depicted as a seated "thinker." His authority may be expressed in his elevated position or in the lavish and dignified chair on which he sits. On a fine stele now in Winchester (fig. 101), a citizen of Smyrna gives instruction looking down from his elevated seat, the fingers of his right hand ticking off the arguments. His face, with its look of

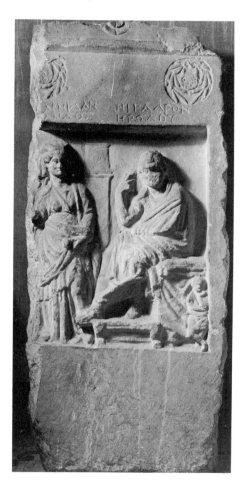

FIG. 101 Grave stele from Smyrna. Second
century B.C. Winchester College.

concentration, is turned not to his wife, but to the viewer. As in the
portrait of Chrysippus, the image speaks directly to the viewer. The
female figure, as on many of these stelai, stands in casual proximity to
the "philosopher," her appearance recalling that of a priestess of De-
meter. This suggests that in her role as wife, she is celebrated above all
for her piety.49

It is no accident that the image of the seated man calls to mind that

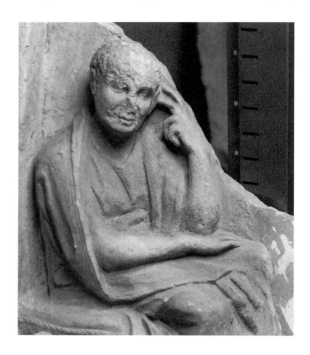

FIG. 102 Grave stele of an elderly citizen from
Smyrna. Second century B.C. Leiden, Rijksmuseum.

of Chrysippus (fig. 54). Other stelai as well betray a visual association
with well-known statues of poets and philosophers of the third cen-
tury. Interestingly, the most popular motif is that of meditation with
the head propped up on one hand, in the manner of the philosopher
in the Palazzo Spada and the bronze statuette of Kleanthes (cf. fig. 58),
which has the effect of distancing the thinker from the world outside.
A particularly fine example, again from Smyrna, shows an old man
with markedly individualized features and the unmistakable expres-
sion of a thinker (fig. 102).[50]

Such instance are not, however, deliberate quotations of famous
monuments. Rather, the familiar images of mental and intellectual ac-
tivity created in Early Hellenistic art had simply become ingrained in
the popular consciousness, along with their connotations of dignity
and authority. That these images were indeed understood as signs of

FIG. 103 Grave stele from Byzantium. First century
B.C. Istanbul, Archaeological Museum.

outstanding intellectual ability or achievement is confirmed by the fact
that the men so depicted can in many instances be shown to have held
an office in the gymnasium.51

In the course of the later second and first centuries B.C., the imagery
of *paideia* becomes widespread in the funerary art of Hellenistic cities.
In Byzantium, for example, the venerable image of the "Totenmahl"
(funerary banquet) relief is transformed into what we might call a "Bil-
dungsmahl." Tables and shelves are filled not with food, but rather
food for thought: book rolls and writing implements. Cultivated gen-
tlemen hold open book rolls instead of drinking vessels, and one even
seems to be playing the part of one of the Seven Wise Men, the scholar
and astronomer expounding on the globe with his pointer (fig. 103).52
The familiar look of contemplation here gives him a rather self-
satisfied appearance. It is worth noting that this motif of the "Bil-
dungsmahl" seems to appear in Byzantium on the largest and artisti-
cally most ambitious grave stelai. It is, in other words, the upper class
that so insistently lays claim to the value of learning, even in a city that

at this time was still on the margins of Greek cultural life. At one time, in the third century B.C., such images, attached to pioneering thinkers, were seen as a challenge to society and to traditional political and social ideas, a harbinger of a new way of thinking. Now the image looks merely blasé, the very essence of acceptable behavior among the established bourgeoisie.

Man the Reader: Paradigm for a New Age

Rudolf Pfeiffer christened the Hellenistic world the "Age of the Book."[53] For Alexandrian philologists and scholars, the new age began under Ptolemy I, but as a broad cultural phenomenon it took time to evolve. By the second century, as we have just observed on the gravestones, books and reading occupied a place of central importance in the life of the average city dweller. Unfortunately we know very little about the actual production and distribution of books in the Hellenistic age. On the basis of papyri found in Egypt, we can say that the number of volumes in circulation was increasing in the Late Hellenistic period but was still far fewer than under the Roman Empire. The buying of books must, however, have been an important part of the whole enterprise of education, for about 100 B.C. the grammarian Artemon of Cassandreia could publish two volumes aimed at an already existing clientele, *On the Collecting of Books* and *On the Use of Books*. This marked the founding of a new genre of literature that was to become very popular under the Empire.[54]

The image of the reader was already a part of intellectual iconography in Early Hellenistic art (cf. fig. 71). But at that time reading was only one of many possibilities for expressing a particular form of intellectual activity. By Late Hellenistic times, however, reading seems to have become the very essence of the intellectual process in general. From now on it was no longer possible to imagine an intellectual other than with a book in his hand or sitting nearby. The image was evidently so appealing that it was eventually adopted for the great figures of the past, both poets and philosophers. Plato and Sophocles are both turned into avid readers, and even Homer—apparently undeterred by his blindness—is shown as a bent old man reading from his *Iliad*

FIG. 104 Homer seated on an altar, reading. Fragment of a Tabula Iliaca. Augustan (?). Berlin, Staatliche Museen.

on a fragment of a Tabula Iliaca (fig. 104). Even the Cynics, who once despised reading, as also every other form of learning, are turned into readers. Diogenes himself emerges from his barrel book in hand, though first on engraved rings of the Early Roman period. In such instances, the motif does not carry a specific message about the subject but serves only as a general symbol of intellectual activity. The writers of old, it suggests, were also learned men.55

Compared to the portraits created in the later third and second centuries, these images of the poet or philosopher as reader represent a surprising standardization and impoverishment of the iconography of the intellectual. That said, we should be careful to bear in mind that we are almost entirely dependent on copies in the minor arts. Nevertheless, the coins that we noted with the type of Homer reading

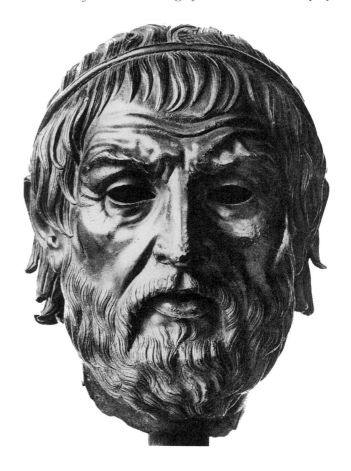

FIG. 105 So-called Arundel Homer. Bronze head,
probably from the seated statue of a reading figure.
First century B.C. London, British Museum.

(fig. 88c) suggest that we cannot dismiss the reader type as an incidental
or occasional phenomenon. It must have been used for major public
monuments as well. One such may be represented by the impressive
life-size bronze head of a poet reading, a Late Hellenistic work said to
come from Istanbul and known as the Arundel Homer (fig. 105).[56]

A small marble relief provides at least some idea of the body. The poet sits in a simple chair, bent over and holding in both hands an unrolled book.

The mature, handsome face is placid and patrician. The uniform, classicizing arrangement of hair and beard concentrates our attention on the subtle movements of the lively brow and the deep-set eyes. The effect is not one of energy or mental strain; rather the artist wanted to convey the passive concentration of the reader in the portrait of a poet. The mouth is open but fully relaxed, as he reads aloud to himself. It is not enough to say that this is just an example of classicistic style and the modulation of expressionism. This is rather the new model of the intellectual. The poet is so lost in his reading that he is oblivious of the world around him. The quiet beauty of his physical features reflects a sense of inner perfection, achieved through total dedication to the classics. When viewed in this light, this work too reveals a didactic aspect.

The reader has become the exemplar of an isolated intellectual existence. Reading is a solitary process that removes the reader from the world around him. He lives instead in the world of the author and communicates only with him instead of in open discussion. In so doing, the reader creates his own private world, distant from the public life of his society. In the following chapter we shall observe how this paradigm came to fruition in Rome and its empire.

V. Hadrian's Beard

For myself, when I hear people speaking of the "ancients"
[antiquos], *I take it that they are referring to persons remote
from us, who lived long ago* [veteres, olim nati]: *I have in
my mind's eye heroes like Ulysses and Nestor, whose epoch
antedates our own times by about 1,300 years. You on the other
hand bring forth Demosthenes and Hyperides, whose date is
well authenticated. They flourished in the days of Philip and
Alexander, and indeed survived both these princes. This makes
it plain that between our era and that of Demosthenes there is
an interval of not much more than 300 years: a period which
may perhaps seem long if measured by the standard of our feeble
frames, but which, if considered in relation to the process of the
ages* [saeculum] *and the endless lapse of time* [aevum], *is
altogether short and but as yesterday.*

—Tacitus *Dialogus* 16 (trans. W. Peterson)

In Rome, the pursuit of intellectual activities was at first a strictly private matter, unlike the situation in the Hellenistic cities of the Greek world. For the Romans, these were the leisure pastimes of the élite, manifestations of *otium* confined to the home. They were kept separate, both spatially and temporally, from *negotium,* the sphere of political, legal, and social responsibilities that occupied the senator and *patronus* in Rome. The professional intellectual, who played such a conspicuous role in Greek society, had always been a rather marginal figure in Rome. The origins of this phenomenon are clear: from the third century B.C., Greek teachers had come to Rome as slaves and entered the homes of the nobility. Later, many stayed on as in-house philosophers, poets, librarians, schoolteachers, and doctors, all dependent on the favor of a *patronus* or other paying customers, even though they might often enjoy a special position as *amici*. In their confronta-

tion with the Greeks, as is well known, the Romans had come to see themselves principally as statesmen and soldiers born to rule. They imagined all their chief virtues and ideals most perfectly embodied in the figure of the pious, fiercely decent, and courageous peasant farmer of ancient Rome. This paragon was created, of course, at a time when he no longer existed—if indeed he ever had.

It is not hard to see how in these circumstances the public acknowledgment of intellectual activities was rather problematical. The Roman attitude toward intellectual pursuits remained ambivalent well into the period of the Empire, fluctuating between passionate devotion in private and restraint, if not actual distrust, in public, for everything that concerned culture and learning was clearly the domain of the conquered Greeks.

Even though this ideological claim eventually became little more than a well-worn topos, a certain wariness remained.[1] Under these circumstances, it is obvious why no Roman of the upper class would have displayed his intellectual interests, much less ambitions, as part of his public image. It would never have occurred to a Cicero or a Seneca to appear in public dressed like a poet or philosopher or to have himself portrayed in a way that celebrated his intellectual abilities or pretensions. Rather, their portraits are realistic and present us with men whose faces radiate a sense of energy and concentration (figs. 106, 107). They wish to be seen as active statesmen, not as distracted thinkers racking their brains over theoretical problems.[2]

Likewise, the professional intellectuals, usually from a Greek-speaking and servile background and dependent on Roman patrons, tried to assimilate to the general citizen image and had themselves depicted in the toga of the Roman citizen, with appropriate hairstyle and facial expression—insofar as they ever received honorary statues in the first place or could afford their own funerary monument. The rare exceptions only confirm the rule.

The public image of the philosopher was molded largely by the filthy and lower-class itinerant Cynics. The Roman citizen had an ambivalent relationship with them, comparable to the popular attitude toward mendicant monks in the Middle Ages. They were, on the one hand, held in contempt because of their parasitic nature, their outra-

FIG. 106 Cicero (106–43). Augustan copy of a por-
trait made in his lifetime. Rome, Capitoline Museum.

geous appearance, and their arrogance and pushiness. Yet, at the same
time, they were admired for the way they adhered entirely without
compromise to their "alternative life-style." Nevertheless, the distaste
with which Seneca reacts to their moral insistence shows how irritat-
ing they could be, even to a socially assimilated Roman intellectual
(*Ep.* 5.1–2). We shall see how a certain fascination for the man in the
street later emanated from this image of otherness.3 But for now Se-
neca's reaction to their vulgar appearance only confirms the general
bias against Greek philosophers.

FIG. 107 Seneca (ca. 4–65). Small-scale
double herm (with Socrates) of the third cen-
tury A.D., after a portrait made in Seneca's
lifetime. Berlin, Staatliche Museen.

I do not mean to suggest, however, that no positive image of the
intellectual existed at all. Rather, as we have already seen in chapter 1,
the houses and villas of the rich often contained whole series of por-
traits of poets and thinkers. But these were almost exclusively images
of celebrated Greeks of the distant past.4 Copied from Classical and
Hellenistic portrait statues, only reduced to busts, they shaped the Ro-
mans' image of the man of intellectual pursuits, as someone who en-
joyed a position of great authority but belonged to a very different age.
Their unfamiliar beards and hairstyles alone immediately separated
them from the outward appearance of contemporary Romans. As we
shall see, every subsequent attempt by the Romans to visualize their
own intellectual strivings remained indebted to these icons of classical
culture, not only in Rome itself but throughout the Empire.

The picture I have just sketched was not, however, an unchanging
one. In the course of the first and second centuries A.D., the funda-

mental values of Roman society underwent a profound transformation. With the advent of a monarchy, political concerns became gradually secondary, while culture and learning moved into the very center of the social discourse. (In the cities of the Greek East, this process had begun already in the Hellenistic period.) The introspective preoccupation with all forms of Greek culture—myth, art, literature, philosophy, as well as history and customs—gradually created its own dynamic and evolved into various kinds of intense devotion that are reminiscent of religious ritual. In the process the very identity of the Romans underwent a thoroughgoing change. The dichotomy of Greek and Roman tradition largely disappeared as "classical" culture became the common culture of the entire *imperium Romanum.*

In view of this I believe it is quite legitimate to speak of a "cult of learning." The object of this cult was the whole of classical culture. To Roman society it appeared in the form of a self-contained entity, an absolute and unquestioned religious dogma in which one could take part through particular cultural pastimes and from which one could derive a model for proper behavior and self-fulfillment. The rituals in the cult of learning consist essentially of various forms of commemoration and assimilation. The objective was to adapt the whole of society to the ideals and example of classical culture. In this process, each individual had to strive to become, as far as possible, a perfectly "classical" man. This meant not only "the care of the self," as Michel Foucault put it, a philosophical way of life embracing both body and soul, but also the shaping of the physical environment according to Greek models, including the outward appearance of the individual. Thus it is that in the course of the second century A.C. much of the male population took on a "classical face," or at least the beard of the learned man. It is Hadrian's beard that marks the turning point.

Because of the extraordinary "classicism" that permeated all of Roman culture under the Empire, this chapter and the next will be concerned less with the representation of particularly important individuals than with society's attitude toward intellectual activity and the implications of this for the way the Romans saw themselves and chose to have themselves portrayed. For more than three hundred years the intellectual layman will be the protagonist of our story, which begins

with the aristocracy of the Late Republic, who played at Greek culture in their great villas and surrounded themselves with galleries of portrait busts representing the famous Greeks of the past.

The World of *Otium* and the Gentleman Scholar

Portraits of well-known Greeks have been found almost exclusively in lavish villas and private houses. Very rarely were they set up in public buildings, even theatres, as had been the case in the Greek cities.5 This is in keeping with the almost exclusively private nature of the Roman experience of Greek culture at the beginning, and with the peculiar separation of the two spheres, *otium* and *negotium,* that resulted from the dramatic process of acculturation of Roman society after the incorporation of the Greek city-states into the Empire. The feeling that the Roman senator could abandon himself to the pursuit of Greek culture only while on vacation, and preferably outside the city of Rome, was directly related to the senatorial aristocracy's concern for the preservation of its own traditions. Again and again it passed largely symbolic legislation, such as sumptuary laws, the banning of private cults of Dionysus, or the persecution of Greek intellectuals, in an attempt to define a Roman "national identity" in the face of the Hellenistic world. What passed for Roman traditions were of course recognized as such only in the process of defending them from any intrusions from the Hellenistic culture of the Greek cities.6

The reality was naturally often very different from what the ideology of the *mores maiorum* would lead one to expect. The great Roman families had long been "Hellenized," both in the conduct of their daily lives and in their interest in Greek literature and art. By the second half of the second century B.C. parts of Rome already looked like a Hellenistic city, and Rome was unquestionably one of the centers of the Hellenistic world. This transformation necessarily included an intellectual life played out in public, though within definite limits. Theatrical productions at the great festivals of the gods were copied from Greek models, and Greek rhetoricians and philosophers gave public lectures. The latter phenomenon must have gotten so out of hand after

the Third Macedonian War (171–168 B.C.) that the Senate felt com-
pelled to set an example by imposing a general ban on the itinerant
Greek intellectuals. When, a few years later in 156 B.C., the jeunesse
dorée of Rome came to hear Carneades' lectures in droves, Cato saw
to it that the philosophers beat a hasty retreat from the city "so that
such men go back to their own schools and debate with Greek boys,
while the Roman youth turn their attention to their laws and their
leaders" (Plut. *Cat. mai.* 22).

The Senate's conservatism and resistance to the public display of
Greek *luxuria* continued for another hundred years after the first wave
of Attic philosophers and was so strong that these same senators, in
many respects already men of the Hellenistic world, had to construct
their own private world in which they could unabashedly and without
regard for public opinion in Rome act the part of Greeks, that is, of
sophisticated men of the world. The large country estates of the no-
bility and of local aristocracies were transformed into islands of Greek
culture, complete with smaller-scale and compact versions of the pub-
lic cultural institutions of Hellenistic cities. This phenomenon is re-
flected not only in the architectural forms employed but in the vo-
cabulary used to designate them. Thus particular residential areas of
the villa might be given names like gymnasium, palaestra, and xystus,
or, even more specifically, academia, lyceum, and biblioteca, pinaco-
teca, or mouseion. The decoration of such rooms was intended as an
invitation to the world of Greek culture. Against this stage set, which
could include real Greek philosophers, teachers, scholars, or poets as
part of the "props," were played out carefully contrived rituals of high
culture that ranged from readings of ancient authors to literary and
philosophical discourse, to creative literary endeavors. The need to
inhabit fully this world of Greek *paideia* seems to have been so great
that its devotees even dressed the part, exchanging their toga for the
Greek himation and sandals (e.g., Cic. *Rab. post.* 26).[7] In this way,
while still Romans, they assumed a secondary identity as cultivated
Greeks, much as they might build a large Greek peristyle onto their
Roman atrium-style houses, a phenomenon we encounter from the
second century B.C.

In the Hellenistic world, most intellectual activity had been an in-

tegral part of the public life of the city, conducted in such places as the stoas in the agora, the gymnasia, and the bouleuterion. But the Roman aristocrat at first could experience the life of the intellectual only in an exclusive and private world of leisure removed from public space. It is particularly revealing, as well as appropriate, that all the forms of Greek culture being adopted in Rome were regularly lumped together under the heading *luxuria,* not only in sumptuary legislation, but in contemporary social criticism. The notion that arose out of this, of culture as an appealing but not strictly necessary embellishment of real life, is one that clearly to this day shapes the popular understanding of high culture.

At the beginning of the *Brutus,* Cicero invites his friends Atticus, then living privately in Athens, and Brutus, the future assassin of Julius Caesar, to gather at his villa and, seated on the lawn around a statue of Plato, to engage in learned conversation (*Brut.* 24). The three probably wore the Greek himation on such occasions. The scenario presents us with two images of the intellectual at once: the statue of Plato in the garden and the staged gathering of Cicero and his friends around it. Two centuries later the Platonic philosopher Nigrinus would receive his friend Lucian "with a book in his hand and surrounded by many busts of ancient philosophers standing in a circle" (Lucian *Nigr.* 2).

The portrait of Plato takes on particular significance in Cicero's villa, for we know that Cicero revered Plato above all others as *the* intellectual authority.[8] In Atticus' villa this position was occupied by Aristotle. Beside his portrait stood a bench that Cicero remembered fondly as the spot where the two men had philosophized together (*Att.* 4.10.1). For Brutus, whose passion was public speaking, it was Demosthenes, and he even set up a portrait "among his ancestors" (*inter imagines:* Cic. *Orat.* 110).

"One must acknowledge one's spiritual ancestors and honor them as gods. Why should I not possess the images of great men to inspire my mind and celebrate their birthdays? I worship them and model myself after these great names," remarked Seneca (*Ep.* 64.9–10). Brutus and Seneca are not isolated instances. "Spiritual ancestors" often

played the role of personal protectors and patrons. A number of bronze statuettes survive from the Early Empire, such as that of the reader (fig. 71), which stood in a domestic shrine of the Lares, as did Brutus' portrait of Demosthenes.9 Lucian mentions a physician who particularly treasured a small bronze bust of Hippocrates (*Philops.* 21), and the fine bust of Hippocrates discussed earlier (fig. 83) was found in the grave of another physician in Ostia.10 The many rings that were worn and used as seals, bearing portraits of Greek poets and philosophers, may also perhaps be seen as less demonstrative means of acknowledging a particular intellectual "patron saint" (Cic. *Fin.* 5.3; Pliny *HN* 35.2).11

Richard Neudecker has drawn a fundamental distinction between portraits of intellectuals that were objects of reverence or even cult worship and those that were purely decorative elements in the furnishing of a villa. In practice, however, there was probably considerable overlap between the two functions, since intellectual pursuits were not as a rule restricted to special rooms within the house. One might study and converse in a small room for relaxation (*cubiculum*) or at meals, just as well as in the portico or garden. Thus portraits of famous Greeks could be found in all these places, in the widest variety of materials and sizes, from over-life-size statues to herms to little statuettes and busts in marble, bronze, silver, or plaster. There were also images painted on wood (often attested in libraries), in wall paintings, and in floor mosaics, as well as on drinking vessels and expensive furniture.

But the primary purpose of the portrait galleries of celebrated Greeks in Roman houses and villas was undoubtedly to conjure up an impression of learning. In the overly competitive climate of the Late Republic and Early Imperial period, cultural pretensions quickly became a vehicle for winning distinction. Soon Juvenal would complain that you could not go to the home of the most uneducated man without seeing plaster casts of the great philosophers and wise men (2.1–7). Trimalchio boasts of never having heard a single philosopher, even though he owned two libraries, one Greek and one Latin (Petron. *Sat.* 48.4), and Seneca complains that the uneducated nouveaux riches misuse the most precious books as bits of decoration (*Dial.* 9.9.4).12

Particularly effective were the "galleries" of numerous herms,

FIG. 108 View of the Stanza dei Filosofi. Rome,
Capitoline Museum.

which usually stood in a portico or the park, lining the paths or beside
fountains. It is easy to picture the heads of great men lined up in long
rows when we recall the eighteenth- and nineteenth-century galleries
of busts in the Vatican or Capitoline Museum (fig. 108). As a rule,
however, these rows of busts in the villa gardens did not embody any
artfully conceived program, as we might be led to expect from modern
experience. Rather, the same types are repeated countless times, in
constantly changing but mostly random combinations. Representa-
tives of the different philosophical schools could stand alongside one
another as cordially as statesmen who had been mortal enemies in life.

Most villa owners will not have given a great deal of serious thought
to the choice of decorative sculpture they bought (or had bought for
them), or have paid much attention to it later on. Cicero's worrying
about just the right selection for the gymnasium in his Tusculan villa
is rather the exception.[13] The point was to evoke the leading lights of
Hellenic history and culture in all their rich variety, though, interest-

ingly, the intellectuals account for at least three quarters of all the portraits found in Roman villas and thus must have largely determined their character. The man who purchased these statues and busts wanted in the first instance to show that he belonged to the educated class and therefore to the upper ranks of society.[14]

Yet there is more to this practice than just the element of display. The imagery of the Roman house is permeated by a fundamental need to recall to mind and conjure up earlier Greek culture. Indeed, the Roman villa of the Late Republic may be considered the origin of the cult of learning that would come to characterize the Principate. Like the many mythological scenes on walls, ceilings, and floors, the portraits of famous Greeks were meant to evoke in encyclopedic fashion all of classical Greek learning.

For the same reason, catch phrases or brief quotations attributed to the subject were sometimes carved on the shafts of herm portraits. The intellectual level of these texts is as a rule rather modest. So, for example, the herm of Bias carried a saying that may be authentic but is still not particularly edifying: "All men are evil." Other patrons, however, were more ambitious. Thus one portrait of Socrates has beneath it a quote from Plato's *Crito,* and a particularly zealous proprietor might have a brief biography of each subject added to the stone, or even a catalogue of a poet's works. Neudecker has been able to demonstrate that second-century A.C. galleries of herms were sometimes arranged in alphabetical order, marble encyclopedias of classical learning that the viewer could commit to memory as he strolled back and forth.[15]

All this is, of course, reminiscent of the decoration by the cultivated bourgeoisie of houses and other dwellings in the nineteenth century with countless heads of Laokoon, contorted with pain, and stately heads of Zeus on heavy oak furniture. But then, the presence of such cultural icons in the Roman house signified not only self-conscious pride in a hard-earned humanistic education and social standing, but also a kind of voluntary obligation on the part of the owner of such treasures, a reminder, amid the fashionable trends, of a commitment to a certain system of values.[16]

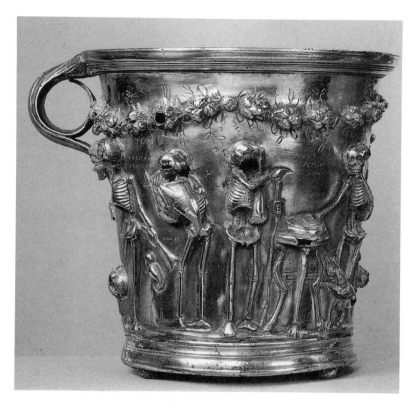

FIG. 109 Silver cup from a villa at Boscoreale. First
century B.C. H: 10.4 cm. Paris, Louvre.

Amid the ubiquitous presence of so many serious portrait heads of
long-dead Greeks, surely some comic relief was needed. Two silver
cups were found in the treasury of the villa at Boscoreale depicting a
whole series of well-known Greek poets and philosophers—only as
skeletons (fig. 109).[17] No amount of wisdom can ward off death. Yet
the skeletons of the great still continue their debate on the Boscoreale
cups. Epicurus reaches greedily for a large cake that the proverbial pig
beside him has also been sniffing. *To telos hēdonē* ("Pleasure is the high-
est goal") is inscribed above the cake. On the other side, the skeleton
of Zeno, with hand upraised, argues passionately against this view.
Other sayings written in Greek, as well as the pictures on the second

cup, all come down to the same basic message: Enjoy life while you can. Yet the image of the ancient poets and philosophers as skeletons also reminded the contemporary viewer of how Greek philosophers had long been made fun of because of their apparent preoccupation with death. If this seems banal, the iconography nevertheless implies a certain level of education and suggests that making fun of philosophers was a standard part of the cultivated banter at the symposium. The skeletons on the Boscoreale cups are not the only images of this type. The gluttony of ancient wise men was also a popular subject (cf. fig. 70). In the Terme dei Sapienti in Ostia, the Seven Wise Men are shown magisterially giving instruction, including advice on digestion and bowel movement.[18]

In order to evaluate the role and significance of Greek intellectual portraiture within the context of the whole pictorial vocabulary of Roman Imperial art, we must bear in mind this ubiquity in every conceivable size and medium. Hardly a single Roman who lived in one of the larger cities could have failed to have these portraits firmly fixed in his mind. And this situation obtained equally in the Greek East of the Empire and in the Latin West, for the classicizing aspect of Roman civilization became one of the important cornerstones of the uniform culture that permeated the whole Empire.

Humble Poets and Rich Dilettantes

Against this background, two statues in the Vatican, which we considered earlier in discussing Hellenistic portrait statues of poets, take on an added significance as evidence of the Roman preoccupation with *otium* (fig. 110). As we have noted, sometime after the middle of the first century B.C. the heads of the Greek poets were reworked into portraits of contemporary Roman aristocrats.[19] That the patrons were indeed members of the senatorial aristocracy is revealed by their shoes. The indication of the *calceii senatorii* is indisputable proof of their social rank. Thus cultural pretensions and pride in one's social status go hand in hand. The provenance suggests they originally stood in the garden of a city residence on the Viminal Hill, that is, that they served to dis-

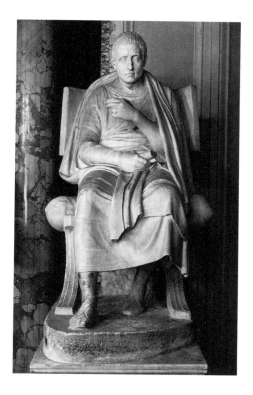

FIG. 110 Statue of the Hellenistic comic poet
Poseidippus. The portrait head was reworked
into that of a Roman senator after ca. 50 B.C.
Cf. fig. 75. Rome, Vatican Museums.

play the patrons' cultivated image within the private sphere. The claims
they make were directed at invited guests of comparable status. This
case is typical of the whole phenomenon. Portraits of famous Greeks
were so pervasive in their influence that by the first century B.C. the
Romans could express their own intellectual aspirations only by allu-
sion, assimilation, or by actual appropriation, as in this instance. Such
statues blatantly transform the would-be intellectual's habit of affect-
ing Greek dress, about which we have already heard, into a permanent
image.[20]

It is no accident that these two Romans had themselves depicted

not as philosophers, but as poets. In the Roman imagination, the cultivation of Greek literature was desirable, but only as a means for perfecting one's skills in public speaking or one's style in the writing of history. The pursuit of philosophy, especially when taken too seriously or for its own sake, remained suspect well into the High Empire—even though more than a few Roman aristocrats did indeed practice serious philosophy from the first century B.C. on. The writing of poetry, on the other hand, early on enjoyed recognition in society. Ennius was already frequenting the houses of the aristocracy, and Augustus would later accord public honors to his favorite patriotic poets. Yet the professional poets at Rome, even the greatest among them, were not autonomous and remained dependent on a *patronus*.[21]

This is all the more remarkable when we consider that literary dilettantism was virtually epidemic in Rome by the time of Augustus and involved the entire aristocracy, including the imperial family. (Nero's artistic career and public appearances performing his own compositions may be counted here as well.) In his *Darstellungen aus der Sittengeschichte Roms* of 1922, Ludwig Friedländer already recognized the cultural significance of this dilettantism and the cottage industries associated with it. He also pointed out the connection between the old aristocracy's loss of political influence and its new preoccupation with amateur versifying. This is not the place for a detailed account of the various forms taken by such literary games. Suffice it to say that the combination of a plethora of public and private poetry readings, performances of song and dance, poetry festivals and competitions instituted by Nero and Domitian, with the expansion of both public libraries and the book trade gradually created something of a "literary public." The dimensions and spread of this self-propelling literary juggernaut seem to have been tremendous. The volume of invitations that were not to be declined must have quickly become too great, even for someone like Pliny the Younger, who himself wrote and recited poetry.[22]

Along with the culture of *otium,* this passion for literature, beginning in the time of Augustus, represented another important step toward the "cult of learning." In both instances, one was transported through literary and other pastimes into a world of high culture far

FIG. 111 Portrait of a woman composing verse. Fresco from Pompeii, ca. A.D. 50. Naples, Museo Nazionale.

removed from the reality of life. The poetry itself was predominantly on apolitical themes, cloaked in a veil of allegory and mythological allusion. The intellectual culture of *otium* spread out from the villas and to some extent took over public life as well. Not only recitations of poetry, but also theatrical performances and pantomime, seduced the audience into a world of myth. Juvenal ironically condemns the resulting loss of any sense of reality: "No one knows his own house as well as I know the grove of Mars, the cave of Vulcan, and the Aeolian rock" (1.7ff.).

These literary pastimes were not limited to the city of Rome, as one might suppose from the written record alone. I would argue that they are also reflected in the many small-scale wall paintings in the houses of Pompeii showing writing utensils along with readers and writers, images that have never been satisfactorily explained. On a well-known portrait tondo (fig. 111), a young woman with Claudian coiffure looks out at the viewer while pressing a stylus to her lip in a gesture of distracted contemplation. The little tablets in her hand also allude to her

interest in writing. This distinguished woman, adorned with earrings and a golden hair net, is surely not a writer by profession, nor would she need to demonstrate that she is able to write. Probably she is the mistress of the house, or one of the daughters, shown composing poetry. Another equally famous tondo depicts a young married couple. Once again the woman holds writing utensils, but her husband is also characterized as an educated man by the prominently displayed book roll. Similar portrait tondi have been found in several other Pompeian houses. Some of these show a youth with book roll and a laurel wreath in his hair, a reference perhaps to actual or anticipated victories in poetic competitions. The tondo form suggests that the bourgeoisie adopted this newly fashionable manner of having themselves portrayed from the public libraries, which we know displayed portraits of poets. It is also striking that those shown as poets are almost invariably women or youths. In the private world of *otium,* women were equally admired for their literary pursuits. It is unlikely that the citizens of the once Oscan city of Pompeii were any more passionate about learning than those of other Italian cities. Rather, these small pictures attest to an astonishingly pervasive enthusiasm for the reading and writing of poetry throughout the Italic world.[23]

The flowering of this extraordinary preoccupation with learning must have enhanced the self-esteem of the professional poet, even if his material circumstances, as the example of Martial indicates, had in fact worsened between the time of Augustus and the end of the first century. He remained dependent on the favor of a patron, compelled to celebrate his patron's villa or wife or taste in the fine arts.

A seated statue from Rome, now in the Albright Art Gallery in Buffalo, somewhat under life-size, presents a poet in a mood of remarkable, if rather strained, self-assurance (fig. 112). We recognize him as a poet by the book roll and Greek manner and clothing, a mantle that leaves the entire torso exposed. The models for this figure are not the earlier Greek statues of poets, in their citizen dress and relaxed pose, like Menander and Poseidippus, but rather the exaggerated heroic imagery of Late Hellenistic art that we saw exemplified in reliefs of Menander (fig. 74). The pose is here even more exalted. The poet sits straight as an arrow, with his legs apart, not unlike the type of Jupiter that inspired images of the enthroned emperor. The sculptor of a sec-

FIG. 112 Funerary statue of an Augus-
tan poet, from Rome. Buffalo,
Albright Art Gallery.

ond statue of a poet in similar pose, Trajanic in date and now in the
Terme, added the realistic features of advancing age to the bare torso,
thus creating a link to the iconography of the philosopher. Both sta-
tues probably stood in grave precincts and represent professional poets.
A member of the aristocracy could hardly have had himself so de-
picted, with none of the attributes of his social status. Furthermore,
the statue in Buffalo was hollowed out inside, probably to contain the
ashes of the deceased. It will most likely have stood in the funerary
precinct of the patron, who may also have paid for this statue of his in-
house poet.[24]

Whereas in these statues the use of allusion to Greek tradition to
proclaim a particular virtue is somewhat heavy-handed, the parents of
an aspiring and gifted poet who died in his youth, named Sulpicius

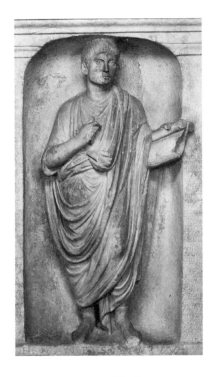

FIG. 113 Portrait of the boy poet
Q. Sulpicius Maximus. Detail from his
funerary monument, ca. A.D. 94.
Rome, Palazzo dei Conservatori.

Maximus, had their son depicted as the proper Roman citizen, in a toga (fig. 113). He had competed against fifty-two Greek-speaking rivals in a poetry contest sponsored by the emperor Domitian. The proud and devastated parents spared no expense, including having the entire Greek poem that he recited inscribed on the gravestone. Interestingly, the poem portrays Zeus denouncing Helios for entrusting the chariot of the sun to the young Phaethon. It was too much for the poor boy, like Sulpicius Maximus himself, who died of exhaustion "because day and night he thought of nothing but the Muses."[25]

It seems as if the contemporary poet in the early Empire had a choice between only two radically different images with which he could identify: a seated statue in the Greek manner (but with the stan-

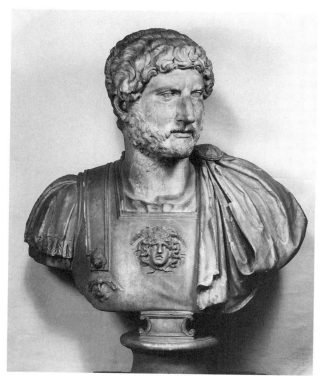

FIG. 114 Cuirassed bust of the emperor Hadrian.
After A.D. 117. Rome, Palazzo dei Conservatori.

dard *Zeitgesicht* derived from the current fashion of the imperial house)
or the basic type of the Roman citizen.

Hadrian's Beard: Fashion and *Mentalité*

After the ultimate failure of Trajan's wars of conquest, the emperor
Hadrian made cultural interests the focal point of his reign, and the
Romans' new orientation in relation to Greek culture now found ex-
pression in the art of portraiture. At his accession to power in A.D. 117,
the new emperor's official portraits presented him with artfully curled
hair and a beard (fig. 114). The contrast with his straight-haired and

clean-shaven predecessor could hardly have been more striking.[26] The widespread amazement occasioned by the emperor's new fashion can be detected in the *Historia Augusta,* whose author claims that Hadrian wore a beard to cover facial warts (*Hist. Aug.,* Spart. Hadr. 26). I would not rule out that such an imperfection did in fact impel Hadrian to let his beard grow. But this is hardly an explanation for the whole phenomenon, and especially its ramifications.

The Romans had been basically clean-shaven for centuries, although there had, of course, always been men who grew beards, especially soldiers. This is evident, for example, on the Column of Trajan. Yet in official portraiture, beards were generally avoided. This is probably in large part a reaction to the beards of the Greeks of old. To wear a beard was considered simply "un-Roman," even though Varro was aware that the ancient Romans had worn beards and that the first barbers came to Rome from Sicily about 300 B.C. (*Rust.* 2.11.10).

Hadrian's was not the long beard of the philosopher, to be sure, but it was full and carefully styled. He probably did not see himself as making a programmatic statement with his beard and hairstyle, and most likely he had worn the beard before becoming emperor. Wavy hair and a trimmed beard had emerged as a fashion under Domitian and later, under Trajan, became widespread, especially among younger men, as an alternative to the austere look of the emperor.

But by retaining the fashion as emperor, Hadrian consciously or unconsciously turned it into a "message." Inevitably it was adopted as the norm throughout the Empire by men both young and old. Since, however, the same emperor elevated philhellenism to the level of a political program, the beard's connotation of being Hellenized, or what I would call the "cultivated beard," was unavoidable. Unlike Trajan, Hadrian conspicuously surrounded himself with Greek intellectuals, dabbled in various learned pursuits, spoke a pure Attic dialect, and enjoyed appearing at both public and private occasions dressed in the Greek manner. Cyrene was surely not the only city that paid homage to him in this style (fig. 115). Furthermore, his philhellenism and dedication to the cause of high culture were regularly celebrated.[27]

I believe there are two principal phenomena that argue in favor of this often asserted, but occasionally questioned thesis, that the new

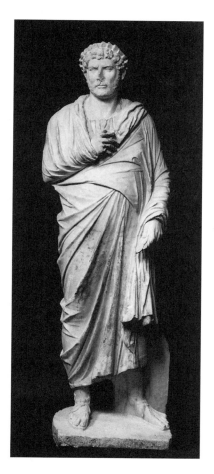

FIG. 115 Statue of the emperor Ha-
drian in Greek-style citizen's dress (cf.
fig. 26), from the Temple of Apollo in
Cyrene. London, British Museum.

fashion for beards did indeed connote learning and Greek culture once
the emperor had set it in motion. First, in this same period, at first in
Athens and soon in other cities of the Greek East, members of the
ruling aristocracy began not only to grow beards, but also in many
other ways—hairstyle, dress, manners—consciously to model them-

selves after the statues and portraits of well-known Greeks of the past. And second, as we shall presently observe, beards became steadily longer, until by the Late Antonine period they had reached the length of any self-respecting philosopher's beard.

The best examples of the self-styled classicism of the Greeks themselves are the portraits of *kosmētai* in Athens, which happen to survive in large numbers.[28] These were annually chosen magistrates who were responsible for the city gymnasia. They came from prominent Athenian families and usually held other civic offices later in life. They are therefore by no means professional intellectuals. Yet this new fashion among the Athenian aristocracy is only one of many manifestations of a movement toward an all-embracing cultural renewal, whose impetus was in turn an economic revival in the Greek cities and the growing influence of the Greek élite in the running of the Empire.[29] The ostentatious acknowledgment of their own cultural traditions, combined with what was at first a departure from the Empire-wide fashion emanating from Rome, suggests that a new kind of self-consciousness was suddenly coming to the fore. In this way the Greeks asserted that the era of their cultural greatness was not past but lived on. This reversion to being "true Greeks" could also sometimes carry an anti-Roman connotation, as Dio of Prusa attests when he describes with admiration the Greeks of Borysthenes, or Olbia on the Black Sea, who have faithfully maintained the customs of their ancestors: "They all wore long hair and flowing beards, according to the ancient custom, as Homer describes the Greeks. Only a single man was shaven, and he was despised and scorned by the rest. They said he did this not for his own enjoyment, but to flatter the Romans and to proclaim his sympathy for them" (36.17). In actual fact the beards of these Borysthenians were probably those of Scythian barbarians, but that is of no consequence. What is important is the nostalgic search for ancient Greece that colors Dio's view. Among the *kosmētai,* who proudly identify with their famous ancestors, some have long beards, some shorter; some bear a general resemblance to the Greeks of old, while others seem to follow a specific model. Thus one contemporary of Hadrian looks like a latter-day Plato (fig. 116; cf. fig. 38), though he has severely trimmed his hair in comparison with Plato's (we shall see presently why he did this).

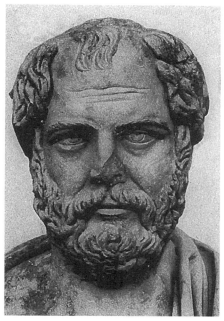

FIG. 116 Athenian *kosmētēs* assimilated to the likeness of Plato. Ca. A.D. 140. Athens, National Museum.

FIG. 117 Athenian *kosmētēs*. Second half of the second century A.D. Athens, National Museum.

Socrates, Aeschylus, Theophrastus (fig. 117), and Demosthenes were all pressed into service as models. By the Antonine period, Antisthenes enjoyed a special popularity in Athens, which, as we shall see, also entailed the rigorous pursuit of a philosophical way of life. The same trend is evident in the nicknames and tags that became popular once again. Thus, for example, Arrian was celebrated as "the new Xenophon."[30]

Hadrian's new Hellenizing image is comparable to these Athenian "memorializing" portraits. His beard could be likened to those of such Late Classical portraits as Aeschines (fig. 26). When we consider that only six years before becoming emperor, Hadrian had held the office of archon in Athens, it is tempting to associate his beard with the classicizing fashion that was just taking hold there.[31] Perhaps the young

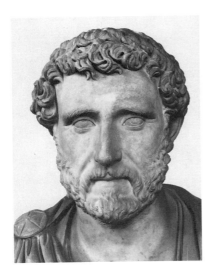

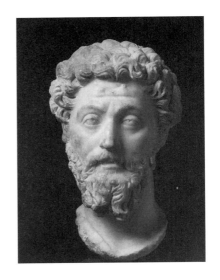

FIG. 118 Antoninus Pius (emperor
138–161). Rome, Capitoline
Museum.

FIG. 119 Marcus Aurelius. After
A.D. 176. Frankfurt, Liebieghaus
Museum.

aristocrat had occasion during his stay in Athens to redefine what had
been a beard connoting Roman *luxuria* into an Atticizing "cultivated
beard."

Be that as it may, for our inquiry the most important question is,
how did the public throughout the Empire react to Hadrian's new
beard? First of all, we must make a distinction between the general
spread of the new hair and beard style, on the one hand, and the as-
similation to specific, earlier Greek portraits, as by the *kosmētai,* on the
other. The fact that the emperor's beard was immediately imitated
through the whole Empire, including the West, need not surprise us.
The emperor and his family had long been the ultimate arbiters of
popular style, their portraits the decisive inspiration for changes in
fashion.[32] More important, however, in this case is the fact, as we have
already noted, that in the course of the next two generations, beards
became steadily longer, until by the late second century they reached
the length of the extremely full philosopher's beard. The portrait of
Hadrian (fig. 114) and the three later heads juxtaposed here (figs. 118–

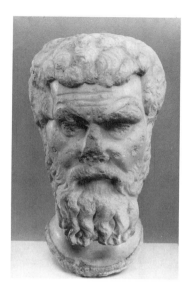

FIG. 120 Portrait of the emperor
Pertinax (A.D. 193). Leiden,
Rijksmuseum.

20) will illustrate this process. Trends in fashion are always in some
way a reflection of collective values, and there is good evidence that
the lengthening beard over a period of more than two generations is
tied directly to a widespread cult of learning in the Antonine age.

When an entire society, or at least those groups that shape its char-
acter, devote all their spiritual and intellectual energies to recreating a
classical culture, when this is the standard for all approved entertain-
ment, and the participants, dressed as Greeks, play "Classical Greece"
on the public stage (we shall hear more about this later), then we can
hardly escape the conclusion that these steadily lengthening beards
must carry a reference to classical learning. This is not to say that each
individual made such a personal commitment, as in the case of the
kosmētai. Rather, this is a fashion that becomes an integral part of the
social discourse. The individual who wears a beard need not even be
aware of his role in all this.

The portraits of the *kosmētai* and that of Hadrian belong to the early

stages of this process of the ever-growing beard. In its latest phase, starting roughly with the later portraits of Marcus Aurelius (ca. 175; fig. 119), we find a whole series of distinguished bearded men, including the emperor Pertinax (fig. 120), with deeply furrowed brow and raised eyebrows.[33] In this context such traits can hardly mean anything other than introspection and an intellectual bent. Another element of the fashionable "intellectual look" is the receding hairline or bald head, suddenly popular in the later second and early third centuries. Prior to this, baldness had been very rarely shown, though it can hardly have been any less common in real life. If in the Late Antonine period it first was thought worthy of representation, then it was probably because the evocation of Classical portraits of intellectuals conferred on these individuals a mark of spiritual distinction. Support for this interpretation can best be found in the *Praise of Baldness* (*Phalakras enkōmion*) of Synesius of Cyrene (370–413), who refers specifically to the portraits of such "ancient wise men" as Socrates and Diogenes in order to prove that the wisest men had been bald. Socrates, he claims, had identified with the silen's mask "to mark his skull as the seat of wisdom" (*nou docheion*).[34]

Often baldness and the thinker's brow are combined in the same head and mutually reinforce one another (figs. 121, 122). One former athlete even had himself depicted in this manner, in a portrait whose intellectual forehead, with brows drawn up and tensed furrows, is especially pronounced (fig. 122c).[35] A well-known portrait type of Severan date with a highly spiritual effect, once identified as Plotinus by H. P. L'Orange, may also be mentioned in this context (fig. 122f).[36]

The plethora of examples over a relatively short span of time suggests that we are dealing here with the phenomenon of the *Zeitgesicht,* analogous to the assimilation of civilian portraits in fashion and physiognomy to the reigning emperor. But in this case it is not Imperial portraiture that set the trend, but the reverse. There are individual

FIG. 121 a–f Portraits of the Late Antonine and Severan periods in the guise of intellectuals. Sources: see p. 178 n. 35.

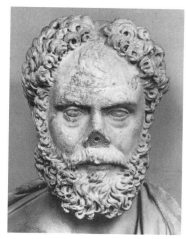

A

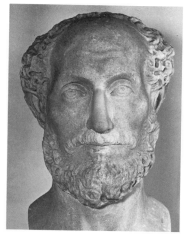

B

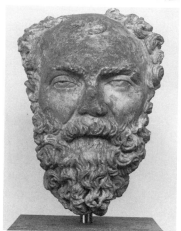

C

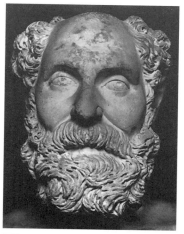

D

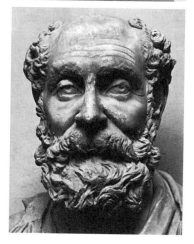

E

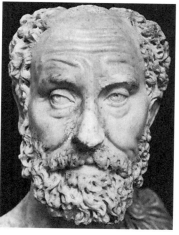

F

replicas of the official portraiture of Marcus Aurelius and Pertinax that are assimilated to this popular *Zeitgesicht* of the intellectual.

Even more clearly than the general phenomenon of the ever-lengthening beard, this *Zeitgesicht* reflects a widespread consensus, at least among that class that commissioned marble portraits, on the central importance of all aspects of education and learning. Of course in some instances wrinkles or baldness could simply be a realistic rendering of an individual's appearance, and some scholars have rightly detected a stylistic tendency toward realism in Late Antonine art. This is not, however, at odds with what I like to call the "intellectual *Zeitgesicht*," since what matters most is always *which* elements are realistically rendered.

There can be no doubt, however, about the meaning of what I would call the "learned busts": portrait busts wearing only the Greek himation and often leaving most of the chest bare. (These become popular in the same period when the beard is becoming longer). They are quite different from the completely nude busts of athletes and must rather be understood as a kind of abbreviated form of the Classical Greek draped statue, or perhaps of the ascetic Hellenistic philosopher type. It is difficult to decide from the busts alone whether a particular example is meant to celebrate the subject more generally for his classical learning or for specific philosophical pursuits. This is a question to which we shall return. These "learned busts" were equally popular in both East and West.37 Their numbers and geographical distribution alone prove that a Greek education had become a crucial element in the self-definition and public image of the kind of men who could afford such a bust, in all parts of the Empire. To be sure, the Roman citizen bust or statue type in toga, the bust wearing cuirass or *paludamentum,* both embodying the ideal of *virtus,* have not been entirely replaced by the "learned bust," but at least we can say that this new symbol now takes its place among the others as a perfectly respectable alternative.

FIG. 122 a–f Portraits of the Late Antonine and Severan periods in the guise of intellectuals. Sources: see p. 178 n. 35.

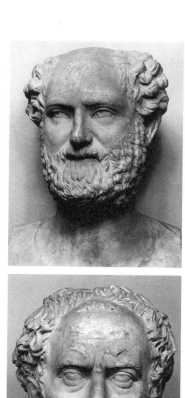

A

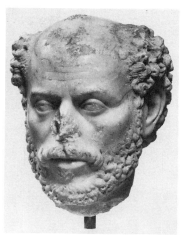

B

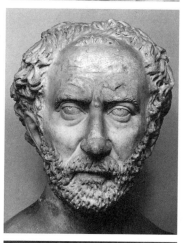

C

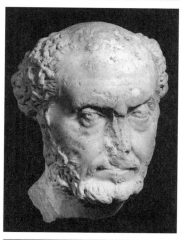

D

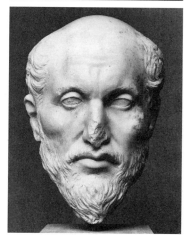

E

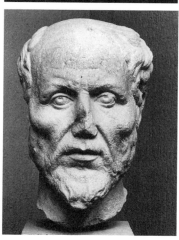

F

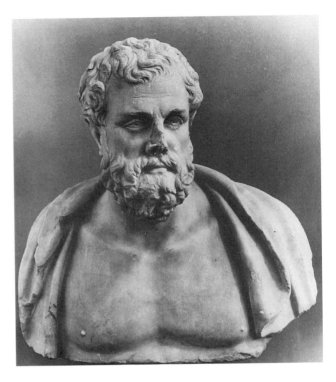

FIG. 123 Bust of a Roman citizen in the guise of a
philosopher. Antonine period. Thessaloniki,
Archaeological Museum.

In those instances where a portrait head showing the features of the
Classical intellectual is combined with a bust draped in the Greek hi-
mation, as is the case, for example, with two splendid Greek busts in
Thessaloniki (fig. 123) and Budapest, as well as a whole series of others
from Rome and the Western and Eastern provinces, most archaeolo-
gists have not hesitated to identify the subjects as professional philoso-
phers or rhetoricians.[38] But the considerable number of these busts
alone makes this unlikely. Rather, as with the *kosmētai,* we are prob-
ably dealing here with members of the urban élite who wished to ad-
vertise their classical education but, unlike the *kosmētai,* not necessar-
ily with reference to a specific model.

In certain cases, especially among examples from Greece itself, the physiognomy is assimilated so closely to that of a famous Greek figure of the past that the subject's individuality is all but lost. This phenomenon should not overly disturb us, for other Romans had for some time adapted their own faces to that of the reigning emperor. Now, however, there is another authority, alongside the imperial family, as a role model after which to pattern oneself and one's image. In the Greek East, the effects of this can also be read in funerary and honorific inscriptions. The epithet *philosophos* is widely used and may even take precedence over the more expected *philokaisar* and *philopatris*.39

Nevertheless, I wish to emphasize that not every full beard signifies a passionate intellectual, nor was there any shortage of competing styles and values expressed in portraiture of the very period when the Antonine beard was at its height, and especially the period that followed. We need only think of the lush curly locks of a Lucius Verus, who was said to have sprinkled gold dust in his hair (*Hist. Aug.*, Capitol. Verus 10.7), or of the crew cuts of the soldier-emperors. But amid this rivalry of symbolic statements, and perhaps because of it, the intellectual image remained for quite some time an influential standard in both East and West.

It was quite possible, for example, to combine the portrait type of the third-century soldier-emperor, projecting toughness and energy, with a bust clad in the philosopher's mantle or even a full statue in the pose of a classical philosopher. Such combinations indeed occur in two of four statues found recently in a wealthy house at Dion, adopting the pose of the seated Epicurus (figs. 124, 125).40 The other two statues had portrait heads with long beards (in one instance only partially preserved) of the Late Antonine/Severan "intellectual" type. It is entirely possible that the group does not represent philosophers and their pupils, but rather a family of the Greek aristocracy who were devotees of philosophy and learning and wanted to show off their cultivated way of life in an ostentatious family portrait gallery. The older generation still wears the "philosopher's beard" fashionable in the Late Antonine period (fig. 125a), while the younger adopts the *Zeitgesicht* based on the portrait types of Caracalla and subsequent emperors (fig. 125b). The fact that all four had themselves shown in the pose of Epicurus

FIG. 124 Statue group from a wealthy residence in
Dion (Macedonia). Severan period. Dion, Museum.

could imply that they wanted to acknowledge themselves as followers
of Epicurean philosophy, but need not. As we shall see, the iconogra-
phy of Hellenistic philosopher portraits was rather eclectically used,
not always adhering strictly to the original connotations. The pose of
the Epicurus statue was probably favored because it gives the appear-
ance of the upstanding citizen with one arm enveloped and the mantle
properly draped. This would appeal especially to would-be intellec-
tuals of the bourgeoisie in the Greek East, where Classical drapery
styles were still being worn.[41] If this proposition is correct, then we
must consider whether other supposed philosopher statues of the same
period, such as the so-called Aelius Aristides in the Vatican Library,
might not also rather represent an intellectual layman. One could
easily imagine a statue like this in the context of a portrait gallery in
which the honorand was depicted in a variety of costumes, each pro-
jecting different virtues (cf. p. 279).[42]

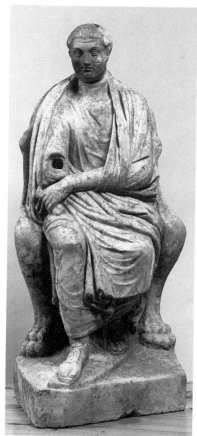

FIG. 125 a–b Two seated statues from the group in
Dion. Dion, Museum.

Superficially, we are dealing here with the same phenomenon as the
two reworked statues of poets in the Vatican of ca. 50 B.C. (cf. fig. 110):
a Greek body type taken over to stand for the idea of intellectual ac-
tivity. But now it is not a phenomenon limited to an aristocratic and
exclusive culture of *otium,* conferring the notion of Greek learning on
an élite stratum in the Late Republic. Rather, learning is now a gen-

erally recognized ideal in Rome itself, one that is publicly acknowl-
edged and leads to the acquisition of high status and even political
office.

 As we would expect, under these conditions professional intellec-
tuals of all types traded in their toga for a Greek himation as the public
insigne of their career. At least this was true in the West; in the East,
such differentiation was not possible, since everyone wore the hi-
mation. In Carthage around the year A.D. 210, if we may believe the
testimony of Tertullian, "simple elementary schoolteachers, teachers
of figures, grammar, rhetoric, and dialectics, as well as doctors, poets,
musicians, astrologers, augurs, in short, everyone who cares about
scholarly pursuits, wears the Greek mantle" (*De pallio* 6). It was prob-
ably the new position of authority now accorded the leading orators
and philosophers more than anything else that in the Late Antonine
age induced ordinary teachers and doctors to identify with their im-
age. A fine example from Rome itself is the under-life-size statue of
the *grammaticus graecus* M. Mettius Epaphroditus, a freedman in Rome
whose former slave Germanus set up the statue, most likely as a funer-
ary monument. Epaphroditus sits on a raised teacher's chair, though
he is not actually shown giving instruction, like the elementary
schoolteacher on the famous relief in Trier. He holds in his left hand a
book roll, in which he has been reading (or perhaps reading aloud),
and now contemplates what he has just read, turning his head to the
side and looking up (fig. 126).43 The fact that Germanus had his *pa-
tronus* shown in this meditative pose suggests that he wanted to com-
memorate him not simply as a teacher, but as a man who cultivated a
philosophical way of life.
 Tertullian's inclusion of doctors in this group can also be corrobo-
rated by the archaeological evidence. A well-known strigilated sar-
cophagus of the late third or early fourth century, now in New York,
shows a physician from Ostia. He, too, is a reader, sitting at home next
to a cabinet in which we can make out more book rolls and a dish
(perhaps for opening veins), and, above, a set of surgical instruments,
propped up so that we can see them better. In other words, the wisdom
and learning of the ancients are more important to this individual than

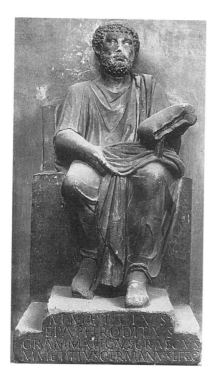

FIG. 126 Funerary statue of the *gram-maticus Graecus* M. Mettius Epaphroditus. Severan period. Rome, Palazzo Altieri.

the tools of his trade.44 Under the Early Empire, in contrast, physicians and teachers had modeled themselves on the general image of the Roman citizen, clad in the toga and wearing a hairstyle derived from that of Imperial portraiture.45

Apuleius and the Case of the Uncombed Hair

When the writer Apuleius, who came from Madaura in North Africa, married a wealthy widow about A.D. 160, her family, fearing the loss of their inheritance, ensnared him in a lawsuit on charges of magic that

could have had serious consequences.[46] He was also accused, among other things, of passing himself off as a philosopher under false pretences. As evidence they cited his handsome and carefully tended appearance, describing him, ironically, as *philosophus formosus*. Instead of philosophy, they claimed, he was really practicing the magical arts, that is, he had bewitched the widow. Thus if a man wanted to be acknowledged publicly as a philosopher, at least according to Apuleius' accusers and the people of Sabratha, where the trial took place, the one thing he could not appear was handsome. Apuleius at first responded with a learned defense, in which he cited examples of handsome Greek philosophers, including Pythagoras, but then continued:

> And yet this sort of defense does not suit a man of my humble appearance. The constant strain of study has drained all the charms of my body, bent my posture, dried out my vital juices, turned my face pale, and crippled my powers. And as for my hair, which these brazen liars claim to be worthy of a seducer: just look at it, and see how elegant and seductive it is! Twisted and tangled, stiff like straw, stringy, clotted in little lumps, it has been untended for so long that it could never be disentangled, let alone combed or parted.
>
> *(Apol.* 4.1)

Undoubtedly this is how Apuleius appeared in court, otherwise his eloquent defense would have seemed ludicrous. The learned proconsul Claudius Maximus was won over and declared him not guilty. Yet his accusers were probably not the "shameless liars" he claimed them to be. For as a celebrated rhetorician, priest in the imperial cult, and suitor for the hand of the widow, he cannot have appeared in public with unwashed hair all the time. The citizens of Carthage celebrated him, in the inscription beneath his honorific statue, as *philosophus platonicus*,[47] and such a comparison had always conjured up a well-tended appearance (cf. p. 240). We can conclude only that Apuleius deliberately played a variety of roles, depending on the exigencies of a particular situation. And this is probably true of other famous intellectuals of the second century as well, who moved, as J. Hahn put it, "in that shadowy zone between philosophy and the Sophists."

The case of Apuleius shows that there was a certain pressure on the professional intellectual who was also a public figure to define his own image, that is, to declare himself as either rhetorician/Sophist or philosopher. When a well-known figure officially made the transition from one profession to the other, this might even be staged as a kind of public ritual. For example, when one Aristokles, a Pergamene aristocrat, gave up his affiliation with the Peripatos and became a rhetorician and pupil of Herodes Atticus, he also renounced his earlier disregard for his own appearance, with uncombed hair and filthy clothes (these had evidently become generally recognized symbols of the philosophical way of life, irrespective of which school one belonged to), and took on not only a soigné image but also the appropriate friends. From now on he would cultivate a life of luxury and pleasure, replete with music, theatre, and banquets (Philostr. *VS* 2.3.567). And when Peregrinus Proteus did the reverse, taking the "vows" of a strict philosophical life and, like a medieval saint, giving away his inheritance to the city of Parion, this was done in the form of a public spectacle, at which the people cheered his conversion, shouting: "Yea, thou art truly a philosopher, truly a patriot, a true follower of Diogenes and Krates" (Lucian *Peregr.* 15).[48]

These efforts at self-definition, and others like them, were "classical revivals," as it were, replaying the old debate between Isocrates and Plato on what should take precedence in the education of the young. But the insistence upon a fundamental distinction between the two ways of life cannot have been mirrored in the actual practices of daily life, which was marked rather by continual compromise. Indicative of this is the way that Philostratus speaks of "the philosophical oratory" of the ancient Sophists (*VS* 1.480).

It is against this background, I believe, that a whole series of unusual portraits becomes intelligible. A well-known bust in Vienna has long been taken to be that of a barbarian, on account of the unkempt, almost ravaged appearance (fig. 127).[49] In fact, the head could be an illustration of Apuleius' masquerade in court. The long, coarse, and irregularly trimmed hair is presented as a hopelessly tangled mass of thickly matted strands against which no comb would stand a chance. The short beard grows irregularly and is as wild and unkempt as the

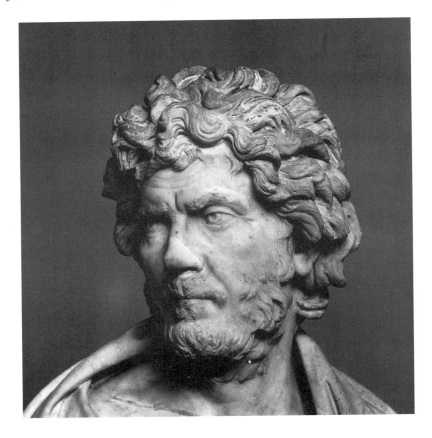

FIG. 127 Bust of a man in the guise of a
serious philosopher. Ca. A.D. 160. Vienna,
Kunsthistorisches Museum.

hair. In addition, ugly traits like the scar and a wandering eye are em-
phasized. The lower part of the bust, with its Greek himation, which
is not modern restoration, confirms that this individual is indeed a man
who wishes to proclaim his adherence to a rigorous philosophical way
of life. An earlier, Hadrianic head of an old man is no less unkempt
and likewise lays claim to the life-style of a Cynic philosopher, since
his wild hair is a virtual quotation from portraits like that of Antisthe-
nes (fig. 128).[50]

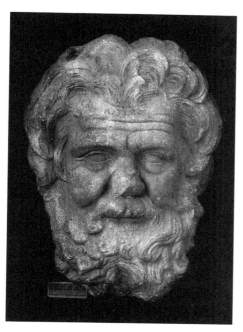

FIG. 128 Portrait of an Athenian characterized
as a "new Antisthenes." Antonine period.
Athens, National Museum.

Both these heads come from Athens, the mecca of the cult of learn-
ing in the Imperial period, as also do the portraits of the *kosmētai,*
which remain the most impressive examples of the revival of the "an-
cient Greek" image. But even in Rome itself there were men who
valued an image of strict philosophical observance. Thus, for example,
a portrait in the Capitoline Museum presents a haggard old man with
ill-tempered expression, his hair matted in little clumps and a long
"Pythagorean" beard that would defy any comb (fig. 129).51

Such extreme instances are, to be sure, not very numerous. Inter-
estingly, the types most commonly met are compromises, uniting var-
ied iconographical elements into an eclectic combination. Evidently
the majority of men who prized the philosophical image also wanted
to appear at the same time cosmopolitan and thus combined features

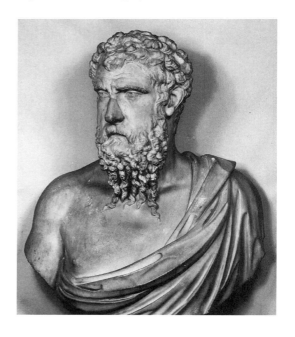

FIG. 129 Bust of a philosopher, or of a Roman citizen leading a strict philosophical life. Rome, Capitoline Museum.

of philosophical seriousness with those of a bourgeois urbanity. In another portrait from Athens, for example—this one found on the Acropolis—the stylization of the hair across the forehead is clearly an allusion to Antisthenes, the original Cynic, while the beard and facial expression, in contrast, look carefully tended, and even the hair relaxes into gentle locks as it moves toward the sides (fig. 130).[52] The figure from the Dion group discussed earlier, with the long beard and the Epicurean body, has a hairstyle that is rather in the tradition of Antisthenes and, strictly speaking, does not suit at all the proper bourgeois pose of the statue of Epicurus (fig. 125a).

Once we have become attuned to this phenomenon, it becomes clear that there exists a whole series of heads with noticeably unkempt hair, for which we must consider the possibility that the subject in-

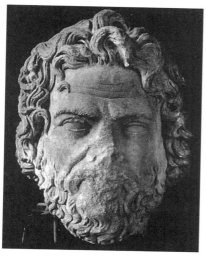

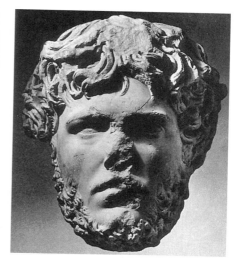

FIG. 130 "New Antisthenes" from the Acropolis. Antonine period. Athens, Acropolis Museum.

FIG. 131 Portrait of an anonymous contemporary of Lucius Verus, ca. A.D. 160. Rome, Terme Museum.

tended in this way to call attention to his ascetic way of life. The most striking examples come once again from Athens, but quite a few have been found in the West as well.[53] The story of Apuleius' day in court confirms that this trait was indeed generally understood as a symbol of asceticism. An even earlier example of this phenomenon may be seen in the splendid Hadrianic shoulder bust from Rome, now in Copenhagen (fig. 132).[54] The carving of the locks of hair is a tour de force, but the mass of thick clumps could be meant to look matted and uncombed, especially since the young man has had himself depicted with no undergarment and with a skeptical, almost glowering look. Likewise, the subject of a well-known head in the Terme Museum in Rome (fig. 131), once erroneously taken to be a portrait of Lucius

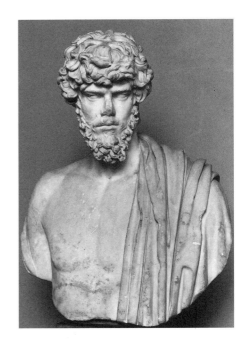

FIG. 132 Bust of a dandy with philosophical
pretensions. Hadrianic period. Copenhagen,
Ny Carlsberg Glyptotek.

Verus, might have used the same means to project a philosophical im-
age.⁵⁵ For the modern viewer it is of course not always easy (particu-
larly with the state of preservation of some heads) to distinguish be-
tween an artfully arranged wig and naturally wild hair.

 Yet the case of Apuleius makes it clear that defining oneself as an
ascetic no longer entailed an identification with a particular philo-
sophical school. Apuleius, after all, who boasted in court of his Cynic's
unkempt hair, was regarded as a Platonist, while Theon of Smyrna, a
contemporary of Hadrian, who is likewise designated as *platonikos
philosophos* on a bust from Smyrna now in the Capitoline Museum
(fig. 133), has a well-tended appearance with the close-cropped hair
that traditionally marked the Stoic (cf. p. 111).⁵⁶ He, too, apparently

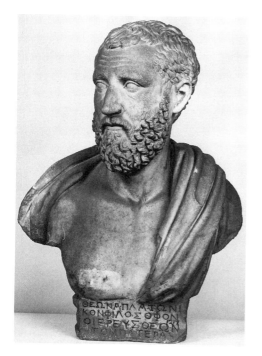

FIG. 133 Bust of the Platonic philosopher Theon.
Hadrianic period. Rome, Capitoline Museum.

wished to be considered a "moderate" ascetic. This would also explain
why the contemporary *kosmētēs* in Athens who is otherwise so remi-
niscent of Plato wears his hair cut very short (fig. 116).

We do not know where most of these busts were originally dis-
played and whether the majority of them represent a professional
philosopher or a "layman." But the large number of busts bearing a
"philosophical" look in itself suggests that most are laymen. The origi-
nal viewer probably could not distinguish either, in the absence of an
inscription or knowledge of the individual. But the visual evidence
tends to confirm the argument that in this period philosophy was less
concerned with the clear definition of specific schools of thought than
with promoting a spiritually oriented attitude and way of life.57 These

portraits, then, stand in sharp contrast to the original portraits of the great philosophers of the third century B.C., which had drawn clear distinctions among the various life-styles and philosophical orientations. The contemporary philosopher Demonax, who was so revered by Lucian (or perhaps invented by him), explicitly admits to a kind of eclecticism in the matter of academic teachings and sees the philosophical way of life as the true essence of all philosophical thought (Lucian *Demon.*). Asceticism, the renunciation of luxury, and continual mental exercise had become the basic components of philosophy in all the different schools. Neglect of one's outward appearance was the visible symbol of this way of life and proclaimed a commitment to a form of self-fulfillment based on strict moral principles. Thus when an otherwise elegant gentleman like the Platonist Theon had his hair cut short, this was probably a none-too-subtle indication that he wanted to be taken more seriously.

Those individuals who had themselves portrayed with unkempt hair and glowering mien may on occasion actually have appeared in public this way, like Apuleius in court. This would in turn imply that projecting such an image did not necessarily do any harm to a man's reputation among his social equals and the community at large. Self-control was now the mark of a man of distinction and justified his social status. A regimen of daily mental exercise was indispensable. The emperor Marcus Aurelius is one among many who aimed to put into practice a philosophical way of life. His *Meditations* were meant to instill self-control and to be a reminder of the philosophical principles that should govern our lives. These exercises were not practiced alone, but as part of an interchange with like-minded individuals under the guidance of an instructor.

They were in turn complemented by the practice of a physical asceticism, as in the regimen of the monastery, though we learn little of this in our sources. But we may presume that Marcus Aurelius was just one of many who slept on the floor as a token of his ascetic nature and to set an example for others (*Hist. Aug.*, M. Ant. 2.6–7). Restraint in both eating and sexual activity reflect a concern for body as well as spirit. The same attention was devoted to both maintaining a certain diet and controlling the digestion.

The Elegant Intellectual

The leading orators of the day were the exact opposite of the philosophers in their public image. They wore extravagant clothing, reeked of precious scent, and expended enormous effort on the care of both hair and body. Alexander of Seleucia, for example, whom some considered the son of Apollonius of Tyana, possessed a beauty that was like a "divine epiphany" (if we may believe Philostratus). The Athenians were intoxicated "by the splendor of his large eyes, the lush locks of his beard, the perfect line of his nose, his white teeth, and long slender fingers," even before he opened his mouth to speak (*VA* 2.5.570–71). And yet their contemporaries also attacked the Sophists, whose luxurious ways they so admired, for their greed. This, too, of course, is a classicizing topos. The public appearances of these superstars who elicited such admiration were by no means limited to speech making. Polemon of Laodicea in Asia Minor (ca. A.D. 88–144), one of the most brilliant "concert speakers" of his day, traveled with "a long train of pack animals, many horses, slaves and dogs of various breeds for different types of hunting. But he himself traveled in a Phrygian or Celtic wagon with silver trappings" (Philostr. *VS* 25.533). His own arrogance was a match for his appearance.

We would expect to find portraits of such men marked by a striking elegance and fashionable touches. Yet unlike the images of ascetic philosophers, those of the elegant Sophists cannot with certainty be identified among the plethora of preserved portraiture of the Antonine and Severan periods. If we take the portrait of Herodes Atticus as our standard (fig. 134), it is not all that different from those of other *kosmētai* derived from Late Classical models.[58] The same is true of the portrait of a rhetorician and benefactor of the city of Ephesus in Severan times whose identity is unfortunately unknown to us. The portrait stood in the imperial hall of the gymnasium of Vedius and reveals itself as that of an orator through its Aeschines-like pose.[59]

But this is not really so surprising, since these Classical faces sufficed to express the intellectual pretensions of the orator. In addition, they can hardly have wanted their public portraits to fuel even more the charges of *luxuria* constantly being made against them. On the con-

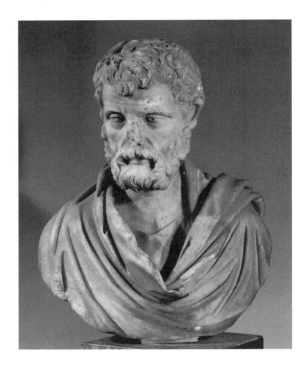

FIG. 134 Bust of the rhetorician and statesman
Herodes Atticus (ca. 101–177). Paris, Louvre.

trary, we may suppose that most of them wished to combine their
man-of-the-world elegance with a hint of philosophical seriousness,
though not going as far as to give an impression of the severity of the
Cynics or the toughness of the Stoics.

Apart from Herodes Atticus there are, unfortunately, no securely
identified portraits of the celebrity orators. Yet a statue like that of
L. Antonius Claudius Dometinus Diogenes, the patron and "lawgiver"
of Aphrodisias, "father and grandfather of Roman senators," may give
some idea of the splendid public image of such men. (fig. 135).[60] As a
sign of his priestly office he wears a diadem adorned with portraits of
the city goddess and the imperial family. The case with many book
rolls alludes to his learning, while the epithet Diogenes expresses his
genuine commitment to the philosophical life. This has not stopped

FIG. 135 Portrait statue of Lucius Antonius
Claudius Dometinus Diogenes, from the
"Odeon" at Aphrodisias. Early third century
A.D. Aphrodisias, Museum.

him, however, from sporting an elaborate coiffure that could hold its
own against that of a Lucius Verus.

Other portraits of this period, such as those of two magistrates from
Smyrna, now in Brussels, are remarkable for their elegantly styled
beards and yet wear their hair closely trimmed, like Theon the Plato-

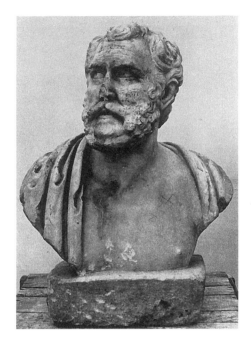

FIG. 136 Bust of the great orator Polemon
(ca. 90 – 145)? Athens, National Museum.

nist. In his case, we took this Stoic trait as a subtle suggestion of a
philosophical seriousness.[61] Anton Hekler made the attractive, but
entirely hypothetical, suggestion that a bust found in the Olympieion
at Athens represents the above-mentioned Polemon of Laodicea
(fig. 136). It was he who, in A.D. 131 in the presence of the emperor
Hadrian, delivered the dedication speech for the Olympieion. He
spoke passionately and, in the Asiatic baroque tradition of oratory, did
not shy away from such dramatic effects as leaping up from his throne.
The portrait's dramatic turn of the head and the mannered gaze,
unique in the portraiture of the Roman Empire, would well suit such
an occasion, particularly since it is reported of Polemon that through-
out the speech he kept his gaze fixed on a single spot.[62]

The search for a specific portrait type for the Sophists seems to lead

to a dead end. For the time being, at least, we cannot detect one with certainty among the preserved material. And yet the examples we have just considered show that, alongside the portraits of amateur intellectuals with Classical faces and the unkempt hair of the true ascetic, there were others with an elegantly soigné appearance steeped in luxury. It seems unlikely in these instances that the bare chest under a philosopher's mantle should be taken literally, with its original connotation of the toughening of the body through physical deprivation, as in the statues of Chrysippus and other Hellenistic philosophers. As we have seen, busts of this type are quite common starting in the Hadrianic period. Rather, this feature has probably become simply a formula signifying Greek-style *paideia*.

The Past in the Present: Rituals of Remembrance

To summarize thus far, we have seen how the upper echelons of society were steadily taking on a new cultivated look. Whether they did this simply by the unthinking adoption of a newly fashionable beard and *Zeitgesicht* or consciously modeled themselves on specific prototypes, whether they looked this way in real life or only in their portraits, there can be no doubt that a man's image in society was defined using stereotypes from the onetime iconography of the intellectual. (The fact that such stereotypes functioned as such only subsequent to their creation made no difference.) The beard is the basic standard by which we can measure the progress of this process of transformation. The phenomenon had its origins in Athens, and it was there and in other cities of the Greek East that this masquerade went to the greatest extremes. But in the West too, in the course of the Antonine period, contemporary faces are gradually assimilated to those of the ubiquitous busts of an earlier age. How are we to understand this phenomenon? Or rather, is there really a phenomenon here at all?

First of all, I cannot stress enough that this was not simply a phenomenon of the visual arts but shaped the real world of daily life as well. The wearing of a beard and the cultivation of an intellectual image were by no means restricted to élite circles, a rarified social game

like playing at being shepherds in the age of the rococo. For the Romans, the setting was the public arena. As I have noted, there is no doubt but that the portraits and their costumes to some extent reflect the public identity and appearance of the subject. (Whether this reverence for high culture extended to walking the streets half-naked in midwinter as an exercise in asceticism one may well question.)

Nevertheless, we must understand the "learned beard" worn by so many men within its larger context. It is but one of many facets of the collective striving to evoke in the present the cultural achievements of the past. The notion of a "Renaissance" often used of this period carries the wrong connotations. It was not a matter of trying to bring back to life something long dead, but rather of claiming that this glorious past was not really past at all but lived on in the present. To support this claim, a whole series of cultural activities served to conjure up the past, and a broad cross section of society took part, some more actively than others. The scenario can be best observed in Athens and elsewhere in Greece.

Fittschen has recently called attention to a group of portraits of youths and young men, mostly found in Greece, which, with their long flowing hair and heroic or elegiac expressions, often make a distinctly romantic impression (fig. 137).[63] Usually the portrait is combined with a nude bust, intended to recall Classical statues of heroes and athletes, as opposed to the "intellectual bust" partially draped in the himation. Fittschen has detected in this fashion an assimilation to Alexander the Great, and, indeed, some of the hairstyles are quite close to those of Alexander's portraits. But in the case of a number of these young men, who occasionally wear a short beard as well, identifying the source of the hairstyle in the portraiture of Alexander does not give the full story. For the contemporary viewer, the range of associations of these portraits must have been much broader. The variety of hairstyles worn by young men starting with Antinoos is particularly striking. I believe the long hair represents rather a general reference to the Classical image of the young hero. This does not, of course, rule out a specific reference in some instances to Alexander, whose own portraits are in turn closely linked to images of Achilles. Many ancient authors, from Homer on down, speak of Achilles' blond hair and the beautiful

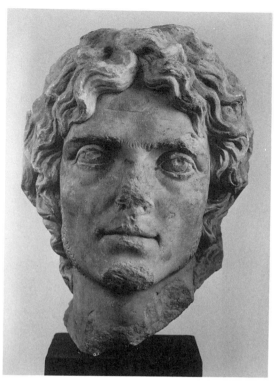

FIG. 137 Portrait of a young Athenian in the guise of the epic heroes. Antonine period. Athens, National Museum.

long locks of other heroes. "From his head she made the thick locks descend like hyacinth," says Homer of Odysseus, when Athena has transformed him into a dazzling youth after his landing on the island of the Phaeacians (*Od.* 6.230). This and other comparable passages are cited by Dio of Prusa in his *Encomium of Hair.* Synesius of Cyrene found Dio's treatise so charming that he quoted parts of it in his own *Praise of Baldness.* Contemporary Roman viewers who were not so steeped in the poetic tradition would nevertheless have understood the connotations of long hair, thanks to the many mythological scenes in wall painting and on floor mosaics and carved sarcophagi.

And the romantic hero was not to be found only in the visual arts. At Marathon Herodes Atticus encountered a real-life Herakles, whom he invited home (he did not, however, accept). Herodes went hunting with his "sons" Achilles, Memnon, and Polydeukion. After their early deaths, he honored them like heroes, with funerary games and banquets, and erected stelai, herms, and altars to them on his vast estates. The Heroic Age of myth should carry on right into the present.[64] The story of Herodes is not a unique instance of the evocation of the mythical past, only unusual in its dimensions. Only recently there appeared on the art market a magnificent bust, probably from Greece, representing a young man as a new Diomedes.[65]

Women's fashions also started to look back at times more or less directly to Classical models, to judge from surviving statues and sculpture in relief. On the hundreds of preserved Attic gravestones of the Early Empire and later, the women are almost exclusively depicted in one of two Late Classical statue types, known in archaeological parlance as the "grande Herculanèse" and the "petite Herculanèse." It is hard to imagine that actual clothing, especially what was worn on festival days, could have looked very different. The men on the gravestones and in honorific statuary are also portrayed in a Classical costume that goes back to the fourth century. At least in the matter of clothing, the past truly did live on in the present. This phenomenon is not limited to Athens. Wherever in the Empire substantial numbers of honorary female statues have been found, they inevitably belong to one of a very few Classical or Hellenistic types. There are, of course, variations in individual preference, but the basic dependence on a relatively small number of models drawn from earlier Greek art remains unchanged through the first two centuries of our era.

The intellectual image was thus only one of several "costumes" that contemporary individuals could put on in order to turn themselves into "ancient Greeks" and, in so doing, demonstrate the unbroken continuity of classical culture.[66] In Athens and other Greek cities of long standing, at least the actors in this masquerade, these latter-day Sophists, heroes, philosophers, and romantic youths, had a genuinely ancient stage setting on which to appear. In many instances these

places now received a major face-lift: we need only think of Hadrian's great building program in Athens and especially of the Olympieion, after so many centuries and so many patrons now finally completed thanks to the emperor. These monuments of the past were real enough and encouraged people to believe that they were not simply living in a dream world.

Along with the costumes and the stage sets came a variety of retrospective rituals. We have already noted, in discussing the literary dilettantes and the public and private poetry readings of the Early Empire, how in general nonpolitical activities and neutral forms of exclusive social intercourse steadily grew under the Principate. By the time of Nero and the Flavians, it is clear that education and intellectual pursuits have become an important measure of social prominence. From the time of Hadrian, poetry is gradually displaced by such prose genres as learned rhetoric, along with philosophy. The curious phenomenon of the Second Sophistic, some of whose elements may be off-putting to us today—the fixation on themes from the distant past, the rhetoricians' spectacular feats of memory, the pedantic straining to achieve the purest Attic dialect with the most arcane expressions—all this can be understood only within the context of an entire society struggling to revive the memories of the past. The formal speeches held at the great city festivals and Panhellenic games are also part of these rituals of remembrance, elements of an all-encompassing discourse in both the public and private spheres that provided the Romans with a communal assurance of the continuity and living presence of the past.

No less than in public, the private sphere and various forms of daily social interaction were characterized by the backward-looking rituals of the cult of learning. Perhaps the most revealing of these is the practice of learned conversation at the symposium. The handy compendia of classical culture contained in the *Attic Nights* of Aulus Gellius and the fifteen volumes of Athenaeus' *Deipnosophistai,* and even earlier in the nine books of Plutarch's *Conversations at Table* (*Quaestiones conviviales*), offer a wide spectrum of useful knowledge of all kinds, organized thematically: mythical and historical, literary and philological, scientific and philosophical, antiquarian, abstruse, and fantastic. From these

works we gain an authentic (and also idealized) picture of the topics, views, and arguments that were likely to come up in learned conversation after a meal. As in the rhetorical showpieces delivered in public, here too in these evening conversations a good memory and mental alertness were all-important. But the strenuous effort required was mitigated by the fact that no one expected originality. Rather, intellectual prowess could be demonstrated time and again by calling up the same topics, the same exempla drawn from myth and history. As odd as this sounds to us, it is not so long ago that it was still common practice in Europe to prepare in advance for a dinner party. In some places the topics of conversation planned for the evening were indicated on the invitation so that one could prepare with the help of such conversation manuals as Isaac d'Israeli's *Curiosities*.[67] At the ancient dinner table, whatever the subject, whether hetairai or philosophers, culinary delicacies or the intricacies of prose style, the examples cited always came from the distant past, the paradigms from the world of myth, and any advice or precedent was centuries old. In short, this was an age of, as it were, living classicism, which shaped much of both art and life.

The most celebrated intellectuals were competing for more than just public recognition. Glen Bowersock has shown how they often came to rank among the leading citizens of their respective cities and led the political and cultural rivalry with other cities, as well as competing among themselves for the favor of the emperor, who would award them higher and higher public office.[68] The emperors themselves even fell under the sway of this cult of the intellect and its high priests. The leading Sophists became their closest advisers and friends, oversaw the Greek bureaucracy, and educated the imperial children. The emperors were not just observers and patrons of this cult but took an active part in it, whether it be the romanticized pederasty of Hadrian or the introverted meditations and philosophical exercises of Marcus Aurelius, composed in Greek.

While for the élite education and intellectual prowess were an avenue to success in the competition for status and influence, for broad strata of the prosperous bourgeoisie these inevitably became tokens of social acceptability. The numbers of those actively involved in the general craze for learned pursuits, like the amateur poets, seem to have

FIG. 138 Sarcophagus of the youth Marcus Cornelius,
with scenes from his childhood, from Ostia. Ca.
A.D. 150. Paris, Louvre.

rapidly increased. This is seen most impressively in the mythological imagery so popular on sarcophagi starting in the time of Hadrian. The Classical imagery employed becomes a form of dazzling and recherché funerary rhetoric, mourning the deceased and celebrating his or her virtues by means of sometimes rather abstruse allegories and mythological parallels.[69] These learned images become much more than mere ornament and directly involve both patron and viewer, since the scenes echo their own situation (e.g., as mourners) or delineate a set of shared ideals. In this way even private experience was expressed through learned parallels, and the ordinary viewer felt drawn into the discourse of high culture as an active participant.

Nor was the daily life of the bourgeoisie unaffected by this phenomenon. On a child's sarcophagus of about A.D. 150, the life of a boy who died young is portrayed (fig. 138).[70] We glimpse the interior of a bourgeois household, with the mother herself quieting an infant. The father, standing nearby, also partakes of the shared familial bliss, but in a curiously distanced and intellectualized manner. He stands in the pose of the Muse Polyhymnia, leaning against a pillar and lost in meditation, a book roll in his hand testifying to his intellectual interests: a professor in the playroom!

On the other side of the scene he personally instructs his now adolescent son. This is a marked departure from both the conventional iconography and the actual circumstances of the age, at least in more

prosperous families. Later sarcophagi with such scenes of reading invariably feature a Greek teacher in this role. While the father here wears a toga, the professional tutors are depicted wearing only a himation over a bare torso, to indicate their strict adherence to the philosophical life. Yet this father is otherwise shown like a philosopher, in his contemplative pose.

The way he holds the child in his arm, again wearing a proper toga, is also without parallel. It would seem that in this instance the patron had a direct influence in determining the imagery and that he wanted to project simultaneously a cultivated life-style and the ancient ideal of the Roman paterfamilias, like the elder Cato. It was said that Cato liked to watch as his wife quieted their small son and, "later on, himself instructed the boy in reading and writing, even though his slave Chilon was an accomplished teacher of grammar" (Plut. *Cat. Mai.* 20.4). At the same time, the patron of our sarcophagus could have been influenced by a contemporary Stoic philosopher from the school of Favorinus, who insisted that even a woman of distinction should cradle her own child, since this was the way of nature (Gell. 12.1). This modest sarcophagus shows how intellectual pretensions were by now almost taken for granted among the middle class, and how they were entirely compatible with a sense of nostalgia for the proud traditions of Rome's past.[71]

The claim to universal learning is made much more spectacularly in the richly decorated funerary chamber of the freedman C. Valerius Hermia in the cemetery underneath St. Peter's. On the principal wall of the chamber stand five stuccoed statues in relief, the three in the middle representing patron deities of the family, including Hermes for prosperity (as well as being Hermia's "namesake") and Athena for education. To either side of these three, however, stand figures of intellectuals (fig. 139). Since both figures bear different portrait features, and the patron himself is shown with his family on the left-hand wall, it seems likely that these are the teachers of the deceased who are so honored. The upwardly mobile former slave evidently shared the ideals of his emperor, Marcus Aurelius, and was as grateful to his teachers as Marcus, who set up their golden *imagines* alongside the Lares in his domestic shrine (*Hist. Aug.*, M. Aurelius 3.5). The two intellectuals

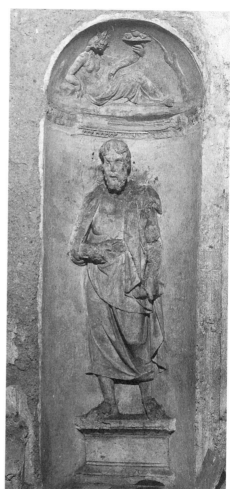

FIG. 139 Philosopher and rhetorician, probably the
teachers of Gaius Valerius Hermia. Stucco reliefs
from the tomb of the Valerii in the necropolis under
St. Peter's. Ca A.D. 170.

on Hermia's monument, it should be noted, are clearly distinguished from one another in manner and appearance. The elder, on the right-hand side, is easily recognized as a philosopher by his long and unkempt hair. The other is most likely the teacher of rhetoric, judging by his carefully draped garment and elegant coiffure.[72]

When a freedman like Hermia honors an ascetic philosopher as his mentor, then we are justified in thinking that the general attitude in Rome toward philosophy has decidedly changed for the better since the days of Trimalchio. To be sure, people's expectations of philosophy had also radically changed. No more contentious debates, abstruse definitions, or scientifically argued theses—in short, all the things the Romans had earlier made fun of. Instead, philosophy was now called on, first and foremost, as a guide to living one's life.

This had, of course, always been the role of the house philosopher. When Livia lost her son Drusus, she asked for *philosophum viri sui* (Sen. *Dial.* 6.4). This casual comment shows that philosophy's role as consolation was already well established at this time. Subsequently, however, people turned to philosophy not only for learned conversation or in moments of great need, but as a fundamental guide to life.

It was their growing "care of the self" that brought people under the Empire to philosophy and to the philosophers (as well as to mystery religions and others promising salvation). Neither the state religion nor the imperial cult could offer anything here, but a strict mental and physical regimen might. Physician and philosopher joined forces, for both taught the principles and standards of behavior, and both counseled their "patients" with advice, admonitions, and chastisement. The onetime scholar and learned partner in conversation became during the Empire a spiritual counselor, to whom people entrusted their well-being. As a result, the authority of the philosopher gradually increased once again, but it was now of a very different kind.

The Long Hair of the Charismatics

Let us return to the age of Nero and the Flavian emperors, for it is in this period that we hear for the first time of a new breed of philoso-

pher, who is celebrated not only for his towering wisdom, but for his extraordinary spiritual powers. Unlike the itinerant Cynics, these men came from wealthy and distinguished families, and, as opposed to the house philosophers, they taught publicly and gained access to the most exclusive circles of society. They had a special aura about them, as if elevated above the rest. Pliny the Younger, in A.D. 97, describes with great admiration one of these wise men, named Euphrates, who came from a prominent Syrian family. As a young man Pliny had established a close relationship of mutual trust with him, and after the death of Domitian, Euphrates taught publicly in Rome.73 He is described as follows:

> As far as I am qualified to determine, Euphrates is possessed of so many shining talents, that he cannot fail to strike and engage even the somewhat illiterate. He reasons with much force, penetration, and elegance, and frequently embodies all the sublime and luxuriant eloquence of Plato. His outward appearance is agreeable to all the rest: he has a tall figure, a comely aspect, long hair, and a large white beard: circumstances which though they may probably be thought trifling and accidental, contribute however to gain him much reverence [*plurimum venerationis*]. There is no uncouthness in his manner, which is grave, but not austere; and his approach commands respect without creating awe. Distinguished as he is by the sanctity of his life [*sanctitas summa*], he is no less so by his polite and affable address. He points his eloquence against the vices, not the persons of mankind, and without chastising reclaims the wanderer. His exhortations so captivate your attention, that you hang as it were upon his lips; and even after the heart is convinced, the ear still wishes to listen to the harmonious reasoner.
>
> (*Ep.* 1.10.5–7, trans. W. Melmoth)

As we saw earlier, in the previous generation Seneca had warned the upper-class Roman who took an interest in philosophy in no uncertain terms not to affect the outward appearance of a philosopher, even if this had become his principal occupation, as was the case with Seneca himself after he withdrew from court. Even Euphrates claims that he had long tried to conceal his pursuit of philosophy from the

outside world (Epictet. *Diss.* 4.8.17). Yet in the course of the Flavian era, the philosopher must have taken on a new authority, culminating in the image of the Charismatic that Euphrates so impressively embodies.

Euphrates had studied with the Stoic philosopher Musonius Rufus (ca. A.D. 30–108), as did many others who later became famous as professional philosophers, including Dio of Prusa, Epictetus, Timokrates, and Athenodotus.74 Musonius Rufus came from a family of *equites* in Volsinii and achieved great success teaching publicly at Rome. To judge from what is known of him, his philosophy was strictly in the pragmatic tradition, his main concern for leading a thoroughly correct and decent life, and to this end he offered specific instructions in proper behavior. When one reads his *Diatribes,* recorded in Greek by another hand, it is difficult to understand just why he enjoyed such tremendous authority. The same is true of Demetrius the Cynic, who was so admired by Seneca and other members of the aristocracy for his honesty and candor and his ascetic way of life.75 The impact of these men, as of Euphrates, must have derived above all from their personal charisma.

With the advent of monarchy, the old Roman aristocracy lost its power, and many a senator will have found little satisfaction in attending the meetings of that body. In the search for a new orientation in life, they too turned in upon themselves. Philosophers like Musonius Rufus or Demetrius helped them, not only to come to terms with themselves, but to understand their political role under the Principate in a new way. As the importance of their pupils grew, so too did the status of the teachers. As had happened once before, in the Early Hellenistic age, this meant that philosophers inevitably came into intimate contact with those in power. There were close associations between the circles around Musonius and Demetrius. Both numbered among their members leading senators, including the heads of the so-called Stoic opposition. Demetrius supported the most famous of these, Thrasea, Paetus, when Nero forced him to commit suicide (Tac. *Ann.* 16.33–35), and another, Rubellius Plautus, was accompanied by Musonius into exile. These political confrontations between, on the one side, philosophically minded senators and their teachers and, on the

other, the emperors Nero and, later, Vespasian and Domitian had nothing to do with "Republican" inclinations, but rather with the determination to sustain a philosophical stance. This entailed, among other things, taking seriously one's duties as a senator and voicing one's views, even when this might have serious consequences for life and limb. The emperors were right in thinking that the roots of senatorial opposition lay with the philosophers. With sensational cases of exile, followed by recall and rehabilitation likewise ordered by the emperor, the prestige of this new breed of wise men rapidly grew, for the persecution enabled them to give proof of steadfast adherence to their own principles. Two senators, Thrasea and Seneca, had ended their lives by staging a kind of "Socratic" suicide, and the murder of Helvidius Priscus turned him into a philosophical martyr (Epictet. *Diss.* 4.1.123; Suet. *Vesp.* 15). This too was a new image of the intellectual, but one that did not find visual expression until Rubens's dying Seneca.[76] Musonius and Demetrius were exiled to barren islands, and Dio, driven out of his native city of Prusa, wandered over the countries of the East like a Cynic, giving philosophical sermons in many cities. Surviving these kinds of exile only strengthened the philosophers' personal conviction, as well as the public recognition they enjoyed.[77]

The persecutions ended with the death of Domitian in A.D. 96, and for intellectuals it was the dawning of a Golden Age. They became the friends and political advisers of emperors, pillars of the Principate. Dio spoke before the emperor Trajan on monarchy and rode with him in his triumphal car. Such was the respect that the emperor accorded him—and even claimed, in the good old Roman tradition, that he understood not a word of what the philosopher was saying. Hadrian befriended such well-known philosophers as Epictetus and Heliodorus and was said to attract *grammaticos, rhetores, musicos, geometras, pictores,* and *astrologos* (*Hist. Aug.*, Spart. Hadr. 16.10). Sophists and philosophers alike struggled to provide a theoretical justification of monarchy and, in so doing, drew upon the whole battery of classical argumentation.

It is remarkable how the philosophers of this period talk about their clothing, hair, and beards as never before, probably because, in a society in which the visual image played such a dominant role, they too

needed recognizable symbols to establish their identity and to reaffirm the considerable authority they had recently acquired. In one extreme instance, the Stoic Epictetus (ca. A.D. 55–135) claimed he would sooner let his head be cut off than his beard, so essential was the beard to his very identity (*Diss.* 1.2.28). His fears may not have been without some justification: Domitian had ordered the beard and long hair of Apollonius of Tyana, who later achieved such fame, to be removed (Philostr. *VA* 7.34).

But their role as public figures necessitated for the Charismatics more than a beard. They needed an entire image that would bring out their extraordinary characteristics, and the traditional image of the philosopher was evidently insufficient to the task. The strict differentiation among philosophical schools was no longer relevant to their new role, and a genuinely unwashed Cynic was not acceptable in civilized society. Euphrates and others of his ilk were strictly correct in their dress, interestingly, and in every respect clearly distanced themselves from the Cynics. They had to do this, given the ambivalent reputation of the itinerant philosophers and the lack of respect that they suffered (cf. p. 199). Euphrates' hieratic appearance and the stately manner of his instruction are dramatically different from the traditional, originally Hellenistic image of the philosopher engaged in discourse. Most of all, his public appearances were crowned with an aura of *veneratio* and *summa sanctitas*.

A small relief of the late second century in Ostia may give us some idea of the lecture style of these Charismatics (fig. 140).[78] While two scribes in the foreground try to capture every precious word, we can make out other captivated listeners behind them. The speaker stands on a podium, elevated above his audience. A curtain hints at a building that, like a portico or basilica, could be subdivided into individual rooms through the use of such curtains. Since the speaker wears only the tunica and not a toga, the scene cannot be set in the law courts. Rather, his upturned gaze and the solemn gestures suggest a philosopher.

But it was not just the general appearance of these new philosophers that was different, but also their faces. Euphrates' expression was "deep and serious" but not "dark" (Pliny has in mind here the faces of the

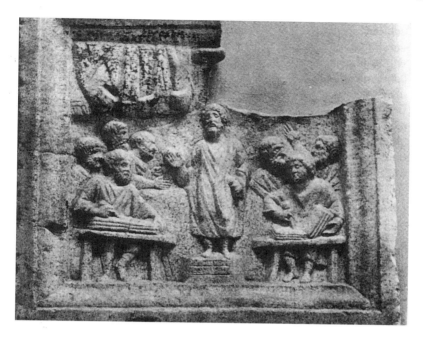

FIG. 140 Grave relief of a Charismatic philosopher (?)
delivering a lecture. Ostia, Museum.

Cynics). The face of the Charismatic radiates a transcendent goodness;
he is not tortured by mental strain, for he knows the path and the
conditions that will lead to a well-ordered spiritual existence. The ex-
ternal appearance provides the guarantee of his internal, spiritual su-
periority. That superiority, however, is not derived above all from an
extraordinary intellectual capacity, as was the case with the great
thinkers of the third century B.C., but from the nature of his very be-
ing. We encounter in him for the first time the *theios anēr,* or holy man,
a figure who will take on much greater significance in the years to
come. Pliny himself refers to the *sanctitas* of his friend Euphrates.79

What Pliny finds most impressive about Euphrates is his noble
countenance, the long white beard, and the "beautiful" hair (clearly
washed and combed) flowing to his shoulders. Long hair, along with
the beard, is constantly remarked upon in connection with Dio of

Prusa and the other Charismatics of the second century, such as Aelius Aristides and Peregrinus Proteus. Unfortunately, in most cases we cannot tell from the context if the long "beautiful" hair of a Euphrates is meant, or the long unkempt hair of the Cynic, as Dio seems to have worn it on his wanderings.[80]

The Pythagoreans also served as a model for Charismatics like Euphrates, or, rather, they too affected a similar image, like the "holy" Arignotus (*hieros daimonios*), who is made fun of in the pages of Lucian, with his long hair and "solemn face" (*Philops.* 29.32). Alciphron describes a gathering of philosophers at which the pale Pythagorean wears "long locks falling from the crown of the head to his chest and a very long and pointed beard" (see p. 110). In Philostratus' account, Apollonius of Tyana identifies himself, in manner and way of life, as a disciple of Pythagoras and refers to his long flowing hair as well as his garment of "pure linen" (*VA* 1.32).[81] Pythagoras was in addition known to have been a particularly handsome man (cf. p. 234). A century after the time of Euphrates, we find in Philostratus a justification for shoulder-length hair in rather dramatic terms: "Let the head of a wise man be spared the clippers, for it is not fit that the iron should touch the place that is the source of all the mental processes and intuitions, whence all principles issue and the words that are the interpreters of his wisdom" (*VA* 8.7).

Philostratus' aversion to the shears is no doubt tied up with a belief in the magical powers of unshorn hair, which is common to a great many otherwise very different cultures. Rulers have worn their hair long as well as prophets, and the giant Samson was robbed of his powers when Delilah cut his hair. Among Classical and Hellenistic portraits of intellectuals, however, it is extremely rare to find shoulder-length hair, and then mainly on Homer. It is not entirely clear in these instances just what it means.[82]

Certain priests also wore their hair long (Dio 35.11). In their portraiture, they can be recognized by the wreaths or fillets on their heads. A particularly fine example is the Antonine portrait of a priest with myrtle wreath, from Apollonia in Cyrenaica (fig. 142).[83] Notice how the hair is distinctively parted in the middle, an iconographical feature that will later become a standard part of the visual imagery of Christ.

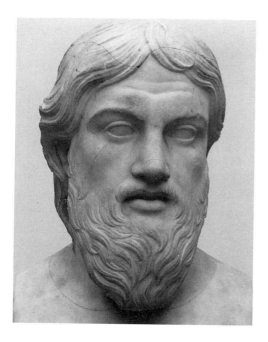

FIG. 141 Portrait of a philosopher. Second
century A.D. (?). Copenhagen, Ny Carlsberg
Glyptotek.

If we take figures like Euphrates or Dio as forerunners or early ex-
amples of the *theios anēr,* whose wisdom far transcends book learning
and who claims access to deeper sources of insight into the human and
divine, then the link to the iconography of the priest would only fur-
ther strengthen the connotation of the holy.

That the charismatic effect of these "holy men" did indeed depend
largely on their physical appearance is well illustrated by the case of
Alexander Abonuteichos, the false priest of Asklepios. Only on his
deathbed was it revealed that his long hair was not natural, but that the
whole time he had been wearing a wig (Lucian *Alex.* 3; 13). Yet the
wig had worked as well as if it had been his own hair. At least the
oracular cult he founded survived this revelation and went on for sev-
eral more generations.[84]

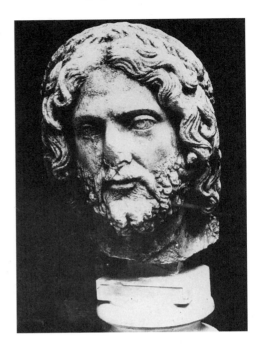

FIG. 142 Lost portrait of a priest, from Apollonia. Second half of the second century A.D.

This new image of the philosopher with shoulder-length hair is unfortunately very seldom attested in the art of the High Empire. Since, however, it will play a key role in the iconography of both the Late Antique philosopher and of the bearded figure of Christ, I should like at least to mention a few dubious instances. Chief among these is a group of several marble portraits with long hair whose authenticity has sometimes been questioned, including heads in Copenhagen (fig. 141) and Munich. In my view both of these are works of the early second century A.D. that have subsequently been heavily restored and reworked. Looking ahead to Late Antique portraits of Christ and the philosophers, it is interesting to note that in several of these heads the hair parted in the middle accentuates the high forehead.[85]

A nearly fully preserved statue of an itinerant philosopher that came to light during excavations of the Agora of Gortyn on Crete can be dated to the Late Antonine period (fig. 143).[86] The usual identifica-

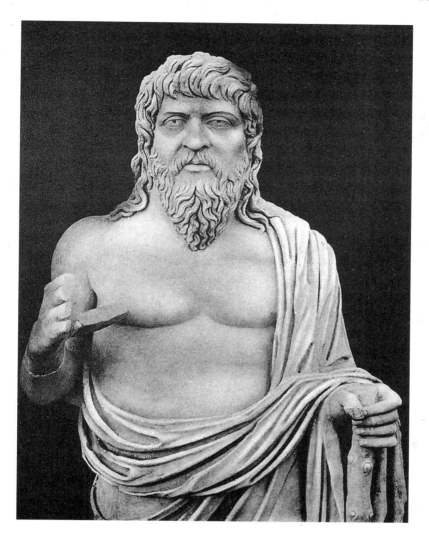

FIG. 143 Statue of a philosopher, from Gortyn. An-
tonine period. Herakleion, Museum.

tion has been based on comparisons with a coin portrait of Heraclitus
with which, however, it has little in common. I would like to see it
instead as the portrait of a Charismatic philosopher in the manner of
Apollonius of Tyana. The raised right hand clearly marks the philoso-
pher as a teacher. In his left hand he holds a staff in the form of a club,

which must contain a clue to his identity. The club was considered an attribute of the Cynics, for two reasons: first, because it recalled Herakles, the patron of the "sect," whose strength and endurance during his lifetime of roaming the world offered a paradigm for their own moral struggle; and second, because in their own itinerant lives they made good use of a club and sometimes needed it to save their skin.[87] Yet no one would want to identify the figure from Gortyn as a typical Cynic. He wears handsome sandals, and his smooth (i.e., clean) himation is carefully draped about the body in the Classical manner. Furthermore, the bundle of book rolls hints at his great learning. The absence of another garment under the mantle bespeaks the ascetic lifestyle of the itinerant philosopher, while the portrait type, with the carefully styled shoulder-length hair, recalls the image of Euphrates. This feature, along with the club, supports the identification as a *theios anēr,* since many of these new Charismatic philosophers spent part of their lives as itinerants, whether willingly or in exile.[88]

We shall see in the final chapter how the image of the bearded Christ with long hair ultimately goes back to that of these "holy men." It is probably no accident that the visual record for the second century is so spotty, for the *theios anēr* had at first no clearly defined place in society, or among the well-established forms of self-representation. If honorific or votive statues were ever set up for such men, these will have been single statues in bronze, unlike the many copies of Greek portraits, and will have long since been melted down.

VI. The Cult of Learning Transfigured

This is what is best about the philosopher's mantle [pallium]:
the very act of immoral thought reddens it. . . . Be glad and
rejoice, o you pallium, *that you now serve a better philosophy,*
since you clothe the Christian.

—Tertullian *De pallio* 6.2

When Caracalla became sole emperor in A.D. 212, his official portraiture depicted him with close-cropped hair, a crude, stubbly beard, and the fierce look of a storm trooper. It was a rather abrupt break with the noble and distinguished appearance of his predecessors, especially in rejecting the "intellectual beard" worn by every emperor since Hadrian, including his own father, Septimius Severus. This portrait signals a new conception of the emperor, probably directed primarily at the army, an image of toughness and power expressed in the language of command and obedience.[1] The rapidity with which these new visual formulas remodeled the image of the average Roman citizen might lead us to suppose that in the age of the soldier-emperors, learning and high culture lost the high status they had enjoyed as central values of Antonine society, while the ideology of *virtus* became once again dominant.

This is not, however, the case. Rather, the life of learning and philosophy seems to have endured with extraordinary vigor in this time of crisis. The archaeological evidence suggests that it attracted ever greater numbers and wider circles within society. In particular, the appeal of the world of the intellect seems to have become more and more sought out for its practical assistance in living one's daily life. I believe this thesis finds its strongest support in the great popularity of certain imagery in the funerary monuments of the middle class. My discussion will therefore be based primarily on the relief sarcophagi that are so plentifully preserved.

In Hadrianic and Antonine portraiture, the self-styled intellectual had been striving above all for a place of distinction in society. In this arena, however, the intellectual image was eclipsed during the age of the soldier-emperors by a new value system. But in the sphere of private introspection, that image retained its significance. Thus the patrons who commissioned the "philosopher sarcophagi" are in effect their own audience. The imagery upon the sarcophagi gives the impression of strong personal convictions, of a private acknowledgment of a certain way of life. The change of pictorial medium from portrait to sarcophagus is surely not without meaning.

As in our discussion of Antonine portraiture, I should like to try to make inferences from the monuments themselves about the generally accepted values of society. H.-I. Marrou adopted this same approach in his book *Mousikos Aner.* We must of necessity focus almost exclusively on the city of Rome, since only here does the relevant imagery survive on such an extensive series of sarcophagi.[2]

Learned Couples and Their Child Prodigies

A well-known fragment of a sarcophagus in the Townley Collection of the British Museum shows a seated, reading figure, dressed in Greek citizen attire, together with Thalia, the Muse of comedy (fig. 144).[3] As he reads, the right hand makes a gesture of speaking. Is he reciting verses, or is this gesture directed at the Muse? This is the same schema that had earlier been used to depict the famous poets and philosophers of the past engaged in their intellectual labors (cf. fig. 74). Here, however, the reader is evidently a contemporary individual, as implied by the portrait features and the standard Late Antonine style of long beard and contemplative brow. The deceased is thus celebrated for one particular quality: his learning, or, more precisely, literary learning.

Although found in Rome, this sarcophagus was in fact produced at Dokimeion, a small town in distant Phrygia, which had a famous workshop producing column sarcophagi of the Asia Minor type. The portrait of the deceased was presumably added only after the export and sale of the sarcophagus in Rome, about A.D. 200. The same work-

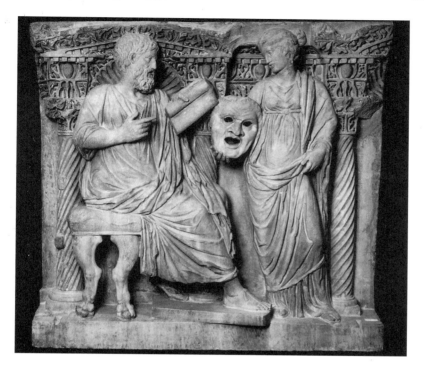

FIG. 144 Man reading, with his Muse. Fragment of a
sarcophagus from Asia Minor, ca. A.D. 200. London,
British Museum.

shop also had in its repertoire other scenes of the ordinary citizen en-
gaged in intellectual pursuits. In such scenes the spouse often sits op-
posite. On a more modest sarcophagus from a local workshop and now
in the museum at Konya in Turkey, a man holds a book roll in his left
hand and raises the right in a gesture of instruction (fig. 145).4 Once
again, as with the portraits in the ancient Greek manner, the stimulus
for this imagery on sarcophagi came to Rome from the Greek East.
But the imaginative adaptation of the new iconography by Roman
workshops, as well as the steady increase in popularity of sarcophagi of
this type into the late third century, especially the more modest ones,
shows how easily the Roman patron was able to identify with the new
visual imagery.5

FIG. 145 Sarcophagus of a married couple, from Asia
Minor. Ca. A.D. 200. Konya, Museum.

The notion of "learning" had already been a popular theme on
Roman relief sarcophagi of the Antonine period. But there it was a
variety of mythological motifs, especially a gathering of the Muses,
that expressed the idea in allegorical terms. The great innovation in
the imagery of the column sarcophagi imported from Asia Minor was
in the direct representation of the deceased as a man of intellectual
pursuits in the real world of his own time. It is quite revealing, for
example, that a motif like that of the Konya sarcophagus found a par-
ticularly receptive audience in Rome, celebrating as it does both the
importance of family values and the dominant position of the pater-
familias (though here in a new guise, as the learned teacher of litera-
ture or philosophy; fig. 146). But unlike the Asia Minor column sar-
cophagi, those made in Rome very seldom employ the motif of the
contemplative man lost in thought. The Roman amateur intellectual
prefers to show off his learning. In other words, in the Roman view,
reading and study should be put to practical use. The writings of the
ancients are an ever-present resource that can be pressed into service

FIG. 146 Sarcophagus with a married couple before
a chorus of Muses. Ca. A.D. 260. Rome, Vatican
Museums.

at any time and transmitted to the next generation. This reflects the
traditional Roman attitude toward the uses of Greek literature, though
it does not rule out the possibility that the teacher with his right arm
raised is directing the lesson to no one so much as himself.

On Roman "philosopher sarcophagi," husband and wife often ap-
pear as a couple, a row of Muses in the background, and, at least at first
glance, they seem to enjoy equal status. For the first time, at long last,
we find women accorded an integral role in the commemoration of
the intellect. There is, nevertheless, a clear division of roles by gender,
one that may be problematical to modern sensibilities. While the man
reads or reflects on his reading (in either case holding a book roll), his
wife usually plays a stringed instrument, though she too may occasion-
ally hold a book. This is undoubtedly more than just an idealized im-
age. In the highly ritualized practice of home entertainment, women
surely did offer just such musical diversion. The "fine arts" were most
appropriate to the ladies, just as in upper-class society in the last cen-
tury it was the ladies who sang or played the piano for the evening's

entertainment.[6] In Rome, however, a woman's musical talents are always expressed by means of mythological allusion. That is, on the sarcophagi, women are included among the Muses. On the sarcophagi from Asia Minor, by contrast, the women appear in normal, everyday citizen dress. The Roman woman is thus differentiated from her mythical counterparts, who often appear in the background, only by her prominent position and her portrait. The analogy has a long tradition, going back to Plato, who called the poet Sappho the tenth Muse (*Anth. Gr.* 9.506).[7] This mythical overlay means, however, that the wife, unlike her husband, is distanced from the real world. There is thus no immediate spiritual rapport between the married couple, as had been the case on the Asia Minor sarcophagi.

The Roman amateur intellectual is often accompanied by professional philosophers, characterized as such by their traditional Greek dress and accoutrements. But unlike the relationship of the Roman matron to the Muses, these Roman men, while they may be reading or teaching, never really belong to the circle of philosophers that surrounds them, nor do they as a rule communicate directly. Indeed, no matter how deeply they immerse themselves in their reading or how passionately they teach, they are still clearly marked off from the professional philosophers around them by their fashionably Roman hair and beard styles and by their Roman dress. That is, the Greek philosophers are understood as the advisers to the educated Roman, and their constant presence underlines how seriously the deceased had cultivated a philosophical way of life.

It has been recognized since the work of Marrou that the men depicted in this intellectual guise cannot actually be those who had devoted their professional lives to scholarship, teaching, or philosophy, as some of the more impressive sarcophagi had originally led scholars to believe. The considerable number of the so-called philosopher sarcophagi alone makes this idea unlikely. But seldom do we learn what their actual profession was, as we do, for example, in the case of the centurion L. Pullius Peregrinus, who was buried in an expensive sarcophagus about the year A.D. 250 (fig. 147).[8]

This commander, a member of the *equites* who probably served in the Praetorian Guard in Rome, is surrounded by a lively group of

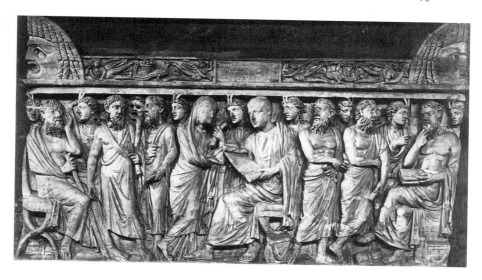

FIG. 147 Sarcophagus of the centurion L. Pullius
Peregrinus and his wife. The centurion is shown as
a "wise man" with philosophers, his wife as a Muse.
Ca. A.D. 250. Rome, Museo Torlonia.

philosophers engaged in discussion or solitary contemplation. They
are evidently intended to represent six of the Seven Sages, with Pere-
grinus, the scholar-officer, joining them as the seventh. Remarkably,
all the wise men are depicted as itinerant Cynic philosophers. Their
asceticism and self-sufficiency are evident in the coarse mantle, the
only garment they wear over bodies toughened with age and hardship.
The straggly beards and hair, indicating a lack of concern for physical
appearance, the knotty staffs, traveling sacks, and the "Cynic's club"
that we have seen before (fig. 143), as part of the statue of the so-called
Heraclitus, all contribute to this impression. As we saw in the story of
Apuleius' day in court, this "costume" was considered proof of a rig-
orously philosophical way of life. On our sarcophagus too, the unusual
presentation of the six wise men must carry the same con-
notation: the officer admires these men and considers them his moral
exemplars. Perhaps this may even explain the significance of his cog-
nomen, Peregrinus ("Wandering Stranger").

This hardly means, of course, that Peregrinus actually imagined himself as an ascetic, contemptuous of the world, any more than the men depicted in comparable Antonine portraits. Indeed, his own hair and beard reflect the fashions of the day, and his finely draped, voluminous Greek mantle, the chiton underneath, and the sandals comprise a relatively substantial outfit.9 This rather comfortable look makes a good comparison with that of the statue of Poseidippus that was reworked about the middle of the first century B.C. (fig. 110). If we may trust Tertullian, a contemporary of Peregrinus, the latter's leisure outfit, as depicted here, is perfectly authentic. While the toga continued to be reserved for public activities and obligations, the mantle (*pallium*), as the Christian apologist explains, marks the relaxed ambience of the home. At the same time, according to Tertullian, this was the garment that made professional intellectuals of all kinds recognizable in public (*De pallio* 6.2).

On the surface, it seems not much has changed since the rituals of *otium* played out in the villas of the Late Republic. The difference is that for Peregrinus learning is no longer a casual occupation for his leisure hours, but rather, as implied by the presence of his ascetic philosopher friends, a means to his goal of a philosophically oriented lifestyle.10 The evocation of the Seven Sages need not surprise us. Their wise sayings probably served Peregrinus as a valuable guide to life, just as did the rules of behavior taught by the philosophers. Philosophy is here understood as the art of life, as we find it also in the *Meditations* of the emperor Marcus Aurelius. This included the ideal of asceticism, however it might be practiced (cf. p. 242). Thus the men surrounding Peregrinus, characterized as wandering Cynic philosophers, may convey the same basic idea as the unkempt and filthy hair of an Apuleius and his cronies, that is, a declaration of loyalty to a rigorously philosophical way of life. Borrowing from an analogous Christian practice, one could speak here of a "philosophical succession."11

Meanwhile, Peregrinus' wife, in the context of his grandiose funerary rhetoric, enjoys the accustomed likeness to a Muse, but in a carefully chosen manner. She is immortalized in the pose of Polyhymnia, and, instead of joining her sisters in the background, she is positioned

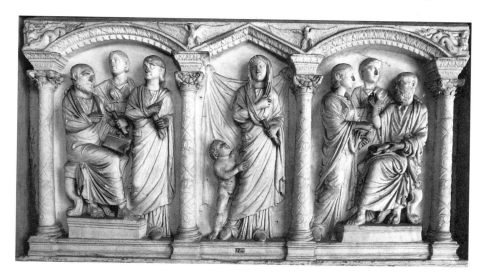

FIG. 148 Sarcophagus with dual representation of
the head of the family. Ca. A.D. 240. Rome, Vatican
Museums.

directly opposite her husband. This confers an added dimension on the
conventional Muse comparison, as the wife takes on the role of her
husband's personal Muse. The traditional grouping of a poet or phi-
losopher and the Muse who inspires him (cf. figs. 74, 144) is here as-
similated to the notion of marital *concordia* in the shared service of the
Muses. Following her own death, the wife would have her portrait
carved in the style of the period, so the sculptor has left her head in-
completely worked.

The intellectual and musical activities portrayed on these sarcophagi
are generally tied to a familial setting. On one of the big, impressive
sarcophagi in the Belvedere of the Vatican, a family man, whose por-
trait could easily be mistaken for that of the emperor Pupienus
(A.D. 238), is shown along with his wife and several daughters (the
scene continues onto the short sides), who constitute the chorus of
Muses.[12] Remarkably, the father appears twice, both times in the
guise of the intellectual (fig. 148). It is unlikely that such a striking

repetition was done only for the sake of symmetry. Presumably the two slightly different images are intended to divide the praise of learning into two categories, the philosophical and the rhetorical, as we have already noted in the case of the burial chamber of C. Valerius Hermia under St. Peter's (cf. fig. 139). On our sarcophagus, the deceased is portrayed in the left-hand scene with the mantle wrapped tightly, thus enveloping the right arm in the Classical manner. Even here, well into the High Empire, this pose could still connote an orator, even if that hardly suits the domestic setting. On the right side, by contrast, he is depicted as a teacher. The conception of learning is once again meant to be as all-embracing as possible.

The praise of education is often extended to the children as well, especially to the boys. Just as the little boys on mythological sarcophagi may be shown in the role of keen hunters, to signal their future *virtus,* so elsewhere the parents commemorate their precocious little scholar, particularly in the guise of the passionate orator. On a child sarcophagus in the Vatican, for example, a boy lectures to a group of his playmates decked out in the attributes of the Muses (fig. 149).[13] The conventional relationship of the Muses to the man of learning is here both elaborated and turned upside down. It is not the Muses who inspire the little professor, but the other way 'round. Clio records the precious words of the wunderkind. But in order to make the scene halfway plausible, the artist has transformed the Muses into little contemporaries of the deceased. The serious purpose of commemorating the dead still admits an element of playfulness.

The same boy appears a second time, on the lid. He is accompanied now by his favorite puppy but otherwise is fully devoted to his studies. This apple of his parents' eye holds in one hand an open book roll (the hand with the book roll is a modern restoration). In front of him lies an open polyptych for taking copious notes. The motif of the precocious child intellectual, which we shall encounter again in connection with the iconography of Christ, is one that was popular throughout the Principate. But the numbers of both the carved scenes and the corresponding grave epigrams increase dramatically in the later third century.[14]

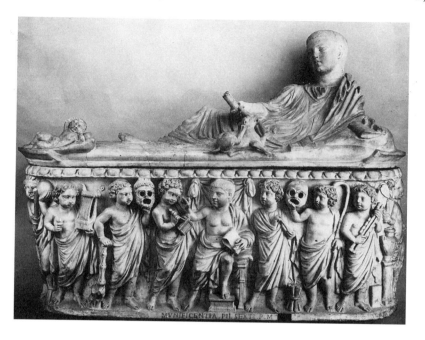

FIG. 149 Sarcophagus of an intellectual wunderkind,
who instructs the "Muses" in the guise of boys his own
age. Ca. A.D. 280. Rome, Vatican Museums.

Political Office and the Philosophical Life

Despite the familial focus of most of this imagery, some of the more
elaborate sarcophagi of the later third century do illustrate the public
recognition and *auctoritas* that come to the educated man who has led
his life following the precepts of the philosophers. On a fragment of a
huge and splendid sarcophagus in the Vatican that was once wrongly
associated with the philosopher Plotinus, the figure of a philosophical
layman is "enthroned" frontally before the viewer, not unlike a mag-
istrate presiding at court (fig. 150). He pauses in his reading and looks
pensively into the distance. The pile of book rolls at his feet alludes to
his devotion to his intellectual pursuits. Two women belonging to his

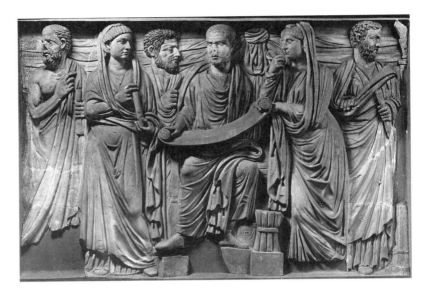

FIG. 150 Fragment of a lavish sarcophagus ca. A.D. 280,
showing an amateur philosopher surrounded by Muses
and philosophers. Rome, Vatican Museums.

family—both have portrait features and wear hairstyles of the pe-
riod—stand beside him and look on admiringly.

Like Peregrinus, the deceased was surrounded by a group of philos-
ophers, though the fragment preserves only three. But unlike Peregri-
nus' itinerant Cynics, these belong to a more presentable breed. In
addition, the sculptor has taken pains to differentiate their outward
appearances. Thus one wears a long undergarment, while a second,
whose balding head recalls Socrates, wears only a mantle, and the
third, who is distinguished from his well-tended colleagues by his wild
hair and beard, nevertheless wears his mantle properly draped. It would
seem that they are meant to be representatives of different philo-
sophical schools, and all served as advisers to the deceased. But the one
with wild hair, who stands beside and addresses him, seems the most
trusted, probably his closest confidant. The arrangement of the figures
makes clear the hierarchy within the ranks of the counselors. An en-
cyclopedic education is the prerequisite for the philosophical life, but

in the end what matters most is adherence to a moral standard, which can be achieved only through constant spiritual exercise and the help of a role model whose own life admits no compromise.

Intellectual superiority is presented here as the highest form of *auctoritas,* expressed in the frontal image borrowed from Imperial state monuments. And yet this is once again not a professional intellectual, but rather, like Peregrinus, a layman or, as Marrou says, an "amateur." The style of his shoes (*calcei*) may suggest his identity as a member of the equestrian order.[15] Although we have thus far considered only sarcophagi whose imagery is confined to the private and domestic sphere, there are other examples from the time of the emperor Gallienus (A.D. 260 – 268) and later that make clear the direct connection between intellectual pursuits and political office. The prestige of learning acquired through rigorous philosophical training had now apparently grown to the point where even men of consular rank considered this an integral element of their identity and not merely a convenient status symbol. In the time of Marcus Aurelius, by contrast, these same Roman aristocrats had used traditional imagery to celebrate their *virtus* and their qualities of military leadership, especially on the battle or "Feldherrn" sarcophagi.[16] Yet this is the same period in which we saw evidence for the high valuation of learning in the *Zeitgesicht* and the fashion for long beards.

The so-called Brother Sarcophagus in Naples presents four versions of the same deceased individual, probably a Roman senator, in different outfits and poses, in contiguous scenes (fig. 151).[17] That it is the same man is clear because his portrait features remain the same. The whole image is thus a kind of "gallery" of the type sometimes partially preserved in the form of busts or statues and attested in written sources for the emperors themselves.[18] So, for example, a painting in the palace of the Quinctilii depicted the emperor Tacitus (A.D. 275 – 276) in five variations, as *togatus, chlamydatus, armatus, palliatus,* and *venatorio habitu* (*Hist. Aug.,* Vopisc. Tac. 16)—that is, in a toga, in a military "traveling outfit," in a cuirass, in the Greek mantle, and in hunting costume. The picture sounds like the visualization of one of those particularly verbose honorific inscriptions. Similarly, the Naples sar-

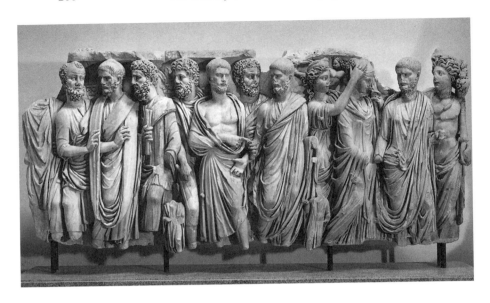

FIG. 151 So-called Brother Sarcophagus, showing the
deceased in various "roles." After A.D. 260. Naples,
Museo Nazionale.

cophagus celebrates in turn each of the most important virtues or
spheres of activity of a senator or other high official. At the left we see
him at the acme of his political career, assuming office, while at the far
right his marriage is shown. Thus his exemplary private life is pre-
sented as the counterpart to his political career. In the center, however,
he is shown once in the guise of the ascetic Greek philosopher, wear-
ing only the himation, and once as a Roman wearing a toga. The two
seem as if in conversation, but this of course is not to be taken literally.
Rather, the pairing expresses the inextricably linked dual identity of
the Roman aristocrat, comprised, in equal measure, of the precepts of
philosophy and the traditional values of the *mores maiorum*—however
the boundary between these two may have been defined. In his guise
as "Roman," the honorand wears a simple toga. The little attendant
next to him alludes to that most important of the old Roman virtues,
religious piety.

 The Brother Sarcophagus is far from unique. There are other,

FIG. 152 Sarcophagus of a married couple. In the middle they share in a sacrifice; in the corners, he is shown as a philosopher, she as a Muse. Second half of the third century A.D. Munich, Glyptothek.

less extravagant sarcophagi that show the deceased both in an old-fashioned toga and in the *pallium,* or as a public official wearing the *toga contabulata,* along with his philosopher-advisers. A good example is an unusually large strigilated sarcophagus in the Glyptothek in Munich, Severan in date (fig. 152).[19] Here again a married couple appears in two different guises. The scene in the middle celebrates their marital *concordia,* while the figures in the corners allude to literary, philosophical, and musical education. The husband gestures toward his book roll as if to make a point; his wife, in the pose of Urania, points to a globe (*sphaira*) that was originally held in her left hand. As on other sarcophagi of this type, both individuals are elevated on pedestals. In this way a connotation of "public honors" is evoked to enhance the praise of the dead.

These are important monuments in the history of Roman intellectual imagery. The *pallium* now enjoys a status equal to that of the toga in the catalogue of virtues prescribed for the Roman aristocracy and even the emperor. We may recall that among the five images of the

emperor Tacitus was one wearing this type of Greek mantle (*palliatus*). What was once a leisure pastime with dubious moral connotations has now become an indispensable prerequisite for the man of public affairs. As is well known, in the Late Empire, a good education, including philosophy, became an important criterion in the recruiting of high officials in the imperial bureaucracy and, just as at one time the withdrawal into a world of intellectual *otium,* it was also a kind of status symbol.[20] The extraordinary value for the historian of the visual evidence lies in demonstrating to what extent these criteria were, by the second half of the third century, firmly established within the value system of urban Roman society.

The number of splendid sarcophagi of high artistic achievement, of the type we have been looking at, is of course relatively small. But at the same time a large class of simpler, so-called strigilated sarcophagi gives evidence of how widespread the same kind of self-image had become among broad strata of the prosperous "middle class" in the city of Rome, those who could afford a marble sarcophagus in the first place (fig. 153). Even among those of modest artistic pretensions, the majority at least allude to the intellectual pursuits of the deceased in the form of a book roll. Generally the front side of the sarcophagus is decorated with three small scenes in relief, in the middle and at the ends, the remainder filled with the ripple pattern. The scenes repeat the visual program of the larger sarcophagi, only reduced to a set of shorthand slogans. The same is true of the widespread integration of these scenes amid other kinds of imagery, in particular of shepherds in a bucolic setting. Often the deceased couple stands or sits opposite one another at the two corners in the traditional roles of philosopher and Muse (or, later on, as praying figures: *orans*), as on the fine sarcophagus in Munich (fig. 152). The husband almost always wears the more ascetic kind of philosopher's mantle, without an undergarment. He is no longer afraid of identifying himself fully with his role model. A striking motif in the middle panel of some examples is of a professional philosopher, either reading alongside a Muse or engaged in conversation with a colleague. The long hair of some of these men recalls the

FIG. 153 Four modest strigilated sarcophagi showing the deceased either in the guise of a philosopher or as a Muse. Second half of the third century A.D. a) Florence, formerly on the Ponte Vecchio. b) Pisa, Campo Santo. c) Porto Torres (Sardinia). d) Rome, Museo-delle Terme. (Wegner 1966, nos. 31, 79, 81, 127.)

Charismatic philosophers, the "holy men" whom we heard about in the previous chapter and will shortly encounter again in our discussion of the image of Christ. In abbreviated form they carry the same message as the circle of ascetic philosophers around Peregrinus or the philosophical friends of "Plotinus," only the feeling of reverence for philosophical instruction is even more clearly articulated.[21]

There are only two themes that can rival the popularity of the Muses and intellectual imagery on sarcophagi of the later third century: hunting, which was the traditional symbol of strength, courage, and valor, and the bucolic shepherds. But it is also significant that the "philosophers" now often take over the pastoral setting, and on one of the more magnificent sarcophagi the tried and true symbol of *virtus* is actually relegated to the back side, while the front is given over to the philosophers.[22]

The Educated Man's Search for Inner Peace

A remarkable change can be detected in the iconography of sarcophagi in the course of the second half of the third century, especially those with bucolic scenes. Whereas the amateur intellectual had previously often appeared as the zealous teacher, we now have the impression that the teaching is directed only at himself. At the same time, the earlier domestic scenes are transported to a bucolic setting in the country. One of the earliest examples, probably not much later than A.D. 250, is a recently published sarcophagus in Basel (fig. 154).[23]

The deceased couple each appear twice with portrait features: once in the central portrait medallion as a proper married couple, the husband wearing the official magistrate's toga, and again in the landscape scene, in which each personifies the values they cherish. He sits in a marble seat, holding a curved staff, and wears only the mantle that marks him as a philosopher or poet. Unlike Peregrinus, he wears no undergarment and has attributes that would suit an itinerant philosopher, yet he is definitely a layman. Despite the poor state of preservation, one can make out that the head bears portrait features and is beardless. Thus, as on other sarcophagi, he must be read as a pendant

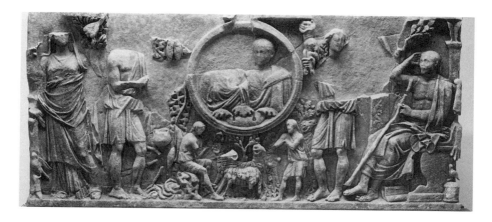

FIG. 154 Sarcophagus of a married couple with bu-
colic figures. After the middle of the third century A.D.
Basel, Antikenmuseum.

to his wife, the woman in the *orans* pose, who likewise had portrait
features.[24]

 This amateur intellectual has interrupted his reading (the open book
roll lies on the ground where he dropped it) and sits lost in thought.
This is expressed, however, in a visual motif that is thus far unique. He
holds his head high and raises one hand to his brow, as if he were look-
ing out into the distance, or as if he were having a vision. On either
side of the medallion stand a man carrying a sheep and a fisherman,
while below, on a smaller scale, are two shepherds with their flock. All
these bucolic elements have a long pictorial and literary tradition and
would have been familiar to the contemporary viewer as symbols of
the happy life.[25] The message seems to be that intellectual pursuits and
the rural life confer on the individual a happiness and peace of mind
comparable to that of the carefree shepherd. This is made even clearer
by two complementary scenes on the short sides of the sarcophagus.
In one, two philosophers, dressed as the seated figure on the front,
engage in conversation, while, in the other, a herdsman pastures his
sheep. On the one hand, the "philosopher" is assimilated to this bu-
colic world through his knotty staff and animal hide, while, on the

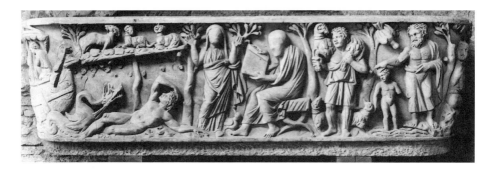

FIG. 155 Sarcophagus of a married couple with bu-
colic and biblical scenes. Late third century A.D.
Rome, Santa Maria Antiqua.

other, his carefully arranged garment and the various props (the marble
seat, sundial, vine-covered pillar, and bookcase) tie him firmly to the
well-tended villa where he devotes himself to his studies.

Along with the infiltration of these bucolic motifs into the world
of the amateur intellectual comes frequently a changing imagery for
women. The Basel sarcophagus, like others of the later third century,
depicts the wife as an *orans,* with both arms raised. Comparison with
images on coins prove that this is a symbol for piety (*pietas*). The Muse
has become a woman of prayer. This too, however, is a role for women
that is well established in the traditions of Roman art. Julio-Claudian
princesses, for example, had sometimes been shown in the same posi-
tion of prayer.

Learning and the life of the mind are now presented as assisting in
the search to attain inner peace and happiness. One of the earliest
Christian sarcophagi, in Santa Maria Antiqua at the Roman Forum,
illustrates this especially vividly (fig. 155).[26] The reader-philosopher
sits in the open air beside his praying wife, framed by a man carrying a
sheep and the figure of the prophet Jonah reclining under a bower (a
popular image in catacomb paintings, which does not correspond to
the biblical tale of Jonah but was first created in this period as a Chris-
tian version of the bucolic idyll). The baptism scene at the right edge,
along with the figure of Jonah, identifies the context here as a Chris-

tian one. Hence the reading figure in the middle is most likely not studying the classics, but rather Scripture. In contrast to earlier imagery, the reader is now devoid of any ostentation. He is completely oblivious of the world around him.[27] Reading itself has become a pious activity, and there is no fundamental difference between the husband's devotional reading and his wife's prayer. This is particularly well illustrated on a sarcophagus relief in the Museo Civico at Velletri.[28] The deceased woman stands in the *orans* pose in the center, flanked at either side by a shepherd. The space in between is filled with a patchwork of small-scale scenes from the Old and New Testaments. In one of these little scenes, right next to the *orans,* a philosopher sits beside a chest filled with book rolls and reads. Thus a chain of associations is created between the reading of the Scriptures, faith and prayer, and the happy condition that these lead to. The direct connection between reading and praying figures must be deliberate; it implies that the whole character of intellectual activity has changed.

Beginning in the later third century, the question was hotly debated in philosophical circles whether the wise man should withdraw from public life entirely or only on occasion, whether by means of a kind of "inner escape" within the city (there were some philosophers who no longer went out of the house) or by moving out to the country. The notion itself was not new. In the Flavian period, the Stoic philosopher Musonius Rufus had explicitly recommended the life of a peasant or shepherd to the philosophically inclined individual: "And if the tending of the flocks did Hesiod no dishonor, nor did it prevent the gods and the Muses from loving him, then neither should it anyone else. For me this is the most agreeable of all rural activities, for it offers the soul the greatest opportunities for leisure and reflection, and for the pursuit of everything we mean by *paideia.*"[29]

Now, however, this association between the philosopher and the pastoral life came to be seen as so desirable that it is not unusual to find a well-dressed wise man actually tending a flock of sheep or, conversely, conventional shepherds depicted with the pose and facial expression of an intellectual.[30] The very fact that such motifs were adopted so naturally into the pictorial vocabulary shows that these

metaphors for spiritual longing must have been firmly fixed in the minds of many people outside the narrow philosophical circles.

But whereas the real philosophers and, soon after, the first of the Christian hermits longed for isolated spots devoid of human contact, the amateur intellectual generally appears in scenes where he is well integrated into the life of a country estate. So, for example, the land-owner might be shown on sarcophagi reading, his wife at prayer, in the midst of scenes of vintaging, the olive harvest, hunting, or a country meal. A large mosaic from a villa at Arroniz (Navarra) shows several men in contemporary dress, probably large landowners, as literati accompanied by their Muses, each against the backdrop of a villa setting. And a North African mosaic combines a bucolic scene with a villa garden and clearly labels the whole ensemble as *filoso[fi?] filolocus*.[31]

Naturally the age-old Roman tradition of *otium* and the continuing attraction of villa culture played an important role in all this.[32] But it is not enough to describe this phenomenon as simply a revival of the old idea of *otium*. At least in the case of some of the Neoplatonists and their followers, we are now dealing with an escape from "the world." The principal goal is to avoid any kind of disturbance so that one may focus on the interior life, tranquility of the spirit, and the search for God.[33] But even for the landowner, the path from Rome to one's country house becomes a symbolic journey into the world of the spirit. As a series of scenes on sarcophagus lids of the early fourth century illustrates, reading and discussion might begin already in the car on the journey out (fig. 156).[34]

In the time of Constantine, Aidesios of Cappadocia, a pupil of the famous Iamblichus, consulted a mystic oracle and was given a choice between a life of "undying fame" in the cities or one as a shepherd or cowherd "with the hope of union with the immortal gods," that is, a divine revelation. (Musonius, we recall, had spoken only of the search "for everything we mean by *paideia*.") Aidesios did actually acquire a small farmstead in the mountains of Cappadocia, but it was not long before his own pupils could persuade him to return to the philosophical schools. In the opinion of Eunapius, who records the story (*VS* 465), this was not the better course. It is only against the background of such hopes for divine revelation through isolation from the

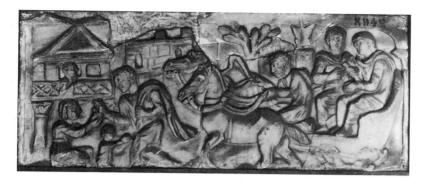

FIG. 156 Fragment of the lid of a large sarcophagus,
showing a man and his wife in conversation on the way
to their villa. Ca. A.D. 280. Rome, Terme Museum.

world that we can grasp the full significance of the visionary gestures
of the "philosopher" on the Basel sarcophagus or the many *orans* fig-
ures directing their admonition straight at the viewer.

Christ as the Teacher of the True Philosophy

> *He who would observe the image of God in earthly colors, on
> the grounds of His having become a man, let him be accursed!*
> —Bishop Epiphanius of Cyprus (ca. A.D. 400)

With the official recognition of Christianity, sculptors' and painters'
workshops in Rome were quick to respond to the changing wishes of
their clientele.35 Traditional imagery, especially drawn from my-
thology, becomes rare, and a new Christian iconography suddenly
takes its place. Bucolic symbolism of peace and happiness is replaced
by scenes of miracles, and Christ, the teacher of wisdom, takes the
place of the cultivated Roman citizen. The fundamental moral objec-
tion to visual imagery on the part of the bishops and church fathers

was evidently outweighed by the layman's powerful need to evoke the new message of salvation in physical form.[36] For our purposes, two aspects of this phenomenon are of particular interest: the remarkable continuity of the imagery and, at the same time, the sharpening of the hierarchical dichotomy between master and pupil.[37] Christ himself, the apostles, prophets, and saints are all depicted like pagan intellectuals. As a rule they wear the Greek mantle (*pallium*) with undergarment and hold a book roll in one hand—even when this seems rather an impediment in certain scenes of miracles.

But it was not through the medium of visual imagery alone that the Christians set themselves firmly in the tradition of the pagan cult of learning. They also assimilated themselves to it in their daily lives. Tertullian first declares the *pallium* to be the suitable garment for a Christian (*De pallio* 6). In the Eastern provinces, this would not have been noticeable, but in the West it meant the adoption of distinctively intellectual dress. In addition, from the third century on, church fathers recommend the wearing of a beard. Clement of Alexandria, for example, writes in favor of the beard on the grounds that it gives a man a dignified and awe-inspiring appearance (*Paid.* 3.11.60). Sometimes the beard is justified on moral grounds, just as earlier the Stoics had done. Augustine writes: "Barba significat fortes, barba significat iuvenes, strenuos, impigros, alacres" (*Enar. in psalm.* 132 [Migne 37.1733]).[38] Thus Christians who followed this advice on dress and appearance would have taken on the traditional image of the philosopher. This was presumably true above all for the clergy. On the Carrand Diptych of ca. 400 (cf. fig. 161), the apostle Paul and his pupils appear in conventional philosopher dress. This evidently reflects the styles worn by the clergy in this period, since the imperial magistrate and his entourage on the same diptych also wear the official outfits current at the time.[39]

But when there was a need to fashion the very essence of Christ into a single visual image, he was depicted exclusively as the teacher of wisdom starting in the later third century, both in catacomb paintings and on sarcophagi.[40] The usual pose was seated frontally facing the viewer, which had already been used on earlier sarcophagi and was

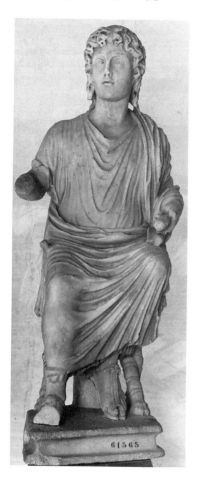

FIG. 157 Christ teaching, from a
column sarcophagus (?). Ca.
A.D. 380. Rome, Terme Museum.

derived from the magistrates in Roman state art. Even earlier, profes-
sional teachers had been depicted in this pose of authority (cf. fig. 126).
The typological similarity is particularly striking when we compare
images of Christ with the "child intellectuals" of Roman funerary art,
for example, the youthful statuette of Christ in the Terme Museum in
Rome (fig. 157) with a child sarcophagus in the Louvre or the funerary

FIG. 158 Funerary mosaic for the nine-year-old
T. Aurelius Aurelianus. Third century A.D. Split,
Archaeological Museum.

mosaic for a nine-year-old boy in the museum at Split (fig. 158).[41]
These wunderkinder, chosen at random, match the image of Christ as
teacher in pose, gestures, and drapery. Indeed, the so-called statuette
of Christ might actually be a fragment from one of the sarcophagi
showing scenes of instruction that has been reworked into a statuette
by the modern restorer.[42] Thus Christ appears in a pictorial formula
that would have been generally familiar and thereby embodies pre-
cisely the same qualities that had long enjoyed such high status in the
self-image of the ordinary Roman: learning and a philosophical ori-
entation in life. To non-Christians, these pictures of the new teacher
of wisdom offered a familiar image as well. In this respect they were
well suited to make Christ's teachings appear to be the continuation of
a long tradition, one that was trusted and revered.

But whereas the amateur intellectuals of earlier funerary art had
been shown accompanied by Muses, philosophical counselors, and

family members, Christ now sits closely surrounded by his disciples, who are also depicted frontally. The pictorial image of the teacher is set within a different context, a kind of public gathering instead of the domestic ambience. Christ invariably holds either a book roll or a codex in his left hand. He does not actually read but rather proclaims his teachings contained therein. On the sarcophagus of Bishop Concordius of Arles (d. 374), the opened codex bears the words *dominus legem dat* (fig. 159a, b).43 Often the apostles have opened rolls or books in their hands as well, and they sometimes converse among themselves. At first glance such scenes are reminiscent of earlier gatherings of philosophers, as, for example, on a small mosaic of the Early Imperial period (fig. 160).44 But while these scenes are composed of several smaller, fragmented groupings, the strict symmetry of the Christian scenes expresses in visual terms the notions of consensus and absolute devotion. The Lex Christi is hailed as the "new philosophy," a metaphor employed as early as Saint Justin and the Alexandrian apologists about A.D. 200. At the same time, however, it is made clear that there is no longer an alternative to this "philosophy."

The motif of frontality had first appeared on "philosopher sarcophagi" of the second half of the third century, but in those scenes the accompanying figures were still turned toward the deceased whose learning they acknowledge. In Christian imagery, however, the viewer is directly confronted by the whole gathering, which gives these scenes an immediacy unknown up to this time. The viewer is drawn into the group receiving instruction, yet at the same time distanced by a sense of awe. If the hypothesis is correct that among the prototypes of the large-scale catacomb paintings and relief sarcophagi were imposing frescoes or mosaics in the apses of Constantinian basilicas, this would only confirm the consciously religious function of the frontal image. We must also keep in mind that the mosaic in the apse was reenacted, as it were, in ritual, whenever, during the service, the bishop and his circle of clergymen took their places on the big bench of the exedra beneath the apse. In this way the bishop drew his authority directly from that of Christ, the teacher of wisdom, and his apostles. We shall return once more to the hierarchical structure of these images.

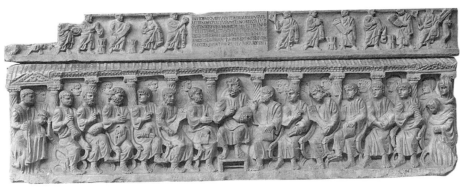

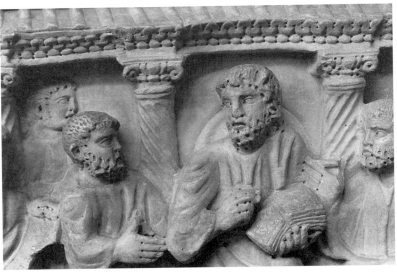

FIG. 159 a–b Sarcophagus of Bishop Concordius. Last
quarter of the fourth century A.D. Arles, Musée d'Art
Chrétien.

Iconographical formulas are stereotyped images, the vehicles that
convey ideas and values. The artist who employs an old formula for a
new idea fixes that idea in a specific form, one that carries with it all
the connotations still attached to the formula from its earlier use. In so
doing, he also, consciously or unconsciously, excludes alternative as-

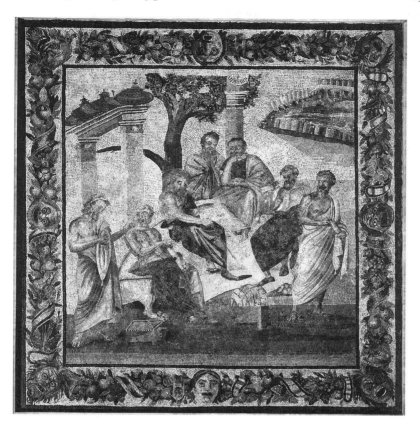

FIG. 160 Mosaic from Pompeii with a gathering of
philosophers. First century B.C. Naples, Museo
Nazionale.

sociations that conceivably are integral parts of the new idea. He may,
that is, alter the very character of the idea.

That Christ should appear in the image of the philosopher-teacher
was anything but obvious and certainly not so ordained by Scripture.
Seeing a youthful Christ in the schema of the intellectual wunder-
kind, the Christian viewer may naturally have thought of his appear-
ance before the Doctors, while the bearded Christ would have re-
minded them of the Sermon on the Mount. But the scenes of his

teaching a group of disciples are not tailored to a specific event in the life of Jesus (with the exception of the scene on polychrome plaques, fig. 162), which would have been easy to do through the addition of the appropriate subsidiary figures. For this reason the likeness to the philosopher-teacher achieves its full effect.

The metaphor of Christ as philosopher amid a learned gathering, however, represented a distortion of what was new and distinctive about Christian doctrine, for Christianity, despite its gradual penetration into the upper strata of society, always wanted to remain the religion of the common people. Christ's message of salvation was directed explicitly at slaves as well as free people, poor as well as rich, uneducated and learned. The apostles themselves had been simple people, and Justin Martyr celebrates Jesus specifically as a carpenter. But the men in these early images come across exclusively as educated and upper class. With the adoption of the earlier iconography of the intellectual, the entire "cultural milieu" of the cult of learning, as Marrou called it, permeates the visual image. The tradition must have been so strong that even the Christians could not envisage their savior in any way other than as the familiar teacher of wisdom. This is yet a further, retrospective corroboration of how thoroughly the cult of learning had penetrated the popular mentality. At the same time, the widespread use of the motif of Christ teaching his disciples on the tombs of average middle-class citizens shows that the concept of Christianity as the "true philosophy," a metaphor originally claimed by the learned apologists in their debate with the pagans, had by at least the early fourth century become current and fully accepted by the Christian populace. These images provide powerful testimony in favor of the controversial thesis, first formulated by Adolf von Harnack, of the "Hellenization" of Christianity. Usually what is meant by this is the assimilation into Christian theology of the terminology and thought patterns of earlier philosophers.[45] The visual imagery illustrates in addition a belief, widespread among the faithful, in Christ as above all a great teacher.

These scenes of highly cultivated apostles with their philosopher-teacher raise yet another issue. The Christians were constantly looked down on as uneducated and subjected to the resulting social discrimination at the hands of the wealthy and educated classes, precisely be-

cause the new religion had had its initial success primarily among the poor. Christian apologists were always trying in vain to counter this prejudice. In this light, the imagery of the cultivated gathering of learned men may be seen as a response to these charges. These formulaic scenes functioned at several levels, directed both at the Christian community and outside it.[46]

The close association between miracles and the gospel of salvation reveals a similar dependence on traditional beliefs. As is well known, the iconography of Early Christian art is based largely on the depiction of certain miracles, and these are the very ones ascribed to the pagan "holy men." The great example is once again Apollonius of Tyana, who is credited in Philostratus' biography with healing the sick, driving away demons, out-of-body experiences, and even raising the dead. There are similar accounts in Eunapius' *Lives of the Philosophers,* recorded about A.D. 390. In both the pagan and the Christian context, the miracles serve to lend credibility to the teachings, as well as to demonstrate the holiness of the teacher. The scenes of Paul on the Carrand Diptych mentioned earlier are a good example (fig. 161a). The apostle teaches in the same pose as Christ, except that he does not face the viewer. The narrative is confined within the scene, where two pupils, also portrayed as philosophers or scholars, devotedly listen to his words. As with both Christ and the pagan "holy men," the authority of Paul's teachings derives from his superhuman powers, which are evoked in two additional scenes. In the central panel, the miracle of the viper on Malta is narrated and, at the same time, substantiated by the secular authority of a magistrate. Below, a crowd seeking salvation presses toward the miracle worker. At the same time, however, Paul's teaching is also seen to derive directly from God by means of the likeness to Adam, who is shown in Paradise at the right side of the image.[47]

The Dual Face of Christ

One of the most remarkable features of Early Christian art is the dual *imago Christi*. Christ is depicted both as a radiant youth or boy and—

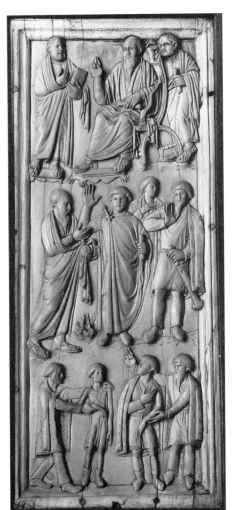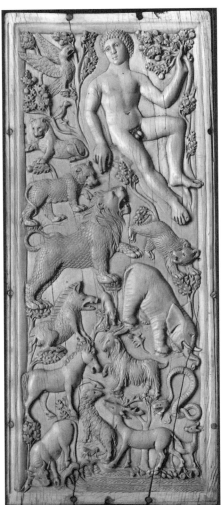

FIG. 161 Ivory diptych showing Paul as teacher and
miracle worker and Adam in Paradise. Ca. A.D. 400.
Florence, Bargello.

though much less often at first—with a full beard and shoulder-length hair. Both portrait types can be used in scenes of the same subject, even many times on the same monument, yet no straightforward differentiation in meaning can be discerned.[48] Evidently there was no single, all-embracing image for the figure of Christ in the traditional vocabulary that was considered adequate. Perhaps, then, we should interpret the deliberate juxtaposition of both types as an attempt to capture the totality of Christ's nature through an accumulative process. The phenomenon is of particular interest for our investigation because both portrait types ultimately go back to ideas and pictorial models from the pagan cult of learning.

Let us consider first the youthful Christ. The picture of Christ given by Justin, Tertullian, and Clement of Alexandria is still unremarkable, and it is only in the course of the third century that the image of the beautiful youth appears, probably first among the Gnostics.[49] This is surely an instance of "Hellenization." In the scholarly literature the radiant youth has often been identified with Apollo, but this does not provide a concrete iconographical link, since Apollo's beauty is best revealed in his nude body. Rather, we may recall the tradition of romanticized portraits of young men with long hair of the second century A.D., which conjured up various Greek heroes from Achilles to Alexander the Great as a kind of nostalgic expression of faith in the revival and preservation of classical culture (cf. fig. 157). Other idealized images of the youth with beautiful long hair may have had an influence as well, such as the *Genius Populi Romani*.[50] Along with the long-haired youth, we also find not infrequently an even younger, almost childlike image of Christ, not only in some of the more modest catacomb paintings, but also on some especially fine sarcophagi. This is surely somehow related to the type of the intellectual wunderkind, which, as we have seen, was especially popular in Roman funerary art of the later third century (fig. 149). Philostratus and Eunapius also, incidentally, regularly report that the charismatic wise men had been wunderkinder too, distinguished both by their spiritual powers and by extraordinary beauty.

This widespread enthusiasm for the intellectual wunderkind, which only increased as the Empire wore on, represents a definitive break

with the traditions of Greece, where mental powers and wisdom were always associated with advancing age. We are now confronted instead with the notion of a new and miraculous kind of wisdom, something one is born with, a gift, no longer the result of either great mental effort or experience. When these idealized notions of the miracle worker are adopted for the image of Christ, they take on an added dimension. This divine youth, the Son of God, stands for an all-encompassing hope for a new world.

The type of the bearded Christ, on the other hand, has always been recognized as inspired by philosopher iconography. A different avenue of interpretation, which seeks to establish a link to the Classical iconography of the Greek gods, whether Zeus or, as more recently suggested, Asklepios, has rightly found little favor.[51] Nevertheless, I believe it is one particular tradition of philosopher iconography with which we are dealing. His shoulder-length hair clearly separates the bearded Christ from the philosopher portraits of Classical and Hellenistic art and places him instead in another tradition, one that we first encountered in the description of Euphrates (cf. p. 257). As I have tried to demonstrate, this type of portrait, or, rather, the self-image that lies behind it, was meant to translate into visual terms a special aura of dignity, as well as magical and spiritual powers to which these "holy men" lay claim. Of all the guises in which intellectuals of the past had appeared, this one radiated the ultimate authority. Although it has proved impossible to arrive at a clearly defined prototype, both because literary descriptions are vague and contradictory and because the visual evidence from the second century is still rather spotty, I nevertheless remain convinced that the image of the bearded Christ with shoulder-length hair is closely associated with that of the *theios anēr*. The comparison of Christ with the pagan miracle workers, who likewise possessed divine powers and, in their own way, also promised a kind of "salvation," was self-evident and became a favorite topos in the debate between pagans and Christians. It is in the portraiture of the later Charismatic philosophers, who were believed even more "holy" and "divine," that we shall once again encounter the type with shoulder-length hair.

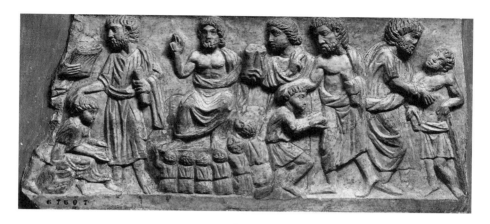

FIG. 162 So-called polychrome plaques, showing
Christ performing miracles and at the Sermon on the
Mount. Ca. A.D. 300. Rome, Terme Museum.

The first secure example of a bearded Christ belonging to this tra-
dition is on the "polychrome plaques" made in Rome about A.D. 300
(fig. 162). But there must have been earlier examples, as we can infer
from references to the images of Christ of the Karpokratians, who used
these as objects of cult worship, along with portraits of Plato, Aristotle,
Pythagoras, and others.[52] Christ appears in several scenes on the poly-
chrome plaques as healer or miracle worker, sometimes still depicted
as an ascetic philosopher with no undergarment, similar to the figure
of the itinerant philosopher in the Herakleion Museum that we saw
earlier (fig. 143). In one scene, however, he turns to look out of the
picture, gesturing like a public speaker and conspicuously holding
aloft a book roll. Several small figures sit listening at his feet, implying
that this must be a specific event, such as the Sermon on the Mount.
Significantly, in this particular scene Christ's long, thick hair is espe-
cially emphasized.

Only about the middle of the fourth century does the image of
Christ as the *theios anēr* become widespread on sarcophagi and in cata-
comb paintings, both in scenes with multiple figures and in the form
of painted busts (fig. 163).[53] He is always shown frontally, and both

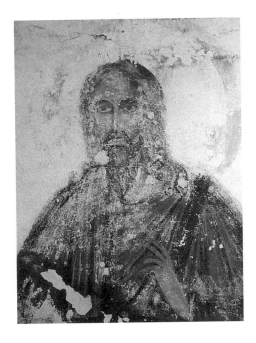

FIG. 163 Detail of a ceiling fresco in the
Catacomb of Saints Marcellino and Pietro in
Rome, showing Christ teaching between Pe-
ter and Paul. Second half of the fourth cen-
tury A.D.

beard and hair are particularly lush and carefully tended. The high
forehead shows no emotion and is emphasized by the central part.
Equally consistent is the immaculately draped garment. All of these
traits must be intended to banish any possible association with the
"filthy" image of the itinerant Cynic philosopher. Instead, the lavish,
dense hair emphasizes his magical powers. The painted portrait busts
in the catacombs, which have rightly been said to reflect major works
of ecclesiastical art, first present us with the fully formed image of
Christ in majesty that will so dominate Byzantine art.

 In the time of Theodosius, when the bearded Christ on sarcophagi
proclaims his law with a magisterial gesture, the old formula has taken

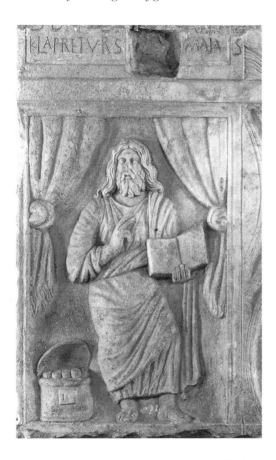

FIG. 164 Strigilated sarcophagus showing Christ
as teacher. Ca. A.D. 370. Rome, Sant'Agnese
fuori le mura.

on a new meaning. Yet a more modest strigilated sarcophagus of
the same period illustrates how the continuity from the image of the
teacher of wisdom has still not been forgotten (fig. 164). As in the
earlier scenes with the gathering of pupils, Christ turns directly to
the viewer and presents him with the Scripture. The chest of book
rolls once again emphasizes the great learning of the teacher. But the

curtains, as in Imperial state art, characterize the site of his epiphany as an impressive public setting. Meanwhile, the lid illustrates that ancient symbol of happiness, the marine *thiasos*.[54]

At this point we should take at least a brief look at the portraits of the apostles. Typologically they are quite distinct from the image of Christ and are based instead on the traditional repertoire and iconography of the intellectual. Particularly characteristic are the conventional beard, the bald head, and the expression of concentrated thought. The countenance of Christ, by contrast, is free of any sign of exertion.[55] This is also true of Peter and Paul, who early on were set apart from the others in Roman art and received a distinctive physiognomy. Paul is usually bald and/or has a long beard tapering to a point, while Peter has a "classically" styled beard and hair.

Sometimes we may even have the impression that the assimilation of the apostles' iconography to that of the ancient philosophers may have served the artists or their patrons as a means of conveying certain specific messages. Thus, for example, on a well-known ivory pyxis in Berlin (fig. 165), the head of Paul is clearly reminiscent of Socrates, while Peter holds a "Cynic's club" and has the unkempt hair of an itinerant philosopher.[56] Both these visual allusions evoke earlier sets of associations.

Yet in spite of all these ties to the pagan iconography of the intellectual, the imagery of Christ quickly transcends the received tradition. Early Christian art brings about a fundamental change in the depiction of the intellectual and of the workings of the mind. For the first time we are confronted with a clearly defined hierarchy, in which the teacher enjoys absolute authority and the pupils appear fully devoted to him. Furthermore, for the first time the viewer is addressed directly and virtually drawn into the scene. The gathering of teacher and pupils becomes a kind of devotionary image. Not incidentally, from now on the book rolls and codices are displayed in such a way that the viewer is able to read the Holy Writ.

From the beginning there had been a growing tendency in scenes of Christ teaching to portray him as the dominant figure. Although some of the earliest catacomb paintings show Christ on virtually the same

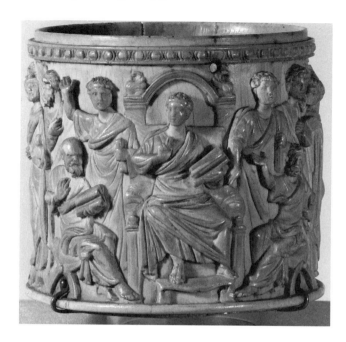

FIG. 165 Ivory pyxis showing Christ enthroned as
teacher above the apostles, with Peter and Paul next to
him. After A.D. 400. Berlin, Staatliche Museen.

scale as the disciples, he soon becomes larger and clearly elevated above
them. Yet even so, the image of Christ as philosophical teacher was
eventually not enough, since it failed to make visible his divine power.
Thus from the late Constantinian period, certain elements of Imperial
imagery were transferred to Christ, while court theologians and writ-
ers of panegyric developed a symbolic system to demonstrate how the
power of the emperor is derived from that of God. On the sarcophagus
of Junius Bassus, a youthful Christ appears enthroned on the arch of
Heaven as *kosmokratōr,* and it is not long before the apostles, imitating
Byzantine court ritual, approach him with their hands cloaked, to
receive the "law" from the hand of Christ. The viewer is invited to
assume the same attitude of reverence. So, for example, on the sar-
cophagus of Bishop Concordius, two patron figures, representing the

FIG. 166 Mosaic in St. Catherine's in Sinai, showing
the transfiguration of Christ. Sixth century A.D.

populace, are brought before the holy gathering in an appropriately
humble pose (fig. 159).⁵⁷

In these hierarchically structured compositions, the artists make
good use of the different portrait types of Christ and the apostles in
order to give added clarity to the relative ordering of status. Apart from
Christ, only the prophets, the evangelists, and a few figures from the
Old Testament who enjoyed positions of special authority, such as
Abraham and Melchizedek, are depicted with long hair and a full
beard. To differentiate them from Christ, they often have grey hair, or
their hair and beard are not as carefully styled. Just how rigidly the
hierarchy was sometimes observed is illustrated by the splendid mosaic
of the transfiguration of Christ in the Monastery of St. Catherine in
Sinai (fig. 166).⁵⁸ Christ hovers between Elijah and Moses, all three

represented in the portrait type of the "holy man." But whereas the two prophets stand on earth, Christ appears in a mandorla. Of the disciples at his feet and the apostles, saints, and true believers in the tondi, however, many are shown in the traditional iconography of the Greek intellectual.

The Late Antique Philosopher "Look"

The image of Christ as the teacher of wisdom was not simply derived from that of the *theios anēr;* it was in some sense in competition with it. It is, unfortunately, not possible to reconstruct this process of mutual influence in detail, since the body of evidence for Late Antique philosophers is tiny compared with the wealth of representations of Christ and is mostly quite late as well. There are, however, some literary descriptions that present an impressive glimpse into the beliefs and concerns of the philosophers. They show that their mentality was in many respects not so very different from that of contemporary Christians.

Starting in the third century, the popular notion of a philosopher and what was expected of him once again underwent a major change. Eunapius' *Lives* of contemporary "philosophers and Sophists," written about 400, are fundamentally different from Diogenes Laertius' *Lives of the Philosophers* or the *Lives of the Sophists* of Philostratus, both works of the early third century. While both these earlier accounts deal with men who were well integrated into urban society and displayed a whole range of human strengths and weaknesses, Eunapius writes what are basically hagiographies. He presents the reader with a new kind of mental and spiritual superman who despises his mortal body and continually seeks purification in order to be nearer the gods, who even enjoys certain divine powers himself, and whose entire life is surrounded by an aura of the mystic and the sacred. Each one of the *Lives* is based upon the same catalogue of physical and spiritual qualities that we first met in Pliny's description of Euphrates. But in addition there is a greatly heightened religious dimension to them, manifested in supernatural phenomena, miracles, and prophecies that attest to the

presence of the divine in these men, "priests of the all-encompassing divinity" (Porph. *Abst.* 2.49). Here, for example, is Eunapius' description of the philosopher Prohairesios: "One could scarcely estimate his size, so much did he exceed all expectation. For he seemed to be nine feet tall, so that he looked like a colossus, even when he stood alongside the tallest of his contemporaries" (*VS* 487). When Prohairesios was summoned to Gaul by the emperor Constans, many "could not really follow his lectures and thus admire the secrets of his soul. For this reason they clung to what they could see clearly before them, the size and beauty of his body. They looked up to him as to a colossal statue, so much did his appearance outmeasure any human standard" (*VS* 487, 492).[59] The religious aura is intensified by the repeated references to looking up to a statue. As early as the mid-third century, in a scene from the tomb of the Aurelii in Rome, is a depiction of one of the miraculous wise men, over-life-size, sitting in some public place and instructing the throngs who crowd around him.[60] We are apparently dealing here with a very widespread need, among Christians and non-Christians, educated and uneducated people alike, to believe in an incarnation of the divine, and even the "holy men" themselves could not escape it. Iamblichus, for example, feels compelled to contradict his pupils when they believe that when he is privately at prayer, "his body would rise up ten ells above the earth, and his garment would radiate with a golden beauty" (Eunap. *VS* 458). When the transfigured Christ appears in the mandorla, he embodies essentially the same visual conception.

With all this, the great philosophers of late antiquity still considered themselves the spiritual heirs to the classical tradition. They sought their philosophical roots above all in certain of the metaphysical writings of Plato, which they had "rediscovered" and "purified." In their daily lives, however, they modeled themselves most closely on Pythagoras, the ascetic, pious, and pure philosopher of Porphyrius' description (*Vit. Pyth.*). Indeed, Philostratus had already turned Apollonius of Tyana into a pure Pythagorean. Starting with Plotinus, this amalgam of Platonic, Pythagorean, and mystical elements was thought to constitute a sacred teaching, which would be passed on within the Neoplatonic school from generation to generation, by one "divine"

(*theios*) or "holy" (*hieros*) man to the next. Unlike in earlier philosophical schools, contemplation of the divine, oracles, and secret teachings all now played a central role. In the practice of what is called theurgy, associated above all with Iamblichus, the gods themselves intervene directly and raise up the human soul to themselves in a gesture that transcends any intellectual effort.[61]

But not every worshipper had equal access to this ultimate mystery. The result was a new set of hierarchical structures within the philosophical schools, very different from that of Christianity. The fundamental distinction was between, on the one hand, the traditionally learned philosophers, known as *philosophoi* or *philomatheis* ("lovers of learning") and, on the other, those few who had attained the highest form of mystic revelation, the *hieratikoi, theioi,* or *hieroi*.[62] These "divine" individuals were above any criticism. Eunapius describes the effect that Maximus of Ephesus, the controversial teacher of Julian the Apostate, had on his pupils: "No one dared contradict him, even the most experienced and verbally skilled of his pupils, on those rare occasions when they dared address him at all. Rather, they listened to him in rapt silence and took in everything he said, as if it had been spoken from the tripod [of Apollo in Delphi]. So sweet and compelling were the words that issued from his lips" (*VS* 473).

This spirit of subservience to a towering figure of intellectual authority is already reflected on a beautiful philosopher mosaic in Apamea made after ca. 350 (fig. 167). Six of the ancient sages sit on either side of Socrates and listen to his teachings. Although they are still characterized by physiognomic differences, it is only Socrates, elevated like Christ by his central position, who is named by a large inscription. The very man who once cast doubt on the idea of certain knowledge now instructs others *ex cathedra*. The mosaic was found at Apamea in Syria, the home of a famous Neoplatonic school where Plotinus' pupil Iamblichus, one of the "golden chain of the divine," had taught.[63]

After the triumph of Christianity, the philosophers and rhetoricians lost the tremendous prestige that they had earlier enjoyed in Roman society. Although their ranks continued to be replenished from the urban aristocracies, and they occasionally still held public office, after the failure of Julian the Apostate they quickly became marginalized.

FIG. 167 Mosaic in Apamea in Syria, showing Socrates
as the teacher of philosophers and wise men. A.D. 362/63.

Men of the church now dominated the intellectual field. This is most
likely the reason for the very modest number of preserved philosopher
portraits from this period.

But in these same circumstances, the pagan philosophers gradually
took on a new role. Their schools became repositories of Hellenism in
this late phase, places where both classical learning and the cults of the
gods were still maintained. It was only natural that, along with their
intellectual activities, these late pagan philosophers also served as
priests. Proclus (412–485) was still making public sacrifices to Askle-
pios, even though the emperor Theodosius had ordered the closing of
all pagan temples in 391.

Of the few securely identified portraits of philosophers, to which I
should now like to turn, it is significant that all of them save one wear
the wreath or fillet that is the mark of priestly office. This makes clear
how central the priesthoods had become to the identity of these Late
Antique philosophers. It may be just an accident of preservation that
these portraits all belong to the early fifth century (figs. 168, 170, 171).
Typologically they are an astonishingly homogeneous group, even

though they have been found in very different parts of the Empire. All wear a beard and the thick, shoulder-length hair of Christ and the earlier "divine men." Their appearance is consistently elegant, the beard and hair neatly combed and parted, the garment impeccably draped. In contrast to the Christian ascetics, who neglected their outward appearance in the manner of the Cynics, the pagan "holy men" always remained an integral part of urban culture. Their style reflected their mainly aristocratic origins. The finest of the portraits are characterized by a remarkably dramatic facial expression turned upward, a trait not found in portraits of contemporary individuals. This must have a specific meaning, a point to which I shall return presently.

Given the striking similarities of these portraits, one might well question how true to life they can be, especially with respect to the long hair. These can hardly be realistic representations, since it is rather unlikely that all these men of advancing age had consistently luxuriant, full heads of hair. Could it be that the "divine" figures in the philosophical schools wore hieratic wigs or masks, like the earlier priest of Asklepios, Abonuteichos (cf. p. 263)?

The provenance of four of these portraits is known: Athens, Constantinople (Istanbul), Aphrodisias, and Rome. We can therefore assume that this last of the ancient types of intellectual portraiture was spread through the whole of the Empire.[64] The uniformity within the group also leads to the inference that differences among the various philosophical traditions no longer mattered in shaping the identity of the individual. The known provenances echo precisely what Garth Fowden has called the "topography of holiness." For along with the revived Platonic Academy in Athens, the major schools were located in the cities of Asia Minor—Pergamum, Ephesus, Sardis, Aphrodisias—as well as in Apamea in Syria and Alexandria in Egypt. It was in these great centers, which transcended regional boundaries and were closely linked to one another, that classical studies still flourished into the fifth century.

R. R. R. Smith has been able for the first time to reconstruct a specific setting for one of these portraits of an old philosopher, based upon the archaeological context of the recent discovery at Aphrodisias (fig. 168).[65] Together with several other tondo portraits, it decorated an exedra, which, along with a porticus and an apsidal room, was built

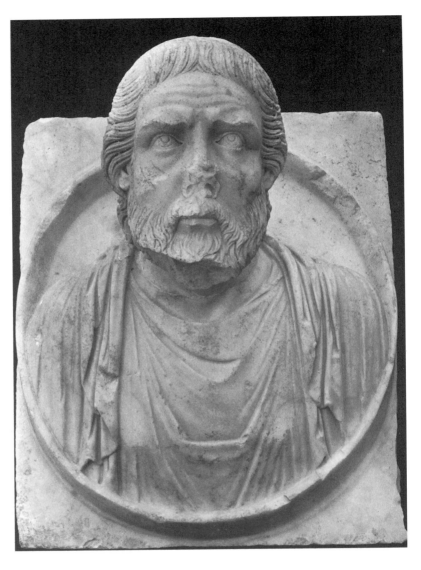

FIG. 168 Tondo from an apsidal hall: portrait of
a contemporary philosopher. Early fifth century A.D.
Aphrodisias, Museum.

onto a wealthy residence of the Early Imperial period. The building was situated in the middle of the city, directly behind the well-known Caesareum. Smith adduces good reasons for identifying the complex as the location of the Neoplatonic philosophical school of Aphrodisias, where Asklepiodotus taught in the fifth century. He had studied with Proclus in Athens and later married the daughter of one of the richest citizens of Aphrodisias. The lavish decoration and central location of the school confirm that the philosophers of Aphrodisias still enjoyed public recognition and had access to substantial funds. The tondi, of course, were placed to be visible not from the outside, but rather from inside. That is, they served as inspiration to the teachers and pupils, not as a means of showing off to the public at large.

The preserved portraits and fragments fall into two different series. The one includes heads of ancient poets and philosophers, identified by inscriptions, some shown with their famous pupils (Aristotle with Alexander, Socrates with Alcibiades); also Pindar, Pythagoras, and Apollonius (presumably the one from Tyana). The other group comprises the contemporary philosopher, a beardless, rather youthful pupil, and a third contemporary male portrait, identified by Smith as a "Sophist." The latter two may be identified as members of a local family of *honoratiores,* who had accommodated the school in their home or been its benefactors in some other way. Unlike the first group, these carry no names inscribed, perhaps a token of modesty. Yet the head of the philosopher is larger than all the other portraits. He must have occupied a key position in the school's hierarchy.

A particularly interesting figure in this context is the so-called Sophist, who is also characterized as an intellectual yet is clearly several notches below the philosopher in status (fig. 169). The receding hairline and closely trimmed beard recall the "learned portraits" of the second century A.D., which were in turn assimilated to great thinkers of the past (see pp. 225ff.). In contrast to the philosophers, his hair falls only to the nape of the neck, not onto the shoulders. He could also be a member of the school, one whose inferior spiritual rank is expressed through differences in hair and beard.

The whole program of busts of ancient philosophers and poets gives us some insight into the profile of the philosophical school. Classical

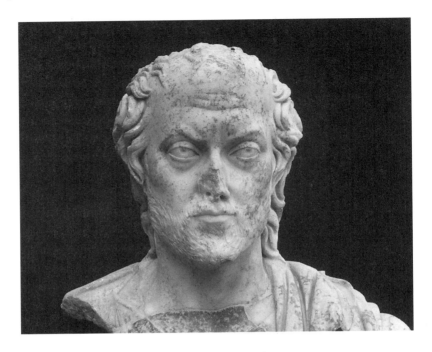

FIG. 169 Portrait of an amateur philosopher (?), from
the same series as fig. 168. Aphrodisias, Museum.

authors still constitute the foundation of its teaching, with the close
teacher-pupil relationship highlighted by the famous pairs, that is, as
models for the present-day relationship of wise teacher to pupils. The
portraits of Pythagoras and Apollonius (Plato must have been in this
series too) perhaps represent a particular branch of Late Antique Neo-
platonic philosophy. The analogy with the famous teacher-pupil pairs
underscores the close relationship between the contemporary philoso-
pher and the beardless youth. Perhaps his parents had entrusted his
entire upbringing to this philosopher. Porphyrius, in his *Life of Ploti-
nus,* records that parents of the noblest families, just before their
deaths, would entrust both their children and their fortunes to a phi-
losopher as "divine and holy protector" (*Plot.* 9).

 The visual program of the Aphrodisias school is not a unique in-
stance. Evidence of tondo portraits of classical philosophers and poets

has also been found elsewhere. The choice of those deemed worthy of a portrait varied, but the principle was always the same. The presence of these classical authors was intended to certify the Late Antique philosophers as direct heirs to a long intellectual tradition. In the Early Empire there had already been galleries of portrait tondi in the libraries, representing the *veteres scriptores* (Tacitus, *Annals* 2.83). The Christians then adopted the same form of commemoration. Christ appears surrounded by the apostles, saints, and devout patrons, in the same manner as the pagan holy man with his classical authors, more advanced disciples, and boyish pupils.

The wisdom and divine revelation of the philosopher spring from the stores of classical learning. The portraits of the ancient poets and philosophers represent the whole of the Greek tradition, called up in order to confirm the authority of these latest teachers of wisdom. The law of Christ, on the other hand, is founded upon the divine kingdom of the teacher himself. The one series of portraits is retrospective, while the other looks ahead. Christ is the origin of all things, and all lead back to him.

When the original context is lost, it can indeed be difficult in particular instances to distinguish the bust of a holy man from that of Christ in the same schema. Thus, for example, one might at first wonder if the impressive bust in Istanbul (fig. 170) could represent Christ. But in this instance the priest's fillet in the hair suggests instead one of the holy men. A problematic case is the bust of a teacher in Ostia with his right hand in a teaching gesture and a nimbus around his head, done in opus sectile technique (fig. 172).[66] The portrait was found in association with the tondo portrait of a youth in the lavishly decorated marble hall of a patrician house at the Porta Marina. The pairing of what seem to be teacher and pupil must, on the basis of the recent discovery at Aphrodisias, raise doubts about the widely held interpretation of the teacher as Christ. Likewise, two splendid scenes of animal combat with circus lions in much larger format on the same wall argue for a pagan setting. The chamber was abandoned before its completion, ca. A.D. 395. Most likely this was a kind of private philosophical school in the home of a wealthy pagan family, and the animal com-

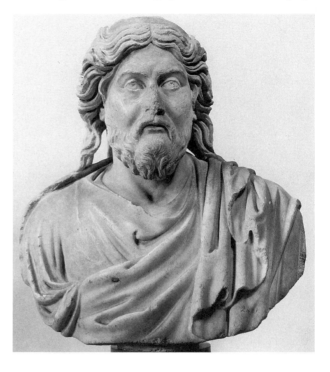

FIG. 170 Bust of a contemporary philosopher. Ca.
A.D. 400. Istanbul, Archaeological Museum.

bats, as on some third-century sarcophagi, allude to the family's public
benefaction of sponsoring the games. If this is the case, then the expla-
nation for the interruption of building activity would be different from
that proposed by Giovanni Becatti and Russell Meiggs. It was caused
by the Christian reaction to the revival of pagan cults, especially under
the emperor Eugenius (d. 394).

The usual interpretation of the hall as a gathering place for Chris-
tians rests on the identification of the sage as Christ, and this in turn
rests largely on the nimbus. But as a representation of light, and hence
a symbol of inner strength, this could be an attribute of a wide variety
of figures and even finds a direct equivalent in the contemporary image
of the "holy man."[67] About A.D. 485 Marinus described the philoso-
pher Proclus thus:

FIG. 171 Philosopher of the early fifth century A.D.
Athens, Acropolis Museum.

He seems truly to have enjoyed a particular divine grace. The words issued
from the wise man's mouth like snowflakes. His eyes were like lightning
bolts, and his whole face was filled with a divine radiance. One day, when
a high magistrate named Rufinus, a serious and distinguished man, came
to his lecture, he actually saw a light running around Proclus' head. After
the lecture he got up, threw himself before him, and bore witness under
oath to this divine manifestation.

(*Vit. Procl.* 23)

FIG. 172 Opus sectile with the portrait of a Charis-
matic philosopher (*theios anēr*) in a nimbus. Ca.
A.D. 395. Ostia, Museum.

Porphyrius had already recorded something similar of Plotinus, and in Eunapius' *Lives* of the philosophers, the gleaming eyes are a standard topos. The eyes of the divinely inspired wise man in Ostia have a particularly intense effect thanks to the colorful intarsia work. The viewer is practically blinded by the dark pupils set amid the big white disk.

In the mysterious rituals of theurgy, which were preceded by fasting, silence, and purification, philosophy became a kind of revelation that surpassed rational thought, a uniting of the soul with the divine. The unusual expressions of the heads in Athens (fig. 171) and Aphrodisias (fig. 168) may be consciously alluding to this mystery. In any case, the sculptors of both works were surely trying to render a state of inner arousal with the head turned upward, the emphatically opened eyes, the brows drawn up, and the lines in the forehead. All these traits are probably meant to convey a readiness for the divine, in expectation of the mystic experience. Everything depended on the degree of one's inner receptivity. As we have seen, the expressions of these "holy men" are entirely different from those of Hellenistic philosophers such as Zeno or Chrysippus (fig. 55), concentrated thinkers whose faces are marked by the will to understand and by the conviction that this can be achieved by dint of their own intellect. The philosopher-priest, by contrast, releases himself, listens expectantly to his inner voice, and turns his spirit into a vessel or a medium.

His expression of longing and of readiness is at the same time profoundly different from the sense of calm and illumination expressed in the portraits of Christ.[68] According to this interpretation, the notion of the "divine" would be represented in the "holy man" in the state of expectation of a higher good, the perfection of his earthly life. But he cannot make this happen, nor can he teach it, for it requires a divine gift that comes to only a few. The portrait in this way expresses something of the curious role of the Late Antique philosophers as élitist outsiders, who saw themselves more and more relegated to the margins of society, even though they usually came from established families and occasionally still served their cities in public office, as Fowden has shown. Christ, however, with his radiant visage, promises the blessings

of divine revelation to *all* the faithful. This was a message with which the pagan holy man could not compete.

Late Roman Copies: New Faces on Old Friends

Let us look once again at the copies based on earlier portraits of the ancient poets and philosophers. In the fourth century A.D., cultivated people were still decorating their houses with mosaics and wall paintings that included the famous Greek intellectuals of the distant past. Most popular were Socrates and the Seven Sages, but occasionally there was a broader selection of philosophers, poets, lawgivers, historians, and orators.[69] Even more interesting for our investigation than these examples of traditional decorative arts are the copies of sculptured portrait types. The exedra in the school at Aphrodisias demonstrates that these were still being produced in the fifth century, while copies of other kinds of Greek statuary had almost ceased to be made by the end of the third century. The setting at Aphrodisias explains the continuing interest in the great thinkers of the past. A number of these portraits are of strikingly high quality and attest to a level of skill and commitment on the part of the sculptor that we find elsewhere only in the best portraits of *honoratiores*.[70]

But what makes the late copies so fascinating is the way the sculptors no longer strive to produce exact copies, as was true earlier, but instead consciously translate the prototype into the visual language of their own epoch. In some cases this is so extreme that we have difficulty identifying a portrait at all. The primary interest was obviously no longer to represent the individual appearance or specific characteristics of each of these great men of the past, but rather to emphasize certain capacities and mental powers that transcend the individual. This process of transformation had already begun in the late third century.

A portrait of Karneades in Bonn, for example (fig. 173),[71] which dates to this period, can still be recognized by the furrowed brow and the turned-down mouth derived from the well-known type (cf. fig. 95). But the immediacy of the expression has been lost. His gaze no longer connects with an interlocutor but is directed upward. The

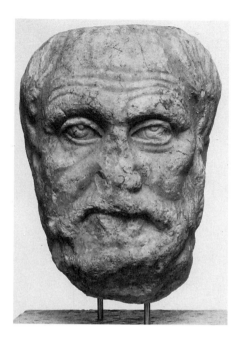

FIG. 173 Carneades. Late Antique version of
the Hellenistic portrait type in figs. 95–96.
Late third century A.C. Bonn, F. J. Dölger
Institute.

only expressive element is the eyes themselves, which are proportion-
ally larger and further accented by the powerfully arched brows. In a
portrait likewise of the late third century, from Ephesus, Socrates has
lost the last vestiges of the silenlike physiognomy (fig. 174).[72] His gaze
fixes the viewer. It is perhaps not surprising that a bust of Menander,
also from Ephesus (fig. 175), was at first taken to be a portrait of a
contemporary of Constantine the Great, so radically has the "copyist"
altered the proportions and facial expression.[73] The lines in the face
and the gentle and vulnerable expression of the copies in Venice and
Copenhagen (cf. figs. 46, 47) have been completely expunged. In-
stead, we simply stare into the enormous eyes. Compared to the Soc-
rates, the expression is considerably intensified, yet the gaze is no

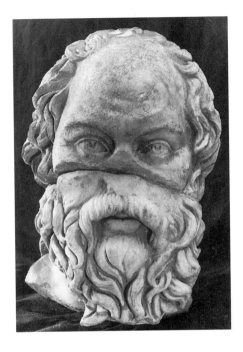

FIG. 174 Socrates. Late Antique version of
the Late Classical portrait type in fig. 35. Ca.
A.D. 300. Selçuk, Museum (from Ephesus).

longer directed at anyone. Instead it conveys an inner illumination that
is by now familiar from the images of philosophers. In another por-
trait of Menander, the tondo formerly at Marbury Hall, this mediat-
ing quality of the expression is further heightened by the wide-open
mouth.74 The late portrait of Pindar from the gallery in Aphrodisias
(fig. 176) may at first glance seem more faithful. But a comparison with
the Late Republican copy in Oslo (cf. fig. 7) reveals that here too the
sculptor has modified the original expression of old age and mental
strain through alterations to the forehead and eyebrows, in order to
create a look of anticipated revelation.75

I think these examples will make the point. Despite all the differ-
ences in individual detail and the variety of styles in different periods,
all these heads are linked through the expression. By emphasizing the

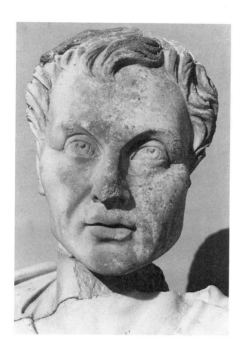

FIG. 175 Menander. Late Antique version
of the Hellenistic portrait type in fig. 47.
Constantinian period. Selçuk, Museum (from
Ephesus).

eyes and the forehead the sculptors wanted to convey the notion that
these intellectuals of the past were also steeped in the spiritual and the
divine. The absence of an individualized face assimilates these portraits
to those of contemporary Romans, who often have a very similar ex-
pression. But in this way the sense of historical distance that was the
basis for the exemplary status of these ancient thinkers is lost.

The process is symptomatic of the age and finds an exact parallel in
the use that the Late Antique philosophers and theurgists made of the
ancients. Like them, the copyist knew the original (in this case, the
portrait, or replicas of it) but kept only as much of the old physiog-
nomy as was necessary for the subject to be recognizable. His true
interest was in his own striving for spirituality and mystic revelation,

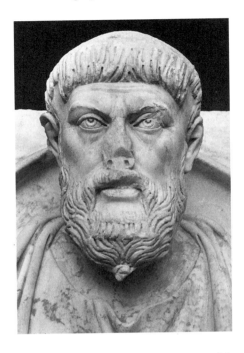

FIG. 176 Pindar. Late Antique version of the
Early Classical portrait type in fig. 7. Early
fifth century A.D. Aphrodisias, Museum.

which he tries to find in the great figures of authority from the past.
The ancients are no longer of interest for who they really were, but
only as forerunners of contemporary forms of the search for the self.
The nature and content of their writings no longer play any part in the
shaping of the portrait. Menander is every bit as "spiritual" as Plato or
Pythagoras. Whether poet or orator, philosopher or merely a pupil, all
of these figures—Homer, Pindar, Socrates, Aeschines, Demosthenes,
Alcibiades, Alexander, Apollonius—transform themselves into seekers
after God, and in the process their portraits become ever more alike.

Through a lucky chance we have preserved two full-length por-
traits, of Homer and Plato, in a very rare art form, that will help sup-

port this interpretation. About the year A.D. 370 a flood caused the land around the harbor of Kenchreai to sink into the sea.[76] A whole series of scenes in glass, including gods, mythological figures, donors, landscapes, and several famous Greek thinkers of the past, intended for the windows of a sanctuary of Isis at the harbor, was lost. These precious examples of glass mosaic in opus sectile technique were still in transport containers at the time and were found in the excavations at Kenchreai with their backings stuck to one another. (This explains why the illustration [fig. 177] is reversed.)

The portraits of Homer and Plato have nothing in common with earlier images of these men. Homer has the look of a Late Antique philosopher with long hair that, like Christ's, is parted in the middle (fig. 177). He wears a voluminous mantle; in his left hand he holds a book roll, while the right is raised in the gesture of a teacher. His eyes are open wide and directed at the viewer. Plato, however, looks ahead, his legs and hands drawn together, and contemplates. With his shorter hair receding at the sides, he stands in the same relationship to Homer as the apostles to Christ. The privileging of Homer by iconographical means is remarkable. Apparently the artists and patrons in the sanctuary of Isis considered Homer's authority to be higher than Plato's. If this were a Neoplatonic school, it would no doubt have been the other way around.

The iconographical setting at Kenchreai looks rather conventional. The mythological figures and the landscape scenes recall the earlier association of learning and country life in the ideology of the villa. But, as we have just seen, country life also played an important role for the Late Antique philosopher. Iamblichus, for example, despite his exercises in asceticism, was a wealthy man who owned several villas outside Apamea. But the fact that Homer and Plato are shown larger and more carefully rendered than the other subjects, and that they appear in the costume of the contemporary philosopher, suggests that these icons of classical learning were expected to be more than they had been in the sculptural decoration of the earlier Roman villa. They too have turned into teachers of wisdom.

The number of ancient poets and thinkers whose portraits were still

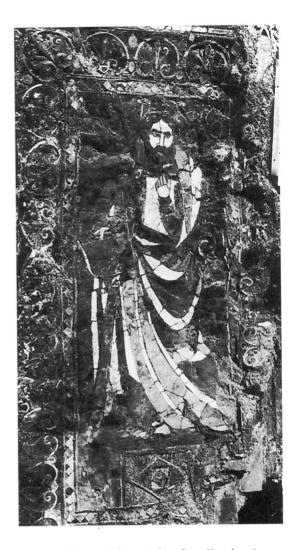

FIG. 177 Homer. Glass window from Kenchreai (reversed). Ca. A.D. 370.

being copied (or, rather, refashioned) in the fourth and fifth centuries is relatively small. Even Julian the Apostate wrote: "We should not concern ourselves with all the philosophers and teachings, but only those who fill us with wisdom and teach us something about God" (*Ep.* 300d–301a, cf. 301c). Proclus' views, a century later, are much more extreme: "If it were up to me, the only writings of the ancients that would still be read and propagated would be the oracles and the *Timaeus* [of Plato]" (Marinus *Vit. Procl.* 38). Fortunately not everyone was so narrow. Particularly in the schools of grammar and rhetoric, which carried on independently of the new religion and numbered Christians among their pupils, the range of interests was broader. So, for example, portraits of Menander still occur in considerable numbers, presumably because his diction was considered to be the perfect embodiment of the purest Attic Greek. Didactic and pedagogical concerns may also explain the late replicas of the portraits of Demosthenes and Aeschines.77

The Power of the Muses

The source of all poetry and thought was the Muses, daughters of Zeus and Mnemosyne. From them flowed all knowledge and inspiration. Thus I would like to end this final chapter with a glance at the Muses, and not only to pay them due respect. The fact is, they had never before assumed such a powerful role in the visual arts as they did in the Late Antique. When the thought process itself is directed at divine revelation, then all intellectual activity can be perceived only as a form of divine dispensation or grace. These in turn are transmitted to man by divine creatures, Muses or angels.

In the Hellenistic world, the conception of the intellectual enterprise was informed by the notion of individual will. The figure of the thinker himself, with his energy and concentration, was the focus of attention. This affected the Muses too, for they were sometimes depicted immersed in deep meditation as well. In this process, the mythological relationship of Muse and poet could even be inverted, so

highly prized were the achievements of the creative intellectual. At the opening of the *Argonautica,* Apollonius invokes the Muses, but only as "servants" of *his* composition. They are no longer, as for Homer and the early poets, the Muses from whom all song emanates.[78] Similarly, on a well-known Hellenistic votive relief in the Palazzo dei Conservatori in Rome, the Muse looks up to a blind old poet like an adoring schoolgirl to her teacher.[79]

But in the course of the Roman period, the pendulum swung once again in favor of the Muses. Now there is scarcely a poet, philosopher, or scholar who does not appear along with his Muse. But the relationship between the two seems now more direct and personal. This is especially clear on the sarcophagi that show husband and wife as teacher and Muse, seated or standing opposite one another, since here the pairing of intellectual and Muse serves also as a metaphor for conjugal harmony (*concordia;* cf. fig. 147). The mosaic in Madrid that depicts several intellectuals with their Muses against a villa setting has already been mentioned. The Muses have grown in stature; in some scenes they no longer stand quietly, and their vivid expressions seem to be having a powerful impact on their protégés. On the beautiful diptych in Monza, a poet with shaved head listens with rapt attention to the chords of his kithara-playing Muse. His inspiration comes not from the writings strewn carelessly on the ground, but from the Muse and her song.[80]

A diptych of the fifth century in the Louvre presents the Muses as mighty, elemental forces who literally "come over the poets," dancing and flying like the Angel of the Annunciation (fig. 178). The poets, who simply watch and listen, are reduced to purely passive roles.[81] Meanwhile, the Muses themselves have turned into learned figures: Calliope (or perhaps Clio) reads to her charge from a book roll the words that he is to write down!

The notion of spiritual inspiration that marked Late Hellenism and the Christian belief in the creation of Holy Writ through the agency of celestial powers are in essence the same. And this general picture will obtain well into the Middle Ages: wisdom is a mercy that comes directly from God, transmitted by his messengers. This is vividly

FIG. 178 Ivory diptych showing poets with their
Muses. Fifth century A.D. Paris, Louvre.

FIG. 179 Illuminated codex: an angel (?) assists Saint
Mark in writing the Gospel. Sixth century A.D. Arch-
episcopal Library, Rossano.

illustrated in the Rossano Gospels, where a female personification—
or is she an angel without wings?—has taken the place of the Muse
and dictates word for word to Saint Mark, even going over with her
finger and checking what he has just written (fig. 179).[82] The concept
of the transmission of knowledge will from now on be dominated by
such images of authority. The medieval teacher sits or stands elevated
above his pupils and dictates to them. This stereotypical image will
long help shape the iconography of the university.[83]

There is a corresponding change in the representation of the book.
Instead of a simple attribute that the learned man holds or ponders, it
becomes a spiritually charged cultural icon whose power is aimed di-

rectly at the viewer. As in the scenes of teacher and pupils, the image speaks directly to the viewer, and Christ, the saints, and evangelists hold the roll or codex up to him. It makes no difference if the codex is open or only the richly ornamented binding is displayed. Salvation springs from the Holy Scripture, and the assurance of the truth revealed: seeing is believing.[84]

Epilogue
Ancient Philosophers and the Modern Intellectual

An engraving made in Paris at the time of the French Revolution shows a little man on a distant mountain observing through a telescope the activities of mankind. There could scarcely be a better image to represent the role and position of the modern intellectual as they differ from those of his counterparts in classical antiquity. He has no secure home, no well-defined purpose. His main occupation is observing and commenting on others. In contrast, ancient intellectuals were firmly integrated in their society, whether it be the poet performing in cults and festivals, the philosopher teaching in the gymnasium and agora, or the politician in the popular assembly. Their place in society was in the city, and this was true well into late antiquity. Even the countercultural way of life of a Diogenes is unthinkable without the public arena.

In this book, we have come to know the poets and philosophers of antiquity as people who felt sure of themselves, and of their role and purpose in society. Of all the faces we have looked at, there is not one that betrays even the faintest hint of a melancholy type suffering beneath the weight of his own intellectual gifts. There is no ancient equivalent, say, of the famous photograph of Giselle Freud, with Walter Benjamin looking out at the viewer, his head propped on his hand, his face filled with loneliness and weltschmerz.

There have been few societies that celebrated their poets and thinkers as did the Greeks. Yet the votive and honorific statues of the Classical period celebrate them not as great intellects, but as exemplary citizens. Homer appears as the distinguished elderly man, Anacreon as the properly behaved symposiast, Sophocles as the decorous public speaker. Aeschylus' gravestone recorded only that he had fought the

333

Persians at Marathon: not a word of his success as a writer. No matter how great a man's reputation for intellectual achievement, in democratic Athens at least, this was no reason to set him apart from the conventional appearance of his fellow citizens.

At the beginning of this book, I referred to the famous monument to Goethe and Schiller in Weimar (fig. 2), which likewise shows both poets in ordinary dress. But in contrast to the Classical statues of the model citizen, the Weimar poets in their gestures recall their individual characters as both poets and people. The encounter takes place not in public, but in some ideal "private" space. Goethe and Schiller are depicted as great minds with enviable human qualities, but not as model citizens with whom any of their fellows could identify. Once again there is no direct ancient parallel.

The first genuine intellectual portrait in antiquity is the likeness of Socrates with the ugly face of Silenus. This affront to the aesthetic and ethical norms of *kalokagathia* was designed to provoke the statue's contemporaries and, in so doing, began a long tradition that continued in the "dog's life" of Diogenes, the dessicated old bodies of Hellenistic philosopher statues, all the way to Apuleius' filthy hair. In the figure of Socrates, the Silenus mask becomes an archetype of the philosopher who questions social convention and faulty thinking, claiming for himself the role of educator in how best to think and to live one's life.

It was only about a century later, as the unifying structure of the polis was coming undone, that the Greek philosopher first acquired an image distinct from that of the average citizen and became a public figure with an authority of his own. From the early third century B.C. on, the philosopher defined himself as "the other." Interestingly, this consisted at first simply in adhering to the traditional citizen image. While their contemporaries quickly adopted the clean-shaven look initiated by Alexander the Great, the philosophers continued to let their beards grow. And while others favored more elaborate (and warmer) clothing, they clung to the simple citizen's cloak. In this sense the philosopher's image had from the start a "conservative" element. His criticism of the new mores invoked ancestral ways, that is, the age of the free and democratic polis.

But the ascetic quality is only one aspect of the philosopher's rejec-

tion of the undergarment. Exposing the naked bodies of these old philosophers gave the sculptors an opportunity to portray the aging process with ruthless honesty. The "revelation" of the aging male body took on an even more dramatic quality following on the tradition of flawless physiques in Classical statuary. Like the mask of Socrates, this too was a calculated violation of the standards of *kalokagathia* that still dominated the Greek citizen's self-image. In both cases the provocative statement contains a particular message: death is the fate of every individual, but the philosopher alone can teach us how, in the face of death, to live a life "in accordance with nature."

Greek religion had no codified dogma, no set of moral teachings like the catechism, no established clergy who could minister to the pastoral needs of the faithful. Starting with Socrates, it was the philosophers who came increasingly to fill this role. Thus the philosopher's mantle designated the counselor and the in-house philosopher, who were expected by society to lead demonstrative and exemplary lives. The Christian priest and the monk are the true successors of the ancient philosopher, and it is no coincidence that they early on assumed both the beard and the cloak.

The statue of Voltaire in old age is also characterized by physical frailty and spiritual passion (fig. 1). But Houdon was not trying to convey an exemplar of the philosophical way of life. Rather, by placing Voltaire on a throne, he broadcast the intellectuals' claim (here in the name of the *philosophes*) to a share in the running of the state. The statue embodies the excitement of the Enlightenment set in the political situation shortly before the French Revolution. No Greek philosopher ever sat on a throne, at most an academic "chair." Even Epicurus' "throne" turns out to be rather a seat of honor, used by his pupils to convey the unique intellectual and moral authority of their master. As much as Houdon may have relied on the antique for his vision of Voltaire, his is a kind of philosopher who never existed in antiquity.

Unlike the ancient philosopher, most modern intellectuals since the Enlightenment have been committed to the notion of progress, or at least of an improvement in social and political conditions. They may appear, however, as the spokesmen for a whole variety of forces and

groups, ideologies and movements. They analyze, shape, and propagate the interests of the particular group, shaping the entire zeitgeist, or perhaps only a momentary circumstance. But the crucial difference is, they have no "teaching" and no specifically moral authority, except perhaps in the case of those who happen to have suffered under a recently discredited political system. But even in such instances, the aura of moral authority does not last for long, as we can observe in the fate of dissidents in the former Socialist states of Eastern Europe.

The real reason for this failure is the modern intellectual's lack of practical knowledge, as soon as a situation calls for some basic and generally applicable advice. Wherever he becomes involved, the specialists are better informed. In principle, of course, the intellectual is a specialist too, at least to the extent of his personal experience and his own field. Even freelance writers and critics move in a little literary world of their own. The ancient philosopher was rather a "generalist" and attempted both to understand and systematically to explain the world and human existence. Whatever school he may have belonged to, his ethical imperatives and the way of life implicit in them at least claimed to be rooted in all-embracing theoretical principles of physics and perception, mathematics and metaphysics.

Having said this, we need not wonder that the modern intellectual in the West has never developed a single coherent image. His functions in society are too varied, his identity too contradictory. Certain attributes, like the beret or rimless glasses, might enjoy a brief vogue but are nothing more than fashion accessories. The only somewhat consistent phenomenon that might recall the ancient philosophers is the ongoing attempt, in the form of more or less deliberate flouting of conventions of dress and manners, to set onself apart from the "proper" behavior of officialdom and the bourgeoisie. But in the present climate such attempts are usually doomed to failure, since anything that attracts attention for its "otherness" is quickly co-opted by the market into a trendy new look. The only category of intellectual that has attempted in modern times, at least on certain ceremonial occasions, to project a specific corporate image is the professoriate. Interestingly, when the traditions of this group were invented in the last century, it was by reaching back to the dress of Late Medieval clerics and guilds-

men, in order to define the academics as a kind of secular order, the guardians and dispensers of knowledge and wisdom. But the student unrest of the late 1960s demonstrated just how insecure was the identity implied in this image. This leaves only the phenomenon of judicial robes, but these are not a symbol of any particular intellectual capacity. Rather, they are a relic of an absolute authority transcending the individual, something still indispensable to the modern secularized state.

One conclusion of this study has been that the philosopher turns out to be the only category of intellectual in antiquity that defined itself as such by means of a consistent and unmistakable image. At first the philosophers were clearly differentiated according to schools of thought and life-styles, but later the sharp contours were lost as they ceased to correspond to reality. This did not, however, imply a loss in the philosopher's prestige. Rather, over the course of centuries the philosopher's image steadily took on an added authority and mystique. It was for this reason that under the Empire, intellectuals in other fields assumed the philosopher's cloak and let their beards grow. This is particularly true of teachers of all kinds as well as doctors, who, in the Imperial period, saw themselves as physicians of the soul, not just the body. They realized that the "care of the self" involves body and soul in equal measure.

It was only with the poets that we have been able to detect indications of a self-contained iconographic tradition. But the sorry state of our evidence forbids any sweeping generalizations. In striking contrast to the philosophers, Menander and Poseidippus in the Early Hellenistic age were visualized dressed in the latest fashions and enjoying an enviably comfortable, even luxurious style of life. We can readily understand why these comic poets felt themselves to be champions of the world of the private individual, since it was they who brought that world onto the stage. But does this apply to other writers as well? Certainly not to the official poets of Augustan Rome, who were naturally envisaged in their togas. Yet there are still some indications that the notion of poetic inspiration, in contrast to philosophical thought, as something associated with a pleasantly "soft" way of life survived well into late antiquity.

The Roman aristocrat who immersed himself in Greek literature

while at his villa is related to this figure of the Hellenistic poet, not so much because he often dabbled in writing verse himself as because he experienced the life of the private intellectual, if only from time to time. During the Late Empire, this idea of withdrawal from public life to the pleasures of reading amid a bucolic setting takes on a deeper meaning. It comes to symbolize a happy existence freed from all external pressures. Yet even in these later images, the intellectual life of the villa is still linked with the notion of material comforts and enjoyments.

Starting with Aristotle, philosophers were always in addition scholars, historians, and philologists. In this guise they interpreted the texts of earlier poets and thinkers, mastered and transmitted the ancient wisdom. In the Hellenistic world, classical culture became for the first time an object of reverence, at times even in a religious sense. In this setting there arose a new kind of retrospective "literary" portrait that sought to render the great minds of the past as unique individuals on the basis of their works or their lives. In the context of hero cults, these literary portraits honoring the poets could take on the aspect of genuine cult images. For the Greek cities, whose world had been utterly changed by the coming of Rome, the preoccupation with paying homage to the intellectual heroes of the past became a way of reaffirming their own spiritual identity and solidarity as Greeks.

The incorporation of these new heroes into well-established rituals and cult practices is the fundamental element lacking in the sculptural monuments of the late nineteenth century that celebrate the apotheosis of the intellectual hero. Rodin's statue of Victor Hugo and Max Klinger's Beethoven (fig. 3) are entirely individual visions of the artist, divorced from society. As such they serve as much to glorify the sculptor, who dreams of his own apotheosis, as to honor the subject. Such creations are monuments that have no true place of their own, no certain function in the real world. We perceive them only as works of art, even when they stand in parks or gardens instead of in museums. Unlike the Hellenistic monuments that they may seem to evoke, and despite all their mighty pathos, they carry no weight as cultural artifacts and do not express any values with which the society around them could identify.

The culture of learning in the High Empire, with its particular kind of retrospective rituals, belongs in the tradition of the cities and courts of the Hellenistic world that had likewise nourished their cultural heritage, and yet there is a fundamental difference. While the earlier period perceived an unbroken continuity and sought only to reactivate, embellish, and broadcast its cultural legacy, the Romans had to invent a tradition that in fact never existed in Classical Greece. The forging of a national identity that would help unify the *imperium Romanum* would not have been possible without an acknowledged set of shared values and life-styles. The cult of imperial power and its attendant myths were not sufficient to fill this need. The Romans needed a common language, a shared vocabulary of visual imagery.

What began in Hadrianic Athens as a game of taking on Classical costumes and faces grew into a personal statement, a kind of religion of high culture whose rituals aimed at appropriating the classical tradition and turning it into a palpable entity throughout the Empire. The manifold range of activities and forms of participation in this cult—costumed performances, formal orations, learned dinner-table conversation, pictorial imagery—add up to an extraordinary collective effort to bring the past into the present. In essence these activities were nothing more than a selective restructuring of what had been standard cultural practice in the cities of Classical and Hellenistic Greece. But by a process of separating these off, multiplying them, and stressing certain elements, there arose a pure and depoliticized "classical" tradition that outdid the authentic Greek culture now long past. This and the imperial cult were the two forces that together laid the foundations for that sense of belonging and shared identity that united all the inhabitants of the Empire.

In this context the mask of Socrates, along with the other intellectual giants of old, once again takes on great importance. The initiates in this cult of learning recreated themselves as likenesses or versions of the classical icons. The "care of the self" transformed the amateur philosopher and initiate into a new kind of artist. Not only in his beard, hair, and expression did he model himself after the ancients, but in his entire self.

If Socrates' provocative Silenus mask stands at the beginning of our

story, then we reach the end with the face of the enlightened Charis-
matic. The beard was no longer by itself sufficient to mark the other-
ness of these "divine men" and miracle workers. The spirituality and
"holiness" of the Late Antique mystics required a mask of their own
that would separate them from traditional images of the philosopher.
Thus the shoulder-length hair becomes the defining element in this
last intellectual portrait type of antiquity, an image that in many ways
recalls a modern guru more than a classical thinker. When this final
mask was adapted for likenesses of the bearded Christ, the Hellenistic
image of the mighty thinker and dialectician had long been aban-
doned. The dogma of official teaching had taken the place of philo-
sophical dialogue, and a strict hierarchy had established itself within
intellectual circles. It seems to me, finally, not without significance that
the portrait types and narrative images of Hellenistic origin have had
little influence on the art of more recent times, while the mask of the
Charismatics lives on, in the imagery of Christ, to the present day.

ABBREVIATIONS OF FREQUENTLY CITED WORKS

(Abbreviations in the notes follow the guidelines of the
Archäologischer Anzeiger 1992, 743ff., and the
Archäologische Bibliographie 1993)

AA	Archäologischer Anzeiger
ABr	Griechische und römische Porträts. Edited by P. Arndt and F. Bruckmann
AJA	American Journal of Archaeology
AM	Mitteilungen des Deutschen Archäologischen Instituts, Athenische Abteilung
ANRW	Aufstieg und Niedergang der römischen Welt
AntK	Antike Kunst
Beazley, ARV²	J. D. Beazley, Attic Red-figure Vase-Painters² (1963)
ASAtene	Annuario della Scuola archeologica di Atene e delle Missioni italiane in Oriente
BCH	Bulletin de correspondance hellénique
BdA	Bollettino d'arte
BJb	Bonner Jahrbücher des Rheinischen Landesmuseums in Bonn und des Vereins von Altertumsfreunden im Rheinlande
BSA	The Annual of the British School at Athens
BSR	Papers of the Brithish School at Rome
CVA	Corpus Vasorum Antiquorum
DialA	Dialoghi di archeologia madrilenas
EA	Photographisch Einzelaufnahmen antiker Skulpturen. Edited by P. Arndt and W. Amelung
FR	A. Furtwängler – K. Reichhold, Griechische Vasenmalerei I (1904); II (1909); III (1932)
Guida Ruesch	A. Ruesch, Guida illustrata del Museo Nazionale di Napoli (1909)
IGR	Inscriptiones Gracae ad Res Romanas Pertinentes
IstMitt	Istanbuler Mitteilungen
JbAChr	Jahrbuch für Antike und Christentum
JdI	Jahrbuch des Deutschen Archäologischen Instituts

JHS	The Journal of Hellenic Studies
JRS	The Journal of Roman Studies
Lippold, Vat. Kat. III	G. Lippold, Die Skulpturen des Vaticanischen Museums
1.2	III 1 (1936); III 2 (1956)
MarbWPr	Marburger Winckelmann-Programm
MemAcInscr	Memoires de l'Academie des inscriptions et belles-lettres
MemLinc	Memorie. Atti della Accademia nazionale dei Lincei, Classe di scienze morali, storiche e filologiche
MM	Madrider Mitteilungen
MonPiot	Monuments et memoires, Fondation E. Piot
MüJb	Münchner Jahrbuch der bildenden Kunst
ÖJh	Jahreshefte des Österreichischen Archäologischen Instituts in Wien
RAC	Reallexikon für Antike und Chistentum
RE	Paulys Realencyclopädie der classischen Altertumswissenschaft, Neue Bearbeitung
RendLinc	Atti dell'Accademia nazionale dei Lincei. Rendiconti
RendPontAc	Rendiconti. Atti della pontificia accademia romana di archeologia de Louvain
RM	Mitteilungen des Deutschen Archäologischen Instituts, Römische Abteilung
RömQSchr	Römische Quartalschrift für christliche Altertumskunde und Kirchengeschichte
Roscher, ML	W. H. Roscher, Ausführliches Lexikon der griechischen und römischen Mythologie
TrWPr	Trierer Winckelmannsprogramme
TrZ	Trierer Zeitschrift für Geschichte und Kunst des Trierer Landes und seiner Nachbargebiete

NOTES

Chapter One

[1] D. Bering, *Die Intellektuellen* (Stuttgart, 1978) 32ff.; M. Walzer, *The Company of Critics* (New York, 1988).

[2] W. Sauerländer, *Voltaire,* Reclam's Werkmonographie 89 (Stuttgart, 1963).

[3] P. Raabe, "Dichterverherrlichung im 19. Jahrhundert," in *Bildende Kunst und Literatur* (Frankfurt, 1970) 79–101; T. Nipperdey, "Nationalidee und Nationaldenkmal in Deutschland im 19. Jh.," *HZ* 206 (1968) 530–85; R. Selbmann, *Dichterdenkmäler in Deutschland. Literaturegeschichte in Erz und Stein* (Stuttgart, 1988). Just how long this monument continued to inform the image of the "bourgeois" is well illustrated by the photograph that caricatures Kandinsky and Klee in the pose of the two princes of poetry: see P. Raabe, *Spaziergänge durch Goethe's Weimar* (Zurich, 1990) 141.

[4] From the dedication address for Schwanthaler's monument to Goethe in Frankfurt, 1844, quoted by Raabe 1970 (supra n. 3).

[5] See, for instance, P. O. Rave, *Das geistige Deutschland im Bildnis* (Berlin, 1949).

[6] *La gloire de Victor Hugo,* exh. cat., Grand Palais (Paris, 1985–86) 318ff.; R. Cadenbach, *Mythos Beethoven,* exh. cat., Verein Beethoven-Haus (Bonn, 1986) 13ff.

[7] A. Dückers, *Max Klinger* (Berlin, 1976); G. Winkler, *Max Klinger* (Leipzig, 1984). For the positive reaction of some contemporaries see E. Asenijeff, *M. Klinger's Beethoven: Eine kunsttechnische Studie* (Leipzig, 1902); J. Vogel, *Leipziger Skulpturen* (Leipzig, 1902) 77ff. Cf. N. Himmelmann, *Ideale Nachtheit,* Abh. Rhein.-Westf. Akad. Wiss. 73 (Opladen, 1985), 20f.

8 Raabe 1970 (supra n. 3).

9 On the history of scholarship see Fittschen 1988, 9ff.

10 For recent examples of thorough *Kopienkritik* in the field of Greek portraiture see Kruse-Berdoldt 1975; Scheibler 1989; Stähli 1991; von den Hoff 1994.

11 See Neudecker 1988, 64ff. On copying techniques see now M. Pfanner, *JdI* 104 (1989) 154ff.

12 Richter 1962.

13 My dating of the Oslo copy to the first century B.C. disagrees with that of Bergemann (1991, 159ff.). I do not believe that the doubts expressed by S. Sande, *AAAH* ser. B, 2 (1982) 27, on the authenticity of the head in Naples are well founded.

14 See the recent discussion by Neudecker (1988, 64ff.).

15 Richter I, 47ff. and pls. 1–17. On the copy in Munich, with earlier bibliography on the type, see B. Vierneisel-Schlörb, *Glyptothek München, Katalog der Skulpturen,* vol. 2, *Klassische Skulpturen* (Munich, 1979) no. 5, pp. 36–48; Giuliani 1980, 60, no. 15; Voutiras 1980, 54ff.; Fittschen 1988, 18 and pl. 13.

16 Red-figure amphora by Euthymides, Munich, Antikensammlungen 2307; *CVA* Munich 4, pls. 166–67. Many vases of this period show other attempts to conceal baldness with an artful coiffure or distract attention from it: cf. Fittschen 1988, pl. 26, 3. On the coiffure of the Homer portrait see Voutiras 1980, 61. I am, however, not persuaded by the suggestion of H. Kenner, *Der Apoll von Belvedere,* SBWien 297.3 (Vienna, 1972), adopted by Voutiras, that the knot over the brow carries a cultic reference. The examples she cites have nothing in common. On the characteristics of old age see F. Preisshofen, *Untersuchungen zur Darstellung des Greisenalters in der frühgriechischen Dichtung,* Hermes Einzelschriften 34 (Wiesbaden, 1977) esp. 117ff.

17 A. Esser, *Das Antlitz der Blindheit*[2] (Leiden, 1961); R. Kretschmer, *Geschichte des Blindenwesens* (Ratibor, 1925); *RAC* 3 (1954) 433–46, s.v. Blindheit (E. Lesky).

18 B. Ashmole and N. Yalouris, *Olympia: The Sculptures of the Temple of Zeus* (London, 1967) figs. 32–40.

19 Plut. *Mor.* 432B (*De def. or.* 39). Cf. Esser (supra n. 17), with further references.

[20] Cic. *Fin.* 5.29; *Tusc.* 5.114; cf. Esser (supra n. 17) 64.

[21] B. E. Richardson, *Old Age among the Ancient Greeks* (Baltimore, 1933) 4ff.

[22] See R. Stupperich, *IstMitt* 32 (1982) 224f.

[23] Naples, Museo Nazionale inv. 6216; D. Comparetti and G. de Petra, *La villa ercolanese dei Pisoni* (Naples, 1883) 277, no. 83; Lorenz 1965, 13.

[24] F. Eckstein, *Anathemata: Studien zu den Weihgeschenken strengen Stils im Heiligtum von Olympia* (Berlin, 1969) 33–42.

[25] W. Burkert, *Griechische Religion der archaischen und klassischen Epoche* (Stuttgart, 1977) 440ff.

[26] Cf. Fittschen 1988, 15ff.

[27] B. Gentili, *Poesia e pubblico nella Grecia antica: Da omero al V secolo* (Rome and Bari, 1985) 207 and passim.

[28] C. Meier, *Die politische Kunst der griechischen Tragödie* (Munich, 1988) 75ff.

[29] See most recently Vierneisel-Schlörb (supra n. 15) 39–41, with summary of earlier literature.

[30] On this passage see most recently L. Beschi, in *Pausania, Guida della Grecia,* vol. 1, ed. D. Musti and L. Beschi (Vicenza, 1982) 355.

[31] Hölscher (1975, 191) assumes that Pericles was the patron responsible for both statues. Cf. Lippold 1912, 35; F. Poulsen 1931, 6; Schefold 1943, 64; Gauer 1968, 141.

[32] The statue is now in the Ny Carlsberg Glyptotek in Copenhagen: V. Poulsen 1954, 25ff., no. 1, pls. 1–3, 33. On the copies see Richter I, 75ff. and figs. 271–90. For the dating of the copies see Voutiras 1980, 77–91; H. Lauter, "Zur Chronologie römischer Kopien nach Originalen des V. Jh." (Diss., Bonn, 1966) 114. As far as style and dating of the original are concerned, the association with Phidias was made by A. Furtwängler, *Meisterwerke der griechischen Plastik* (Leipzig and Berlin, 1893) 1 : 92ff. Cf. E. Buschor, *Pheidias der Mensch* (Munich, 1948) 60ff.; Voutiras 1980, 85ff.

[33] K. C. Kurtz and J. Boardman, "Booners," in *Greek Vases in the J. Paul Getty Museum* 3 (Malibu, 1986) : 67ff.

[34] Cf., for example, the Doryphorus of Polyclitus: most recently, P. C. Bol, in *Polyklet: Der Bildhauer der griechischen Klassik,* exh. cat., Liebieghaus (Frankfurt, 1990) 111ff. For this interpretation of the pose see Lippold 1912,

35; also Schefold 1943, 64; Buschor (supra n. 32); Gauer 1968, 141; Metzler 1971, 266. An opposing view is held by F. Poulsen (1931, 4–6, 13–15), Voutiras (1980, 87f.), and L. Giuliani (review of Voutiras, in *Gnomon* 54 [1982] 54), who all reject the interpretation of both Pausanias and modern scholarship and believe the pose is derived from a Hellenistic conception of Anacreon.

35 Schefold 1943, 50–53; Kurtz and Boardman (supra n. 33) 47–70; H. A. Shapiro, *AJA* 85 (1981) 138–40; N. Hoesch, in *Kunst der Schale: Kultur des Trinkens,* exh. cat., ed. K. Vierneisel and B. Kaeser (Munich, 1990) 276ff.

36 See Gauer 1968, 142.

37 Kalathos-shaped krater attributed to the Brygos Painter, Munich, Antikensammlungen 2416; Schefold 1943, 54f.; Simon 1976, pl. 150; M. Ohly, *Attische Vasenbilder in den Antikensammlungen in München nach Zeichnungen von K. Reichhold*[2] (Munich, 1981) 54ff. Professional singers who entertain at a symposium are clearly characterized as such: cf., for example, a somewhat later hero or funerary relief in Rome, Museo Barracco inv. 118; Helbig[4] II, no. 1887 (W. Fuchs); K. Schefold, *Meisterwerke griechischer Kunst* (Basel, 1960) 84, 246, 248, no. 307.

38 See Giuliani 1986, 129ff., on "Mimik und Verhaltensnormen in klassischen Zeit"; Hölscher 1975, 197.

39 The copies of this type, then erroneously identified as the Spartan king Pausanias, are collected in Richter I, 100 and figs. 412–25; Richter-Smith 1984, 176ff.; Smith 1990, 132ff.; Fittschen 1988, 19. The series and interpretation are now discussed in detail by Bergemann (1991, 157–89). Cf., however, N. Himmelmann, in *Antike Welt* 24.1 (1993) 56ff., who gives a very different interpretation, detecting in the portrait peasant features. Cf. id., *Realistische Themen in der griechischen Kunst der archaischen und klassischen Zeit,* JdI-EH 28 (Berlin, 1994) 69ff.

40 See Voutiras 1980, 194; Fittschen (1988, 31 n. 58) rightly rejects Voutiras's classicistic dating of the statue.

41 The copies generally agree closely in the rendering of the face. The subtlest version is the head in Berlin: Richter I, figs. 277, 280. The copy with erect head: once Palazzo Altemps; Richter, figs. 288–90.

42 *RE* 9 (1916) 2545ff., s.v. infibulatio (J. Jüthner); Voutiras 1980, 89; W. E. Sweet, *Sport and Recreation in Ancient Greece* (Oxford, 1987) 129f.; id., 11 (1985) 43–49; J. P. Thuillier, *Nikephoros* 1 (1988) 35ff.

43 E.g., red-figure stamnos by the Kleophon Painter, Munich, Antiken-sammlungen 2414 (contemporary with the statue of Anacreon): *CVA* Munich 5, pl. 256; B. Philippaki, *The Attic Stamnos* (Oxford, 1967) 144, no. 4. Cf. the Nolan amphora, a generation earlier, Munich 2339; *CVA* Munich 2, pl. 53. 3 – 4, with a komast playing the lyre. Other early examples include the red-figure cup Berlin F 2289; *CVA* Berlin 2, pl. 80; another red-figure cup, Berlin F 2309; *CVA* Berlin 2, pls. 69 – 70, with clear differentiation between older and younger komasts. I am indebted to B. Kaeser for helpful discussion of this problem. For older satyrs cf. the red-figure pelike by the Kleophon Painter, Munich 2361; Beazley, *ARV*² 1145, no. 36; Simon 1976, pls. 208f.; cf. also J. L. Caskey and J. D. Beazley, *Attic Vase-Paintings in the Museum of Fine Arts Boston,* vol. 3 (Oxford, 1963) pl. 87; *RA* 15. 1 (1910) 222 – 26, figs. 5 – 8.

44 For instance, on the pinakes from Penteskouphia; *Antike Denkmäler* I, pls. 7 – 8; II, pls. 23 – 24; N. Himmelmann, *Archäologisches zum Problem der griechischen Sklaverei,* AbhMainz 13 (Mainz, 1971) figs. 3, 6. Cf. in particular the man working the kiln on the foundry cup in Berlin: *CVA* Berlin 2, 73. See H. Licht, *Sittengeschichte Griechenlands,* Supplement (Zurich and Leipzig, 1928) 218, on the word *kollops* as a derogatory term for a catamite with a fat penis head. See also Sweet (supra n. 42) on the practice of lengthening the foreskin (*epispasmos*) and on the efforts of Hellenized Jews to conceal their circumcision.

45 H. Flashar, *Der Epitaphios des Perikles,* SBHeid (Heidelberg, 1969) no. 1, reprinted with additions in id. *Eidola* (Amsterdam, 1989) 435 – 81.

46 Cf. *Kunst der Schale* (supra n. 35) 293ff. and passim.

47 If there was actually a personal bond between Pericles' father and Anac-reon, as a fragment of the poet has suggested to some, then putting up the statue would have been an ideal opportunity for Pericles to portray his close association with artists and intellectuals as an old family tradition. On the supposed association see *RE* 1 (1894) 2038, s.v., Anakreon (O. Crusius); D. Page, *Poetae Melici Graeci* (Oxford, 1962) 493.

48 So Voutiras 1980, 87ff., followed by N. Himmelmann, *Ideale Nacktheit in der griechischen Kunst,* JdI-EH 26 (Berlin, 1990) 77. The unusual stylization of the statue, which can hardly be read as a specifically oligarchic message, would seem to argue against this interpretation. Besides, the position of the oligarchic party in the years when Pericles was at the height of his power makes this scenario very unlikely. Cf. E. Stein-Hölkeskamp, *Adelskultur und Polisgesellschaft* (Stuttgart, 1989) 139ff. The fact that Anacreon was later in-voked by oligarchs like Kritias (the basis of Voutiras's argument) simply

shows how popular the poet continued to be in Athens as a symbol of the life of pleasure.

49 This portrait type, referred to as A, was first fully investigated in a detailed study by Scheibler (1989), who summarizes the arguments for the early dating. Cf. Richter I, 109, figs. 456–82.

50 G. B. Kerferd, ed., *The Sophists and Their Legacy,* Hermes Einzelschriften 44 (Wiesbaden, 1981); J. Martin, *Saeculum* 27 (1976) 143ff.

51 Weiher 1913, 5ff. Cf. K. J. Dover, *Aristophanes' Clouds* (Oxford, 1968) xxxii–lvii; P. Green, "Strepsiades, Socrates, and the Abuses of Intellectualism," *GRBS* 20 (1979) 15–25.

52 Paris, Louvre G 610; E. Pottier, *Vases antiques du Louvre,* vol. 3 (Paris, 1922) pl. 157; Metzler 1971, 101, fig. 11.

53 Schefold 1943, 56, 103; Metzler 1971, 94f.; Helbig⁴ I, no. 978 (H. Sichtermann), with the correct dating in the second half of the fifth century. I assume that the identification is correct, though in the present context it makes no difference.

54 See Xen. *Symp.* 5.5–7 for the bulging eyes, the pug nose with flaring nostrils, and the large mouth with thick lips; Pl. *Symp.* 215f. for the comparison with silens, satyrs, and Marsyas; and Pl. *Meno* 80A for the comparison with a stingray. Cf. Scheibler 1989, 25ff., with further references.

55 *Sokrates* 1989, 33ff. On the iconography of silens and satyrs see Roscher, *ML* IV : 444ff., s.v. Satyros (E. Kuhnert).

56 Naples, Museo Nazionale: H. Fuhrmann, *RM* 55 (1940) 78ff.; Schefold 1943, 162, 215; Richter I, 117f.; F. Winter and E. Pernice, *Die hellenistische Kunst in Pompeji* (Berlin and Leipzig, 1932) 5 : 76ff., pls. 48f.; A. Rumpf, in *Analecta Archaeologica, Festschrift F. Fremersdorf* (Cologne, 1960) 93ff. Apart from the Naples relief, the scene is repeated on two terra-cotta appliqués (imitating a bronze vessel). The J. Paul Getty Museum recently acquired a fine fragment of another bronze copy: *GettyMusJ* 20 (1992) 142f., no. 7. The head of Socrates, however, cannot be identified with Type A but is rather a free conflation of the two principal types. As evidence of this, one may note the sharp elevation of the right shoulder in the copy of the head in Toulouse (Richter I, figs. 473–75), which matches the image on the relief.

57 F. Brommer, *Der Parthenonfries* (Mainz, 1977) pls. 165, 177; cf. H.-G. Hollein, *Bürgerbild und Bildwelt der attischen Demokratie auf rotfigurigen Vasen des 6.–4. Jh. v. Chr.* (Frankfurt, 1988) 17ff., 56, 255 ("Schole-Typus").

58 Red-figure skyphos, Bari, Museo Nazionale R 150; F. A. G. Beck, *Al-*

bum of Greek Education (Sydney, 1975) pl. 53. 276a. Cf. A. Greifenhagen, *RM* 46 (1931) 27ff. On the relationship of Socrates and Silenus see C. Weickert, in *Festschrift J. Loeb* (Munich, 1930) 103 – 110; see most recently H. Schulze, "Trophos: Unfreie Erzieher in der antiken Kunst und Gesellschaft" (Diss., Munich, 1994).

59 This interpretation is hinted at by Giuliani (1980, 63, no. 19).

60 A portrait like this does, however, presuppose viewers able to look critically at Athenian art, with its idealizing style and its tendency to suppress the variety of actual appearance. But there is also evidence starting in the second quarter of the fifth century for more "realistic" portraiture, that is, portraiture more oriented toward characteristic features of actual appearance. These sources suggest that a sculptor like Demetrios of Alopeke, whom Quintilian (12.10.9) describes as *similitudinis quam pulchritudinis amantior,* was not completely eccentric. If he could portray the Corinthian general Pellichos with protruding belly, bulging veins, and disheveled hair, "just like a living man" (Lucian *Philops.* 18), then there must have been people in the late fifth century who were prepared to discuss such violations of aesthetic norms in the same way they discussed Kleon and his violation of traditional standards of conduct in the popular assembly (cf. pp. 45ff.). On Demetrios see Laubscher 1982, 63f.

Chapter Two

1 H.-G. Gadamer, *Platon als Porträtist* (Munich, 1988) 7ff.

2 W. Helbig, *JdI* 1 (1886) 71 – 78 (= Fittschen 1988, 62f.); Pfuhl 1927, 28ff. (= Fittschen, 246f.); H. von Heintze, in Helbig⁴ I, no. 86; cf. Berger (infra n. 4), who speaks of "the hard intellectual labor of one who has to struggle for the truth."
On the portrait type see Boehringer 1935; Schefold 1943, 74, 205; H. von Heintze, *RM* 71 (1964) 31ff.; Richter II, 164ff., figs. 903 – 72; Richter-Smith 1984, 181ff.; Giuliani 1986, 138f.; K. Vierneisel, in *Ein Platon-Bildnis für die Glyptothek* (Munich, 1987) 11 – 26; Fittschen, 22, 24.

3 Lippold 1912, 55f.; cf. Pfuhl 1927, 28.

4 On the Holkham Hall-Basel type see Pfuhl 1927, 29; F. Poulsen, *Greek and Roman Portraits in English Country Houses* (Oxford, 1923) 32f., no. 5; E. Berger, *Perspektiven der Philosophie, Neues Jahrbuch* 13 (1987) 371ff. (though I disagree with his dating of this more dramatic version in the Antonine period; as far as I can see, no new adaptations of Classical or Hellenistic portrait

types were created in the Imperial period); Fittschen 1988, 25, pl. 125; *Sokrates* 1989, 43.

5 On Lycurgus' dedication see Lippold 1912, 49ff., 62f.; G. M. A. Richter, *Greek Portraits,* (Brussels, 1962) 4 : 24ff.; Fehr 1979, 54ff.; Gauer 1968, 132–35; C. Schwingenstein, *Die Figurenausstattung der griechischen Theatergebäude* (Munich, 1977) 74ff.; Giuliani 1986, 138f. On the dating see most recently Fittschen 1988, 21. On Lycurgus and his political program see *RE* 13.2 (1927) 2446ff., s.v. Lycurgus 10 (Kunst); Mitchel 1970, 165ff.; C. Mossé, *Athens in Decline, 404–86 B.C.* (London, 1971) 8off.

6 On the statue of Sophocles in the Vatican see now C. Vorster, *Vatikanische Museen, Museo Gregoriano Profano, Römische Skulpturen* (Mainz, 1993) I : 154, no. 67, figs. 297–308. For the copies see Richter II, 128ff., figs. 680–88; Richter-Smith 1984, 205ff.; Schefold 1943, 90–93; Fittschen 1988, 36 n. 146.

7 I base my interpretation primarily on the work of Fehr (1979, 51ff.), though I would see the statue of Sophocles less as a model for the "Normalbürger" than for the citizen presented as politically engagé. I have subsequently discovered that Theodor Reinach had already suggested this interpretation in *JHS* 42 (1922) 50–69. He identified the statue, however, as the portrait of Solon on Salamis. Cf. the response of F. Studniczka, *JHS* 43 (1923) 57.

8 Paris, Louvre G 222; Beazley, *ARV*² 272, no. 7; *CVA* Louvre (III, Ic), 32f., pl. 42, 5–7; E. Pottier, *Vases antiques du Louvre* (Paris, 1922) 3 : 207, pl. 130; A. Shapiro, in *The Birth of Democracy,* exh. cat., National Archives (Washington, D.C., 1993) 24, fig. 4.

9 Aeschin. *In Tim.* 21ff.; Arist. *Ath. pol.* 28; Plut. *Nicias* 8.3. Cf. Giuliani 1986, 132; Fehr 1979, 94 n. 102.

10 On the statue of Aeschines see Richter II, 212ff.; Richter-Smith 1984, 73ff.; Schefold 1943, 102, 208; P. C. Bol, *Liebieghaus Frankfurt: Antike Bildwerke,* vol. I, *Bildwerke aus Stein und aus Stuck* (Melsungen, 1983) 210ff., no. 62. The suggestion that the statue should be dated posthumously, after 315, is supported by both historical circumstances (the Macedonian domination) and stylistic indicators: see R. Horn, *Stehende weibliche Gewandstatuen in der hellenistischen Plastik,* RM-EH 2 (Munich, 1931) 21f. On the problem of the relationship of statue and viewer, see F. Hiller, *MarbWPr,* 1962, 53ff.

11 Cf. Dem. *De cor.* 129; Fehr 1979, 57f., esp. n. 410.

12 Cf. the illustrations collected in G. Koch-Harnack, *Knabenliebe und Tiergeschenke* (Berlin, 1983). For school scenes see Simon 1976, pls. 99–100.

13 E.g., a votive relief to Asklepios: Athens, NM 1345; U. Hausmann, *Griechische Weihreliefs* (Berlin, 1960) 71, fig. 40; I. N. Svoronos, *Das Athener Nationalmuseum* (Athens, 1908) no. 1501, pl. 83; cf. the Atarbos Base in the Acropolis Museum: C. E. Beulé, *L'Acropole d'Athènes* (Paris, 1854) pl. 4. Later, in the Hellenistic period, the type of Aeschines and Sophocles is used, for example, on East Greek gravestones: see Zanker 1993, 217.

14 Studniczka (supra n. 7) 61; A. Krug, "Binden in der griechischen Kunst" (Diss., Mainz, 1968) 129f. On Sophocles as priest, and the hero cult after his death, see, most recently, L. Beschi, *ASAtene* 45–46 (1967–68) 424ff.

15 H. C. Avery, "Sophocles' Political Career," *Historia* 22 (1973) 509–14.

16 Cf. the grave stele Athens, National Museum; B. Schmaltz, *Griechische Grabreliefs* (Darmstadt, 1983), 204, pl. 18, 1; Conze I, no. 337, pl. 85 = Einzelaufnahmen 692. The elimination of any intellectual trait from the portrait would be all the more significant if, as has been suggested, another portrait type preserved in numerous copies, the so-called Sophocles Farnese, which does have a "spiritual" expression, does indeed reflect a statue created about 400 B.C. See most recently Fittschen 1988, 19f., pls. 36ff. In this version, Sophocles is depicted as an old man. The later statue would then have made him younger in deliberate opposition to an already existing iconographical tradition, in order to emphasize the aspect of the subject as still politically active.

17 See Richter I, 121ff. figs. 577–603; Richter-Smith 1984, 74ff.; Schefold 1943, 88f., 207; Fittschen 1988, 36 n. 146, pl. 56. The most finely nuanced copy is preserved in the herm in Naples, Mus. Naz. 6139; ABr 401f.; Richter, fig. 597. The identification as Aeschylus is based on two arguments: first, a close stylistic similarity to the Sophocles in the Vatican; second, the association of this head with that of Sophocles in a "gallery" of herms and on a double herm. The similarity of hairstyles, especially at the temples, and beard, as well as in the modeling of the face, is considerable, even in a comparison of the early Augustan copy of Aeschylus from the Villa dei Papiri with the Vatican Sophocles, which is probably Augustan in date.

18 S. Karusu, *AM* 96 (1981) 179–94, pls. 53ff.

19 As in the case of Sophocles, it is possible that the portrait of Aeschylus is a "regularized" version of an earlier portrait more in the physiognomic tradition. Aeschylus' baldness is first attested in late literary sources (*Vita* in Page's OCT, p. 332; Val. Max, 9, 12. Ext. 2; Ael. *NA* 7.16). Some gems and glass pastes of questionable authenticity (Richter I, figs. 606, 608–9) allude to the anecdote about Aeschylus' death in which a turtle was dropped on his

bald head by an eagle that mistook his head for a rock! An Early Classical portrait of a bald-headed man, preserved in only a single copy in the Capitoline Museum (Richter, figs. 604–5; Fittschen 1988, 18, 24, pl. 14), with eyebrows sharply drawn together, could in fact represent an intellectual, but an identification as Aeschylus must remain completely hypothetical because of the problematical nature of the gems. Cf. Gauer 1968, 159ff. Pausanias' comment that the portrait of Aeschylus was created long after the poet's death and after the painting of the battle of Marathon (1.21.2) nevertheless implies that he was familiar with another physiognomy for Aeschylus. The bald portrait head in the Capitoline may in any event, apart from its uncertain identity, give us an idea of what a portrait of Aeschylus made in his lifetime might have looked like.

20 On the portrait of Euripides see Richter I, 133ff., figs. 717–61; Richter-Smith 1984, 121ff.; Schefold 1943, 94, 208; H. von Heintze, *RM* 71 (1964) 71–77. As far as the copies are concerned, of the nearly thirty replicas of the head, the best is probably the early Augustan herm from the Villa dei Papiri, now in Naples (Richter, figs. 717–19). The accuracy of its details is confirmed by the finely worked head in Mantua (Fittschen 1988, pl. 75) and the recently discovered herm from Lucus Feroniae (Richter, figs. 753–54), both made in the first century A.D. The dating of the original must, I believe, be based on the plastic modeling of the forehead and brows, which has good parallels only in works of the second half of the fourth century (cf. Fittschen, 24). The early dating, in the late fifth or early fourth century, argued, for example, by H. Walter, *AM* 71 (1956) 178f., is based primarily on the style of the long hair. But this is rather an iconographical motif characterizing the subject as an old man, which, because of its normative value, cannot be used as a dating criterion. It seems to me therefore questionable whether we may see in this trait a historicizing reference to the period of Euripides' lifetime (what Fittschen calls a "Rekonstruktionsporträt"), especially since such evocations of the High Classic are frequently found in the fourth century; cf. Borbein 1973, 43ff. On the dating see most recently E. Voutiras, in *Villa Albani* II, 191f., no. 210 (ca. 330/20). The Rieti type, which is occasionally identified with the statue in Lycurgus' dedication, presupposes the existence of the Farnese type and must, I believe, be dated ca. 300 or later. Cf. L. Curtius, *RM* 59 (1944) 22ff., and, most recently, Giuliani 1986, 294; Fittschen 1988, pls. 118–20.

21 M. Meyer 1989.

22 Istanbul, Archaeological Museum 1242 (from Smyrna); Lippold 1912, 49f.; Richter I, 137, fig. 767. The association of the portrait of Euripides with this relief is also discussed by H. von Heintze, in Hekler 1940, 27, pl. 33.

On the form of the chair cf. Conze I, 27f., no. 95, pl. 37; 84, no. 370, pl. 91; Conze II, 154, no. 720, pl. 139; 161, no. 752, pl. 145. On the book roll and the pillow in the iconography of older men see M. Meyer 1989.

23 See Giuliani 1986, 244 n. 144; G. Xanthakis-Karamos, *Studies in Fourth-Century Tragedy* (Amsterdam, 1980) 28ff.; H. Flashar, *Poetica* 16 (1984) 1ff. = id., *Eidola* (Amsterdam, 1989) 147ff.

24 *AC* 12 (1983) 1032ff., s.v. Greisenalter (C. Gnilcka); P. Roussel, "Essai sur le principe d'ancienneté dans le monde hellénique du Ve s. a. J.-C. à l'époque romaine," *MémAcInscr* 43.2 (1951) 123–228.

25 Giuliani 1986, 139. Cf. also Voutiras 1980, 147, 289; I. Scheibler, in *Sokrates* 1989, 65. On the construction of Euripides' character from his work see Lefkowitz 1981, 88ff.

26 Cf. the illustrations in Fittschen 1988, pls. 38, 42, 43, 45, 49.

27 *Lycurgue, Contra Léocrate, Fragments,* ed. and trans. F. Durrbach (Paris, 1956) 100, p. 64.

28 Cf. the survey of C. Schneider, *Kulturgeschichte des Hellenismus* (Munich, 1967) 1 : 159ff.; T. Hölscher, "The City of Athens: Space, Symbol, Structure," in *City-States in Classical Antiquity and Medieval Italy,* ed. A. Molho, K. Raaflaub, and J. Emlen (Ann Arbor, 1991) 368–75.

29 On the "program" of Lycurgus see Mitchel 1970, 190ff.; Fehr 1979, 54ff. On the cult of Demokratia see A. E. Raubitschek, *Hesperia* 31 (1962) 238–43. On the Eponymous Heroes, see J. Travlos, *Pictorial Dictionary of Athens* (London, 1971) 210; H. A. Thompson, *The Athenian Agora*³ (Athens, 1976) 70f.

30 For the copies of the Socrates portrait Type B see Richter, I, 112ff., figs. 483 ff.; Fittschen 1988, pls. 58–64. The type has most recently been treated in detail by I. Scheibler, in *Sokrates* 1989, 44ff.; also Giuliani 1980, 84f., who arrives at a similar interpretation. It is uncertain whether the statue was in fact set up in the time of Lycurgus, and this cannot be confirmed through stylistic analysis. The dates suggested in the scholarly literature vary, as usual: e.g., Gauer 1968, 124 (mid-fourth century); Giuliani 1980, 64, no. 21 (330s); Scheibler, in *Sokrates* 1989, 51 (soon after 320). A comparison with grave stelai such as that of Korallion (Diepolder 1931, pl. 45, 2; D. Ohly, *AA,* 1965, 344) suggests to me that a date ca. 330 is the most likely (cf. Braun 1966, 50, 90). Mitchel (1970, 209 n. 197) had already suspected an association with the Lycurgan program. The story reported by Diogenes Laertius (2.43) that the motive for the new statue was the "regret" of the Athenians for the condemnation of Socrates is probably a later interpretation.

31 The holding tight of the excess fabric with one hand is depicted on many grave stelai (e.g., Diepolder 1931, pls. 44, 45. 2) and some statues (Richter II, fig. 1368). The other gesture, however, of the free arm with hand gripping the overfold, is rare in the fourth century, and so may have to do with the standard gestures of *dexiōsis* on the gravestones and of prayer on the votives (cf., for example, the votive relief to Demeter in the Louvre: *EncPhotTEL* III, 216a). For Socrates, therefore, the gestures of *both* hands reflect correct behavior, and, as the comparison with the grave stelai reveals, they cannot be interpreted psychologically or as indicative of a specific situation; cf., most recently, *Sokrates* 1989, 50, and Giuliani 1980, 65. A good example of disorderly draping of the mantle is found in the statue of a Cynic in the Capitoline (cf. fig. 72).

32 Two heads, Louvre MA 59 (Richter I, figs. 513, 516; Fittschen 1988, pl. 58) and Museo Capitolino inv. 508 (Richter, figs. 484–86; Fittschen, pl. 61), offer the most reliable versions of the original. This is then confirmed by several heads of lesser quality, such as the inscribed herm in the Conservatori (Richter, fig. 511), a head in St. Petersburg (Richter, figs. 505–7), a head in a private collection (Richter, figs. 494–96), and a fragment in the museum in Sfax (Fittschen, pl. 60). The fine Early Imperial head in the Terme Museum (Richter, fig. 490; Fittschen, pl. 63), which is often reproduced as the "best" copy, with its sunken cheeks and "Socratic" expression, represents, in my view, an eccentric interpretation of the original derived from the philosopher's biography. The superb sculptor undoubtedly wanted to convey more of Socrates' personality than the original of Type B ever contained. In two other copies, both of the second century A.C., an inscribed herm in Naples and a tondo bust in the Villa Albani (Richter, figs. 483, 500, 501, 503, 512; *Villa Albani,* II, 272, pl. 193), the physiognomic qualities of the original have been entirely done away with.

33 Travlos (supra n. 29) 477ff.; W. Höpfner, *Kerameikos,* vol. 10, *Das Pompeion und seine Nachfolgerbauten* (Berlin, 1976); U. Knigge, *Der Kerameikos von Athen: Führung durch Ausgrabungen und Geschichte* (Athens, 1988) 79ff. On the pinakes see Fittschen 1991, 278.

34 Richter I, 96, figs. 381–97. Cf. the convincing interpretation and dating of ca. 350 in Gauer 1968, 128ff.; Fittschen 1988, 24 n. 142. But the head is—pace Gauer—entirely without expression and in this respect comparable to the tragedians set up by Lycurgus in the Theatre of Dionysus, to which it is also close in style. Cf. in particular the subtler copy in Aranjuez: D. Hertel, *MM* 26 (1985) 239, no. 4, pl. 52, together with Aeschylus, fig. 28.

35 See D. Pandermalis, "Untersuchungen zu den klassischen Strategenköpfen" (Diss., Freiburg, 1969). On the typology of statues of *stratēgoi* see,

most recently, N. Himmelmann, *Ideale Nacktheit in der griechischen Kunst,* JdI-EH 26 (Berlin, 1990) 86ff.; T. Hölscher, *Gnomon* 65 (1993) 524. On the portrait of Archidamus III of Sparta (?), see Richter II, 160ff., figs. 888–89; Gauer 1968, 154; cf. Giuliani 1986, 140ff.

36 See B. Schweitzer, *Zur Kunst der Antike* (Tübingen, 1963) 2:186; Gauer 1968, 130. On such reuse see H. Blanck, *Wiederverwendung alter Statuen als Ehrendenkmäler bei Griechen und Römern* (Rome, 1969).

37 The two portraits are, however, very different in style. For Lysias see Richter II, 207, figs. 1340ff.; Richter-Smith 1984, 157; Voutiras 1980, 205ff.; Fittschen 1988, pls. 44f. For Thucydides, see Richter I, 147ff.; figs. 825ff.; Schefold 1943, 76, 205; Fittschen, pls. 41–43.

38 The existence of the group portrait of the Seven Wise Men in Athens has been correctly inferred from the epigram *Anth. Gr.* 16.332. It is, however, quite uncertain whether any connection exists between this group and the surviving portrait types. The latter include inscribed copies of the heads of Periander, Bias, and Pittakos of Mytilene (Richter II, 81ff.; Brommer 1973; von Heintze 1977a, 1977b). The Athenian Solon, who also belongs to this élite company, had previously been represented in the guise of the model citizen (see pp. 45ff.).

39 The key monument illustrating this phenomenon is the statue of Eirene, or Peace, in the Agora; see Borbein 1973, 113ff. and passim. On Isocrates see, most recently, C. W. Müller, "Platon und der 'Panegyrikos' des Isokrates," *Philologus* 135 (1991) 140–56.

40 On the historical significance of the Sophists see J. Martin, "Zur Entstehung der Sophistik," *Saeculum* 27 (1976) 143ff.

41 See Weiher 1913; Sassi 1988, 32.

42 The tomb of Theodectes stood on the road to Eleusis, that of Isocrates at Kynosarges (ps.-Plut. *X orat.* 837D, 838C). The tomb of Theodectes was still standing in the time of Pausanias (1.37.4). Instead of the usual family grouping that we find on the tombs of Athenian citizens in this period, the poet appeared surrounded by his spiritual predecessors, much as the princes and noblemen of the day dedicated in major sanctuaries groups of themselves with their ancestors going back to mythological heroes. One of these, the monument of the Thessalian dynast Daochos at Delphi, may give the best idea of the architectural form of Theodectes' tomb; see Borbein 1973, 68ff. Certainly Theodectes' gallery of poets cannot have looked anything like the standard bourgeois tomb monument in the form of an aedicula. Isocrates' "trapeza" will probably have been no less noticeable or expensive. A monumental column, thirty ells in height, topped by a mourning sphinx, would

have recalled Archaic grave monuments and was perhaps part of the family's earlier tomb. Thus as a member of the Athenian aristocracy, unlike the immigrant from Phaselis, Isocrates would have combined a display of family tradition with his own claim to the special status of an outstanding intellectual. Cf. B. Schmaltz, *AM* 83 (1978) 90, and now the detailed study of A. Scholl, in *Jdl* 109 (1994), 242-54.

43 On the portrait of Plato see the references above in n. 2. The Early Imperial (Tiberian?) copy in Munich (figs. 24, 38) is certainly of high quality, but whether it represents the "best" copy in every respect seems to me questionable. Thus, for example, the stylization of the hair across the brow is less precise in the subtler copies and the edges of the forehead are not so pronounced. These features suggest a partial assimilation to a hairstyle of the period of the copy. One could also question the material rendering of the flesh tones.

44 M. Weber, *RM* 98 (1991), 218f., pl. 52.

45 For Isocrates we know of two statues set up during his lifetime: see K. Gaiser, "Philochoros über zwei Statuen in Athen," in *Praestant Interna, Festschrift U. Hausmann* (Tübingen, 1982) 91 – 100. Gaiser's restoration of the papyrus text does not seem to me compelling, as it starts from the unfounded assumption that Plato did not allow any honorific statue of himself during his lifetime.

46 The following examples are illustrated here (fig. 44a–d): (a) Copenhagen, Ny Carlsberg Glyptotek 213; *Billedtavler* I, pl. 16; *EA* 3995/6; (b) Athens, National Museum 719; Conze I, 83, no. 359, pl. 89; (c) Copenhagen, Ny Carlsberg Glyptotek 218; *Billedtavler* I, pl. 16; *EA* 3995/6; (d) Copenhagen, Ny Carlsberg Glyptotek 212 (= infra n. 51). Cf. also Malibu, J. Paul Getty Museum 73.AA.116: A. N. Oikonomides, *GettyMusJ* 5 (1977) 41f.; Athens, National Museum 3505: S. Karusu, *AM* 96 (1981) 186, with n. 16, pl. 61, 1; and a fragment illustrated in *ArchDelt* 20 (1965) Chron. 101, pl. 57 b, c. And cf. the wrinkled brows of all the older men on the base of an Attic grave monument of the later fourth century illustrated by Schmaltz (supra n. 42) pl. 28. I am indebted to J. Bergemann, who is preparing a study of Attic gravestones, for a number of suggestions, improvements, and photographs.

47 Giuliani 1986, 134ff., with a collection and interpretation of the relevant texts. Cf. in particular Xen. *Symp.* 8.3; Isoc. *Dem.* 1.15.

48 Weiher 1913, 45ff.

49 A statuette of a seated man, now lost, with the inscription . .LATON, must belong in the Hellenistic period by the rendering of the drapery:

Fittschen 1987, 153; Richter II, 167, fig. 960. The bust in Kassel (supra n. 44) is also not evidence for a seated statue. The pattern of the drapery folds is also consistent with a standing figure; cf. the statuette of Socrates, fig. 33. On grave stelai there are mature men who have drawn the mantle over their right shoulder: e.g., the stele of Artemon; B. Vierneisel-Schlörb, *Glyptothek, München, Katalog der Skulpturen*, vol. 3, *Klassische Grabdenkmäler und Votivreliefs* (Munich, 1988) 43ff., no. 9. The erect posture of the head on the small bust in Kassel could well be an accurate reflection of the original, and this too would argue against a seated statue. The same is true of a portrait type of Isocrates, which should be combined with a normal standing statue like the statuette of Socrates: Richter II, 208, figs. 1346ff.; Richter-Smith 1984, 141; *Villa Albani* I, 216f., no. 70, pls. 120–21 (L. Giuliani).

50 Giuliani 1986, 138.

51 Copenhagen, Ny Carlsberg Glyptotek 212; *Billedtavler* I, pl. 16; E. Bielefeld, *AA,* 1962, 91f.; Vierneisel (supra n. 2) 26; Fittschen 1988, 24, pl. 50.2. On this phenomenon see further Fittschen, 24; V. Poulsen, *ActaArch* 14 (1943), 68.

52 For Theophrastus see Schefold 1943, 98; Richter II, 176, fig. 1022; and, most recently, L. Giuliani, in *Villa Albani* I, 463, no. 152. For Aristotle see F. Studniczka, *Das Bildnis des Aristoteles* (Leipzig, 1908) = Fittschen 1988, 147ff.; Schefold 1943, 96; Richter II, 172ff., figs. 976ff.; Richter-Smith 1984, 97; Fittschen, pls. 76ff. The facial expression of the fine copy of Antonine date in Vienna (Richter II, figs. 976–78, 985) goes beyond the other preserved copies in the rendering of signs of old age, and I believe the Antonine copyist may have exaggerated these.

A comparable phenomenon has also been observed in Roman portraiture, though to an even greater extent. That is, the portraits of average citizens were assimilated, even in physiognomic detail, to those of the reigning emperor, who served as the exemplar. On this phenomenon of the "Zeitgesicht" in the Imperial period see Zanker 1982.

53 See, for example, N. Himmelmann's article in the *Frankfurter Allgemeine Zeitung,* 1993, no. 46, p. N5.

54 There are, of course, exceptions. Cf., for example, the stele of Thraseas and Euandria in Berlin: Diepolder 1931, pl. 44; or the stele in Kansas City: B. F. Cook, *AntPl* IX (Berlin, 1969) 70, fig. 5.

55 Cf. *PCG,* ed. Kassel and Austin (Berlin, 1986) 5: 142f.; Weiher 1913, 52ff. With its piling up of other topoi of the ridicule of philosophers, as well as its enumeration of other targets, the passage can hardly, in my view, be

interpreted as having a "programmatic meaning" for the self-image of the philosophers, as Himmelmann has argued.

56 W. Hoepfner and E. L. Schwandner, *Haus und Stadt im klassischen Griechenland* (Munich, 1986).

57 A votive relief of a shoemaker, for example, from the Athenian Agora, depicts four men at work. They wear their mantles in the same correct manner as their contemporaries on grave stelai or in honorific statuary, although this can hardly be the way they dressed in real life. It must have been their principal concern as well to emphasize what exemplary citizens they were. See J. M. Camp, *The Athenian Agora: Excavations in the Heart of Classical Athens* (London, 1986) 147, fig. 126.

58 The standard work for reconstruction of the historical sequence is now C. Habicht, *Untersuchungen zur politischen Geschichte Athens im 3. Jahrhundert v. Chr.* (Munich, 1979). After the collapse of the democracy (and the death of Demosthenes) in 322, there followed first an oligarchy for four years, then the ten-year quasi-tyrannical regime of the Peripatetic philosopher Demetrius of Phaleron, 317–307. Then a democratic phase of four years' duration, a reasonably democratic constitution from 303 to 294, seven years of oligarchy until 287, then the radical democracy under Demochares until 270/69.

59 Fittschen 1991. This monographic treatment includes all the relevant evidence, as well as a complete list of copies. R. Röwer undertook a complete study of the copies in a Munich dissertation, "Studien zur Kopienkritik frühhellenistischer Porträts" (1980), that is unfortunately still unpublished.

60 For the copies see Richter II, figs. 1528ff. The bust in Venice should be dated to the Late Republic and overemphasizes the wrinkles, while the youthful version in Copenhagen rather takes account of both tendencies. Cf. fig. 46.

61 For the anecdotes see *RE* 15.1 (1931) 707ff., s.v. Menandros 9 (A. Körte); Studniczka 1918 = Fittschen 1988, 211.

62 On Demetrius of Phaleron see *RE* 4.2 (1900) 2817–41, s.v. Demetrios 85 (Martini); *RE* Suppl. II (1968) 514–522, s.v. Demetrios of Phaleron (F. Wehrli). On Demetrius Poliorcetes see Plut. *Demetr.* and *RE* 4.2 (1900) 2769–91, s.v. Demetrios 33 (Kaerst).

63 On the statue of Demosthenes see Schefold 1943, 106; Richter II, 216ff., figs. 1397 ff.; Balty 1978; Giuliani 1986, 139f.; Fittschen 1988, pls. 108–16. The literary testimonia are collected by R. E. Wycherley, *Agora*, vol. 3, *Literary and Epigraphical Testimonia* (Princeton, 1957) 210f., nos. 697ff.; cf. B. Hebert, *Schriftquellen zur hellenistischen Kunst* (Graz, 1989)

8ff. On the decree, recorded in Plut. *Mor.* 847D, cf. the commentary of F. Ladek, *WS* 13 (1891) 63 – 128. On the location of the statue see, most recently, I. Worthington, "The Siting of Demosthenes' Statue," *BSA* 81 (1986) 389. For the historical background see Habicht (supra n. 58) 68ff.

Concerning the transmission of the statue type, the torso in Brussels of Early Imperial date (Balty 1978) represents the most faithful copy of the body. It has keenly observed and realistic elements of old age that are suppressed or beautified in the two other surviving copies of the body. The hands are preserved only in a modern cast of a now-lost bronze statuette (Richter II, figs. 1511 – 12) and in one fragment of a hand. The contraction of the brows is also rendered in a variety of ways, but the subtlest copies are also the most expressive, and this is even confirmed by some gems. For the best copies of the head, and especially the facial expression, see in particular the small bronze bust in Naples (Richter II, figs. 1441 – 43; our fig. 49), a marble bust in Cyrene (Richter, figs. 1485 – 88), and an amethyst in a private collection (Richter, fig. 1506).

64 On the motif and its interpretation see T. Dohrn, *JdI* 70 (1955) 50ff.; S. Settis, *Prospettiva* 2 (1975) 4 – 28; Giuliani 1986, 135. For the multiple meanings of this gesture cf., for instance, *Anth. Gr.* 2.17ff. and 254f.

65 Those who would interpret the mood of the statue as one of melancholy introspection would have to offer evidence that such a possibility even existed at this period. In that case, where are we to think the speaker is actually standing? At home? There is no indication that the viewer is meant to imagine him in private.

66 See Pfuhl-Möbius I, 80f., no. 111, pl. 25; 185, no. 664, pl. 100; Zanker 1993.

67 Torso in the Ashmolean Museum, Oxford, the so-called Arundel Homer: D. Haynes, *The Arundel Marbles* (Oxford, 1975) pl. 4 (second century B.C.). Cf. the drawings by Rubens, reproduced in Boehringer-Boehringer 1939, pls. 108 – 13. Cf. the torso from Samos: R. Horn, *Hellenistische Bildwerke auf Samos,* vol. 12 of *Samos* (Bonn, 1972) 14, 86, no. 7, pl. 20f. (ca. 160 B.C.).

68 Giuliani 1986, 139f.

Chapter Three

1 For Type A, with the hand laid on the head, see S. Besques, *Catalogue raisonné des figurines et reliefs,* vol. 3.1 (Paris, 1972) 33, no. D 178, pl. 41b; *EncPhotTEL* II, pl. 186 A; E. Paul, *Antike Welt in Ton* (Leipzig, 1959)

no. 202, pl. 55. For Type B, with the chin propped up, see F. Winter, *Die Typen der figürlichen Terrakotten* (Berlin, 1903) 2:258, 2; Besques, 33, no. D 179 d.e (wearing a petasos), pl. 40; J. Sieveking, *Die Terracotten der Sammlung Loeb* (Munich, 1916) 2: pl. 79; G. Schneider-Herrmann, *Eine niederländische Studiensammlung antiker Kunst* (Leiden, 1975) 13, no. 16 (wearing a kausia). Type B is often wearing either the petasos or the kausia, which transforms the contemplative gesture into a motif of relaxation. This may suggest how foreign the original motif must at first have seemed.

2 On what follows see now the important study of Caizzi (1993).

3 For the portrait of Zeno see Schefold 1943, 108; Richter II, 186ff., figs. 1084–1105; V. Kockel, *BdA* 70 (1985) 71f., no. 8; Thielemann-Wrede 1989, 110f.; and, most recently, with full bibliography, von den Hoff 1994, 89ff. For the history of the copies see H. J. Kruse, *AA*, 1966, 386ff. The Augustan bust, from a herm, in Naples, inv. 6128, fig. 53 (Richter II, 188, figs. 1084f.), represents the most reliable copy, apart from the drapery. This is also the view of Thielemann-Wrede, while Kruse disagrees. This is especially true of the particular form of the beard, with its limp strands, which most of the copyists have altered to give the appearance of carefully curled locks.

4 On the honorific decree see most recently C. Habicht, in *Bathron, Festschrift H. Drerup* (Saarbrücken, 1988) 173–75; Habicht 1988, 15f. Of earlier studies see especially U. von Wilamowitz-Möllendorf, "Antigonos von Karystos," *Philologische Untersuchungen* 4 (Berlin, 1881) 232, 340–44. On Zeno see *RE* 19 (1972) 83–121, s.v. Zenon 2 (K. von Fritz); Long 1986, 109ff.

5 Cf. Caizzi 1993, 311ff., who I believe stresses too much the Socratic-Cynic element of poverty in Zeno's image.

6 Cf. the statuette in the Glyptothek in Munich that has been associated with the portrait of Zeno by Thielemann-Wrede 1989, 147ff., pls. 24–25. This could indeed derive from a portrait of a Stoic, but probably not Zeno, because the draping of the mantle is different.

7 L. Stroux, "Vergleich und Metapher in der Lehre des Zenon von Kition" (Diss., Munich, 1965); K. H. Rolke, *Die bildhaften Vergleiche in den Fragmenten der Stoiker Zenon bis Panaitios* (Hildesheim, 1975).

8 On the statue of Chrysippus see Richter II, 190ff., figs. 1111ff., and, most recently, with earlier bibliography, von den Hoff 1994, 96ff. As for the copies, the herm bust in Naples (fig. 56; Richter II, figs. 1115–17) gives the best idea of the plastic forms of the head, while for pose and expression the bust in London (fig. 55; Richter, figs. 1118–20) is best. The statuette

in the Palazzo Conservatori Museo Nuovo in Rome (Richter, fig. 1142) is evidently a variant, in which Chrysippus has been positioned upright on a throne, modeled on the statue of Epicurus. The statue in Paris is, happily, confirmed in this respect by a statuette recently found in Cyrene: L. Bacchielli, "Arato o Crisippo," *QAL* 10 (1979) 27f. On the identification of Chrysippus: the body type is identified on the basis of an inscribed headless bust in Athens. Bacchielli has reopened the discussion of the identification of the head type, but I believe that the careful evaluation of all the arguments by von den Hoff (101ff.) has settled the question in favor of Chrysippus, rather than Aratus. The most recent contribution is that of Fittschen (1992a, 21ff.), who rightly insists that the association of the securely identified statue and the head type cannot be proven. I would nevertheless adhere to this association, even though my attempts to achieve a perfect grafting through the use of casts have persuaded me that this is not possible. The identification of the head type still seems likely based on the well-known numismatic evidence, since the inscribed bust in Athens preserves enough of the neck to prove that we cannot assume a long beard of the type worn by Aratus on the coins that are supposed to depict him. In addition, the movement of the neck seems to match that of the preserved busts. Von den Hoff (99, no. 14) has been able to adduce a previously overlooked double herm, Athens, NM 537 (Richter, fig. 1145), which connects the Chrysippus type with that of Zeno. Finally, the large number of copies favors Chrysippus rather than Aratus, since Juvenal (2.4 – 5) explicitly mentions how numerous Chrysippus' portraits were. On all three busts, the rendering of the mantle is different and cursorily executed and therefore cannot be used to posit another statue independent of this one. It is likelier that these are simplified versions, as is also the case with the copies of other portrait types.

In the existing reconstructions, the motion of the head thrusting forward, which is attested in several of the copies, especially the busts in London (Richter, figs. 1118 – 20), the head in Copenhagen, National Museum (Richter, figs. 1136 – 38), and the coin from Soloi (Richter, fig. 1147), has been too little stressed, or not at all. I have attempted a new reconstruction, in the form of a photo montage which has now been realized with plaster casts by S. Bertolin: fig. 54a–b. Cf. *Sokrates* 1989, 75; Fittschen 1992a. In this experiment, the chest area of the London bust (fig. 56) could be joined almost seamlessly to the cast of the statue in Paris, though the back of the bust's head overlaps the garment folds at the nape of the neck on the statue. The discrepancy is best explained by positing that the copyist of the statue evened out both the position of the head and the fall of the drapery. As the busts demonstrate, the folds at the back of the original statue were clearly pushed back by the upward thrust of the head. These photos of the new reconstruction should be understood simply as an aid in giving a reasonable optical impres-

sion of the pose of the entire figure. In view of the numerous disparities among the individual copies of a single portrait type, I do not believe that an "implantation" which is less than perfect can be used as an argument against the compatibility of head and body types.

9 See P. H. von Blanckenhagen, "Der ergänzende Betrachter," in *Wandlungen: Studien zur antiken und neueren Kunst, Festschrift E. Homann-Wedeking* (Waldsassen, 1975) 193–201.

10 On the literary sources see Richter II, 190. R. E. Wycherley, *The Athenian Agora,* vol. 3, *Literary and Epigraphical Sources* (Princeton, 1957) 143, no. 458, considers it possible that the statue in the Gymnasium of Ptolemy is identical with that in the Kerameikos. See, most recently, von den Hoff 1994, 109ff.

11 It is just possible, however, that the entire right hand has been subsequently restored. This is the view of H.-U. Cain, to whom I am grateful for his detailed observations of the original, and was already suspected by Bacchielli. The restorer would then have been inspired, through a learned adviser, by such literary accounts as Cic. *Fin.* 1.39, Pliny *HN* 34.88, and Sid. Apoll. *Epist.* 9.9.14. Only the dismantling of the statue and examination of the marble could provide a definitive answer. The only certainty is that the hand was held with palm up. Specific interpretations based on the positioning of the fingers must also, then, remain hypothetical. But in this context it can hardly mean anything other than "persuasion through argumentation" (so Scheibler, in *Sokrates* 1989, 75; cf. Thielemann-Wrede 1989, 127ff.) or "a speaker gesticulating in a lecture or conversation" (von den Hoff 1994, 114). Cf. Sittl 1890, 252–62; Fittschen 1988, 26 n. 157 (with a later dating); Thielemann-Wrede, 125ff.; von den Hoff, 113f.

12 See Lippold 1912, 57; Schefold 1943, 121, 210; Richter II, 175, figs. 1018f.; Helbig⁴ II, no. 2016 (von Heintze); Schefold 1980, 160ff.; Schefold 1982, 85; von den Hoff 1994, 114, 162.

13 On the so-called Kleanthes see Lippold 1912, 86 n. 3; Schefold 1943, 146, no. 2; Richter II, 189ff., figs. 1106ff.; Schefold 1980, 161; Thielemann-Wrede 1989, 136; von den Hoff 1994, 165. The type is preserved in only five statuettes, but since they are of different sizes, it may be only an accident that no full-size copy survives. There are other full-size philosopher statues of which many copies as statuettes are preserved. I take the bronze statuette in London to be the most faithful copy. This is the only one, for example, that preserves the folds of the garment falling over the left hip, a motif that is attested with certainty for other, contemporary seated statues, e.g., Hermarchus (fig. 64) and Poseidippus (fig. 75). In these, of course, the hem lies be-

tween the legs, whereas here it has been pushed to the side by an involuntary movement of the left hand. The deviations of the other statuettes in this respect could derive from a simplified variant of the original. The different chairs and pillows of these statuettes are also not reliable copies of the original, since they vary so. The drapery style of the copy in the Museo Baracco looks decidedly Late Hellenistic, and this is the only copy that exaggerates the characteristics of old age. The bronze statuette can only have sat on a flat seat, perhaps a stone bench, as in the case of the philosopher in the Palazzo Spada (fig. 57) or Chrysippus. On the dating see C. Reinsberg, *Studien zur hellenistischen Toreutik* (Hildesheim, 1980) 135. The massive quality is comparable to that of the statue of Poseidippus (fig. 75).

[14] On the statuette of Antisthenes see L. Curtius, *RM* 59 (1944) 38ff.; Schefold 1943, 206; Richter II, 181, fig. 1056; V. Kockel, *AA*, 1986, 486, fig. 26; N. Himmelmann, in *Phyromachos-Probleme,* ed. B. Andreae (Mainz, 1990) 16, pls. 44–47, who rejects an association with the portrait type. Cf. pp. 174ff.

[15] On Eudoxus see A. Hekler, *Die Sammlung antiker Skulpturen, Museum der bildenden Künste in Budapest* (Budapest, 1929) 60f.; Schefold 1943, 157, no. 4; Richter II, 244, fig. 1679; Richter-Smith 1984, 120.

[16] On beards and shaving see *RE* 3 (1899) 30ff., s.v. Bart (Mau); Hahn 1989, 32ff.; Fittschen 1988, 25.

[17] This, at least, is how he appears on the one ancient portrait that identifies him by inscription, on a Roman mosaic in Sparta, which I believe could well reflect a Classical original (probably fourth century rather than fifth): Richter-Smith 1984, 81, fig. 46. Alcibiades is also shown beardless on one of the fragmentary tondi from Aphrodisias (cf. pp. 313ff.).

[18] Good examples would include the Etruscan sarcophagi and urns (R. Herbig, *Die jüngeretruskischen Steinsarkophage,* ASR 7 [Berlin, 1952]), East Greek grave stelai (Pfuhl-Möbius I–II), and Cypriot sculpture (J. B. Connelly, *Votive Sculpture of Hellenistic Cyprus* [Nicosia, 1988]).

[19] *CAF* III, 333ff.; *RE* 20.1 (1941) 380, s.v. Phoinikides (A. Körte).

[20] Cf. Hahn 1989, 36.

[21] It is unclear whether Alciphron means that the Stoic's hair was too long or merely unkempt. I gratefully acknowledge the kind advice of Mathias Gelzer in the interpretation of this and other texts.

[22] The irregular pattern of the beard is especially clear on the copies in London, British Museum 1836 (Richter II, figs. 1139–41) and in the Vatican (fig. 60; Richter, figs. 1121–22). Von den Hoff (1994, 112f.) also recog-

nizes this feature but interprets it simply as a sign of the neglect of external appearances.

23 The quote is from *SPh* II 139, 14ff. Cf. Laubscher 1982.

24 On the Epicureans see Long 1986, 14ff.; Long-Sedley 1987, 25–157; *RAC* 5 (1962) 681–819, s.v. Epikur (W. Schmid); and the forthcoming article of W. Erler, in W. Uberweg's *Grundriss der Geschichte der Philosophie*, vol. 4, ed. H. Flashar (Basel and Stuttgart, 1993). More specialized studies include M. L. Clarke, "The Garden of Epicurus," *Phoenix* 27 (1973) 86f.; D. Clay, "Individual and Community in the First Generation of the Epicurean School," in *Studi Gigante* (Naples, 1983) 255–79.

25 On the statues of the Epicureans see Schefold 1943, 118; Richter II, 194ff., figs. 1149ff.; Richter-Smith 1984, 116. For the most complete lists of copies, with critical analysis, see von den Hoff 1994, 63ff. His detailed stylistic analysis confirms the traditional dating based on the date of death. Fittschen's recent reconstructions in Göttingen, with the help of casts, have provided a more reliable basis for assessing the overall effect of the portrait statues of Epicurus and Metrodorus: see Fittschen 1992a. A careful study of the copies was earlier undertaken in Kruse-Berdoldt 1975.

26 See A. Long, "Pleasure and Social Utility—The Virtues of Being Epicurean," *Fondation Hardt, Entretiens sur l'antiquité classique* 32 (1985) 283–316.

27 Wrede (1982, 235–45) has persuasively established the order of importance and associated it with the notions of hierarchy and orthodoxy in the Kepos.

28 On the throne of Epicurus see Kruse-Berdoldt (1975, 150f.), who likens it to the honorary seats in the theatre; Wrede (1982), who compares it to the thrones of the gods; and B. Frischer (*The Sculpted Word* [Berkeley, 1982] 199ff.), who sees a play on the fatherly role and the iconography of Herakles and Asklepios. On the theatre seats see G. M. A. Richter, *The Furniture of the Greeks, Etruscans, and Romans* (London, 1966) figs. 138ff., 146ff., 490, 499ff.; M. Maass, *Die Prohedrie des Dionysostheaters in Athen* (Munich, 1972) 60ff.; J. Travlos, *Pictorial Dictionary of Ancient Athens* (New York, 1972) 544ff. The occasional depiction of men on this kind of honorary chair, on East Greek grave reliefs (e.g., Pfuhl-Möbius I, 222, no. 854, pl. 125; 275, no. 1109, pl. 167), is probably also more a token of public honors than of intellectual accomplishments.

29 Epicurus' facial features are rendered with the finest nuances in the double herm in the Capitoline Museum, fig. 66 (Richter II, fig. 1153) and in

the fragment in Copenhagen (Richter, figs. 1205–6). The turn of the head, however, could be most reliably rendered in a bust in the Capitoline (Richter, figs. 1151–52). My views here differ from those of Kruse-Berdoldt (1975). Cf. now the excellent new reconstruction of the statue by Fittschen (1992a, 15ff.), which is based upon the head of the Capitoline bust (fig. 62).

On the significance of the raised eyebrows see Giuliani 1986, 140ff. The suggestion of B. Schmaltz (*MarbWPr*, 1985) that the portraits of Epicurus divide into two traditions that derive from different originals cannot be right. Cf. the counterarguments of von den Hoff (1994, 70f.). A comparison with Herakles is not, in my view, supported by the brow of the Herakles Farnese, since there it expresses something different, connoting physical exertion. Cf. Wrede 1982, 243.

30 The Hadrianic bust in the Capitoline (Richter II, figs. 1233–35; cf. Kruse-Bertoldt 1975, 69f.), though the carving is unfortunately too hard and angular, provides the best idea of the original statue of Metrodorus (fig. 67). The inclination of the head seems to be faithfully rendered in a bust in Athens (Richter, figs. 1255–57). Schmaltz (supra n. 29) 37, pl. 14, rightly compares the head with an Attic grave stele of the fourth century, although the comparison applies only to the iconographical type and not to the style, which is closely related to that of Epicurus' portrait. This Classical formula, which seems so inappropriate to the early fourth century, also explains attempts to associate the portrait with the classicizing mode of the Late Hellenistic period. Cf. the counterarguments of von den Hoff (1994, 64f.).

31 The portrait of Hermarchus is best represented by a Hadrianic bust in Budapest (Richter II, figs. 1306–9) and a small inscribed herm from the Villa dei Papiri, in Naples, fig. 68 (Richter, figs. 1291–93). For the full statue type cf. the statuette in Florence (Richter, figs. 1319–20).

A stylistically earlier type, closely related iconographically, has been most recently discussed by B. Freyer-Schauenburg, *RM* 96 (1989) 313ff., though I do not believe her identification as Democritus can be defended. Gauer (1968, 168f.) had taken it to be an earlier portrait of Hermarchus himself. But given the astonishing iconographical similarity to the genuine portrait of Hermarchus, one could also consider the possibility that it represents another of the early Epicureans.

32 Even a slight raising or stretching of the lower arm would have to result in a tension in the musculature of the shoulder. The right elbow probably rested on the wrist of the left hand, as indicated by damage at this spot on the statue in Athens. The recently discovered copies from Dion (see p. 230) also imply this relaxed position of the arm and, in any event, invalidate the suggested reconstruction of Frischer (1982, 175, fig. 6) and the interpretation that he bases upon it.

33 M. Guarducci, *RendPontAcc* 47 (1974–75) 177, fig. 13.

34 On the process of reading see Birt 1907; Blanck 1992, 72.

35 On the cult of the Epicureans see *RAC* 5 (1962) 746, s.v. Epikur (W. Schmid); Wrede 1982, 237, with further references.

36 See I. Gallo, "Commedia e filosofia in età ellenistica: Batone," *Vichiana* n.s. 5 (1976) 206–42, esp. 219.

37 For the statuette in New York, Metropolitan Museum of Art, see Schefold 1943, 124, no. 4; 211; Richter II, 199, fig. 1220; M. True, in *The Gods Delight,* ed. A. Kozloff and D. G. Mitten, exh. cat., Cleveland Museum of Art (Cleveland, 1988) 154, no. 26; and, most recently, the detailed analysis of von den Hoff 1994, 171ff. He dates the work correctly in the Late Hellenistic period but traces the philosopher to a genre figure of the years around 200 B.C.

38 P. W. Lehmann, *Roman Wall Paintings from Boscoreale in the Metropolitan Museum of Art* (Cambridge, Mass., 1953) 34ff., fig. 27; Schefold 1943, 132f.

39 P. C. Bol, *Die Skulpturen des Schiffsfundes von Antikythera* (Berlin, 1972) 24ff., pls. 10–11; R. Lullies, *Griechische Plastik*⁴ (Munich, 1979) 129, pls. 258–59.

40 Bronze statuette: Paris, Bibl. Nationale 853; Schefold 1982, 85; L. Beschi, *I bronzetti romani di Montorio Veronese,* Istituto Veneto, Memorie 33.2 (1962) 13ff., the prototype convincingly dated to the second half of the third century; Richter I, 132, figs. 711–12; Schefold 1980, 162; most recently treated in detail by von den Hoff (1994, 161ff.), who identifies the same type on the philosopher mosaic in the Villa Albani (Richter, fig. 319). I am indebted to R. von den Hoff for important observations in this context. Silver statuette: Paris, Bibl. Nationale; G. M. A. Richter, *Greek Portraits,* vol. 4, Coll. Latomus 54 (Brussels, 1962) 41, pls. 23–24, figs. 56–57; Schefold 1980, 162.

41 Paris, Louvre MA 79; Richter I, 144, fig. 784.

42 Johansen 1992, 142f., no. 58. I believe the upper body, bent forward, and the position of the arms make it clear that the statue represents a reader.

43 The statue is in Rome, Capitoline Museum 137; Richter II, 185, figs. 1071, 1074; Schefold 1943, 122; Helbig⁴ II, no. 1431; Laubscher 1982, 44 with n. 162, 62; von den Hoff 1994, 118ff., confirming the traditional dating.

On the appearance of the Cynics see *RE* 12 (1923) 4ff., s.v. Kynismus

(Helm); P. R. Dudley, *A History of Cynicism* (London, 1937); M. Billerbek, *Der Kyniker Demetrios* (Frankfurt, 1979). That the figure was barefoot is certain, for enough of the lower leg is preserved to say that there were no sandals. On the *tribōn* see *RE* 6, 2d ser. (1937) 2415ff., s.v. Tribon (Schuppe).

44 On the relation of the Cynics to society see G. Bodei Giglioni, "Alessandro e i Cinici," in *Studi ellenistici,* ed. B. Virgilio (Pisa, 1984): 51–73. Since the importance of the Cynics was already in decline in the third century, the statue could be a retrospective honor for one of the early Cynics set up, for example, by the Stoics. The latter felt indebted to the founders of Cynic teaching for some aspects of their own philosophy. The statue would in that case have been a kind of didactic reminiscence. The main difficulty with this interpretation is the lack of retrospective or hagiographic elements of the kind we shall encounter in the statuettes of Diogenes and other retrospective portraits.

45 On the "Cynic" in Paris, Louvre 544, see ABr 619–20; Hekler 1912, pl. 103; K. Fittschen, *AA,* 1991, 261, figs. 6, 8. The copy belongs to the later second century A.C. Certain details, such as the "moustache" and the locks of the beard might lead one to suspect that this could be an image of a contemporary individual that has merely been stylized with traits of the philosopher (cf. pp. 235ff.). On the other hand, the plastic structure of the head and especially the arrangement of the hair on the crown of the head would argue against this interpretation.

46 See Bodei Giglioni (supra n. 44).

47 Fittschen 1992b, pl. 17.

48 For the Late Hellenistic copies of Menander see Richter II, figs. 1533–35, 1536–38, 1592–95.

49 Richter II, figs. 1524, 1526, 1527; cf. Studniczka 1918 = Fittschen 1988, 207ff., pl. 105. For a similar kind of anecdotal representation see Schefold 1980, 166.

50 Fundamental for what follows is the investigation of Fittschen (1992b), which has put the scholarship on this monument on a new and firmer footing. Cf. Schefold 1943, 110; Richter II, 238, figs. 1647–50. On Poseidippus see *RE* 22.1 (1953) 426ff., s.v. Poseidippos (W. Peek).

51 E. M. Rankin, *The Role of the Mageiroi in the Life of the Ancient Greeks* (Chicago, 1907) 25.

52 H. Kyrieleis, *Die Bildnisse der Ptolemäer* (Berlin, 1975). One should also note in this connection the portraits on Etruscan sarcophagi and urns, which

derive from Greek prototypes. Fittschen (1992b) also rightly associates the ample forms of the portrait in Copenhagen, which he connects with the statue of the pseudo-Menander, with the ideal of *tryphē*.

53 The Menander relief, formerly in the Stroganoff Collection, is now in the Art Museum, Princeton University. See M. Bieber, in *Festschrift A. Rumpf* (Cologne, 1952) 14–17. On the funerary altar of the Roman poet see fig. 113.

54 H. Bartels, *Olympia-Bericht* (Berlin, 1967), 8:251ff., pl. 120; N. Himmelmann, *Alexandria und der Realismus in der griechischen Kunst* (Tübingen, 1983) 49f., pl. 30. The identification as a poet was already proposed by Bartels on the basis of the figure's beardlessness and the undergarment.

55 R. Wendorf, *The Elements of Life: Biography and Portrait Painting in Stuart and Georgian England* (Oxford, 1990) 251f., fig. 69. Cf. W. Busch, *Das sentimentale Bild* (Munich, 1993) 417, fig. 116. On the portraits of Dr. Johnson by Reynolds, five in all, see *Boswell's Life of Johnson,* ed. G. Birbeck Hall (Oxford, 1934) 4:448ff.

56 Fittschen 1992b.

57 For the statuette of Moschion, Naples, Museo Nazionale 6238, see Richter II, 242, figs. 1666–67; Richter-Smith 1984, 169, fig. 130; Fittschen 1991, 262 n. 70, pls. 56, 2; 62, 4.

58 Cf. the diptych from the cathedral treasury at Monza: Schefold 1943, 184; W. F. Volbach, *Elfenbeinarbeiten der Spätantike und des frühen Mittelalters*[3] (Mainz, 1976) 57, no. 68, pl. 39.

59 For the grave stele of Hermon see E. Walter-Karydi and V. von Graeve, "Der Naiskos des Hermon: Ein spätklassisches Grabgemälde," in *Kanon, Festschrift E. Berger,* AntK-BH 15 (Basel, 1988) 331ff., pls. 93–95.

60 One may also mention in this context the youthful poet Demetrios on the Pronomos Vase in Naples with a depiction of a satyr play. He sits nude on a handsome bench and is characterized by book rolls and a lyre. Buschor rightly interpreted his relaxed pose and his wide-eyed, excited facial expression with open mouth as one of poetic inspiration. In any case, we should not see him as part of the theatrical context. He is, rather, depicted as a poet, and as a particularly handsome young man (thus the nudity) with luxurious locks and in the midst of a festive and extravagant gathering. See Buschor's comments in A. Furtwängler and K. Reichhold, *Griechische Vasenmalerei,* vol. 3 (Munich, 1932) text to pls. 143–45.

61 On the so-called Vergil (or Ennius) see V. Poulsen I, 44ff., nos. 5, 6; Giuliani 1986, 163ff.; K. Fittschen, *AA,* 1991, 255ff. Cf. two additional sup-

posed portraits of contemporary Hellenistic poets, which may substantiate what we have said of the so-called Vergil: a beardless portrait belonging to a double herm in Naples (Guida Ruesch no. 1135; H. von Heintze, *RM* 67 [1961] 8off., pls. 20, 2; 21, 2; 23; Fittschen 1988, pls. 150f.); and a herm with a likely portrait of an elderly Hellenistic poet in Rome, Palazzo dei Conservatori (Helbig⁴ II, no. 1466; ABr 887–88; H. von Heintze, *RM* 67 [1960] 103ff., pls. 31, 33; Fittschen-Zanker II [forthcoming]). Yet another Greek poet of the second century B.C. may be identified in the ivy-wreathed head with fleshy face and dramatic turn of the head in London, BM 1852; R. P. Hinks, *Greek and Roman Portrait Sculpture* (London, 1935) 15, fig. 16a.

Chapter Four

¹ For the seated statue in Copenhagen, Ny Carlsberg Glyptotek, see Lippold 1912, 68ff.; Schefold 1943, 138 (identified as Pindar); Buschor 1971, 30, no. 111; V. Poulsen 1954, 77f., no. 53; Richter I, 67ff., figs. 231ff. (Archilochus); Richter-Smith 1984, 176ff.; Giuliani 1986, 159 n. 229; E. Voutiras, in *Villa Albani* II, 193f., no. 211 (dated late third century); von den Hoff 1994, 108.

² *Anth. Lyr.²* I, frag. 86; Lobel-Page frag. 50 B 18. Cf. F. Preisshofen, *Untersuchungen zur Darstellung des Greisenalters in der frühgriechischen Dichtung* (Wiesbaden, 1977) 65f.

³ For the statue of Pindar from Memphis see Lauer-Picard 1955, 48ff., pls. 4ff.; Richter I, 143, fig. 783. Cf. below in n. 27.

⁴ On the "Pseudo-Seneca" see Schefold 1943, 134; E. Buschor, *Bildnisstufen* (Munich, 1947) 183; Richter I, 58, figs. 131–230; Buschor 1971, no. 115, fig. 30; Richter-Smith 1984, 191; E. Simon, *Pergamon und Hesiod* (Mainz, 1975) 59 (who suggests the presence of a Stoic viewpoint); Giuliani 1980, 70 n. 34; Fittschen 1988, pls. 138f. Most archaeologists are currently inclined to the identification as Hesiod.

⁵ See Laubscher 1982, 12 and passim; Bayer 1983, 17ff. On Rubens's "Dying Seneca" see M. Morford, *Stoics and Neostoics: Rubens and the Circle of Lipsius* (Princeton, 1991).

⁶ See Richter-Smith 1984, 170f. On the copies see M. G. Picozzi, *StMisc* 22 (1974) 191ff., and, most recently, von den Hoff 1994, 157 (who dates the original to the mid-second century).

⁷ The description of this as a "literarisches Idealporträt" is owed to A. Hekler, *ÖJh* 18 (1915) 61–65. Cf. Hafner 1954, 64 A 9, pl. 27; Stewart 1979, 29, pl. 5, with further details.

⁸ See Richter I, 151ff., figs. 860ff.; Richter-Smith 1984, 136ff.; A. Krug, *Heilkunst und Heilkult: Medizin in der Antike* (Munich, 1985) 41f., fig. 10; von den Hoff 1994, 157, with a summary of earlier literature and a dating about the middle of the second century. On the identification see, most recently, A. Hillert, *Antike Ärztedarstellungen* (Frankfurt, 1990) 30.

⁹ ABr 581–84; J. Frel, *Greek Portraits in the J. Paul Getty Museum* (Malibu, 1981) 96. For the recent association with the Terme relief (Richter I, figs. 299–300; Richter-Smith 1984, 86) see von den Hoff 1994, 155ff.

¹⁰ Cf., for example, the funerary reliefs from Smyrna in Pfuhl-Möbius I–II; Zanker 1993.

¹¹ On what follows see especially R. Pfeiffer, *Geschichte der klassischen Philologie: Von den Anfängen bis zum Ende des Hellenismus* (Hamburg, 1970) 125ff.; Fraser 1972, 305f.

¹² See *Satiro, Vita di Euripide,* ed. G. Arrighetti, in *Studi classici e orientali* 13 (1964); *RE* 2, 2d ser. (1921) 228ff., s.v. Satyros (Kind); U. von Wilamowitz-Moellendorf, *Sappho und Simonides* (Berlin, 1913) 157. More generally, see A. Momigliano, *The Development of Greek Biography* (Cambridge, 1971).

¹³ M. Gabathuber, "Hellenistische Epigramme auf Dichter" (Diss., Basel, 1937). On the distancing of the "ancient" poets from the present day see P. Bing, "Theokritos' Epigrams on the Statues of Ancient Poets," *Antike and Abendland* 34 (1982) 117–22.

¹⁴ The relief is fully documented and well described by D. Pinkwart, in *Antike Plastik* (Berlin, 1965) 4:55ff., pls. 28ff. Cf. H. von Hesberg, *JdI* 103 (1988) 333–36; E. Voutiras, *Egnatia* 1 (1989) 131–70, who sees in the relief a specifically Stoic interpretation of Homer and associates it with the school of Krates of Mallos at Pergamon. He identifies the poet represented in the statue on the Muses' hill as Homer himself. But this is unlikely in light of the seated figure of Homer elsewhere on the relief and is also contradicted by all the numismatic evidence. On the portrait features of Chronos and Oikoumene on the Archelaos Relief see, most recently, E. la Rocca, in *Alessandria e il mondo ellenistico-romano: Studi in onore di A. Adriani* (Rome, 1984) 3:638, with n. 45.

The interpretation of the draped statue before a tripod occurs already in Goethe's analytic description: *Sophien-Ausgabe* (Weimar) ser. 1, vol. 49², 25. Cf. E. Grumach, *Goethe und die Antike* (Berlin, 1949) 2:572ff.

¹⁵ On the heroon of Bias in Priene see F. Hiller von Gaertringen, *Inschriften von Priene* (Berlin, 1906) 97ff., no. 111; 106ff., no. 113. On the Bias coins

from Priene see K. Regling, *Die Münzen von Priene* (Berlin, 1927) 34, no. 30, pl. 3; Richter I, fig. 357; Schefold 1943, 173, fig. 8.

16 On the Archilocheion see N. M. Kontoleon, *Fondation Hardt, Entretiens sur l'antiquité classique* 10 (1963); *RE* Suppl. 11 (1968) 136ff., s.v. Archilochos (M. Treu).

17 Lefkowitz 1981, 25ff., esp. 31.

18 See Schefold 1943, 173, fig. 6, with commentary by H. Cahn, p. 219.

19 See Schefold 1943, 172f. with 218ff., for a collection of coins with retrospective portraits of intellectuals, and cf. the relevant sections of Richter I–II.

20 K. A. Esdaile, *JHS* 32 (1912) 318–25; C. Heyman, "Homer on Coins from Smyrna," in *Studia Paulo Naster oblata,* vol. 1, *Numismatica Antiqua,* ed. S. Scheers (Leuven, 1982) 162–73; and, most recently, D. O. A. Klose, *Die Münzprägung von Smyrna in der römischen Kaiserzeit* (Berlin, 1987) 34ff.

21 On the Hellenistic blind Homer see Boehringer-Boehringer 1939, which has the best documentation of all the copies; Schefold 1943, 142, 213; Richter I, 45ff., figs. 58–106; Richter-Smith 1984, 147ff.; Laubscher 1982, 20; Fittschen 1988, 26. For the dating, in the late third century B.C., see, most recently, N. Himmelmann, *AntK* 34 (1991) 110f.

22 Boehringer-Boehringer 1939, pls. 92–95; M. Comstock and C. C. Vermeule, *Sculpture in Stone* (Boston, 1976) 75, no. 119. There are excellent illustrations of the head in *ÖJh* 18 (1915), 64f., figs. 33–34.

23 Boehringer-Boehringer 1939, pls. 66–68; Richter I, figs. 70–72.

24 J. W. Goethe, on a "Buste, die in Gyps Abguss vor mir steht," in J. C. Lavater, *Physiognomische Fragmente zur Beförderung der Menschenkenntnis und der Menschenliebe* (Leipzig and Winterthur, 1775) 245. Cf. the comments of Jakob Burkhardt, in *Der Cicerone*[10] (Leipzig, 1910) 1:161: "I confess that nothing gives me a better impression of the greatness of Greek sculpture than its ability to perceive and to render these traits. A blind singer and poet: that is all they had to go on. And yet the artist endowed the brow and cheeks of the old man with this divine mental struggle, this mighty, conscious effort, yet at the same time, the perfect expression of the inner peace that only the blind enjoy. In the bust in Naples, every stroke of the chisel breathes a spirit and the wonder of life."

25 A thorough study of all the copies is still lacking. The analysis of Bayer (1983, 62ff. 204ff.) is based on the plastic forms of the face, which are difficult to apprehend, and comes to the erroneous conclusion that the bronze

head in Florence is the best copy of the type. A more promising approach would be to start with the details of the coiffure, especially the thick cork-screw curls at the temples and the roll of hair at the nape, which are most clearly rendered in the Boston head. To this basic type, which is also characterized by the "active" quality of the physiognomy, I would assign the heads in the British Museum (Boehringer-Boehringer 1939, pl. 81), in a private collection (pls. 99ff., though I am not certain it is ancient), in the Capitoline (pls. 59f.), and in Schwerin (pls. 88–91), as well as the now-lost bust that appears in Rembrandt's painting of Aristotle in New York, Metropolitan Museum of Art (pls. 53–55).

26 Lefkowitz 1981, 16.

27 Lauer-Picard 1955; cf. the review by F. Matz (*Gnomon* 29 [1957] 84–93), who noted the significance of the two fragmentary heads with fillets (Lauer-Picard, 85, figs. 41–42; 259, figs. 142–43). On the basis of stylistic criteria and historical considerations he suggested a date in the early second century, which has also been supported by C. Reinsberg, *Studien zur hellenistischen Toreutik* (Hildesheim, 1980) 118, 184. See now B. S. Ridgway, *Hellenistic Sculpture* (Madison, 1990) 1 : 131ff. A new study of the group, which has been quite inadequately published, is being prepared by M. Bergmann and R. Wünsche.

28 On the Hellenistic Socrates see Richter I, 110f.; L. Giuliani, in *Villa Albani* I, 466ff., no. 153, pls. 270–71, with earlier bibliography; *Sokrates* 1989, 52, which refers to a painting of the seated Socrates in one of the so-called *Hanghäuser* in Ephesus. On Socrates' importance for Hellenistic philosophy see A. A. Long, "Socrates in Hellenistic Philosophy," *CQ* 38 (1988) 150–71.

29 Cf. Richter I, figs. 563–563a; *Sokrates* 1989, 53. The head type that appears on the side of the Louvre sarcophagus might actually be the same as the Albani type. A terra-cotta statuette of Socrates may derive from a creation of the Middle Hellenistic period and give us at least some idea of the appropriate body type: see R. Özgan, *Selçuk Üniversiti: Edebiyat Fakültesi Dergisi* 1 (1981).

30 See Andreae (1980) and, most recently, von den Hoff (1994, 140ff.), who traces the history of the copies and provides a stylistic analysis, also arriving at a date in the early second century B.C. He also suggests iconographical parallels with contemporary images of centaurs, satyrs, and giants. I cannot accept the idea that the classicizing beard contains a direct reference to Socrates, for how would the ancient viewer have recognized this? N. Himmelmann, in *Phyromachos-Probleme,* ed. B. Andreae (Mainz, 1990) 13ff., adheres to the earlier dating of the portrait, in the lifetime of Antisthenes.

31 An inscription in Ostia (Helbig[4] IV, no. 3388) suggests that the Antisthenes portrait could be a work of one Phyromachos, who worked at the Pergamene court in the first half of the second century B.C. In that case, we might suppose a link to the Stoic circle centered around the philosopher and grammarian Krates of Mallos at Pergamon, for the Stoics considered Antisthenes, beside Socrates, their greatest forebear. Unfortunately several uncertainties detract from this hypothesis, including the fact that there were several Phyromachoi. Cf. Andreae (supra n. 30) 13ff.

32 See Schefold 1943, 146, 213; Richter II, 182ff., figs. 1057–65; Bayer 1983, 38ff.; L. Giuliani, in *Villa Albani* I, 180ff., no. 55, pls. 100–102, with earlier bibliography; von den Hoff 1994, 129ff. The statuette in the Villa Albani, along with the ancient fragments incorporated into a modern statuette in New York, gives the best idea of what the body looked like, while the head is best represented by the copy in Aix-en-Provence.

Because of the problems of the transmission of the type, I do not believe it is possible to arrive at a dating any more specific than late third or second century B.C. On Diogenes and the Cynics see H. Niehues-Pröbsting, *Der Kynismus des Diogenes und der Begriff des Zynismus*[2] (Frankfurt, 1988); G. Bodei Giglioni, "Alessandro e i Cinici," in *Studi ellenistici,* ed. B. Virgilio (Pisa, 1984) 1 : 51–73.

33 There is a particular problem in the transmission of the statue. Since all five copies thus far known are on the same scale (ca. fifty-five centimeters in height), we must assume that the prototype was also of this size. It is quite possible, however, that this was a kind of "intermediary" original, that is, a reduced version of a life-size original created for a domestic context. The existence of large-scale statues of Diogenes is securely attested (D. L. 6.78; cf. Richter II, 182, no. 1; Neudecker 1988, 231, no. 66, pl. 16, 5).

Whereas the small-scale version broadens the narrative aspect of the composition, a life-size original could, like the Cynic in the Capitoline, have confronted the viewer more directly. Several details would seem to support this notion, such as the detailed working of the back, with its insistently realistic rendering of the aging body, the extended right hand, and the compact form of the head. The flatness of the figure in a side view is best seen in the copies in the Villa Albani and in Afyon. The frontal view of the Albani statuette clearly shows that this small-scale version was intended to be seen at an oblique angle, as the plinth also suggests: Giuliani (supra n. 32) pl. 100. Small-scale statuettes of this kind were popular already in the Hellenistic period and were used in the decoration of ostentatious living areas. The Hellenistic houses of Delos have niches for the exhibition of such statuettes: see M. Kreeb, *Untersuchungen zur figürlichen Ausstattung delischer Privathäuser* (Chicago, 1988). On miniature copies see now E. Bartman, *Ancient Sculptural Copies in Miniature* (Leiden, 1992).

34 K. Herding, "Diogenes als Bürgerheld," in id., *Zeichen der Aufklärung: Studien zur Moderne* (Frankfurt, 1989) 163–83. On the Roman funerary altar see H. Wrede, *JdI* 102 (1987) 384ff., figs. 3–5, whose interpretation I find too narrow.

35 J. Delorme, *Gymnasion* (Paris, 1960); E. Ziebart, *Aus dem griechischen Schulwesen*[2] (Leipzig and Berlin, 1914); M. P. Nilsson, *Die griechische Schule* (Munich, 1955); H. Maehler, "Die griechische Schule im ptolemäischen Ägypten," in *Egypt and the Hellenistic World,* Proceedings of the International Colloquium, Leuven, 1982 (Leuven, 1983) 191–203; Blanck 1992, esp. 149ff.

36 See U. Sinn, *Die homerischen Becher* (Berlin, 1979), with full references; U. Hausmann, *Hellenistische Reliefbecher aus attischen und böotischen Werkstätten* (Stuttgart, 1959); on silver vessels and carved rings see especially the illustrations in Richter I–II.

37 Richter I, 5, figs. 114–16; cf. U. Pannuti, "L'apotheosi d'Omero," *MemLinc* ser. misc. 3. 2 (1984) 43–61.

38 The most recent study of the portrait of Carneades, with a thorough discussion of the copies, is that of A. Stähli, *AA,* 1991, 219–52. His argument that the portrait was created posthumously cannot be substantiated with epigraphical evidence, as Christian Habicht kindly assures me. Aside from the prosopographical arguments, Habicht points out that, according to S. V. Tracy, *Attic Letter Cutters, 229 to 86 B.C.,* Hesperia Suppl. 15 (Princeton, 1975) 138–41, the Carneades inscription is attributed to the "cutter of IG II[2] 3479," who was active during the philosopher's lifetime. Likewise, Stähli's stylistic comparisons do not, in my view, support a dating in the last quarter of the second century. The two dedicators, Attalus and Ariarathes, are not foreign princes, as previously believed, but Athenians with royal names, as shown by the new victor list of the Panathenaic Games of 170: cf. Tracy and Habicht, *Hesperia* 60 (1991) 188f.

39 Habicht 1988.

40 For the portrait of "Panaitios" see ABr 999–1000; Hafner 1954, 11 R 2; G. Lippold, *Vat. Kat.* III, 2, 480, no. 50, pl. 213; 493, no. 68; von den Hoff 1994, 113.

41 Schefold 1943, 150; Hafner 1954, 10 R 1; Richter III, 282, fig. 2020; Richter-Smith 1984, 189f. Cf. the statue of a man from Rhodes, a Greek original with a similar head: Hafner, 22 R 17, pl. 7.

42 For the grave monument of Hieronymos see Pfuhl-Möbius II, 500f., pl. 300; P. M. Fraser, *Rhodian Funerary Monuments* (Oxford, 1977) 34ff.,

129f., fig. 97. The style suggests a date in the second half of the second century (also according to Pfuhl-Möbius), so that he cannot be identified with the Peripatetic philosopher of the same name.

43 Berlin, Staatliche Museen inv. SK 1462; for a good illustration see H. Froning, *Marmor-und Schmuckreliefs mit griechischen Mythen* (Mainz, 1981) 80, pl. 66, with earlier bibliography; cf. H. von Hesberg, *JdI* 103 (1988) 348. Of relevance to the interpretation may be Isidorus' explanation of the symbolic meanings of letters: *Orig.* 1, 3, 7–9. He reports, for example, that the Y represents the Pythagorean *exemplum vitae humanae,* because the two strokes symbolize the steep ascent to the *vita beata,* as well as the easy descent into ruin.

44 On a somewhat later relief in Berlin, the element of heroization is now quite explicit. Of interest for us is the fact that the physician accorded heroic honors is rendered in the manner of a philosopher giving instruction, seated on a high-backed, thronelike chair: A. Hilpert, *Antike Ärztedarstellungen* (Frankfurt, 1990) 14ff., fig. 14. On the position of the "house philosopher" in Rome see E. Rawson, "Roman Rulers and the Philosophic Adviser," in Griffin 1989, 233–57.

45 On the comments that follow see Giuliani 1986, 156ff.; Fittschen 1991, 258ff.; P. Zanker, "Individuum und Typus," in *Akten des III. internationalen Kolloquiums über das römische Porträt, Prague, 1988* (in press).

46 For an overview of the material see Michalowski 1932; Buschor 1971; Hafner 1954; Stewart 1979; P. Zanker, "Zur Rezeption des hellenistischen Individualporträts in Rom und in den campanischen Städten," in *Hellenismus in Mittelitalien,* vol. 2, ed. P. Zanker, *AbhGött* 3d ser., no. 97 (1976) 581ff.

47 Cf. Giuliani 1986, 156ff.

48 In the discussion that follows I rely on the as-yet unpublished dissertation of Fabricius (Munich, 1992); cf. also Zanker 1993.

49 For the stele in Winchester see Pfuhl-Möbius, I, 222, no. 855, pl. 125.

50 Stele in Leiden: Pfuhl-Möbius I, 217, no. 831, pl. 121.

51 See, most recently, the testimonia cited by Fittschen 1991, 264 and pl. 67, in connection with the statue of Menander.

52 The stele of Theodotos in Istanbul: N. Fıratlı, *Les steles funéraires de Byzance gréco-romaine* (Paris, 1964) 54, no. 33, pl. 8; Pfuhl-Möbius II, pl. 489; no. 2034, pl. 294; Fabricius 1992.

53 Pfeiffer (supra n. 11) 34, 132ff.

54 See T. Kleberg, *Buchhandel und Verlagswesen in der Antike* (Darmstadt, 1967) 20; F. G. Kenyon, *Books and Readers in Ancient Greece and Rome*[2] (Oxford, 1950).

55 See the following sources for images of reading philosophers and poets. Homer on a fragment of a Tabula Iliaca: Richter I, 54, fig. 119; A. Sadurska, *BCH* 86 (1962) 504–9; a statuette of Plato now lost: Richter II, 167f., fig. 960; Diogenes in the barrel on a glass paste: Richter II, figs. 1063, 1068–70; and cf. Zwierlein-Diehl 1986, 180, nos. 443f., pl. 79; 188, no. 488, pl. 85; an anonymous Cynic on a Roman relief, Copenhagen, Ny Carlsberg Glyptotek 185: F. Poulsen 1931, 58ff. Cicero (*Verr.* 2.87) refers to a statue of Stesichorus reading. This cannot, however, be identified with the figure shown reading on a coin: Schefold 1943, 173, 14. On readers and book rolls on East Greek gravestones see Fabricius 1992, 250ff.

56 London, British Museum 2320; ABr 989f.; J. J. Bernoulli, *Griechische Ikonographie* (Munich, 1901; repr., Hildesheim, 1969) 1 : 135f., pl. 15; H. B. Walters, *Catalogue of the Bronzes, Greek, Roman, and Etruscan, in the British Museum* (London, 1899) 153, no. 847; id., *Select Bronzes, Greek, Roman, and Etruscan, in the Department of Antiquities* (London, 1915) pl. 64; Lippold 1912, 52; Pfuhl 1927 = Fittschen 1988, 245; F. Studniczka, *Zeitschrift für bildende Kunst* 62 (1928–29) 121–34 = Fittschen, 264; Richter I, 131, figs. 708–10; Fittschen, 26, pls. 136f. A dating in the Late Hellenistic period was already argued by Pfuhl and Studniczka. A secure identification of the subject does not seem to me possible. The fillet certainly suggests a poet, and the most likely candidate is Homer. The relief with which this head type has correctly been associated is in Paris, Bibl. Nationale; see Richter II, 131, fig. 713.

Chapter Five

1 See Hahn 1989, with extensive bibliography; J. Christes, *Bildung und Gesellschaft: Die Einschätzung der Bildung und ihrer Vermittler in der griechisch-römischen Antike* (Darmstadt, 1975); Bardon 1971, 95–106; P. Courcelle, "La figure du philosophe d'après les écrivains latin de l'antiquité," *JSav*, 1980, 85–101; A. B. Breebaart, "The Freedom of the Intellectual in the Roman World," *Talanta* 7 (1975) 55–75; P. Desideri, "Intellettuali e potere," in *Civiltà dei romani,* vol. 2, *Il potere e l'esercito,* ed. S. Settis (Milan, 1991) 235–40; S. Laursen, "Greek Intellectuals in Rome—Some Examples," *Acta Hyperborea* 5 (1993) 191–211.

2 On the portrait of Cicero see, most recently, H. R. Goette, *RM* 92

(1985) 291ff., who questions the identification; in favor: Giuliani 1986, 324f. For the portrait of Seneca see C. Blümel, *Katalog der Sammlung antiker Skulpturen,* vol. 6, *Römische Bildnisse* (Berlin, 1933) R 106, pl. 71; M. Bergmann, in *Römisches Porträt* 1982, 144.

3 Hahn 1989, 172ff.

4 There are, however, a number of literary references to portraits of Roman writers: see Neudecker 1988, 71.

5 On this subject, and on what follows, see Neudecker 1988, 65ff.; M. Fuchs, *Untersuchungen zur Ausstattung römischer Theater in Italien und in den westlichen Provinzen des Imperium Romanum* (Mainz, 1987).

6 E. Gruen, *Studies in Greek Culture and Roman Policy* (Leiden, 1990); E. Rawson, *The Intellectual Life of the Late Republic* (London, 1985).

7 See my comments in Zanker 1988, 28–29.

8 Neudecker 1988, 14f.; Cic. *Att.* 4.16.3: *deus ille noster Plato.*

9 L. Beschi, *I bronzetti romani di Montorio,* Istituto veneto memorie 33.2 (Venice, 1962) 13ff.; *Hist. Aug.,* Aurel. 3.5; *Hist. Aug.,* Lampr. Alex. 29.2. Cf. Neudecker 1988, 32, 72.

10 On busts of Hippocrates as tomb offerings see G. Becatti, *RendPontAcc* 21 (1945–46) 123–41. The authenticity of the interesting notices of the two lararia of the emperor Severus Alexander in the *Historia Augusta* (29.2; 31.4) has been questioned. See Neudecker 1988, 72, 32.

11 For surviving examples of such rings see Richter I–II, passim, and the catalogues of individual museums.

12 V. M. Strocka has recently found evidence for such a private "home library" with the fittings for a large built-in bookcase. The room measures about twelve square meters and is located between a smaller dining room and a *cubiculum* and, like the latter, opens onto a terrace with a view. Well-preserved frescoes of the Second Style on two of the walls show two contemporary Romans (identifiable as such because they are beardless), one of them shown as a poet, the other, as Strocka suggests, as a scholar with his pointer. Both wear the Greek himation. These frescoes were probably meant to celebrate the literary abilities of the house's owner or those of his friends. It is also quite possible that both figures represent the same individual. See Strocka 1993.

13 Neudecker 1988, 12.

14 On Roman copies of Greek portraits in the form of herms, see

A. Stähli, "Ornamentum Academiae," *Acta Hyperborea* 4 (1992) 147–72. This material has never been collected and studied. Cf. Richter I–II and the index to K. Schefold, *Die Wände Pompejis* (Berlin, 1957); Theophilidou 1984, 243–348.

15 For Bias see Richter I, 87, fig. 354. For Socrates, Richter, 113, no. 12, fig. 503. For a seated statue of Euripides with a catalogue of his work see Richter, 137, figs. 760–61. On the encyclopedic galleries see Neudecker 1988, 64ff.

16 It is only in this light that we can make sense of a dramatic anecdote like that of Herodes, the father of the famous orator, who ordered his slaves to stone the herms of the orators of the past, on the grounds that they had taught his son the wrong kind of oratory (Philostr. *VS* 521).

17 A. Héron de Villefosse, "Le trésor de Boscoreale," *MonPiot* 5 (1899); Schefold 1943, 166f.; F. Baratte, *Le trésor d'orfèvrerie romaine de Boscoreale* (Paris, 1986) 65–67; K. M. D. Dunbabin, "Sic erimus cuncti . . . The Skeleton in Graeco-Roman Art," *JdI* 101 (1986) 185–255, esp. 224ff.

18 G. Calza, "Die Taverne der Sieben Weisen in Ostia," *Die Antike* 15 (1939) 99–115; A. von Salis, "Imagines illustrium," in *Eumusia, Festgabe für E. Howald* (Zurich, 1947) 11–29. Cf. R. Neudecker, *Die Pracht der Latrine* (Munich, 1994) 35ff., which offers a new interpretation.

19 Fittschen 1992a.

20 Such figures represented with Greek dress and manners were evidently common. Cf. the statue of a young man in long mantle from the Villa dei Papiri: Zanker 1988, 30, fig. 24; and the two intellectuals in Greek mantle in the library of House VI 17, 41 at Pompeii, recently discussed by Strocka 1993.

21 The need on the part of Roman politicians and generals to have their deeds celebrated in literary panegyric goes back to the Middle Republic. If Ennius was able to cultivate close relationships with the heads of several noble families and could not only be buried in the tomb of the Scipiones but even have a statue of himself placed before the facade of the monument, between two famous members of the family (a story, however, that may be doubted), this can mean only that there was already considerable prestige attached to being acquainted with a well-known poet. On the literary sources see W. Suerbaum, *Untersuchungen zur Selbstdarstellung älterer römischer Dichter,* Spudasmata 14 (Hildesheim, 1968) 208ff. Giuliani's (1986, 163ff., 172ff.) identification of this statue with a portrait in the Ny Carlsberg Glyptotek in

Copenhagen remains entirely hypothetical. Cf. K. Fittschen, *AA*, 1991, 253—70, esp. 255ff.

[22] Friedländer II, 191 and esp. 214f.; Bardon 1971, 101ff. Cf. now M. Bergmann, "Zu Nero," *TrWPr*, 1994.

[23] For collections of sources see M. Nowicka, *Le portrait dans la peinture antique* (Warsaw, 1993) 130ff.; G. Cavallo, "Libro e cultura scritta," in *Storia di Roma* (Turin, 1989) 4: 693—734, with extensive illustrations; id., "Testo, libro, lettura," in *Lo spazio letterario di Roma antica,* ed. G. Cavallo et al. (Rome, 1990) 307—41. K. Stemmer, *Casa dell'Ara Massima VI 16, 15—17* (Munich, 1992) figs. 154ff., gives a good idea of how the tondi were placed on the wall. E. G. Turner, *Greek Papyri* (Oxford, 1968) interprets the "Hermione grammatike" of a well-known mummy portrait at Girton College, Cambridge, as a "literary lady . . . of the Graeco-Roman middle class" (p. 77).

[24] For the statue in Buffalo see K. Lehmann-Hartleben, "Some Ancient Portraits," *AJA* 46 (1942) 204—16; R. Wünsche, "Eine Bildnisherme in der Münchner Glyptothek," *MüJb* 31 (1980) 25ff. For the statue in the Terme see Wünsche, 26f. and figs. 22—23.

[25] Helbig⁴ II, no. 1734; *IGR* I, 116ff., nos. 350—52; Marrou 1938, 130, no. 151, 205f.; and, most recently, Blanck 1992, 72ff., fig. 45.

[26] On the typology of the portraits of Trajan and Hadrian see Fittschen-Zanker I, 44ff., nos. 46ff.

[27] M. Bergmann, "Zeittypen im Kaiserporträt," in *Römisches Porträt* 1982, 144f.; S. Walker, "Bearded Men," *Journal of the History of Collections* 3.2 (1991) 265—77; P. Cain, *Männerbildnisse neronisch-flavischer Zeit* (Munich, 1993) 100—104, with earlier references on the problem of beards in Roman portraiture.

For the statue in Cyrene see E. Rosenbaum, *A Catalogue of Cyrenaican Portrait Sculpture* (London, 1960) no. 34, pl. 26; H. G. Niemeyer, *Studien zu den statuarischen Darstellungen der römischen Kaiser* (Berlin, 1968) 90, no. 31, pl. 9, 1.

[28] See P. Graindor, "Les cosmètes du Musée d'Athènes," *BCH* 39 (1915) 241—401; E. Lattanzi, *I ritratti des cosmeti* (Rome, 1968); Bergmann 1977, 80ff.; H. Meyer 1991, 225ff.; von den Hoff 1994, 8f.

[29] Bowie 1970, 3—41; J. Day, *An Economic History of Athens under the Roman Domination* (New York, 1942) 183ff.; S. Follet, *Athènes au II^e et au III^e siècle* (Paris, 1976); D. J. Geagan, "Roman Athens: Some Aspects of Life and Culture I," in *ANRW* 2.7.1 (1979) 389ff.; D. Willers, *Hadrians panhellenisches*

Program: Archäologische Beiträge zur Neugestaltung Athens durch Hadrian, AntK-BH 16 (Basel, 1990).

30 For the *kosmētēs* who resembles Plato see Lattanzi (supra n. 28) 62, pl. 30 (the date is late Hadrianic; Bergmann's [1977, 88] dating is too late); the Socrates look-alike: Munich, Residenz EA 964; E. Weski and H. Frosien-Leinz, *Das Antiquarium der Münchner Residenz* (Munich, 1987) 245, no. 129, pl. 169; the Theophrastus look-alike: Lattanzi 55, pl. 22; Bergmann 1977, 83f.; the Demosthenes look-alike: *ArchDelt* 9 (1924–25), Parart. 26, fig. 22; Bergmann 1977, 89. For Arrian as "Neos Xenophon" see J. H. Oliver, *AJA* 76 (1972) 327f.

31 I do not mean to suggest that the resemblance is so close that we may postulate a typological connection. Hadrian's hairstyle is completely different, closer to the luxurious style of a Flavian coiffure (cf. Mart. 7.95.11).

32 Zanker 1982, 307–12.

33 For the fourth portrait type of Marcus Aurelius see Fittschen-Zanker I, 76, no. 69, pl. 81; Bergmann 1978, 30ff. On p. 26 Bergmann refers to two versions of this type with furrowed brow, but she interprets them as signs of age and worry. My interpretation, for at least some of the late portraits of Type IV, is not vitiated by the fact that the dramatic locks over the brow and the eyes in other copies, and perhaps in the original as well, may carry quite different associations. The message conveyed by such ruler portraits was often composed of a variety of formulas incorporating different qualities. For Pertinax see Bergmann, 33 n. 72.

34 There is a text and Italian translation in *Classici greci, Opere di Sinesio di Cirene, Epistole operette inni,* ed. I. Lana and A. Garyza (Turin, 1989) 620f.

35 For the portraits illustrated here see the following sources: fig. 121a: Rome, Palazzo dei Conservatori 2411; 121b: Vatican Museum, Chiaramonti 1750; 121c: Munich, Glyptothek 429; 121d: Rome, Villa Albani (*Villa Albani* I, no. 154, pl. 272; and cf. the other examples at pls. 266–67); 121e: Florence, Museo Bardini (cf. K. Fittschen, in *Eikones: Festschrift H. Jucker,* AntK-BH 12 [Bern, 1980] 108–14, pl. 38, 3); 121f: Toulouse, Musée Saint Raymond (cf. Fittschen, pl. 38, 4). Fig. 122a: Rome, Capitoline Museum 513 (Hekler 1912, pl. 274a; Fittschen, in the still unpublished text to the catalogue in Fittschen-Zanker II, lists numerous additional examples of this type with bald head); 122b: Malibu, J. Paul Getty Museum 85.AA.112; 122c: Rome, Capitoline Museum 710 (Stuart Jones, *Cap.,* 318, no. 11, pl. 79; the interpretation as an athlete is given by Fittschen in the unpublished text cited above); 122d: New York, Collection of Shelby White and Leon Levy (D. von Bothmer, ed., *Glories of the Past* [New York, 1990] 221, no. 161); 122e: Ostia

Museum 1386 (Helbig⁴ IV, no. 3135); 122f: Ostia Museum 68 (Helbig⁴ IV, no. 3136; H: 34 cm). One can find many more examples in the various museum catalogues.

36 For the so-called Plotinus (fig. 122f) see R. Calza, *BdA* 38 (1953) 203ff., figs. 1–8; Helbig⁴ I, no. 412 (H. von Heintze); H. P. L'Orange, *Likeness and Icon* (Odense, 1973) 32ff., figs. 1ff. Since all the preserved copies come from Ostia, one of them over-life-size, and one found in a public bathing establishment, the subject must have been an important public figure in the city. He is therefore unlikely to have been a professional philosopher. A very similar head, likewise from Ostia (fig. 122e; now Ostia Museum inv. 1386), displays certain typological differences and thus probably represents yet another public personality of the type with bald head.

37 A glance through the catalogues of the major collections of portraits will confirm this impression. Despite the generally problematic state of our evidence, it would nevertheless be worthwhile to compile more precise statistics on the various types of bust, in order to judge more accurately which were held in high regard in each individual period.

38 Thessaloniki, Archaeological Museum inv. no. 1058: G. Bakalakis, *AA,* 1973, 682, fig. 9; J.-C. Balty, *BMusBrux* 55 (1984) 57. Budapest, National Museum 176: A. Hekler, *Die Sammlungen antiker Skulpturen* (Budapest, 1929) no. 176; id., *Die Antike* 16 (1940) 133, figs. 19–20; Stemmer 1988, 192, no. M 10. Cf. also a head in Beirut: *Berytus* 4 (1937) 111ff.

39 Hahn 1989, 161.

40 The "philosophers" from Dion are as yet unpublished, though illustrated in calendars and elsewhere. I wish to thank the excavator, D. Pandermalis, for information and photos. Cf. *Ergon,* 1987, 64f., figs. 64–65; *BCH* 112 (1988) 646, fig. 71; *ArchRep* 35 (1988–89) 66, fig. 92. M. Bergmann points out to me that the heads with facial features assimilated to those of Caracalla are significantly smaller, thus perhaps reworked. We are dealing, then, with two different bodies of material.

41 We may also compare a group of five philosopher statues of eclectic types found in Athens, two of them in the pose of Epicurus. See Dontas 1971, 16–33, pls. 1–8.

42 For the so-called Aelius Aristides see Richter III, 287, figs. 2051–53; Helbig⁴ I, no. 463; A. Giuliano, *DialArch* 1 (1967) 72ff., who, however, takes the inscription as ancient, though I would rather think it is modern.

43 Richter III, 285, fig. 2033 (tentatively dated to the Severan period); *La colonna Traiana,* ed. S. Settis (Turin, 1988) 65.

44 For the sarcophagus New York, Metropolitan Museum of Art 48.76.1, see A. M. McCann, *Roman Sarcophagi in the Metropolitan Museum of Art* (New York, 1978) no. 24; A. Hillert, *Antike Ärztedarstellungen* (Frankfurt, 1990) 155ff., no. 29, fig. 32; Amedick 1991, 116, 135, no. 81, pl. 114f.

45 Cf. the examples collected by Hillert (supra n. 44).

46 On Apuleius see *RE* 2.1 (1896) 246ff., s.v. Apuleius 9 (Schwabe).

47 G. Brugnoli, "Le statue di Apuleio," *AnnCagl* 29 (1961–65) 11–25. The portrait of Apuleius on contorniates is beardless and has long hair; thus the prototype cannot belong to his own lifetime. The type was probably created in the fourth century A.D., as suggested also by a comparison with the "Sophist" from Aphrodisias; see Alföldi-Rosenbaum 1982, pl. 2, 5.

48 See Hahn 1989, 51, 59; A. D. Nock, "Conversion and Adolescence," in *Pisculi: Studien zur Religion und Kultur des Altertums, Festschrift F. J. Dölger*, Antike und Christentum Ergänzungsband 1 (Münster, 1939) 165–77; reprinted in A. D. Nock, *Essays on Religion in the Ancient World* (Oxford, 1972) 469–80. On Peregrinus see Jones 1986, 117ff.

49 Vienna, Kunsthistorisches Museum I 113; R. von Schneider, *Album auserlesener Gegenstände der Antikensammlung des allerhöchster Kaiserhauses* (Vienna, 1895) 7; E. Buschor, *Das Porträt* (Munich, 1960) 135, fig. 93; Stemmer 1988, 192, no. M 11.

50 Athens, National Museum 340, from the Athenian Asklepieion according to Kavvadias; ABr 438–39; H. Meyer 1991, 227, pl. 138, 3–4.

51 For the old man in the Capitoline see Stuart Jones, *Cap.*, 239, no. 50, pl. 54; Hekler 1912, 43, pl. 278a. The head will be treated by K. Fittschen in Fittschen-Zanker II.

52 Athens, Acropolis Museum; ABr 440; H. Meyer 1991, 227, pl. 138, 2, with additional examples.

53 I give here only a few of the many examples that will indicate the direction of my argument: Copenhagen, Ny Carlsberg Glyptotek; V. Poulsen II, 85ff., no. 62, pls. 99, 100 (from Athens); no. 63, pl. 101; no. 65, pls. 104–5; 153, no. 152, pl. 245; Berlin, Pergamonmuseum SK 318; Stemmer 1988, 42f., no. D9; cf. K. Fittschen, in *Mousikos Aner, Festschrift Max Wegner* (Bonn, 1992) 115ff., with a different interpretation. K. Fittschen, *Katalog der antiken Skulpturen in Schloss Erbach* (Berlin, 1977) 90, no. 33, pl. 39 (for the contrast of hair and beard); Rome, Museo Torlonia; R. Calza, *Scavi di Ostia,* vol. 9 (Rome, 1978), *I ritratti,* 34, no. 38, pl. 30; Florence, Uffizi inv. 1114.n.371; G. Mansuelli, *Galleria degli Uffizi: Le sculture* (Rome, 1961) 2: 96, no. 110.

54 Ny Carlsberg Glyptotek 706; V. Poulsen II, 105f., no. 92, pls. 154–55. M. Bergmann dates the portrait "nicht zu spät in hadrianische Zeit" (*Gnomon* 53 [1981] 183).

55 B. M. Felletti-Maj, *Museo Nazionale Romano: I ritratti* (Rome, 1953) 113f., no. 222 (identified as Lucius Verus); cf. no. 201: K. Fittschen, *JdI* 86 (1971) 214–52.

56 For the bust of Theon see Hekler 1940, 124f., fig. 3; Schefold 1943, 180, 3; K. Fittschen, in Inan-Alföldi-Rosenbaum 1979, 162ff., no. 115, pls. 95, 105. On Theon himself see *RE* 5.A2 (1934) 2067, s.v. Theon 14 (K. von Fritz).

57 P. Hadot, *Philosophie als Lebensform: Geistige Übungen in der Antike* (Berlin, 1991); M. Foucault, *The Care of the Self,* vol. 3 of *History of Sexuality,* trans. R. Hurley (New York, 1986) esp. 53ff.

58 On Herodes Atticus see Richter III, 286, figs. 2044ff.; Schefold 1943, 180f.

59 Inan-Rosenbaum 1966, 127, no. 150, pls. 83, 3 and 87, 3–4.

60 Inan-Alföldi-Rosenbaum 1979, 186, pl. 139, with commentary on the inscription by J. Reynolds.

61 For the two busts said to come from Smyrna, now Brussels, Musée du Cinquentenaire inv. A1078/79, see Inan-Alföldi-Rosenbaum 1979, 164ff., nos. 116–17, pls. 96–97.

62 Athens, National Museum 427; ABr 639–40; Hekler 1940, 125, figs. 6–7; Schefold 1943, 180f.; Richter III, 235, figs. 2034–37; Willers (supra n. 29) 44, pl. 4, 1–3 (dated Late Hadrianic/Early Antonine). On Polemon see *RE* 21.2 (1952) 1320ff., s.v. Polemon 10 (W. Stegemann), esp. 1353 on the speech in Athens.

63 K. Fittschen, in *Greek Renaissance* 1989, 108–13.

64 See Philsotr. *VS* 552, 558; W. Ameling, *Herodes Atticus* (Hildesheim, 1983) 1: 113ff.; 2: cat. nos. 148–82; K. A. Neugebauer, "Herodes Atticus, Ein antiker Kunstmäzen," *Die Antike* 10 (1943) 99f.; H. Meyer, *AM* 100 (1985) 393–404.

65 *Glories of the Past: Ancient Art from the Shelby White and Leon Levy Collection,* ed. D. von Bothmer (New York, 1990) 214f., no. 155. We might also place in this context the famous bust of the so-called Rhoimetalkes from the Theatre of Dionysus in Athens: Fittschen (supra n. 63) 109, pl. 38; Bergmann 1977, 80ff.

66 See my paper in *Greek Renaissance* 1989, 102–7.

67 See *Sympotica: A Symposium on the Symposion,* ed. O. Murray (Oxford, 1990), esp. the paper on Athenaeus by A. Lukinovich on pp. 263–71; *Dining in a Classical Context,* ed. W. J. Slater (Ann Arbor, 1991).

68 Bowersock 1969, 43ff.; E. L. Bowie, "The Importance of Sophists," in *Later Greek Literature,* Yale Classical Studies 17 (New Haven, 1982) 29–59.

69 See Koch-Sichtermann 1982. For an example of this method of interpretation see L. Giuliani, *JBerlMus* N.F. 31 (1989) 25–29.

70 Paris, Louvre MA 659; Baratte-Metzger 1985, 29ff.; Amedick 1991, 63ff., 140, no. 114, pls. 52–53; cf. Koch-Sichtermann 1982, 107ff.

71 Cf. M. R. Lefkowitz and M. B. Fant, *Women's Life in Greece and Rome* [2] (London, 1992) 188-89.

72 J. Toynbee and J. Ward Perkins, *The Shrine of St. Peter and the Vatican Excavations* (London, 1956) 82f.; H. Mielsch and H. von Hesberg, *MemPontAcc* 16.2 (in preparation; cf. the preliminary remarks of Mielsch in Stemmer 1988, 186ff.).

73 Hahn 1989, 35; *RE* 6 (1909) 1216, s.v. Euphrates 4 (H. von Arnim). On the characteristics of these "divine men" see Bieler I.

74 See *RE* 16.1 (1933) 893, s.v. Musonius Rufus (K. von Fritz).

75 See M. Billerbeck, *Der Kyniker Demetrius: Ein Beitrag zur Geschichte der frühkaiserzeitlichen Popularphilosophie* (Leiden, 1979); *RE* 4 (1900) 2843, s.v. Demetrios 91 (H. von Arnim).

76 M. Morford, *Stoics and Neostoics: Rubens and the Circle of Lipsius* (Princeton, 1991) esp. 155f., figs. 6, 23.

77 P. A. Brunt, "Stoicism in the Principate," *BSR* 43 (1975) 7–35; J. Malitz, "Helvidius Priscus und Vespasian," *Hermes* 113 (1985) 231–46. Cf. P. Desideri, *Dione di Prusa* (Messina and Florence, 1978) esp. 187ff.

78 Ostia Museum 130 (said to be "da una specie di aula tardo-antica presso il Tempio di Ercole"). The dimensions are 50 × 51 × 12.7 centimeters. G. Calza, *Capitolium* 14 (1939) 230 ("copisteria antica"); H. Fuhrmann, *AA,* 1940, 439, fig. 18 ("Versteigerung"); E. G. Turner, *Greek Papyri* (Oxford, 1968) 189f., pl. 6 ("rhetorician or a teacher"); R. Calza and M. Floreani-Squarciapino, *Museo Ostiense* (Rome, 1962) 82f., pl. 13 (Christian scene of instruction?); Blanck 1992, 70, fig. 44. I am indebted to H. Blanck for discussing this interesting relief with me.

79 See Bieler I.

80 On Apollonius see Philostr. *VA* 1.32. On Dio's long hair see Dio Chrys. 72.2, 12.15; and cf. Hahn 1989, 33ff. See also W. Speyer, "Zum Bild des Apollonios bei Heiden und Christen," *JAC* 17 (1974) 47ff.

81 On the beard styles of the Pythagoreans see also Ath. 4.163f. The one securely identified portrait of Pythagoras himself, on a contorniate of the fourth century A.C., does not actually show shoulder-length hair, though he does have an extremely long, tapering beard. See Schefold 1943, 172f., no. 19; Richter II, 79, fig. 304.

82 On the magical associations of long hair see L'Orange 1947, 28ff., with further references; E. R. Leach, "Magical Hair," *Man: Journal of the Royal Anthropological Institute* 88 (1958) 147–68. The best-known of the Classical portraits of intellectuals with long hair is the Homer of the so-called Apollonius type, which probably derived from an original of the late fourth or early third century B.C. See Richter I, 48ff., figs. 25ff.; S. Schröder, *Katalog der antiken Skulpturen des Museo del Prado in Madrid* (Mainz, 1993) 42f., nos. 17–18. It was because of the long hair that the type was originally identified as Apollonius of Tyana. It is not clear whether in this case the long hair was inspired by analogy with Zeus (as early as 350 B.C. a coin struck on the island of Ios shows Homer with the long hair of Zeus; cf. p. 164 above), or whether it is connected with the long hair of the singer; cf. H. Lohmann, *Grabmäler auf unteritalischen Vasen* (Berlin, 1979) 278, no. L 3, pl. 13, 2; 283, no. L 34. Occasionally we come across anonymous portraits with long hair. On the well-known philosopher mosaic in Cologne, Chilon the wise man sports long hair: Richter I, fig. 359. In general, however, very long hair is alien to the intellectual portraits of the Classical and Hellenistic periods.

83 Rosenbaum (supra n. 27) 65, no. 70, pl. 45; K. Fittschen, in *Greek Renaissance* 1989, 112. Cf. the similar head with band across the brow in Houghton Hall: F. Poulsen, *Greek and Roman Portraits in English Country Houses* (Oxford, 1923) 47, no. 21. A key piece of evidence in this context is the Hadrianic relief in Eleusis, showing a hierophant, identified by inscription, with very long hair and a priestly fillet: *AJA* 64 (1960) 268, pl. 73; *BCH* 84 (1960) pl. 13.

84 O. Weinreich, "Alexander der Lügenprophet," *NJbb* 47 (1921) 129; Jones 1986, 133ff.

85 Copenhagen, Ny Carlsberg Glyptotek inv. 2464; ABr 349–50; V. Poulsen 1954, no. 58, pl. 44; Johansen 1992, 146, no. 60 (here described as modern). See the additional references in Poulsen (supra n. 83) 47, no. 21; and cf. the text on *EA* 4209–13. The prototype of the so-called Modena

Euripides could also belong in this context, if indeed there was one, as I believe (as also Fittschen 1988, 122, pl. 159, and, most recently, M. L. Morricone, "Il cosidetto Omero della Galleria degli Uffizi," *RendLinc* 9.3.2 [1992] 163–92). In a case like this, it is of course not possible to draw a clear distinction from the type of the ascetic with unkempt hair.

86 Herakleion Museum; Richter I, 80f., figs. 306–7, 310 (here identified as Heraclitus because of the club); Schefold 1943, 160, no. 14 (here called Heraclitus, "based on a not much earlier classicistic prototype"); Hölscher 1982, 214; Fittschen 1988, pl. 51, 1–2.

87 On the identification of the Cynics with Herakles see R. Höistad, *Cynic Hero and Cynic King* (Uppsala, 1948) 50ff.; B. R. Voss, "Die Keule der Kyniker," *Hermes* 95 (1967) 124–25.

88 In the early third century, this portrait type occurs for the bucolic reading figure, the "philosopher" from the tomb of the Aurelii, and later also occasionally for the seated philosophers on relief sarcophagi (see pp. 282ff.). On the tomb of the Aurelii see G. Bendinelli, *MemLinc* 28 (1922) 440; G. Wilpert, *RendPontAcc* 3.1.2 (1924) 25, pl. 7; Himmelmann 1975, 19f.; A. Grabar, *The Beginnings of Christian Art* (London, 1967) fig. 107 (color illustration).

Chapter Six

1 On the portrait type see Fittschen-Zanker I, 105ff., pl. 111, Beilage 71ff.

2 I shall deliberately omit from consideration the aspect of "heroization" or of continued life after death as a reward for exceptional service to the Muses, a motif that often echoes in the poetic imagery of funerary epigrams. Marrou (1938, 209ff., 253f.) already recognized that these represent a rather marginal group in relation to the wealth of sources pertaining to the praise of learning, and that their evidence is anything but clear-cut. The enormous influence of F. Cumont's *Recherches sur le symbolisme funéraire des romains* (Brussels, 1942) esp. 253–350, has, in my view, unjustly made this aspect the focus of most subsequent interpretation.

3 See, most recently, S. Walker, *Catalogue of Roman Sarcophagi in the British Museum,* CSIR Great Britain 2.2 (London, 1990) 51, no. 66, pl. 26, who gives a date of ca. 200. Wiegartz (1965) places this sarcophagus in his chronological chart at about 230–235. He also gives other examples of this type. On the export of Phrygian sarcophagi see M. Waelkens, *Dokimeion: Die Werkstatt*

der repräsentativen kleinasiatischen Sarkophage (Berlin, 1982) 124ff.; G. Koch, *Sarkophage der römischen Kaiserzeit* (Darmstadt, 1993) 121ff.

4 See Koch-Sichtermann 1982, 548, fig. 538.

5 This material was first gathered together by Marrou (1938), then by Wegner (1966); cf. the important review of Wegner's book by Fittschen (1972), and Koch-Sichtermann 1982, 203–6. See also T. Klauser, *JAC* 3 (1960) 112ff.; id., *JAC* 6 (1963) 71–100; Gerke 1940, 272ff. There is, however, a noticeable time lag between the early examples of imported sarcophagi depicting the amateur intellectual, such as the fragment in the British Museum (fig. 144) or the sarcophagus in the garden of the Palazzo Colonna (Wiegartz 1965, 162, dated ca. 180), and the adoption of comparable motifs by workshops in the city of Rome, which will have begun only in the years around 230 to 240, if the dating based on stylistic criteria is correct.

6 On the musical education of women and on dance see Friedländer I, 271f.; II, 137, 183. On the image of Roman women generally see B. von Hesberg-Tonn, "Coniunx carissima: Untersuchungen zum Normcharakter im Erscheinungsbild der römischen Frau" (Diss., Stuttgart, 1983).

7 The same notion also occurs in contemporary inscriptions. Cf., for example, S. Nicosia, *Il segno e la memoria* (Palermo, 1992) no. 85 (= M. Guarducci, *Epigrafia greca* [Rome, 1974] 3: 187ff., fig. 75), in which an actress is celebrated as the tenth Muse.

8 Rome, Museo Torlonia 424; Wegner 1966, no. 133, pls. 60, 62, 64a, 73a. See the interpretation of Fittschen (1972, 492f.); Hölscher (1982, 214); Berger-Doer (1990, 425); Ewald (1993, 66ff.), who has rightly recognized in the "wise men" a reference to itinerant philosophers of the day, on account of their dress. On the social status of L. Pullius Peregrinus see R. Stein, *Der römische Ritterstand: Ein Beitrag zur Sozial- und Personengeschichte des römischen Reiches* (Vienna, 1927) 141.

9 On the difference between the *pallium* and the toga in seated statues see Goette 1989, 75f.; Fittschen 1992b, 266ff.

10 Like many of his contemporaries, Peregrinus believed in astrology, including the notion that the hour of one's death is already fixed by the constellations governing one's birth. Fittschen (1972, 493) was able to infer this from the fact that the inscription records the exact length of his life down to the minute. At his death Peregrinus was only twenty-nine years, three months, one day, and one-and-a-half hours old.

11 Brown 1980, 12: "These silent figures are the ghosts of what each dead man might have been." See also Hadot 1981.

[12] Vatican, Belvedere 68; Wegner 1966, 55, no. 135, pls. 55, 57; Helbig[4] I, no. 218 (B. Andreae); Fittschen 1972, 493; Wrede 1981, 149, 287, no. 243, pl. 35, 1–4.

[13] Vatican, Galleria dei Candelabri inv. 2422; Lippold, *Vat. Kat.* III, 2, 116ff., pl. 154; Wegner 1966, 58, no. 139, pls. 59, 69; Helbig[4] I, no. 514 (B. Andreae); Fittschen 1972, 494 (dated ca. A.D. 280). Amedick 1991, 69ff., traces the motif to scenes of magistrates and provides further examples.

[14] See Bieler I, 34f.; Marrou 1938, 197–207; Amedick 1991, 70f.—all of which also include references to the epigrams and inscriptions.

[15] Vatican, Museo Gregoriano Profano 9504; Wegner 1966, 47, no. 116, pls. 64, 70f.; Fittschen 1972, 491f.; Koch-Sichtermann 1982, 204f. On the outfits see Goette 1989, 97; and, on the shoes, id., *JdI* 103 (1988) 451, fig. 35c; 459ff. The philosopher in the long undergarment was originally intended to be a female figure: Himmelmann 1980, 144 n. 498; cf. G. Koch, *Roman Funerary Monuments in the J. Paul Getty Museum* (Malibu, 1990) 1: 59–70. Such differentiation among the philosopher-advisers also occurs elsewhere, e.g., on the well-known sarcophagus from the Via Salaria in the Vatican (ex-Lateran 181): Koch-Sichtermann, fig. 123; *Repertorium* 1967, I 62, no. 66; pl. 21; *Age of Spirituality* 1979, 518f., no. 462; Himmelmann, 132f.

[16] For the *Feldherrn* sarcophagi, as well as sarcophagi with battles and weddings, see Koch-Sichtermann 1982, 90ff., 99ff., 106f.; G. Rodenwaldt, *Über den Stilwandel in der antoninischen Kunst,* AbhBerl (Berlin, 1935) no. 3, 3ff.; T. Hölscher, "Die Geschichtsauffassung in der römischen Repräsentationskunst," *JdI* 95 (1980) 288ff.

[17] Naples, Museo Nazionale; Koch-Sichtermann 1982, 102, fig. 203. Fundamental to the interpretation is Himmelmann 1962. V. M. Strocka's reading, in *JdI* 83 (1968) 221–31, of the middle scene as the dispute between the *vita activa* and the *vita contemplativa* is undermined by the outmoded supposition that there must be a narrative. On the interpretation see K. Fittschen, *JdI* 94 (1979) 589ff. The deceased need not be of consular rank, as Himmelmann assumed. He could be some lesser magistrate (cf. Goette 1989, 94), which for our purposes would not affect the essential meaning of the image. There is a fine example of a philosophical adviser in a scene of a Roman magistrate on a sarcophagus in the Museo Torlonia: B. Andreae, "Processus consularis," in *Opus Nobile, Festschrift U. Jantzen* (Wiesbaden, 1969) 3–13, pls. 1–2; N. Himmelmann, *Typologische Untersuchungen an römischen Sarkophagreliefs des 3. und 4. Jahrhunderts n. Chr.* (Mainz, 1973) 6ff., pl. 10.

[18] See K. Fittschen, *AA,* 1977, 319–26.

[19] D. Ahrens, *MüJb* 19 (1968) 232, figs. 3–4. I owe the parallel with Urania to Ewald (1993, 58), who cites other examples combining the toga with the *pallium*. It is unclear whether the "philosopher" bears portrait features.

[20] Marrou 1956, 450ff.; Brown 1980, 4.

[21] Wegner 1966 illustrates numerous examples. Cf. also Wilpert I–III; *Repertorium* 1967. There are, however, a great many more, as a glance through the photo archive of the German Archaeological Institute in Rome reveals (fiches 640–47). Ewald (1993) offers a provisional collection of the material.

[22] On the hunt sarcophagi see B. Andreae, *Die römischen Jagdsarkophage,* ASR 1.2 (Berlin, 1980). Cf. the fragmentary philosopher sarcophagus with the scene of a lion hunt on the back, Vatican, Museo Gregoriano Profano 9523; Andreae, 62, 181, no. 231, pl. 31.5; A. Vaccaro Melucco, *Sarcophagi romani di caccia al leone,* StMisc 2, 1963–64 (Rome, 1966) 22, no. 12, pls. 12, 28; 13, 29.

[23] Berger-Doer 1990, 417ff., no. 256. Cf. the comparanda in T. Hauser, *JAC* 3 (1960) 112ff.

[24] Ewald (1993, 41) suggests a different interpretation. Yet the contradictory iconography (see further below) seems to me to support my interpretation, in which I follow Berger-Doer. Contrast this with the bucolic philosophers or poets on the short sides of a Muse sarcophagus in Paris: Wegner 1966, 36f., no. 75, pl. 135; Baratte-Metzger 1985, 171, no. 84 (ca. 150–160). For the side of the Naples sarcophagus see Himmelmann 1980, 154, pl. 62a.

[25] As Himmelmann (1980, 138ff.) has demonstrated, the figure carrying a sheep was at first only a kind of bucolic shorthand and had nothing to do with Christian beliefs.

[26] *Repertorium* 1967, 306, no. 747, pl. 117; Gerke 1940, pls. 52, 58, 59f. For the interpretation see Himmelmann 1980, 133, 157, pl. 66; Deichmann 1983, 126f.

[27] Wegner 1966, 34f., no. 69, pl. 128b; Schumacher 1977, pls. 27a, 28c, 30. On depictions of Peter as a reader see W. Wischmeyer, in *Kerygma und Logos, Festschrift C. Andresen* (Göttingen, 1979) 482–95.

[28] Gerke 1940, 73ff., pl. 6, 2; *Age of Spirituality* 1979, 413, no. 371; *Frühchristliche Sarkophage* 1966, pl. 7.

[29] *C. Musonius Rufus,* ed. O. Hense (Leipzig, 1905) 58.13; *C. Musonio Rufo, Le diatribe e i frammenti minori,* ed. R. Laurenti (Rome, 1967) 64; cf.

Himmelmann 1975, 20. See also *RE* 16.1 (1933) 893ff., s.v. Musonius (K. von Fritz).

30 Ostia, Isola Sacra; Brenk 1977, pl. 69; *Repertorium* 1967, 435, no. 1938, pl. 166; Koch-Sichtermann 1982, 118, fig. 127; N. Himmelmann, "Sarcofagi romani a rilievo," *AnnPisa* ser. 3, 4.1 (1974) 164, pl. 14, 2. Cf. also the much-discussed sarcophagus lid in New York and the fragment in the Vatican with the shepherd-philosopher supposedly giving instruction: Himmelmann 1980, pls. 72, 62b.

31 For the sarcophagus lid in the Vatican with the scene of a country meal see *Repertorium* 1967, 97, no. 151, pl. 34; Amedick 1991, 169, no. 295, pl. 30, 1. Philosopher in a vintaging scene: T. M. Schmidt, "Ein römischer Sarkophag mit Lese- und Reiterszene," in Koch 1993, 205–18. For the mosaic from Arroniz, now Madrid, Museo Arqueológico Nacional, see J. M. Blasquez and M. A. Mesquiriz, *Mosaicos romanos de Navarra*, vol. 7 of *Corpus de mosaicos de España* (Madrid, 1985) 15, no. 2, pls. 3, 17, 50–54a; Theophilidou 1984, 291–304. On the mosaic from Oued-Atmenia, now lost, see Himmelmann 1975, 18, pl. 21.

32 See L. Schneider, *Die Domäne als Weltbild* (Wiesbaden, 1983); J. Matthews, *Western Aristocracies and Imperial Court, A.D. 364–425* (Oxford, 1975) 1–12.

33 See Fowden 1982, 56ff.

34 On the motif of the wagon journey see Amedick 1991, 49ff.; id., "Zur Ikonographie der Sarkophage mit Darstellung aus der Vita Privata und dem curriculum vitae eines Kindes," in Koch 1993, 143–53, who also discusses and illustrates (pls. 65, 2; 82, 4) the sarcophagus lid Rome, Museo Nazionale Romano 8942, with the married couple conversing (or perhaps the in-house philosopher with the mistress of the house). Cf. W. Weber, *Die Darstellungen einer Wagenfahrt auf römischen Sarcophagdeckeln und Loculus-Platten des 3. und 4. Jh. n. Chr.* (Rome, 1978).

35 For the quotation from Epiphanius of Cyprus see H. Koch, *Die altchristliche Bilderfrage nach den literarischen Quellen* (Göttingen, 1907) 62.

36 *Repertorium* 1967; Deichmann 1983, 118f.; H. Kaiser-Minn, in *Spätantike* 1983, 318–38.

37 On the origins of Christian art see the excellent survey, with extensive references, in Deichmann 1983, 107, and, on the early image of Christ, 160ff.

38 We must bear in mind here the change in fashion in the Late Severan

period. The long Late Antonine beard of which we have spoken (pp. 222ff.) was replaced by the short, stubbly beard of Caracalla and his successors. It is noteworthy, therefore, that Clement of Alexandria, in arguing in favor of beards, is referring explicitly to the traditional symbol of learning.

39 On the beard styles of the Christians see Sauer 1924, 309, 329; J. Wilpert, *Die Gewandung der Christen in den ersten Jahrhunderten* (Cologne, 1898). On the Carrand Diptych see n. 47 below.

40 For catacomb paintings showing gatherings of teacher and pupils see, for example, Wilpert 1903, pls. 126, 148, 155, 170, 177, 193.

41 For the child sarcophagus Louvre MA 1520, see Baratte-Metzger 1985, 31ff.; Amedick 1991, 140, no. 112, pl. 65, 1; Wegner 1966, 38, no. 77, pl. 145, and, for further examples, cf. 58, no. 139, pl. 59; 50, no. 127, pl. 120; and DAI Rome Photo Archive, fiche 646. For the mosaic from a mausoleum at Split see *Guide to the Archaeological Museum at Split* (Split, 1973) no. T7; N. Cambi, in *Römische Gräberstrassen,* ed. H. von Hesberg and P. Zanker, AbhMünch (Munich, 1987) 268.

42 The statuette is Rome, Museo Nazionale Romano 61565; F. Gerke, *Christus in der spätantiken Plastik* (Berlin, 1940) pls. 56–59; *Age of Spirituality* 1979, 524, no. 469. Cf. now Mathews 1993, 129. The suggestion of a modern reworking was made by N. Schumacher, in *Actes du Xe Congrès international d'archéologie chrétienne* (Vatican City and Thessaloniki, 1980) 2: 489–99, who erroneously believes that the type is derived from Serapis. M. Bergmann, however, informs me that there are good reasons for doubting this hypothesis.
 On the connection between representations of Christ teaching with the type of the frontally seated ancient wise man see Kollwitz 1936, 45ff.; Marrou 1938, 55ff.; Cumont 1942, 335f.

43 Arles, Musée d'Art Chrétien inv. 5; *Frühchristliche Sarkophage* 1966, 33, pl. 18, 1; Wilpert I, 46, 83, pl. 34, 3; F. Benoit, *Sarcophages paléochrétiens d'Arles et de Marseille,* Gallia Suppl. 5 (Paris, 1954) 35, no. 4, pl. 3.

44 For the image of Christ singled out among his disciples see, for example, the catacomb in the Via Latina; A. Ferrua, *Catacombe sconosciute: Una pinacoteca del IV. sec. sotto la via Latina* (Rome, 1990) 105f. For later examples in apse mosaics see J. Wilpert and W. N. Schumacher, *Die römischen Mosaiken der kirchlichen Bauten vom IV.–XIII. Jahrhundert* (Freiburg, 1916 and 1976) pl. 6 (Milan, S. Aquilino), pls. 19–22 (Rome, S. Pudenziana). For the mosaics in Rome, Villa Albani (from Sarsina), and Naples, Museo Nazionale (from Pompeii), see Richter I, 82, fig. 316; Helbig4 IV, 327, no. 3350 (K. Parlasca); Schefold 1943, 154, fig. 214. On the relationship of apse mosaic to cathedra,

which is referred to below, see now the important discussion of Mathews (1993, 113ff.).

45 The recent bibliography on this topic is collected by M. Lutz-Bachmann, "Hellenisierung des Christentums," in Colpe 1992, 77–98; L. Honnefelder, "Christliche Theologie und 'wahre Philosophie,'" ibid., 55ff. Cf. now Mathews (1993), who rightly stresses the connection between the image of the philosopher and that of Christ and rejects the association with the emperor.

46 See J. Vogt, "Der Vorwurf der sozialen Niedrigkeit des frühen Christentums," *Gymnasium* 82 (1975) 401–11.

47 On the interpretation of the Carrand Diptych see E. Konnowitz, "The Program of the Carrand-Diptychon," *ArtB* 66 (1984) 484–88; K. J. Shelton, "Roman Aristocrats, Christian Commissions: The Carrand Diptych," *JAC* 29 (1986) 166–80; C. Hahn, "Purification, Sacred Action, and the Vision of God," *Word and Image* 5.1 (1989) 71–84.

48 On the coexistence of the bearded and beardless images of Christ see Deichmann 1983, 149, 164; Dinkler 1980, 28f.; Sauer 1924, 303f. As has long been recognized, when both types appear on the same monument, the youthful Christ is usually the active performer of miracles, while the bearded Christ is more often the inspired teacher and, later, the lawgiver in majesty. In the mosaics of S. Apollinare Nuovo in Ravenna, for example, the type with beard, now getting even longer, first occurs in a scene of the Passion, while the Christ who journeys through the land preaching and working miracles is still shown as youthful. In a case like this, the beard seems to characterize him at a more mature age, that is, as a "realistic" trait. In this way the scenes suggest a narrative of his life and thus correspond to the lives of the philosophers recorded by Philostratus and Eunapius. This would accord well with the derivation of the youthful type from the iconography of heroes for which I shall argue.

49 Sauer 1924, 303f.

50 H. Kunckel, *Der römische Genius* (Heidelberg, 1974).

51 On the image of the bearded Christ see especially Sauer 1924, 303–29; *RAC* 3 (1957) 6ff., s.v. Christusbild (J. Kollwitz). Deichmann (1983, 161, with further references) argues persuasively against Dinkler 1980, 35ff., and B. Kötting, in *RAC* 13 (1986) 201, s.v. Haar.

52 For the polychrome plaques, Rome, Museo Nazionale Romano inv. 67606/7, see *Repertorium* 1967, 320ff., no. 773; D. Stutzinger, in *Spätantike*

1983, 607, no. 200; R. Sörries and U. Lange, *AntW* 17.3 (1986) 13–22. On the Karpokratians and the figure of Christ see Sauer 1924, 306.

53 See R. Warland, *Das Brustbild Christi: Studien zur spätantiken und früh-byzantinischen Bildgeschichte* (Rome, Freiburg, and Vienna, 1986).

54 Relief sarcophagus in Sant' Agnese fuori le mura: Wilpert I, 57, pl. 36, 1; *Repertorium* 1967, 303, no. 739, pl. 116; Dinkler 1980, 36, pl. 20, 29.

55 Some examples: the ceiling fresco from SS. Marcellino e Pietro (first half of the fourth century); J. Deckers, *Die Katakombe "Santi Marcellino e Pietro,"* vol. 1 (Vatican City, 1981) no. 3, folding pls. 2–3. Cf. also Wilpert 1903, pls. 154, 155, 181, 182b. Also the diptych Berlin, Staatliche Museen; W. F. Volbach, *Frühchristliche Kunst* (Munich, 1958) pl. 224; *Spätantike* 1983, 697, no. 272. Cf. M. Sotomayor, "Petrus und Paulus in der frühchristlichen Ikonographie," in *Spätantike* 1983, 199–210; H. P. L'Orange, *Likeness and Icon* (Odense, 1973) 32–42.

56 For the pyxis Berlin, Staatliche Museen, Sculpture inv. 563, see Volbach 1976, 104, no. 161, pl. 82.

57 On the elements drawn from Imperial art for the iconography of Christ see Kollwitz 1936, 56ff.; Kötzsche 1992. For a different view see now Mathews 1993. The most impressive example from the city of Rome may be found in the apse mosaic of Santa Prudenzia (ca. A.D. 400): Wilpert and Schumacher (supra n. 44) pls. 19–23. For the sarcophagus of Junius Bassus in the Vatican see F. Gerke, *Der Iunius Bassus Sarkophag* (Berlin, 1936); *Repertorium* 1967, 279ff., no. 680; Amedick 1991, 170, no. 300, pl. 13.

58 H. Forsyth and K. Weitzmann, *The Monastery of Saint Catherine at Mount Sinai* (Ann Arbor, 1973) 1: 11ff., pls. 103, 136–37; E. Kitzinger, *Byzantine Art in the Making* (London, 1977) 99–101, figs. 177–79; Brenk 1977, pl. 185; J. Elsner, "The Viewer and the Vision," *Art History* 17 (1994) 81–102.

59 See P. Cox, *Biography in Late Antiquity: A Quest for the Holy Man* (Berkeley, 1983); Fowden 1982; Brown 1980; Goulet 1981.

60 On the tomb of the Aurelii in the Via Manzoni see G. Bendinelli, *MemLinc* 28 (1922) 289–520; G. Wilpert, *MemPontAcc* 3.1.2 (1924), and cf. especially the detail view, pl. 22; Himmelmann 1975, 18, pl. 4.

61 G. Shaw, "Theurgy: Rituals of Unification in the Neoplatonism of Iamblichus," *Traditio* 41 (1985) 1–28; G. Fowden, *The Egyptian Hermes* (Cambridge, 1986) 126–41.

62 The basic discussion of this issue is Fowden 1982; cf. Brown 1980 and Cox (supra n. 59).

63 For the Socrates mosaic see Richter I, 82, fig. 315; G. M. A. Hanfmann, *HSCP* 60 (1951) 205–33; J. C. Balty, ed., *Actes du Colloque Apamée de Syrie* (Brussels, 1972) pl. 53, 1; Smith 1990, 151. Cf. the "School of the Anatomists": A. Ferrua, *La pittura della nuova catacomba di via Latina* (Rome, 1960) 70f., pls. 107, 102, fig. 11; Balty, pl. 53, 2.

64 Athens, Acropolis Museum inv. 1313; G. Dontas, *AM* 69–70 (1954–55) 147ff.; Bergmann 1977, 157 n. 637 (dated in the time of Theodosius); A. Frantz, *Agora,* vol. 26, *Late Antiquity, A.D. 267–700* (Princeton, 1988) 44, pl. 44c (on the purported find spot, in the so-called House of Proclus). Istanbul, Archaeological Museum inv. 2461; Inan-Alföldi-Rosenbaum 1979, 282, no. 274, pl. 252; N. Fıratlı, *La sculpture byzantine au Musée Archéologique Istanbul* (Paris, 1990) 18, no. 35, pl. 16. For the Aphrodisias head see Smith 1990, 144ff. The head Rome, Capitoline Museum Magazine inv. 3022 will be published for the first time in the forthcoming Fittschen-Zanker II. Among comparable portraits of unknown provenance are the following: Stockholm, National Museum NM Sk 136; L'Orange 1947, 100f., figs. 71–72; Winkes 1969, 247; Heidelberg, Archäologisches Institut; Hölscher 1982, 213ff. Add, too, the recut busts in Malibu published by J. Raeder, in *Ancient Portraits in the J. Paul Getty Museum* (Malibu, 1987) 1: 5–16. The removal of the edges of the bust could have resulted from reuse as a tondo. On the portrait type see L'Orange, 95ff.; Smith, 144ff.

65 Smith 1990.

66 G. Becatti, in *Scavi di Ostia* (Rome, 1969) 6: 78f., 139ff., pls. 55.2, 56; Brenk 1977, pl. 40; *Age of Spirituality* 1979, 363f., no. 340; 523f., no. 468; R. Meiggs, *Roman Ostia*² (Oxford, 1973) 588f.

67 On the nimbus see now the thorough compilation of material in A. Ahlquist, *Tradition och rörelse: Nimbusikonografin in den romerskantika och fornkristna konsten* (Helsinki, 1990), esp. 367: "Its primary significance can be connected with astral bodies, its symbolism belongs to the concepts of power and craft, to the divine craft that the nimbated figure possesses and with whose help he acts, directly or as a representative."

68 There is, however, a close convergence in the facial expressions between Christian and pagan, for example, in the image of John the Baptist on the throne of Archbishop Maximian in Ravenna. John's role as prophet and "pathfinder" is to some extent comparable to that of the pagan "holy man." Cf. Volbach (supra n. 55) pls. 227ff.

[69] See the collection of material in Smith 1990, 151. Cf. Alföldi-Rosenbaum 1982, which also deals with the contorniates.

[70] Smith 1990, 152; H. von Heintze, *RM* 71 (1964) 77–103, pls. 16–22 (on the portraits of Plato and Socrates); Winkes 1969.

[71] Bonn, F. J. Dölger Institute; H. von Heintze, *JAC* 6 (1963) 35ff., pls. 1–5; Richter II, 250, no. 7; Richter Suppl., fig. 1696a; Stähli 1991, 240.

[72] The head comes from the Baths of Scholastica in Ephesus: Selçuk Museum inv. 745; A. Bammer, R. Fleischer, and D. Knibbe, *Führer durch das Archäologische Museum in Selçuk-Ephesos* (Vienna, 1974) 68; S. Erdemgil et al., *Ephesus Museum Catalogue* (Istanbul, 1989) 34; Smith 1990, 140. I thank Maria Aurenhammer for the photograph reproduced here.

[73] Selçuk Museum inv. 755 (also from the Baths of Scholastica); Richter II, 233, no. 47, fig. 1636; Inan-Rosenbaum 1966, 146f., no. 187, pls. 101.2, 109; Smith 1990, 152.

[74] Richter II, 227, no. 2, figs. 1528–30; Fittschen 1991, 248, no. 26.

[75] Smith 1990, 132, pls. 6–7; Bergemann 1991, 159ff., which gives a history of the copies.

[76] L. Ibrahim, R. L. Scranton, and R. Brill, *Kenchreai: Eastern Port of Corinth,* vol. 2, *The Panels of Opus Sectile in Glass* (Leiden, 1976) 268f.; G. M. A. Hanfmann, in *Age of Spirituality, Symposium, New York, 1977* (New York, 1980) 78.

[77] Richter II, fig. 1382 (Aeschines), fig. 1409 (Demosthenes); Winkes 1969, esp. 237ff.; "Rom," no. 43f.

[78] See L. Paduano Faedo, "L'inversione del rapporto Poeta-Musa nella cultura ellenistica," *AnnPisa* ser. 2, 39 (1970) 1–10.

[79] Inv. 1409; Schefold 1943, 130; W. H. Schuchhardt, *Epochen der griechischen Plastik* (Baden-Baden, 1959) 112, fig. 91; Helbig[4] II, no. 1721 (H. von Steuben).

[80] For the diptych in Monza Cathedral see Schefold 1943, 184; Volbach 1976, 57, no. 68, pl. 39. Cf. the similar scene on an ivory plaque in Paris, Bibliothèque de l'Arsenal, where two poets listen to Erato as she plays the kithara: Volbach, 59, no. 71, pl. 41; *Age of Spirituality* 1979, 258, no. 241.

[81] Louvre SMG 46; Volbach 1976, 58, no. 69, pl. 40; *Age of Spirituality* 1979, 258, no. 242.

[82] Rossano, Archepiscopal Library (dated to the sixth century and

thought to be of Syrian origin); A. Munoz, *Il Codice di Rossano*, fascimile ed. (Rome, 1907); K. Weitzmann, *Spätantike und frühchristliche Buchmalerei* (Munich, 1977) 33 (with good color illustration).

[83] See R. A. Müller, *Geschichte der Universität* (Munich, 1990).

[84] Of the new pictorial types created in the third century B.C., that of the individual reflecting was most often passed on. In the imagery of the evangelists in book illuminations, a particularly popular type has the hand raised to the head in a contemplative gesture that we first saw in the portraits of Epicurus and his circle. But the Christian image is open to the viewer, the Scriptures lying before the evangelist turned so that he can read along. In this way the reflective gesture becomes an admonition to the reader. For a good overview of this material see A. M. Friend, Jr., "The Portraits of the Evangelists in Greek and Latin Manuscripts," in *Art Studies: Medieval, Renaissance, and Modern* (Cambridge, Mass., 1927) 115–47, with full illustrations.

SOURCES OF ILLUSTRATIONS

Photo Alinari: figs. 28, 53a, 160.

American School of Classical Studies, Kenchreai Excavations: fig. 77.

Photo Anderson: figs. 74, 90, 93.

Archäologisches Institut, Göttingen: figs. 45, 62, 75 (photos S. Eckhardt).

Austrian Archaeological Institute, Ephesos Excavation: fig. 174.

J. Balty: fig. 168.

Photo L. Beyer (Weimar): fig. 2.

J. Deckers: figs. 159a, 159b, 163.

Photo Despatin/Gobell: fig. 1.

Photo G. Fittschen-Badura: figs. 44b, 106, 113, 114, 118, 121a, 129, 133.

Forschungsarchiv für römische Plastik (Cologne): figs. 25, 41.

Fototeca Unione at the American Academy in Rome: fig. 65.

German Archaeological Institute (Athens): figs. 77, 82, 100, 116, 117, 137, 171 (photos G. Hellner).

German Archaeological Institute (Berlin): figs. 101, 103.

German Archaeological Institute (Cairo): fig. 91.

German Archaeological Institute (Istanbul): figs. 32, 170 (photos P. Steyer).

German Archaeological Institute (Rome): figs. 8, 21, 30, 36, 37, 80, 81, 83, 84, 110, 131, 142, 146–52, 162, 164.

Hirmer Photo Archive (Munich): figs. 22, 157, 161, 165.

G. Koch: fig. 145.

Kommission zur Erforschung des antiken Städtewesens at the Bavarian Academy of Sciences: fig. 102 (photo V. Brinkmann).

Photo Marburg: fig. 29.

Münzkabinett Berlin (H. D. Schultz): figs. 86b, 87.

Münzkabinett der Stadt Winterthur (H.-M. von Känel): figs. 86a, 86c, 86d, 88a–c.

Museum für Abgüsse Klassischer Bildwerke (Munich), Archive: figs. 4, 6, 15, 33, 70, 98.

D. Pandermalis: figs. 123–25.

R. R. R. Smith: figs. 168, 169, 176.

Author's photo archive: figs. 52, 85b.

The following are museum photos kindly provided by those museums named in the captions:

figs. 7, 9 (photo Kaufmann), 10, 11, 12 (photo J. Selsing), 13, 14, 16, 18, 24 (photo H. Koppermann), 27, 38 (photo H. Koppermann), 43, 44a, 44c, 44d, 47, 48, 50, 63, 66, 71, 72a, 72b, 78, 79, 89, 95, 96 (photo C. Koppermann), 97, 99, 104, 105, 107, 108, 115, 119, 120, 121–22 (see p.362 n.35), 127, 132, 134, 135, 144, 154 (photo D. Widmer), 155, 158, 173 (photo C. Koppermann), 178.

Photos of casts were provided by:

Museum für Abgüsse Klassischer Bildwerke (Munich), photos of casts in the museum's collection, by H. Glöckler unless otherwise indicated: figs. 5, 17, 26, 35, 39a, 39b, 40, 46 (photo C. Koppermann), 53a, 53b, 54 (reconstruction by S. Bertolin), 55, 57, 69 (photo C. Koppermann), 94.

The following are reproduced from the sources indicated:

fig. 3: *Max Klinger,* exh. cat. (Hildesheim, 1984) 6.

fig. 19: Schefold 1943, fig. 79.

fig. 20: *Ansigter,* Ny Carlsberg Glyptotek (Copenhagen, 1989) fig. 56.

fig. 22: P. R. Franke and M. Hirmer, *Die griechische Münze* (Munich, 1964) pl. 15.

fig. 23: F. Winter and E. Pernice, *Hellenistische Kunst in Pompeji,* vol. 5 (Berlin, 1932), p. 49.

figs. 31, 34: Diepolder 1931, pls. 23 and 45.2.

fig. 49: E. Rosenbaum, *A Catalogue of Cyrenaican Portrait Sculpture* (London, 1960) pl. 7.1.

fig. 51: *Enc. Photogr. de l'Art* II, TEL Paris, Louvre (Paris, 1936) 186a.

fig. 60: Richter II, fig. 1121.

fig. 73: ABr 619.

fig. 85a: *Antike Plastik* 4 (1965), pl. 28.

fig. 92: *Villa Albani* I, pl. 270.

fig. 109: F. Baratte, *Le trésor d'orfèvrerie romaine de Boscoreale* (Paris, 1986) 65.

fig. 112: *AJA* 46 (1942) pl. 11.

fig. 126: Richter III, fig. 2033.

fig. 128: ABr 438.

fig. 130: ABr 440.

fig. 131: R. Bianchi-Bandinelli, *Rom: Zentrum der Macht* (Munich, 1970) fig. 318.

fig. 136: Richter III, fig. 2037.

fig. 138: Baratte-Metzger 1985, 30.

fig. 140: Blanck 1992, 70.

fig. 141: E. Rosenbaum, *A Catalogue of Cyrenaican Portrait Sculpture* (London, 1960) pl. 45.1.

fig. 143: R. Delbrück, *Antike Porträts* (Bonn, 1912) pl. 14.

figs. 153a–d: Wegner 1966, nos. 31, 79, 81, 127.

fig. 156: Amedick 1991, pl. 39.1.

fig. 166: H. Forsyth and K. Weitzmann, *The Monastery of Saint Catherine at Mount Sinai* (Ann Arbor, 1973) 1: pl. 103.

fig. 172: *Ostia* VI (Rome, 1969), pl. 56.

fig. 175: reproduced from a photo at the Warburg Institute, London.

fig. 177: K. Weitzmann, *Spätantike und frühchristliche Buchmalerei* (Munich, 1977) 33.

BIBLIOGRAPHY

ABr

Arndt, P., and F. Bruckmann, eds. 1899–1942. *Griechische und römische Porträts*. Munich.

Age of Spirituality 1979

Age of Spirituality. 1979. Edited by K. Weitzmann. Exhibition catalogue, Metropolitan Museum of Art, 1977–78. New York.

Alföldi-Rosenbaum 1982

Alföldi-Rosenbaum, E. 1982, "Animae Sanctiores: Porträt-Galerien berühmter Griechen und Römer aus dem späten vierten Jahrhundert n. Chr." In *Pro Arte Antiqua, Festschrift H. Kenner,* 1: 11–22. Vienna.

Amedick 1991

Amedick, R. 1991. *Die Sarkophage mit Darstellungen aus dem Menschenleben*. Vol. 4, *Vita privata*. ASR 1.4. Berlin.

Andreae 1980

Andreae, B. 1980. "Antisthenes philosophos Phyromachos epoiei." In *Eikones, Festschrift H. Jucker,* 40–48. AntK-BH 12. Bern.

Balty 1978

Balty, J. C. 1978. "Une nouvelle réplique du Démosthènes de Polyeuctos." *BMusBrux* 50: 49ff.

Baratte-Metzger 1985

Baratte, F., and C. Metzger. 1985. *Musée du Louvre, Catalogue des sarcophages en pierre d'époques romaine et paléochrétienne*. Paris.

Bardon 1971

Bardon, H. 1971. "La notion d'intellectuel à Rome." *StClas* 13: 95–106.

Bayer 1983

Bayer, E. 1983. "Fischerbilder in der hellenistischen Plastik." Diss., Bonn.

Bergemann 1991

Bergemann, J. 1991. "Pindar: Das Bildnis eines konservativen Dichters." *AM* 106: 157–89.

Berger-Doer 1990	Berger-Doer, G. 1990. "Fischer-Hirten-Sarkophag für ein Ehepaar." In *Antike Kunstwerke aus der Sammlung Ludwig,* ed. E. Berger, 3: 417–36, no. 256. Basel.
Bergmann 1977	Bergmann, M. 1977. *Studien zum römischen Porträt des 3. Jahrhunderts n. Chr.* Bonn.
Bergmann 1978	———. 1978. *Marc Aurel.* Liebieghaus Monographie 2. Frankfurt.
Bieber 1961	Bieber, M. 1961. *The Sculpture of the Hellenistic Age.* New York.
Bieler I–II	Bieler, L. 1935, 1936. *Theios Aner.* Vols. 1–2. Vienna.
Billedtavler	*Ny Carlsberg Glyptotek, Billedtavler til Katalog et over antike kunstvaerker.* 1907. Copenhagen.
Birt 1907	Birt, Th. 1907. *Die Buchrolle in der Kunst: Archäologisch-antiquarische Untersuchungen zum antiken Buchwesen.* Leipzig.
Blanck 1992	Blanck, H. 1992. *Das Buch in der Antike.* Munich.
Boehringer 1935	Boehringer, R. 1935. *Platon: Bildnisse und Nachweise.* Breslau.
Boehringer-Boehringer 1939	Boehringer, R., and E. Boehringer. 1939. *Homer: Bildnisse und Nachweise.* Breslau.
Borbein 1973	Borbein, A. H. 1973. "Die griechische Statue des 4. Jahrhunderts v. Chr.: Formanalytische Untersuchungen zur Kunst der Nachklassik." *JdI* 88: 43–212.
Bowersock 1969	Bowersock, G. W. 1969. *Greek Sophists in the Roman Empire.* Oxford.
Bowie 1970	Bowie, E. L. 1970. "Greeks and Their Past in the Second Sophistic." *PastPres* 46: 5–6. Reprinted in *Studies in Ancient Society,* ed. M. I. Finley (London, 1974) 169.
Braun 1966	Braun, K. 1966. *Untersuchung zur Stilgeschichte bärtiger Köpfe auf attischen Grabreliefs und Folgerungen für einige Bildnisköpfe.* Munich.
Brenk 1977	Brenk, B., ed. 1977. *Spätantike und frühes Christentum.* Propyläen Kunstgeschichte Suppl. 1. Frankfurt and Berlin.

Brommer 1973 Brommer, F. 1973. "Zu den Bildnissen der Sieben Weisen." *AA*, 663–70.

Brown 1971 Brown, P. 1971. "The Rise and Function of the Holy Man in Late Antiquity." *JRS* 61: 80–101.

Brown 1980 ———. 1980. *The Philosopher and Society in Late Antiquity*. Protocol of the Colloquy of the Center of Hermeneutical Studies in Hellenistic and Modern Culture. Berkeley.

Buschor 1971 Buschor, E. 1971. *Das hellenistische Bildnis*. 2d ed. Munich.

Caizzi 1993 Caizzi, F. D. 1993. "The Porch and the Garden." In *Images and Ideologies* 1993, 303–29.

Colpe 1992 Colpe, C., L. Honnefelder, and M. Lutz-Bachmann, eds. 1992. *Spätantike und Christentum: Beiträge zur Religions- und Geistesgeschichte der griechisch-römischen Kultur und Zivilisation der Kaiserzeit*. Berlin.

Conze I–IV Conze, A. 1893–1922. *Die attischen Grabreliefs*. Vols. 1–4. Berlin.

Cumont 1942 Cumont, F. 1942. *Recherches sur le symbolisme funéraire des romains*. Paris.

Deichmann 1983 Deichmann, F. W. 1983. *Einführung in die christliche Archäologie*. Darmstadt.

Diepolder 1931 Diepolder, H. 1931. *Die attischen Grabreliefs des 5. und 4. Jh. v. Chr.* Berlin.

Dinkler 1980 Dinkler, E. 1980. "Christus und Asklepios." *SBHeid:* 2.

Dontas 1960 Dontas, G. 1960. *Eikones kathemenōn pneumatikōn anthrōpōn eis tēn archaian ellēnikēn technēn*. Athens.

Dontas 1971 ———. 1971. "Eikonistika B'." *ArchDelt* 26A: 16–33.

Ewald 1993 Ewald, B. Chr. 1933. "'Philosophen' auf römischen Sarkophagen." Master's thesis, Munich.

Fabricius 1992 Fabricius, J. 1992. "Die hellenistischen Totenmahlreliefs: Bürgerliche Selbstdarstellung auf Grabreliefs ostgriechischer Städte." Diss., Munich.

Fehr 1979 Fehr, B. 1979. *Bewegungsweisen und Verhaltensideale: Phy-*
 siognomische Deutungsmöglichkeiten der Bewegungsdarstel-
 lung an griechischen Statuen des 5. und 4. Jhs. v. Chr. Bad
 Bramstedt.

Fittschen 1972 Fittschen, K. 1972. Review of Wegner 1966. *Gnomon*
 44: 486 – 504.

Fittschen 1987 ————. 1987. "Die Bildnisstatue des Dichters Menan-
 der: Dokumentation der Überlieferung und Rekon-
 struktion." In *250 Jahre Georg-August-Universität Göt-*
 tingen, Ausstellung im Auditorium, 148ff. Exhibition
 catalogue. Göttingen.

Fittschen 1988 ————. 1988. *Griechische Porträts.* Darmstadt.

Fittschen 1991 ————. 1991. "Die Statue des Menander." *AM* 106:
 243 – 79.

Fittschen 1992a ————. 1992a. "Über das Rekonstruieren griechischer
 Porträtstatuen." In *Ancient Portraiture: Image and Mes-*
 sage, ed. T. Fischer-Hansen et al., 9 – 28. ActaHyp 4.
 Copenhagen.

Fittschen 1992b ————. 1992b. "Zur Rekonstruktion griechischer
 Dichterstatuen 2. Teil: Die Statuen des Poseidippos
 und des Ps.-Menander." *AM* 107: 229 – 71.

Fittschen-Zanker Fittschen, K., and P. Zanker. 1985, forthcoming; 1983.
I–III *Katalog der römischen Porträts in den Capitolinischen Museen*
 und den anderen kommunalen Sammlungen der Stadt Rom.
 Vols. 1 – 3. Mainz.

Fowden 1982 Fowden, G. 1982. "The Pagan Holy Man in Late An-
 tique Society." *JHS* 102: 33 – 59.

Fraser 1972 Fraser, P. M. 1972. *Ptolemaic Alexandria.* Oxford.

Friedländer I–IV Friedländer, L. 1922. *Darstellungen aus der Sittengeschichte*
 Roms in der Zeit von August bis zum Ausgang der Antonine.
 Vols. 1 – 4. 10th ed. Leipzig.

Frischer 1982 Frischer, B. 1982. *The Sculpted Word: Epicureanism and*
 Philosophical Recruitment in Ancient Greece. Berkeley.

Frühchristliche *Frühchristliche Sarkophage in Bild und Wort.* 1966. Edited
Sarkophage 1966 by F. W. Deichmann and Th. Klauser. AntK-BH 3.
 Bern.

Gauer 1968 Gauer, W. 1968. "Die griechischen Bildnisse der klas- sischen Zeit als politische und persönliche Denkmäler." *JdI* 83: 118–79.

Gerke 1940 Gerke, F. 1940. *Die christlichen Sarkophage der vorkonstan- tinischen Zeit*. Berlin.

Giuliani 1980 Giuliani, L. 1980. "Individuum und Ideal: Antike Bild- niskunst." In *Bilder vom Menschen in der Kunst des Abend- landes*, 41ff. Exhibition catalogue. Berlin.

Giuliani 1986 ———. 1986. *Bildnis und Botschaft: Hermeneutische Untersuchungen zur Bildniskunst der römischen Republik*. Frankfurt.

Goette 1989 Goette, H. R. 1989. *Studien zu römischen Togadarstellung- en*. Mainz.

Goulet 1981 Goulet, R. 1981. "Les vies des philosophes dans l'anti- quité tardive et leur portée mystérique." In *Les actes apo- cryphes des apôtres: Christianisme et monde païen*, 161–207. Geneva.

Greek Renaissance 1989 *The Greek Renaissance in the Roman Empire*. 1989. Edited by S. Walker and A. Cameron. Papers from the Tenth British Museum Classical Colloquium. London.

Griffin 1989 Griffin, M., ed. 1989. *Philosophia togata*. Oxford.

Habicht 1988 Habicht, C. 1988. "Hellenistic Athens and Her Philo- sophers." David Magie Lecture, Princeton University.

Hadot 1981 Hadot, P. 1981. *Exercices spirituels et philosophie antique*. Paris.

Hafner 1954 Hafner, G. 1954. *Späthellenistische Bildnisplastik: Versuch einer landschaftlichen Gliederung*. Berlin.

Hahn 1989 Hahn, J. 1989. *Der Philosoph und die Gesellschaft: Selbst- verständnis, öffentliches Auftreten und populäre Erwartung- en in der hohen Kaiserzeit*. Stuttgart.

Hausmann 1980 Hausmann, U. 1980. "Zum Bildnis des Dichters Theo- krit." In *Stele: Gedenkschrift N. Kontoleon*, 511–24. Athens.

von Heintze 1961 von Heintze, H. 1961. "Zu Poseidippos und 'Menander' im Vatikan." *RM* 68: 80–92.

von Heintze ————. 1977a. "Die erhaltenen Darstellungen der sie-
1977a ben Weisen." *Gymnasium* 84: 437ff.

von Heintze ————. 1977b. "Zu den Bildnissen der sieben Weisen."
1977b In *Festschrift F. Brommer*, 163–73. Mainz.

Hekler 1912 Hekler, A. 1912. *Die Bildniskunst der Griechen und Römer.*
 Stuttgart.

Hekler 1940 ————. 1940. *Bildnisse berühmter Griechen.* 1962. 3d ed.,
 revised by H. von Heintze. Mainz.

Helbig⁴ I–IV Helbig, W. 1963–72. *Führer durch die öffentlichen
 Sammlungen klassischer Altertümer in Rom.* Vols. 1–4.
 4th ed. Tübingen.

Himmelmann Himmelmann, N. 1962. "Sarkophag eines gallienischen
1962 Konsuls." In *Festschrift F. Matz*, 110–24. Mainz.

Himmelmann ————. 1975. *Das Hypogäum der Aurelier am Viale Man-
1975 zoni: Ikonographische Beobachtungen.* AbhMainz 7. Mainz.

Himmelmann ————. 1980; *Über Hirten-Genre in der antiken Kunst.*
1980 Opladen.

Hölscher 1975 Hölscher, T. "Die Aufstellung des Perikles-Bildnisses
 und ihre Bedeutung." *WürzJbb* N.F. 1: 187–99.

Hölscher 1982 ————. 1982. "Ein Weiser in Heidelberg: Zum Ver-
 hältnis von typisierender und individueller Darstellungs-
 weise in römischen Bildnissen." In *Römisches Porträt*
 1982, 213–15.

von den Hoff von den Hoff, R. 1994. *Philosophenporträts des Früh- und
1994 Hochhellenismus.* Munich.

Images and Ideolo- *Images and Ideologies: Self-Definition in the Hellenistic
gies* 1993 World.* 1993. Edited by A. Bulloch et al. Berkeley.

Inan-Alföldi- Inan, J., and E. Alföldi-Rosenbaum. 1979. *Römische und
Rosenbaum 1979 frühbyzantinische Porträtplastik aus der Türkei: Neue Funde.*
 Mainz.

Inan-Rosenbaum Inan, J., and E. Rosenbaum. 1966. *Roman and Early Byz-
1966 antine Portrait Sculpture in Asia Minor.* London.

Johansen 1992 Johansen, F. 1992. *Greek Portraits.* Catalogue, Ny Carls-
 berg Glypotek. Copenhagen.

Jones 1986	Jones, C. P. 1986. *Culture and Society in Lucian.* Cambridge, Mass.
Jucker 1968	Jucker, H. 1968. "Zur Bildnisherme des Parmenides." *MusHelv* 25: 181ff.
Koch 1993	Koch, G., ed. 1993. *Grabeskunst der römischen Kaiserzeit.* Mainz.
Koch-Sichtermann 1982	Koch, G., and H. Sichtermann. 1982. *Römische Sarkophage.* Munich.
Kötzsche 1992	Kötzsche, L. 1992. "Das herrscherliche Christusbild." In Colpe 1992, pp. 99–123. Berlin.
Kollwitz 1936	Kollwitz, J. 1936. "Christus als Lehrer und die Gesetzesübergabe an Petrus in der konstantinischen Kunst Roms." *RömQSchr* 44: 45–66.
Kruse-Berdoldt 1975	Kruse-Berdoldt, V. 1975. "Kopienkritische Untersuchungen zu den Porträts des Epikur, Metrodor und Hermarch." Diss., Göttingen.
Laubscher 1982	Laubscher, H. P. 1982. *Fischer und Landleute: Studien zur hellenistischen Genreplastik.* Mainz.
Lauer-Picard 1955	Lauer, J.-Ph., and Ch. Picard. 1955. *Les statues ptolémaïques du Sarapieion de Memphis.* Paris. Reviewed by F. Matz, *Gnomon* 29 (1957) 84ff.
Laurenzi 1941	Laurenzi, L. 1941. *Ritratti greci.* Florence. Reprinted, with bibliography, 1969.
Lefkowitz 1981	Lefkowitz, M. R. 1981. *The Lives of the Greek Poets.* London.
Lippold 1912	Lippold, G. 1912. *Griechische Porträtstatuen.* Munich.
Long 1986	Long, A. A. 1986. *Hellenistic Philosophy.* 2d ed. Berkeley.
Long-Sedley 1987	Long, A. A., and D. N. Sedley. 1987. *The Hellenistic Philosophers.* Vols. 1–2. Cambridge.
L'Orange 1947	L'Orange, H. P. 1947. *Apotheosis in Ancient Portraiture.* Oslo.
Lorenz 1965	Lorenz, Th. 1965. *Galerien von griechischen Philosophen- und Dichterbildnissen bei den Römern.* Mainz.

Lorenz 1977 ———. 1977. "Das Bildnis des Sokrates." In *Perspektiven der Philosophie, Neues Jahrbuch,* 255ff.

Marrou 1938 Marrou, H.-I. 1938. *Mousikos Aner: Étude sur les scènes de la vie intellectuelle figurant sur les monuments funéraires romains.* Grenoble.

Marrou 1956 ———. 1956. *A History of Education in Antiquity.* New York. French original: *Histoire de l'éducation dans l'antiquité* (Paris, 1948).

Mathews 1993 Mathews, T. F. 1993. *The Clash of Gods: A Reinterpretation of Early Christian Art.* Princeton.

Metzler 1971 Metzler, D. 1971. *Porträt und Gesellschaft: Über die Entstehung des griechischen Porträts in der Klassik.* Münster. Reviewed by L. Schneider, *Gnomon* 46 (1974) 397ff., and by D. Pandermalis, *BJb* 173 (1973) 531f.

H. Meyer 1991 Meyer, H. 1991. *Antinoos.* Munich.

M. Meyer 1989 Meyer, M. 1989. "Alte Männer auf attischen Grabstelen." *AM* 104: 49–82.

Michalowski 1932 Michalowski, C. 1932. *Les portraits hellénistiques et romains.* Vol. 13 of *Délos.* Paris.

Minakaran-Hiesgen 1970 Minakaran-Hiesgen, E. 1970. "Untersuchungen zu den Porträts des Xenophon und des Isokrates." *JdI* 85: 112–57.

Mitchel 1970 Mitchel, F. W. 1970. "Lycourgan Athens, 338–322 B.C." Lectures in Memory of Louise Taft Sample, University of Cincinnati.

Neudecker 1988 Neudecker, R. 1988. *Die Skulpturenausstattung römischer Villen in Italien.* Mainz.

Pandermalis 1971 Pandermalis, D. 1971. "Zum Programm der Statuenausstattung in der Villa dei Papiri." *AM* 86: 173–209.

Pfuhl 1927 Pfuhl, E. 1927. *Die Anfänge der griechischen Bildniskunst: Ein Beitrag zur Geschichte der Individualität.* 2d ed. Munich. Reprinted in Fittschen 1988, 224–52.

Pfuhl-Möbius I–II Pfuhl, E., and Möbius, H. 1977, 1979. *Die ostgriechischen Grabreliefs.* Vols. 1–2. Mainz.

F. Poulsen 1931 Poulsen, F. 1931. "Iconographic Studies in the Ny Carlsberg Glyptotek. In *From the Collections of the Ny Carlsberg Glyptotek,* 1: 1–95. Copenhagen.

V. Poulsen 1954 Poulsen, V. 1954. *Les portraits grecs.* Copenhagen.

V. Poulsen I–II ———. 1962, 1974. *Les portraits romains.* Vols. 1–2. Copenhagen.

Repertorium 1967 *Repertorium der christlichantiken Sarkophage.* 1967. Vol. 1, *Rom und Ostia.* Edited by F. W. Deichmann and revised by G. Bovini and H. Brandenburg. Wiesbaden.

Richter 1962 Richter, G. M. A. 1962. "How Were the Roman Copies of Greek Portraits Made?" *RM* 69: 52–58.

Richter I–III, Suppl. ———. 1965, 1972. *The Portraits of the Greeks.* Vols. 1–3 and Supplement. London.

Richter 1965 ———. 1965. "The Origin of the Bust Form for Portraits." In *Festschrift A. Orlandos,* 1: 59–62.

Richter-Smith 1984 Richter, G. M. A., and R. R. R. Smith. 1984. *The Portraits of the Greeks.* Ithaca, N.Y.

Römisches Porträt 1982 *Römisches Porträt: Wege zur Erforschung eines gesellschaftlichen Phänomens.* 1982. Wissenschaftliche Konferenz, 12.–15. Mai 1981, WissZBerl 2–3. Berlin.

Sassi 1988 Sassi, M. M. 1988. *La scienza dell'uomo nella Grecia antica.* Turin.

Sauer 1924 Sauer, J. 1924. "Das Aufkommen des bärtigen Christustypus in der frühchristlichen Kunst." In *Strena Buliciana,* 303–29. Zagreb.

Schefold 1943 Schefold, K. 1943. *Die Bildnisse der antiken Dichter, Redner und Denker.* Basel.

Schefold 1965 ———. 1965. *Griechische Dichterbildnisse.* Zurich.

Schefold 1980 ———. 1980. "Ariston von Chios." In *Eikones, Festschrift H. Jucker,* 160–67. AntK-BH 12. Bern.

Schefold 1982 ———. 1982. "Die Überlieferung der griechischen Bildniskunst." In *Praestant Interna, Festschrift U. Hausmann,* 79–90. Tübingen.

Scheibler 1989 Scheibler, I. 1989. "Zum ältesten Bildnis des Sokrates." *MüJb* 3d ser., 40: 7–33.

Schumacher 1977 Schumacher, W. N. 1977. *Hirt und "Guter Hirt": Studien zum Hirtenbild in der römischen Kunst vom 2. bis zum Anfang des 4. Jh. unter besonderer Berücksichtigung der Mosaiken in der Südhalle von Aquileja.* RömQSchr Suppl. 34. Rome and Freiburg.

Settis 1972 Settis, S. 1972. "Severo Alessandro e i suoi lari (S.H.A., S.A. 29, 2–3)." *Athenaeum* 50: 237–51.

Simon 1976 Simon, E. 1976. *Die griechischen Vasen.* Munich.

Sittl 1890 Sittl, C. 1890. *Die Gebärden der Griechen und Römer.* Leipzig.

Smith 1990 Smith, R. R. R. 1990. "Late Roman Philosopher Portraits from Aphrodisias." *JRS* 80: 127–55.

Smith 1993 ———. 1993. "Kings and Philosophers." In *Images and Ideologies* 1993, 202–11.

Sokrates 1989 *Sokrates in der griechischen Bildniskunst.* 1989. Exhibition catalogue, Glyptothek München. Munich.

Spätantike 1983 *Spätantike und frühes Christentum.* 1983. Exhibition catalogue, Liebieghaus Frankfurt. Frankfurt.

Stähli 1991 Stähli, A. 1991. "Die Datierung des Karneades-Bildnisses." *AA,* 219–52.

Stemmer 1988 Stemmer, K., ed. 1988. *Kaiser Marc Aurel und seine Zeit.* Exhibition catalogue, Abgußsammlung. Berlin.

Stewart 1979 Stewart, A. 1979. *Attika: Studies in Athenian Sculpture of the Hellenistic Age.* London.

Strocka 1993 Strocka, V. M. 1993. "Pompeji VI 17,41: Ein Haus mit Privatbibliothek." *RM* 100: 321–51.

Studniczka 1918 Studniczka, F. 1918. "Das Bildnis Menanders." *Neue Jahrbücher für das klassische Altertum, Geschichte und deutsche Literatur* 21: 1–31. Reprinted in Fittschen 1988, 185ff.

Theophilidou 1984 Theophilidou, E. 1984. "Die Musenmosaiken der römischen Kaiserzeit." *TrZ* 47: 243–348.

Thielemann-Wrede 1989	Thielemann, A., and H. Wrede. 1989. "Bildnisstatuen stoischer Philosophen." *AM* 104: 109–55.
Villa Albani I–III	*Forschungen zur Villa Albani: Katalog der antiken Bildwerke.* 1988–92. Vols. 1–3. Edited by P. C. Bol. Berlin.
Volbach 1976	Volbach, W. F. 1976. *Elfenbeinarbeiten der Spätantike und des frühen Mittelalters.* 3d ed. Mainz.
Voutiras 1980	Voutiras, E. 1980. "Studien zu Interpretation und Stil griechischer Porträts des 5. und frühen 4. Jahrhunderts v. Chr." Diss., Bonn.
Wegner 1966	Wegner, M. 1966. *Die Musensarkophage.* ASR 5.3. Berlin.
Weiher 1913	Weiher, A. 1913. "Philosophen und Philosophenspott in der attischen Komödie." Diss., Munich.
Wiegartz 1965	Wiegartz, H. 1965. *Kleinasiatische Säulensarkophage.* Berlin.
Wilpert I–III	Wilpert, G. 1929–36. *I sarcofagi cristiani antichi.* Vols. 1–3. Rome.
Wilpert 1903	Wilpert, J. 1903. *Die Malereien der Katakomben Roms.* Freiburg.
Winkes 1969	Winkes, R. 1969. *Clipeata imago: Studien zu einer römischen Bildnisform.* Bonn.
Wrede 1981	Wrede, H. 1981. *Consecratio in formam deorum: Vergöttlichte Privatpersonen in der römischen Kaiserzeit.* Mainz.
Wrede 1982	———. 1982 "Bildnisse epikuräischer Philosophen." *AM* 97: 235–45.
Wrede 1985	———. 1985. *Die antike Herme.* Mainz.
Zanker 1982	Zanker, P. 1982. "Herrscherbild und Zeitgesicht." In *Römisches Porträt* 1982, 307–12.
Zanker 1988	———. 1988. *The Power of Images in the Age of Augustus.* Translated by A. Shapiro. Ann Arbor.
Zanker 1993	———. 1993. "The Hellenistic Grave Stelai from Smyrna: Identity and Self-Image in the Polis." In *Images and Ideologies* 1993, 212–30.

Zinserling 1969 Zinserling, V. 1969. "Realistische Bildniskunst der
 Griechen: Anfänge und frühe Entwicklung." *WissZJena*
 18: 187ff.

Zwierlein-Diehl Zwierlein-Diehl, E. 1986. *Glaspasten im Martin von Wag-*
1986 *ner Museum der Universität Würzburg.* Vol. 1. Munich.

INDEX LOCORUM

MUSEUM INDEX

(inventory numbers, if available, in parentheses)

Designer: Janet Wood
Compositor: G&S Typesetters, Inc.
Text: 11/14 Bembo
Display: Bembo
Printer: Malloy Lithographing, Inc.
Binder: Malloy Lithographing, Inc.